The Planting Design Handbook

Second Edition

To my parents, Arthur and Margaret Robinson

The Planting Design Handbook

Second Edition

Nick Robinson

Illustrations by Jia-Hua Wu

ASHGATE

Published by
Ashgate Publishing Limited
Gower House
Croft Road
Aldershot
Hants GU11 3HR
England

Ashgate Publishing Company
Suite 420
101 Cherry Street
Burlington, VT 05401–4405
USA

Ashgate website: http://www.ashgate.com

British Library Cataloguing in Publication Data
Robinson, Nick, 1954–
 The planting design handbook. – 2nd ed.
 1.Planting design 2.Landscape architecture
 I.Title
 715

 ISBN 0754630358

Library of Congress Cataloging-in-Publication Data
Robinson, Nick, 1954–
 The planting design handbook / Nick Robinson -- 2nd ed.
 p. cm.
 Includes bibliographical references.
 ISBN 0-7546-3035-8
 1. Planting design. 2. Landscape design. I. Title.

 SB472.45.R64 2003
 712'.6--dc21

 2003045231
ISBN 0 7546 3035 8

Reprinted 2004, 2006

Typeset by Bournemouth Colour Press, Parkstone, Poole, UK.
Printed and bound in Great Britain by MPG Books Ltd., Bodmin, Cornwall.

Contents

Figures

All drawings are by Jia-Hua Wu, Head of the Environmental Art Department, Zhejiang Academy of Fine Arts, Hangzhou, China, except where otherwise indicated.

Plates

All photos are by the author unless otherwise credited.

Derbyshire, UK. They combine well with climbers and other planted species.

277

Tables

Acknowledgements

I am indebted to many people who have influenced and inspired me in my study, practice and teaching of landscape design. Their enthusiasm and ideas have led, ultimately, to the writing of this book.

I would like to acknowledge my particular gratitude to those people who have had a direct influence on its production. Wu Jia-Hua of the Zhejiang Academy of Fine Arts in Hangzhou, China, has made a major contribution with his engaging and informative sketches and also through our many inspiring conversations about design. Many of the plans were drawn by Stella Lewis in her lively, informal but highly effective style. Oliver Gilbert and Owen Manning of the University of Sheffield and Dan Lewis of Sheffield City Council have offered valuable comment on particular chapters of the book and have helped me to refine and develop these. For the second edition, Landscape Architect Julia Williams provided valuable feedback from a New Zealand perspective. Kenneth Warr and the late Jean Warr's editorial advice, word-processing skills and enthusiasm for the project were invaluable, particularly during the more difficult early stages. Many students at the Universities of Sheffield and Gloucestershire in the UK, Cal Poly at San Luis Obispo, California, and Lincoln in New Zealand have been encouraging and supportive, and have always offered valuable advice when asked what they would hope to find in a book on planting design. Most of all, I hope this book provides a valuable resource and an inspiration for them and other students of design in the landscape.

I would also like to thank all the practices that generously offered and provided examples of professional drawings. These have been invaluable as a means of illustrating the processes and procedures discussed in the book.

Finally, I thank my partner Kris Burrows for her constant interest and advice despite the long hours I spent on the mostly private pursuit of writing.

Preface to the Second Edition

This second edition of *The Planting Design Handbook* has been comprehensively revised to account for developments in planting design practice and theory in the ten years since the book was first published. The design of the book itself has also been improved, to give greater emphasis to the visual nature of the subject.

A particular feature of this edition is the inclusion of many examples from parts of the world in addition to north-west Europe. New Zealand features strongly in both text and illustrations because of the author's practice in that country, and because of the need for a book on planting design that addresses the distinctive character of the vegetation and of planting design there. Although the flora of New Zealand is quite unique, its ecology has links with that of other warm temperate and humid subtropical regions, so the new material will be instructive for designers working in those climates in other regions. Further examples have been added from other countries, ranging from the United States to Singapore, in order to illustrate the application of design principles in a wide range of climates and within different cultural settings. It is hoped that the inclusion of these international examples will make the handbook widely relevant as well as inspiring designers by illustrating contrasting approaches and different plant palettes.

An international focus brings not only interest and variety, but also raises important issues of plant selection. First, plants must be well suited to the climate of the site. The plants illustrated in the plates and given as examples in the text, are from a range of climates and the designer should check on suitability and availability in his or her own region of work. To help the designer and student the location of photos has been given whenever possible. Second, an understanding of both cultural and ecological context is important when designing with plants within an existing ecosystem. A plant that is a choice ornamental in one place (requiring expert care to keep it alive and in good health) may be a serious pest in another (requiring costly management to keep it from degrading local biodiversity) – one man's treasure is another man's rubbish. The reverse also applies – plants that are regarded as worthless in one culture may be of great botanical or technological interest in another. The designer should always check that the species proposed would not become pests, and that those to be removed may not have a special value to another culture or in another context. The examples given in this book are intended only to illustrate design principles and are not recipes for planting. As a general rule, no plant should be used in design without a thorough knowledge of its suitability for the local environment, ecology and culture.

Introduction

Planted vegetation is an essential part of our environment. The human landscape we inhabit results from our manipulation of the inorganic substances and the organic life forms of Earth. As soon as we consciously modify the vegetation in our human home, whether to farm, to build or to make a garden, then we create possibilities for design with plants. This book is about how to use plants in the planned, designed and managed landscapes of the twenty-first century.

When we design with plants, we design with nature. This is true whether we are re-building eroded slopes, re-vegetating cleared forest, or measuring out an urban garden, because all plants are living, growing, changing things that form part of the dynamic pattern of the natural world. This makes plants quite different to any other medium of design. That their medium is alive is the planting designer's greatest asset; it is also their biggest challenge. They must understand natural forms, processes and interactions as well as visual and spatial phenomena. To design with nature does not equate with attempting to imitate natural forms, rather, it means understanding and working with living processes.

In my work as an educator in landscape architecture and horticulture, and in my professional experience as a landscape architect, I am aware of the need for a comprehensive and focused treatment of planting design. It is my belief – indeed it is the premise of this book – that planting design is fundamental to landscape design and to landscape architecture. Planting design can, and should, determine space and form in the landscape, in both rural and urban places, and at scales great and small. To relegate planting to the mere filling of shapes determined by a greater design concept, is to regard it as if it were a paving material or a walling unit. Planting is the one medium that makes landscape design unique among design disciplines and by using its full potential with confidence and innovation designers in the landscape can develop a distinctive professional profile.

The visual and spatial qualities of planting are fundamental to its aesthetic impact and this book is an attempt to provide a systematic examination of these effects. In particular, I would like to help convey the exciting potential of plants as a three-dimensional design medium. At the same time, I hope to show how lasting success with plants is deeply dependent upon an appreciation of plant form and natural processes.

In the text, I commonly refer to the 'planting designer'. This is not a professional title; rather it is a reference to the professional doing the planting design. The 'planting designer' will often be a landscape architect. Because planting design is an integral part of landscape design, much of the advice

contained here will be relevant to the process of landscape design in general, so I hope the book will be particularly helpful to that profession. The book is also aimed directly at professionals working in amenity horticulture, whether they are responsible for private gardens, public plantings or corporate landscapes. In addition, it will be relevant to urban designers, architects and civil engineers, because it can help them solve aesthetic and technical problems that they encounter, and because buildings, roads, bridges and other structures often need planting to help them achieve good site planning.

Some of the principles of spatial and visual design discussed here are shared by architecture and other three-dimensional design disciplines. All are concerned with the qualities and experience of form/space and pattern. This book aims to show both what planting designers have in common with other designers, as well as to explore what makes living plants a unique medium for design. I hope that the common ground revealed by this approach will help to promote shared inspiration among everybody who is working for a better environment.

The first part of this book will examine the principles of design with plants. It will explore in depth the formal qualities of planting and consider the underlying relationship between these and the ecological and horticultural characteristics of vegetation. Planting design is a visual subject, so I will rely heavily on drawings and diagrams to support and complement the text. I hope that these pictures will provide a parallel story to the text.

The second part will explore the diversity of processes by which designers develop an idea or solve a design problem. It will trace the design from project inception to its realization on the ground and will show how design principles can be applied through design procedures. In this way, it will demonstrate how well-devised procedures can help the creative process. Each stage is illustrated with examples of professional drawings produced by landscape architects in practice and students in training. Note, however, that I shall not attempt to give comprehensive advice on the management of landscape commissions or planting contracts. This is the subject of a number of publications on professional practice, for example, Hugh Clamp's *Landscape Professional Practice* (1989).

The final part of the book is entitled Practice. This will attempt to identify good design technique and illustrate good practice in the choice and arrangement of species for various kinds of planting. Examples of drawings of actual projects prepared by landscape designers are used throughout to demonstrate the recommendations of the text.

The text contains numerous plant names. Both scientific names (in italics) and local/common/vernacular names have been given whenever possible. The scientific name helps us to understand the position of a plant in the scientifically ordered plant kingdom while local names help to give some picture of the plant's cultural importance. Where no common name is given this is normally because no such name is in widespread use or because the common name is the same as or unmistakeably similar to the scientific name (for example *Rosa* = rose). If the reader has any doubt about the identity or common name of a tree or shrub they can use reference works such as Mark Griffiths (1994), *Index of Garden Plants*, Macmillan; Geoff Bryant (1997) *Botanica*, Bateman; and Hillier Nurseries (1991) *The Hillier Manual of Trees and Shrubs*, 5th edn, David and Charles. Readers interested in the Maori names of New Zealand plants are referred to James Beever's *A Dictionary of Maori Plant Names* (1991), Auckland Botanical Society. Botanical, ecological and horticultural terms are explained as they are introduced into the text. If further information on such necessary jargon is needed, *The Penguin Dictionary of Botany* (1984), published by Allen Lane, is a comprehensive reference tool.

Principles

Why Design?

What is the purpose of planting design? Plants grow in great quantity and diversity in all sorts of places without, often in spite of, our attentions, so it is quite reasonable to question the role of planting in environmental planning and landscape architecture.

The answer is, I believe, threefold. First, landscape design helps us to make the best use of our environment. A landscape that is truly functional is one that provides for breadth of use and human involvement, rather than narrow exploitation or segregation by a single interest. Planting design is an essential element in making and managing this kind of people-place. Words such as liveliness, complexity, subtlety, resilience, flexibility and sustainability all help to describe the design potential we can unlock with intelligent planting.

Second, planting design helps us to restore and maintain a sustainable relationship between people and their environment in a context of change. It does this by helping to conserve valuable ecological systems and in creating or reconstructing habitats. It also helps simply by introducing green space where before there was only grey space.

Last, but not least, planting design offers aesthetic delights as complex and intense as those found in galleries or exhibitions. Its aesthetic impact can be thought-provoking, soothing, exciting and so on – according to the intentions of the designer and the state of his or her soul. In the realm of the senses, the sights, scents and sensations of plants, even the sound made by wind and rain in leaves and branches – all these add to the quality of daily life. Such aesthetic quality is often hard to quantify, but its effect on well-being can be profound.

These three reasons for planting design – use, ecology, and aesthetics – are not independent. Consider a landscape that gets its basic spatial order from the demands of cultivation and husbandry. A classic example of this was the English countryside of hedged fields, which arose largely from the enclosure of open fields in the eighteenth and nineteenth centuries. This ordered framework provided not only containment and shelter for stock but, as it matured, became an extensive and diverse wildlife habitat. As well as its role in farming and wildlife the English countryside became one of the nation's great assets, attracting tourists from around the world and representing a key part of the national identity. It signified a benign balance between production, nature and beauty. However, its integrated character is now fading fast under extreme pressure from modern farming techniques and urban development.

Without forgetting the interrelationships, let us look a little more closely at each aspect in turn.

Planting Design – an Expression of Function

Throughout history the arrangement and cultivation of plantings has expressed human use of the land. This has been the case not only with the cultivation of food, timber and other crops but also in planting which was intended not for economic production, but for recreational use. The forms of the earliest pleasure gardens in Persia were adapted from the agricultural landscape of the fertile river plain with its irrigation canals and regularly spaced fruit trees. In eighteenth- and nineteenth-century England, hedges planted to enclose fields were planned to improve farming efficiency and increase profits. The shelter, containment and image of productive order that these hedges provided also helped to give the English pastoral landscape a distinctive scenic character. The relationship between usefulness and aesthetic reference is demonstrated by the common structural role of the hedge in English gardens and parks from the nineteenth century onwards. The garden hedge is an echo of the hedged enclosures of the English lowland countryside – it performs a related role, but on a smaller scale.

The character and purpose of planting design is as varied as human use of the land. The landscape designer allows for all kinds and levels of activity ranging from rare visits to private or near inaccessible landscapes to intensive multiple use of the public realm in urban centres. Planting design has a role in the landscapes where we live, play, work, study, gather for community functions, and where we enjoy our leisure. All these places need an environment that fits and facilitates our needs. It must provide the right amount of space, the right microclimate and the right scale and character, as well as specific facilities like a path, a seat, lighting and so on. To make a comparison, the furniture designer creates a seat to sit on; the planting designer creates a place to sit in. The planting is part of an environment that fits the function.

Many activities require buildings, roads, car parks, waterways and other built structures. Planting design is much more than a cosmetic treatment to be applied to indifferent or insensitive architecture and engineering in order to 'soften' the harsh edges or disguise an awkward layout. It plays a major role in integrating structures in the environment by reducing their visual intrusiveness, by repairing damage to existing ecosystems and, more positively, by creating a setting which is comfortable, attractive and welcoming. New planting, as well as conservation of existing, is an essential element in good site planning for many types of land use.

If well designed, planting is an apt expression of function and of the needs of the users. A children's play area makes a good example. The basic provision of equipment like swings and climbing structures allows children to engage in activities, but it does not create the best environment for play. This needs more. It needs a defined and welcoming place, separation from traffic for safety, segregation of boisterous from quiet play, enclosure for shelter and – to give older children a sense of independence – opportunities for discovery and adventure, and the raw materials for creative and fantasy play. All of these can be provided by planting. Shrub planting can enclose, shelter and separate, but trees and shrubs also create a whole environment which can be explored, where dens and tree houses can be built, where there are trees to climb and swing from, and where plants and animals can be discovered. Play planting would need to be robust, varied and vigorous and quite different from the kind of planting that would be right in a communal garden for the elderly or in a busy urban centre precinct.

One of the major challenges of environmental design is the accommodation of several different functions within any single area. Environmentally sensitive

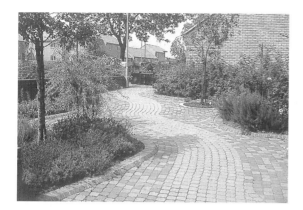

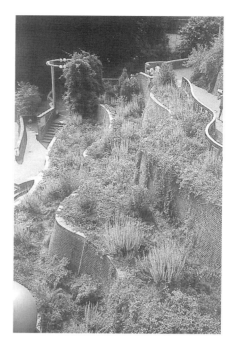

Plate 4 Without planting, retaining structures of this scale would be dominating and intrusive. The planting makes them an asset to the local environment while emphasizing their sculptural form (Munchen Gladbach, Germany).

Plates 1, 2 and 3 Planting design makes an essential contribution to an environment fit for living (housing court, Sheffield, UK; Birchwood Boulevard Technology Park, Warrington, UK, and city street, Singapore).

Plate 5 Tree planting integrates and complements structures at the Paul Piggot Memorial Corridor, Seattle, USA.

Plate 6 Planting helps to create an environment suitable for children's play by providing a comfortable microclimate, the sense of special place, and plenty of robust trees and shrubs for climbing, swinging and imaginative play (Warrington, UK).

forestry practice provides a good example of how recognizing multiple-use requirements has led to more sophisticated design. Early plantations had narrow objectives. They were laid out and managed purely for commercial efficiency, exploiting the maximum available land for timber production. Little or no attention was paid to visual amenity or to habitat conservation. However, increasing recognition of recreational uses, visual amenity and the need for wildlife conservation has led to forestry being more sensitively sited, the inclusion of indigenous species along the visible and accessible edges, and the retention of valuable existing habitats within the forest area. Production forestry development now often includes attractive picnic, walking and wildlife study areas.

So good planting design endeavours to provide for all the uses of a place and to respect the needs of all the users.

Planting Design as Management of Natural Vegetation Processes

There are circumstances in which the natural processes of colonization and succession of vegetation will be enough to repair the loss of the ecosystem, or to make an environment suitable for human need and activities. Spontaneous colonization of vacant urban sites, for example, can result in attractive urban commons that are enjoyed by children, dog walkers, blackberry pickers and naturalists; a road cutting in a rural area can be a home for colourful wildflowers and become a diverse meadow or scrub community.

Landscape designers mostly become involved when natural processes need some assistance or management, for example, to speed up the colonization process, such as on a denuded steep slope which would otherwise erode; or to direct the succession by planting particular species to increase diversity in a young woodland community. These are both examples of managing natural vegetation processes and the intervention is restricted to what is necessary for the site to function. In these cases there is no need to supplant the spontaneous 'natural' plant community with an imposed, planted one. Indeed, there might be good aesthetic reasons for using the spontaneous, indigenous colonizers that reflect the local character or make a better habitat for wildlife.

Most planting design, however, involves a much greater degree of control over natural processes. The extreme case is a highly manicured garden of exotic and tender species that could not exist without constant horticultural intervention. This kind of completely artificial planting is appropriate in the right setting; it is not intrinsically better or worse than the minimum intervention, ecological approach.

Plate 7 No planting or seeding is needed on this sandstone cliff face in Yorkshire, UK. Natural colonization is appropriate.

Plate 8 This verge beside a busy trunk road has developed into an attractive species-rich native meadow (UK).

Plate 9 A roadside verge in rural Canterbury, New Zealand, hosts an attractive range of naturalized flora, including *Echium* and *Achillea* species.

Plate 10 The indigenous European dune species, marram grass (*Ammophila arenaria*), is well adapted to this coastal fill site, but planting to assist establishment is necessary (Cumbria, UK).

Plate 11 After 18 months only a few traces of intervention remain visible. The geotextile netting is employed to reduce surface erosion (Cumbria, UK).

Plate 12 A high degree of control over natural vegetation processes is demonstrated in this highly manicured display of hybridized and selected flowers at Gruga Park, Essen.

Good design means choosing the kind of planting and management that is appropriate to the site and its uses. This will often mean the one that requires the lowest level of intervention in natural processes necessary for the planting to meet the design objectives. There are two reasons for this. Firstly, it will cost less, because less labour and material resources are used. The second is more debatable. It depends on our perception of the environment, and what about it we value most highly. If we accept the environmental ethic that nature is intrinsically valuable then we will take the opportunity to allow spontaneous vegetation to develop with minimum intervention. This is not to say that we should take the ecological approach everywhere, only that we should not replace it with a horticultural landscape without reason.

Both planting design and its subsequent care can be understood in the broadest sense as management of natural vegetation processes. Different types of planting merely need a greater or lesser degree of intervention to establish and maintain the 'target' plant community. Our purpose should be to understand and work with natural processes so as to fulfil the functions of the planting.

Planting Design for Aesthetic Pleasure

Aesthetic pleasure is an important objective of planting design. Planting offers enjoyable sensory experiences and creative opportunities for art and design. The idea of pleasure is deliberately and often falsely associated with consumer products and lifestyles – this is a successful technique for stimulating demand, but the products and experiences rarely live up to their billing. In reality, the consumer culture is one which often frustrates genuine delight. With landscape and planting design we aim to create an environment which can help people to live fulfilling and enjoyable lives. The pleasure of a lovingly tended garden or of contact with wild plants can contribute a lot to our daily well-being and foster a genuine recreation of the spirit.

What is Successful Planting Design?

We have identified three main purposes of planting design: functional, ecological and aesthetic. The extent to which a design serves these purposes can be used to judge its success.

Of course, different planting projects will have different priorities and these should be reflected in the attention given to meeting the functional, ecological and aesthetic requirements. Take shelter planting for an exposed site as an

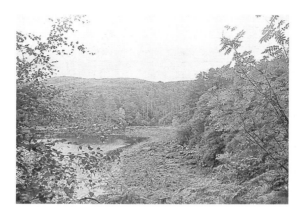

Plate 13 This shelterbelt in north-west Scotland combines effective wind speed reduction, habitat diversification and visual harmony with the local landscape. It provides the microclimate needed for the cultivation of a wide range of plants in Inverewe Gardens, Scotland.

example. Its primary objective will be effective shelter and improvement of the microclimate of the site. The character and aesthetic qualities of the vegetation can best be considered once we are confident that we can provide the technical necessities of optimum wind permeability and aerodynamic profile, conserve valuable habitats and take any opportunities to create new ones. A successful shelter planting will thus

1. reduce wind speed and turbulence over the required distance,
2. improve, or at least not damage, the ecology of the locality and
3. make an aesthetic contribution to the place and the project.

The criteria of functional performance and ecological fitness can be assessed more objectively than aesthetic value. In other words, there is more likely to be disagreement on aesthetic criteria because views about what is visually successful or desirable vary enormously. This is the case not only with different people's opinions, but with one person's taste and views, which can change significantly during their lifetime (many critics and designers are good examples of this). The kind of environment we like or need can also vary from day to day according to mood. It is this variability and the personal element of judgement that leads to the popular notion that design is subjective.

When assessing the success of planting schemes, designers certainly should ask themselves if they like it, and should evaluate and reflect on their work. To review the aesthetic impact of a planting design, we need an understanding of the aesthetic characteristics of plants and the affects of these in planting composition. This is the subject of Chapters 3 to 7.

In addition to our own analysis, we should ask if the client and the users like it: does it satisfy their needs and aspirations? The likes and dislikes of the client and the users of landscape can be different from that of a trained designer and part of our professional role is to understand and provide for their preferences and needs. As designers we might have distinctive styles and firm opinions, but when we are engaged as professional consultants, our first duty to the client is to achieve a landscape which is successful in their terms.

CHAPTER 2

Plants as a Medium for Design

Designers of all kinds share at least some common principles, and those working in three-dimensional media such as landscape, sculpture and architecture share an interest in form and space. However, the qualities and potential of the materials they work with vary, so before considering visual and spatial design principles, we should get to know the characteristics of plants as a design medium.

Plants as Living Materials

Plants are growing, changing, interacting organisms and plant communities, whether spontaneous (those we commonly call natural) or designed, exist in a state of flux. Even a long-established community, such as a mature forest, is unlikely to be unchanging in its composition. Old trees die back or blow over, allowing fresh bursts of growth in the lower layers of vegetation and seedlings to grow into saplings to begin the next generation.

On a larger scale, environmental events such as landslides, floods, volcanoes, freak weather and climatic change all lead to alterations in plant communities.

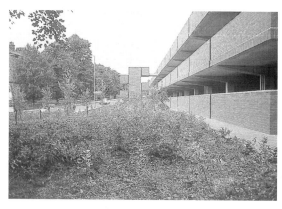

Plate 14 The development of a simple tree and shrub planting association over its first ten years: A view one season after planting shows scattered tree and shrub stock of a similar size to when they left the nursery (car park building, Sheffield, UK).

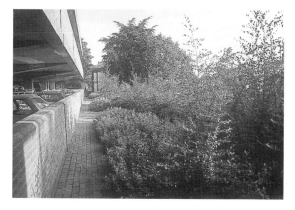

Plate 15 The same area (but viewed from another angle) three years after planting shows a well-established thicket of shrubs and establishing trees.

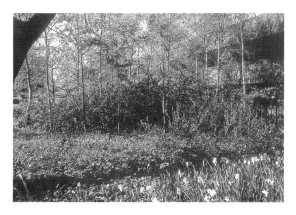

Plate 16 After ten years the trees and larger shrubs have attained a woodland structure at heights of up to 10 metres and have begun to have the impact for which they were planted – the car park building is partly screened and enjoys a woodland setting.

Two examples are the severe storms that, in recent decades, devastated trees and woodlands in south-east England and later in northern France (including the gardens at Versailles); and, in New Zealand, the 1886 Tarawera eruption that destroyed forests, scrub and cultivated land over a large area near Rotorua. In both cases, we can now go and see the natural process of forest creation in full flow. Whether we follow a single plant through its life cycle from seed to senescence, or watch a whole forest develop on cleared land we are experiencing the dynamic, developmental order of the plant world.

Environmental Factors

In addition to the genetically programmed aspects of growth and development, plants are continually interacting with their environment. Environmental factors cause big variations in the growth of plants and some of these can be controlled by design or management, while others cannot. What follows is a brief summary of the environmental factors that are most important in design.

The weather, as it changes from day to day and from year to year, influences growth rate, form, foliage density, flower and fruit production. The elevation,

Plate 17 The favourable microclimate provided by a south-facing wall allows the growing of plants which would not survive in the open. *Abutilon* and *Ceanothus* spp. (shown in this photograph), *Fremontodendron californica* and *Magnolia campbellii* are among the shrubs grown successfully in the walled gardens at Newby Hall in North Yorkshire, UK.

Plate 18 The dramatic effects of light can give unpredictable yet memorable qualities to planting (Bodnant Garden, Wales).

aspect and topography of a site and its surroundings can modify the local climate and cause variations in the microclimate of the site. A favourable microclimate would produce taller, extended and more luxuriant growth whereas an exposed or impoverished location would lead to a compact or stunted habit and smaller leaves. On an ephemeral level, the changing qualities of light at different times of day and season, and the humidity and other atmospheric effects can cause subtle or striking visual effects. Regional and local variations in soil also affect growth characteristics such as extension rate, bio-mass production, leaf and flower colour, ultimate height and vulnerability to pests, disorders and weather damage.

The growth of a plant is also influenced by its neighbours. They modify microclimate, tending to increase shade, shelter and humidity, but to reduce precipitation at ground level. Vegetation also affects soil conditions, tending to reduce available moisture and nutrients in the short term but, over a longer period, to increase the humus and nutrient content of the soil.

Certain types of vegetation, for example many conifers and moorland grasses, can acidify the soil reaction by the chemical composition of their leaf litter. This can lead to a build-up of only partly decomposed organic matter and a reduction in available nutrients. Birch, on the other hand, improves moorland soils by returning leached nutrients to the surface in its leaf litter.

Diseases and pests affect the growth and development of planting. In rural locations, animals such as cattle, sheep, deer, rabbits and opossums are selective grazers that restrict the growth of edible species while allowing the spread of others that they find unpalatable. This kind of influence helps determine both individual plant form and the composition of plant communities.

Finally, human pressures are a crucial and often unpredictable biotic factor affecting plant growth and development. In densely populated areas, pollution, vandalism and rubbish dumping can seriously interfere with the performance of plants. For example, erosion by excessive foot traffic, pedal or motorcycle riding can destroy or prevent the development of the lower layers of vegetation and the regeneration of shrubs and trees. In addition to these incidental human influences we can also regard fashion and taste as habitat factors (Gilbert, 1989). They influence the management and make-up of plantings, favouring those that are in fashion and reducing the survival chances of those regarded as 'untidy', 'boring' or 'past their sell-by-date'. Examples include the spread of dwarf conifers through British suburban gardens in the 1960s and 1970s and the 'niche' for mixed native shrub planting that appeared in New Zealand gardens and landscapes in the 1980s.

Cycles of Plant Growth and Development

Another aspect of plant growth and development that we cannot control or predict with certainty is the time dimension.

The period (length) of different growth rhythms varies greatly, from diurnal rhythms such as the opening and closing of flowers to the annual rhythm of the seasons. The entire life cycle of a plant can, in the case of ephemerals like groundsel or shepherd's purse, occupy a period as short as six weeks. For long lived trees like kauri (*Agathis australis*) in New Zealand, yews (*Taxus baccata*) in Europe and the bristle cone pine (*Pinus aristata*) in North America, it can be in the order of millennia.

As designers, we need to know the distinctive character of the different stages of the plant's life cycle. Young growth, reproductive maturity and senescence are usually distinguished by very different habit and form so, at each stage, the design role the plant can play will be quite different. The New Zealand horoeka or lancewood (*Pseudopanax crassifolium*) provides a classic example of different life stages. The juvenile and adult stages of horoeka are so wildly divergent in

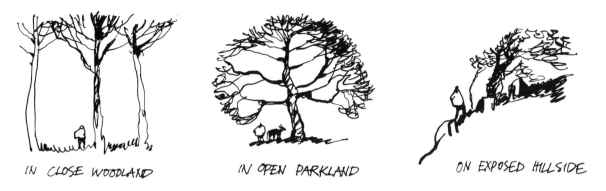

IN CLOSE WOODLAND IN OPEN PARKLAND ON EXPOSED HILLSIDE

Figure 2.1 Mature tree form.

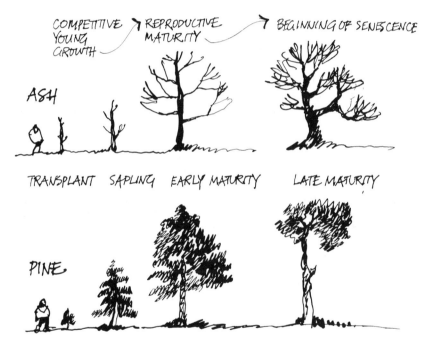

Figure 2.2 Tree form development.

their appearance that the first botanists to classify them (Dr Daniel Solander and, later, Sir Joseph Hooker) actually placed them in different genera! (Kirk, 1889). Growth stage can affect not only a plant's appearance and design role, but also its environmental requirements. For example, some forest dominant trees such as many of the New Zealand podocarps need shelter, humidity and shade to establish, but will tolerate quite harsh exposed conditions when mature.

Aftercare

Another distinctive aspect of planting design is the vital role of landscape management. After installation, the young planting needs careful and creative tending for a number of years if the design intentions are to be fully realized. This

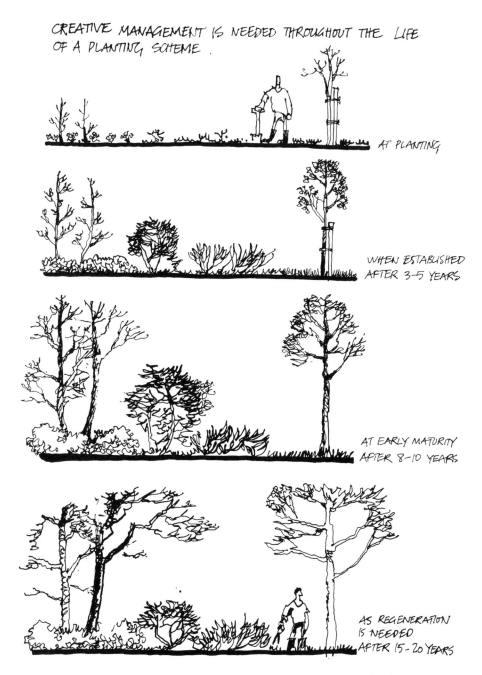

Figure 2.3 Stages of development of tree, shrub and groundcover planting.

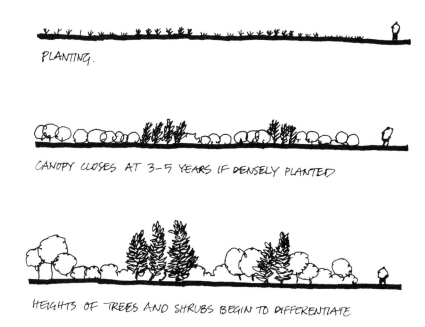

PLANTING.

CANOPY CLOSES AT 3-5 YEARS IF DENSELY PLANTED

HEIGHTS OF TREES AND SHRUBS BEGIN TO DIFFERENTIATE

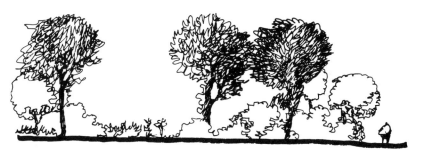

EARLY MATURITY AT 20-30 YEARS AND GLADES CAN BE CREATED FOR REPLANTING.

Figure 2.4 Stages of development of woodland planting.

period of establishment and aftercare is the time when the original idea is actually shaped into a finished product. It is a particularly vulnerable period for a planting design because of the risk that a planting scheme suffers from misunderstanding or from misguided maintenance. It is also the most testing time for the designer, because it is when it will become apparent whether their ideas are practical enough to be properly realized. On the positive side, however, creative landscape management provides an opportunity to achieve something

even better than envisaged on the drawing board, thanks to its ability to respond directly and immediately to the vitality and unpredictability of living plants. Serendipity is one of the joys of planting design.

So there are unpredictable elements in many aspects of planting design. They range from the inherent nature of the material, through the vagaries of climate to the difficulties of communicating design subtleties to managers and maintenance staff over a period of many years.

Developing a landscape with plants is not like building a motor car with steel or even a hard landscape with bricks and mortar. Plants cannot be definitively and precisely represented by a scale drawing or model because the appearance of planting after a certain number of years can never be guaranteed. There will always be an element of unpredictability. This can cause difficulty to students and designers at first, but with increasing horticultural experience and understanding, they will gain more confidence in the results of their design proposals.

The Landscape Designer's View of Plants

What is distinctive about the landscape designer's understanding of plants? What makes their approach to plants different from that of a gardener, a botanist, an ecologist and others with an interest in plants?

First, the landscape design approach is broader. The need for breadth of understanding is both a source of frustration – what exactly is it that we do? – and of strength – the ability to take an overview and integrate. As designers we need to understand the essentials of botany, to be familiar with the basics of ecology and to use appropriate techniques from horticulture, agriculture and forestry. On top of all this, we must have a sculptor's eye for form and texture, a painter's expressive hand and, sometimes, a floral artist's sense of occasion.

Alongside this breadth of knowledge, landscape designers develop a specialized knowledge of design, particularly the understanding of spatial and visual composition in the medium of landscape.

Plants as Spatial Elements

To the designer, plants are like green building blocks that can be assembled to form living and changing 'structures' in the landscape. Design is not only about the form of solid structures, however, it is also concerned with the 'empty' space that the solid form defines and creates. The edges and surfaces of a building, for example, or a chair, or sculpture, all limit and define the space around or within it, and this space has both functional and aesthetic purpose.

Plants also define and create space. This space is created around, between, and even within their canopies. By organizing and manipulating foliage canopies, the designer uses plants to build a structure or what we might call a framework that defines and orders space in the landscape. Planting form and outdoor spaces can be seen at a variety of scales. At the largest, belts of trees, woodlands and forest fragments can form a landscape framework within which large-scale uses, such as industry, residential and recreation, can be accommodated without too much visual or ecological disruption. These activities will also benefit from improved microclimate, wildlife conservation and other environmental benefits brought by the enclosing planting. At the smaller scale of individuals and small groups of people, planting continues to play a vital role in structuring the landscape. Facilities such as a play area, neighbourhood park or private garden all require definition, shelter and privacy in varying degrees. This can be provided with

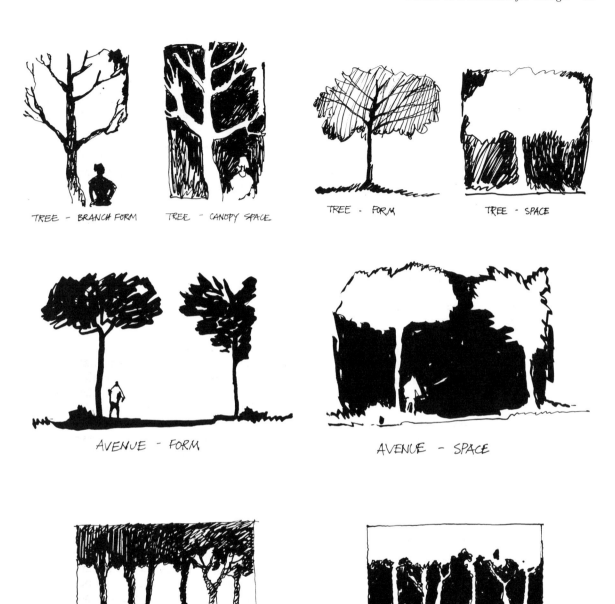

TREE — BRANCH FORM TREE — CANOPY SPACE TREE — FORM TREE — SPACE

AVENUE — FORM AVENUE — SPACE

WOODLAND — FORM WOODLAND — SPACE.

Figure 2.5 Trees: form and space.

Plate 19 The interlocking relationship of form and space within the canopy of this pohutukawa tree in Albert Park, Auckland, New Zealand is emphasized by the presence of the sculpture.

shrubs and trees of the right size and habit. Even a single tree can define a space and identify a place. Its spreading canopy will give containment above and create a domain of influence below.

We see that planting has a structural or framework role in the landscape that is analogous to the space-enclosing envelope of a building and to the combined enclosure of a street or built edge. Planting, however, is used over a much bigger range of scales. The basic language and concept of building architecture offers a spatial vocabulary that can be applied to landscape, including planting design. Rooms, streets, squares, arcades and colonnades, for example, are familiar types of architectural space that can help us to appreciate similar but looser landscape spaces created by plants.

In *Trees in Urban Design*, Henry Arnold summarizes the spatial use of trees with particular reference to the urban environment:

> Trees in the city are living building materials used to establish spatial boundaries. They make the walls and ceilings of outdoor rooms, but with more subtlety than most architectural building materials. They create spatial rhythms to heighten the experience of moving through outdoor spaces ... In addition to actually creating discreet spaces, trees are used to connect and extend the geometry, rhythms, and scale of buildings into the landscape. It is this function more than any decorative and softening effect that is of primary importance to architecture. (Arnold, 1980)

Vegetation also creates more complex and fluid spatial form. We find this in so-called 'informal' planting – that is, organic, curvilinear, casual, or seemingly spontaneous in its form. Examples include spontaneous forest or scrub, revegetation and nature-like planting, where tree and shrub masses interweave with glades, paths and open land. Appreciation of the subtleties of this kind of spatial composition tends to come with familiarity. The work of landscape architect, Jens Jensen, in the United States illustrates a high degree of sophistication in such informal spatial expression – his work expresses the poetic quality of the interface between native forest and open land. Indeed, Frank Lloyd Wright described Jensen as a 'native nature poet'.

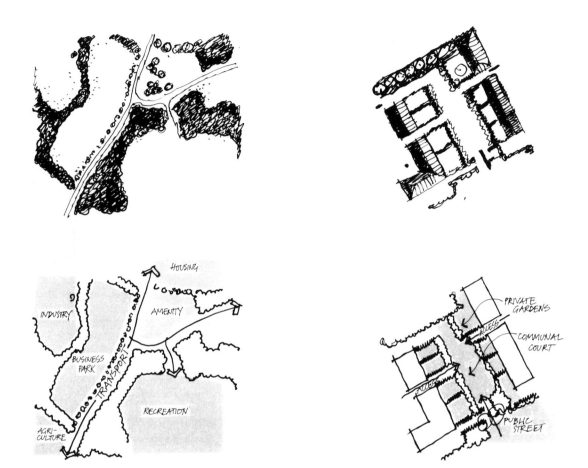

Figure 2.6a Large-scale structure planting of woodland belts creates a framework for various land uses.

Figure 2.6b Small-scale structure planting of trees, shrubs and hedges creates spaces for various people and uses.

Creating spaces is sometimes described as an 'architectural' function of plants (for example, Booth, 1983; Robinette, 1972). This is helpful to the extent that it encourages us to see plants as structural, space-forming elements in the environment – elements that can create 'outdoor rooms', tree-lined squares, avenues and so on – but it is a somewhat limiting analogy. This is because the range of form, scale and character of space that plants can create is greater than can be achieved with architectural elements alone. This potential will be explored further in Chapters 4 and 5.

Plants as Ornament

Ornamentation or decoration is, like the definition of space, also an architectural function. We will distinguish ornament from spatial structure as we discuss planting design. Like the architect of a building, the landscape designer is concerned with the detailed aesthetic qualities as well as the spatial dimensions

Plate 20 The space beneath the canopy of this single beech (*Fagus sylvatica*) is further delineated by a circular hedge and a change of ground level (Hidcote Manor, Gloucestershire, UK).

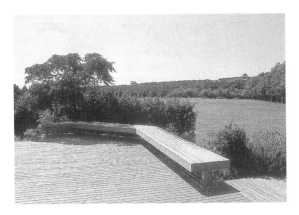

Plate 21 Shrubs and occasional trees define and partly shade the deck space in this garden in Auckland, New Zealand.

Plate 22 The natural growth of belts of trees and shrubs create informal walls of vegetation enclosing the Moon Pond at Studley Royal, Yorkshire, UK.

Plate 23 Trained and clipped cypress (*Cupressus* sp.) form a wall with windows giving views in and out of a small urban park in Malaga, Spain.

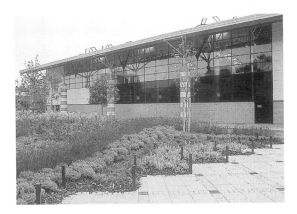

Plate 24 Strips of low groundcover plants form a patterned carpet to the space in front of this recreation centre in Sheffield, UK.

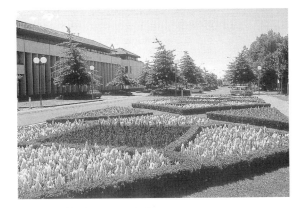

Plate 25 A colourful carpet of floral bedding is kept in precise geometric patterns by the use of dwarf hedging (Rotorua, New Zealand).

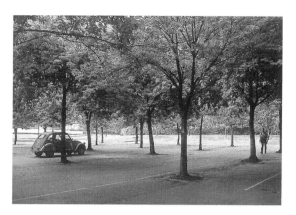

Plate 26 *Wisteria* is trained over supports to form a delightful ceiling of foliage and flower above a patio in Majorca.

Plate 27 The naturally spreading canopies of silver maples (*Acer saccharinum*) form a sheltering and screening ceiling above the car park at Leeds University, UK.

of the basic structure, and similarly, can apply planting as ornament to a basic spatial framework, or can rely on the intrinsic visual and other aesthetic qualities of the spatial elements. Planting, whether or not specifically ornamental in its purpose, offers a wealth of aesthetic detail – the appearance of leaves, twigs, bark, flowers and fruit; the fragrance of flowers and aromatic foliage; the physical texture of bark and leaves; the sound when stirred by the wind or beaten by the rain.

Trees and shrubs with special aesthetic appeal are often planted as ornaments to the basic structure planting. This is analogous to embellishing a building façade or decorating an interior and could be thought of as specifically ornamental planting. Another approach would be to employ the intrinsic aesthetic qualities of the structure planting to give surface detail to the space – additional species would not be introduced just to give variety or for ornament alone. The second approach would produce a simpler landscape, one that is more of the modernist tradition. In practice, most design uses the decorative characteristics of both structure planting and specifically ornamental planting to clothe the spatial framework.

There are two common problems with the decorative aspects of planting design. In one case, too much reliance is placed on a limited number of fail-safe species. This leads simply to monotony (this is how landscape designers get a bad name with the public). In the other, the designer is captivated by variety (a kind of aesthetic acquisitiveness) at the expense of restraint and clarity of purpose. The first fault is usually the result of inadequate plant knowledge due to insufficient experience or lack of interest. The second comes from genuine appreciation and enthusiasm without understanding what makes a good design. To achieve successful and enduring planting design we need both knowledge and discretion – we need first to know our medium and, second, to use it with purpose and skill.

Plant Selection

There is such a diversity of size, habit, flower, foliage, growth rate, soil and climatic requirements among the species and cultivars available, that the task of

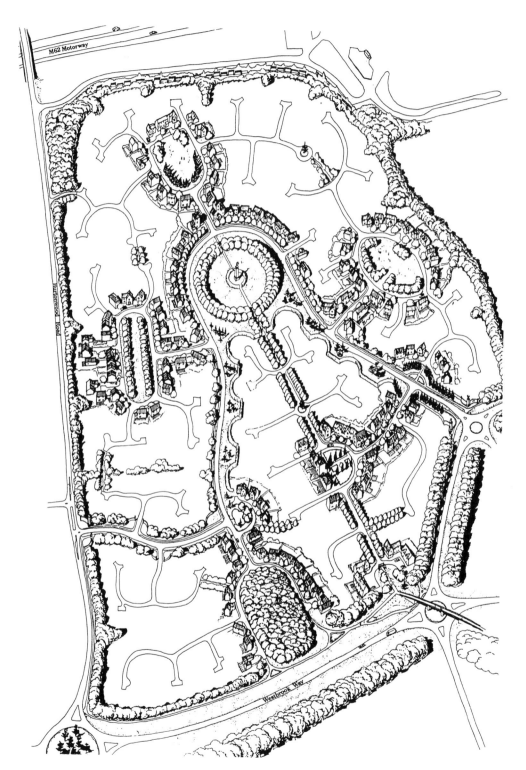

Figure 2.7 This axonometric vividly illustrates how tree planting will form the green spatial structure to a new community.

Figure 2.8　Planting can create the floor, walls and ceiling of intimate outdoor rooms.

choosing the right plant can seem overwhelming. This is one reason why it is useful to have a system or method for choosing plants.

The most reliable method is to make increasingly fine distinctions between groups of plants on the basis of design characteristics. This is a bit like the binary key system used in plant identification, except that the separating characteristics are those of design rather than botany. These design characteristics can be placed under three headings:

1.　Functional and spatial characteristics.
2.　Visual and other sensory characteristics.
3.　Plant growth habit and cultural requirements.

The functional and structural characteristics allow a plant to perform its working role in the landscape. For example, form and foliage density affect its ability to shelter, screen or shade; rooting habit determines its ability to bind the surface soil and protect against erosion; height affects its barrier function. These kind of characteristics allow planting to produce a functioning landscape, a fit environment for human activities.

Visual qualities are key ingredients in planting designed for sensory interest. The amount of care needed when working with these characteristics also depends on the nature of the site and the visual sensitivity of the location. When we plant a garden or courtyard, for instance, we expect to spend a lot of time and effort on detailed composition and expression. A reclamation site, on the other hand, might be less demanding when it comes to the aesthetic and decorative qualities of plants but to get anything to grow at all would be the main challenge.

Growth habit and cultural requirements determine whether a species can succeed in a habitat or ecological niche. This applies both to spontaneous vegetation communities and to designed or managed planting such as urban street trees or roof gardens. On sites with inhospitable or polluted substrates the

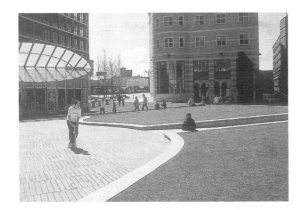

Plate 28 Grass is used with care to provide an accessible ground surface in this public space in Birmingham, UK. The orientation of the slope helps to focus attention towards the centre of the square.

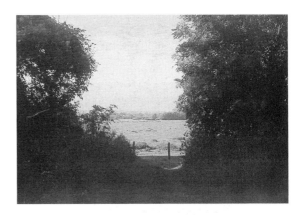

Plate 30 Natural gateways and windows are formed by gaps in otherwise impenetrable vegetation (Buckinghamshire, UK).

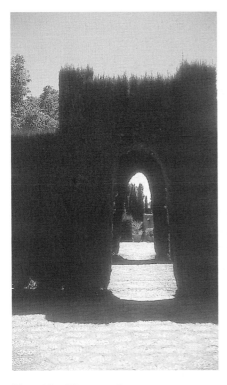

Plate 29 Plants such as cypress (*Cupressus* sp.) can be trained to form green gateways of inviting proportions (Generalife, Granada, Spain).

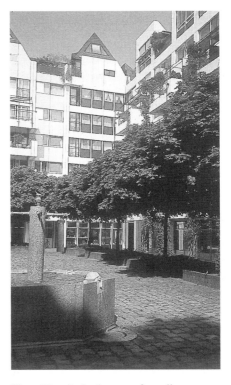

Plate 31 A single row of small trees forms a green colonnade in this residential courtyard in Cologne, Germany.

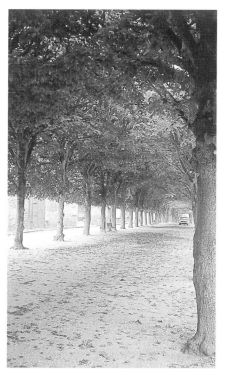

Plate 32 A carefully spaced and regularly pruned double row of limes (*Tilia* sp.) gives overhead enclosure to form this arcade of trees in France.

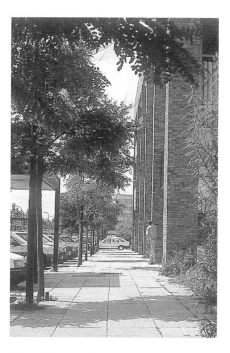

Plate 33 Regular street tree planting echoes the rhythms of adjacent architecture (Milton Keynes, UK).

Plate 34 Analogies in both the structural and decorative aspects of trees and built form are employed in the work of Antoni Gaudí in Parc Guel, Barcelona.

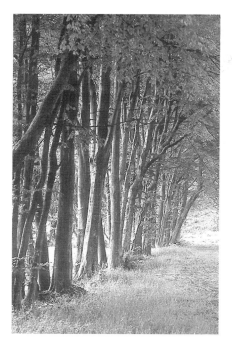

Plate 35 An overgrown beech hedge (*Fagus sylvatica*) creates a curtain of stems at Formakin, Scotland.

technical demands of plant establishment would far outweigh the visual qualities of foliage and flowers when considering species selection. So knowing a plant's habit and horticultural preferences is essential if the designer is to create vigorous and sustainable planting. Unfortunately this information is not readily available in literature on landscape use of plants (in contrast to the vast amount available on planting under garden conditions). Plants in landscape projects are often under greater stress than those in gardens and so personal knowledge of species' preferences and tolerances is very valuable for the landscape designer.

To summarize, a systematic plant selection method is first to establish planting function and spatial form, and then visual character and other detailed aesthetic qualities. Once these design criteria have been decided upon, species and cultivars that are well suited to the site conditions can be chosen to perform those roles. This is the sequence we will adopt in Chapters 3 to 9 that cover basic principles and process.

Functional and Aesthetic Considerations in Design

Landscape planting has both functional and aesthetic effects. However great the need for a landscape to be easy to use and maintain, the designer must also consider its aesthetic impact. The balance between these two facets varies from project to project, according to the demands of the site and the needs of the users, but both are always present to some degree. We should also note that functional effectiveness and sensual quality are by no means independent. Victor Papanek in his classic book on industrial design, *Design for the Real World* (1985), defined the function of an artefact in the widest sense, identifying six aspects of function that included both use and aesthetic quality:

1. Good **method** in design and manufacture, which employs appropriate tools, processes and materials.
2. Ease and effectiveness of **use**.
3. Design for genuine **need**, not artificially manufactured fads and desires.
4. The **telesic content** of a design, that is, the extent to which it reflects the economic and social conditions of its time and place.
5. The materials and forms employed having appropriate **associations** in the minds of the users (no product is free from association in both individual and cultural experience).
6. The intrinsic **aesthetic qualities** of the materials and forms employed being appropriate to the function.

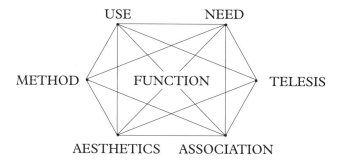

Figure 2.9 The function complex (after Papanek, 1985).

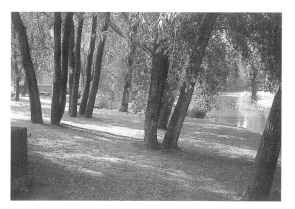

Plate 36 Sculptural organic form and fluid space are
created by the nature-like planting of clumps of
willows (*Salix*) near the water's edge in a Dutch park.

Plate 37 The rich planting in this courtyard plays a mainly
ornamental role, furnishing a space that has been defined by the
structures of building and hard landscape. The tree ferns (*Dicksonia
squarrosa*), ti kouka (*Cordyline australis*) and palms modulate the space
and provide foci (Auckland, New Zealand).

Thus, aesthetic character is an essential part of design for function. This notion
is different, in a subtle but important way, from the saying that 'if it works well it
will look right'. The implication of Papanek's understanding is that we cannot
leave the aesthetic qualities to be the incidental product of a narrowly defined
function. There are usually a number of potential solutions to a problem of
function, especially in landscape design, and aesthetics should be one of the
criteria for choosing the best alternative. The aesthetic qualities of any artefact
convey meaning to the users and that meaning should concur with the function
and the purpose of the artefact if we are to design honestly and with proper
regard for the real needs of the users.

A designed landscape is not only a large artefact but also requires complex
integration of different and sometimes conflicting uses. Many different functions
can be fulfilled by planting (including visual integration, circulation, symbolic
association, business promotion, historical interpretation, wildlife habitat, soil
improvement, climatic modification and so on). These functions are design
objectives that arise out of the designer's analysis of the brief – from the client's
requirements, the user needs and the problems and opportunities of the physical
site. In simple terms, design functions are what we want the planting to do.

Although aesthetic effects are always present and need to be considered as one
aspect of function, in some landscapes, aesthetic enjoyment is the primary design
objective – parks and gardens (both private and public), ornamental courtyards,
hospital grounds, for instance.

CHAPTER 3

Spatial Characteristics of Plants

The spatial characteristics of plants are those that contribute to the space structure of the landscape. They include habit, crown shape, foliage density and speed of growth, and *en masse* they determine the spatial composition of the planted environment.

Spatial Functions of Plants in the Human Landscape

When we are designing spaces for people, the size of plants relative to the dimensions of the human figure is critical. Simply to distinguish areas on a plan by canopy height amounts to an important design stage, because it is height that determines much of the spatial framework and controls vision, movement and physical experience.

Danish landscape architect Preben Jakobsen identified the most useful size categories for the designer as ground level, up to knee height, knee to waist height and below or above eye level (Jakobsen, 1977). The kind of plants that fall within these ranges are as follows:

Canopy height	Plant type
Ground level	Mown grasses and other turf plants, ground-hugging and carpeting herbaceous plants and shrubs.
Below knee height	Prostrate and dwarf shrubs, sub-shrubs, low-growing herbaceous plants.
Knee–waist height	Small shrubs and medium growing herbaceous plants.
Waist–eye level	Medium shrubs and tall growing herbaceous plants.
Above eye level	Tall shrubs and trees.

When it comes to actual dimensions, these heights will, of course, vary for different people. For adults, this variation will be only marginal and would rarely affect our choice of species. For children of different ages and for people in wheelchairs, however, the height difference would be significant, and we must take this into account and allow for their different spatial experience.

Let us consider the design potential of each canopy level in turn.

Ground-level Planting (Carpeting Plants)

This lowest growing vegetation forms a foliage canopy very close to ground level, and often not more than a few centimetres thick. Plants include grasses and other

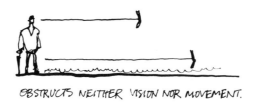

OBSTRUCTS NEITHER VISION NOR MOVEMENT.

IT CAN PROVIDE A VISUAL LINK BETWEEN RELATED AREAS,

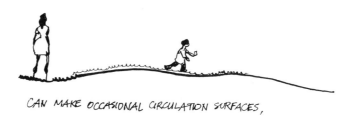

CAN MAKE OCCASIONAL CIRCULATION SURFACES,

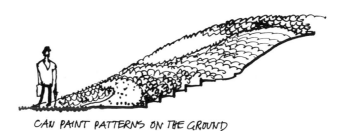

CAN PAINT PATTERNS ON THE GROUND

Figure 3.1 Ground-level planting (carpeting plants).

turf species when mown or grazed, absolutely prostrate shrubs (e.g. *Juniperus* 'Bar Harbour', *Thymus serlyllum lanuginosus*, *Rubus* x *barkeri*) and creeping herbaceous plants (e.g. *Lysimachia nummularia*, *Scleranthus biflorus*, *Pratia angulata*). Its primary spatial role is as a 'floor' that allows both free vision and movement. This enables it to perform a number of roles:

- On even, firm ground carpeting plants can provide a pedestrian circulation surface, although less hard-wearing than a pavement. The most wear tolerant species include many of the turf grasses that, when grazed or mown regularly, form surfaces suitable for relaxing, walking, play, sport, cycling and occasional vehicles. This durability accounts for much of the value and popularity of lawns, meadows and other grasslands in both public and private landscape.
- A uniform carpet of mown grass or ground-hugging, smooth-textured groundcover can be used to enhance the visual effect of ground modelling by closely following the contours. Species include prostrate chamomile (*Chamaemelum nobile* 'Treneague') or piripiri (*Acaena* sp.). Breaks of slope can be emphasized by a change to a groundcover of contrasting foliage.
- Ground level vegetation can be used to make two-dimensional patterns. Carpets of foliage, used alone or combined with boulders, gravel and paving materials, form a tapestry of colour, texture and pattern across the ground surface.

Shrubs and Herbaceous Plants Below Knee Height (Low Planting)

Shrubs and herbaceous plants that form a higher canopy but still below knee height have further possibilities in spatial design. Many of them come within the category of 'groundcover', that is, species that are well adapted to the local conditions and competitive enough to exclude most of the unwanted, self-colonizing 'weed' plants. In addition to this labour-saving benefit, low planting has the spatial role of allowing freedom of vision while defining an edge and deterring (though not preventing) movement.

- Low planting can, when used by itself, form a visual platform or ground plane like carpeting plants.
- It can be combined with taller herbaceous species, shrubs or trees growing up through it. This situation is like a foundation or wash in painting, or a 'ground' against which the 'figure' is to be seen. In this way, low planting can give a common ground or platform that unifies other planting and elements in a composition.
- Many prostrate species that form low groundcover will trail down walls and banks and form hanging curtains (prostrate rosemaries – *Rosmarinus officinalis* – are a classic example). Trailers and climbers can be planted to form a continuous mantle of foliage over vertical and horizontal surfaces. Foliage will cascade down banks and walls and flow over flatter ground, masking the angles between vertical, horizontal and inclined planes. By clothing new and old alike, climbers can give a sense of belonging and maturity to new structures or earthworks that have been inserted in an established landscape.
- Low planting has an essential role at the edges between hard and soft landscape and between soft landscape areas of differing uses. Tall shrubs

ALLOWS UNINTERRUPTED VISION BUT DETERS MOVEMENT

CAN FORM A CARPET OF PATTERNS VIEWED
FROM ABOVE,

CAN FORM A CARPET OF FOLIAGE
BELOW TALLER PLANTS,

Figure 3.2a Planting below knee height (low planting).

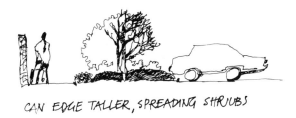

CAN EDGE TALLER, SPREADING SHRUBS

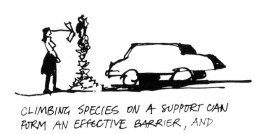

CLIMBING SPECIES ON A SUPPORT CAN
FORM AN EFFECTIVE BARRIER, AND

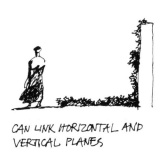

CAN LINK HORIZONTAL AND
VERTICAL PLANES

Figure 3.2b Knee to eye level planting.

need room to spread laterally without encroaching on circulation space. Low planting can provide a groundcover over which the taller species extend freely without the need for frequent cutting back or shaping. If this groundcover spreads over pavement or grass some incidental or natural 'pruning' will result from trampling. Where traffic is light, occasional trimming is needed.

Knee to Eye Level Planting (Medium Height Planting)

Planting that grows to between knee height and eye level can have a similar design role to a low wall, fence or rail. It becomes a barrier to movement and can be used to limit access but it leaves views open and makes little difference to sunlight. This opens up a number of spatial uses for medium-height planting.

- It can separate areas for safety reasons: for example, keeping people or vehicles away from steep slopes, water or from each other.
- It can be used to acknowledge and emphasize desire lines or pathways where visual enclosure is not wanted.
- It can be used to maintain a distance between people and buildings and other private areas, in this way giving privacy while not growing above window sill level and reducing light.
- It can define a building curtilage or domain, in a similar way to a low wall, fence or hedge, but less formally.
- A mass of medium foliage fringing a building or other structure can visually anchor it to the ground and link it to the surrounding landscape. This is particularly important when a building or other structure is introduced into a landscape characterized by generous existing vegetation.

Planting Above Eye Level (Tall Shrub/Small Tree Planting)

Shrubs and small trees with a canopy extending above eye level form a visual and physical barrier. So tall planting with a close knit canopy can, in a similar way to a wall or fence, separate, enclose, screen and shelter on a smaller scale than is possible with larger tree planting.

- In the human scale landscape of parks, gardens, courtyards, streets and playgrounds tall planting gives privacy and shelter and screens intrusions like car parking, service areas and refuse bins.
- Like a wall or fence, tall planting can make a backcloth to ornamental planting such as herbaceous borders and display beds. Clipped 'formal' hedges have traditionally played this role in gardens, but looser shrub planting can also be effective. Classic hedging plants include yew, *Taxus baccata*, beech, *Fagus sylvatica* and hornbeam, *Carpinus betulus* for tall hedges in northern Europe. Monterey cypress, *Cupressus macrocarpa*, and totara, *Podocarpus totara*, make fine clipped hedges in warmer climates.
- Because of its size, tall planting can play an accompanying role to buildings. Its visual mass is similar to small buildings so it can be used to balance areas of their masonry or cladding.
- An isolated pair of tall shrubs or a gap in mass planting creates a frame. It can frame a whole vista or attract attention to a focus or landmark. This kind of arrangement not only focuses attention, but also invites exploration. Like an arch or gateway, it suggests a different place to be discovered.
- When planted as individuals or small groups, choice tall shrubs have the size

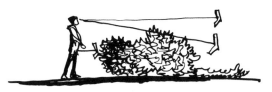

PLANTING BETWEEN KNEE AND EYE LEVEL
OBSTRUCTS MOVEMENT BUT ALLOWS VISION.

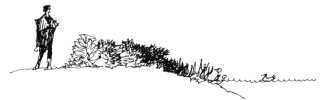

IT CAN SEPARATE PEDESTRIANS FROM HAZARDOUS OR
SENSITIVE AREAS,

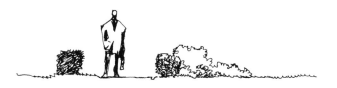

CAN EMPHASISE DIRECTION AND CIRCULATION,

Figure 3.3a Medium shrub planting.

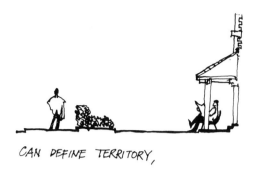

CAN DEFINE TERRITORY,

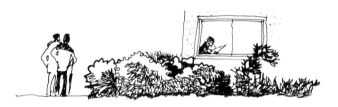

CAN IMPROVE PRIVACY WITHIN BUILDINGS,

AND CAN PROVIDE A MINOR VISUAL FOCUS.

Figure 3.3b Medium shrub planting.

and presence to act as specimens and a feature or visual focus within a human scale landscape.

Tree Planting

The sizes of trees are of the same order of magnitude as buildings, roads, bridges and smaller industrial developments. Tree planting can therefore be used for screening, separating, sheltering, enclosing, accompanying and complementing these larger structures. When tree species grow freely to produce a clear main stem or bole with their canopies above head height they leave the space above the ground open except for the vertical pillars of their boles. This offers a quite different type of spatial element.

Mature heights of trees range from about 5 metres in species such as weeping pear (*Pyrus salicifolia* 'Pendula') and akeake (*Dodonaea viscosa*), to over 40 metres in European ash (*Fraxinus excelsior*), New Zealand kahikatea (*Dacrycarpus dacrydioides*), some conifers from the west coast of North America and many Australian eucalypts (*Eucalyptus* species, especially *E. regnans* the mountain ash). For design purposes it is helpful to divide trees into small: mature height 5–10 metres; medium: 10–20 metres; and tall: 20 metres.

- Small trees are of similar height or lower than the majority of buildings of two storeys, so their influence in the urban environment is mainly local to the spaces between buildings.
- Medium trees can create spaces that contain smaller buildings and therefore have a greater effect on the spatial structure of urban landscape.
- Tall trees are less common in urban areas because of the space they demand, although naturally tall growing species are often planted in streets and gardens only to be lopped or pruned once they begin to shade or dominate nearby buildings. The size of trees over about 20 metres enables them to form the part of the primary spatial structure of streets, squares and parks. In the rural landscape large trees create a large-scale framework.
- Medium and tall tree planting can play a crucial role in integrating massive industrial buildings, like power stations, into the surrounding landscape. Tree belts and plantations enveloping and extending outwards from such sites provide screening of near distance views. From greater distances, although they cannot hide structures on the scale of cooling towers or turbine houses they can visually anchor them to their supporting landscape and screen the lower level ancillary development, temporary buildings and car parks. This is a vital landscape role because the low-level clutter is often the most disturbing part of large-scale industry.
- The ability of trees to screen and obscure views from further away than shrub planting can be made use of to manipulate views as the observer moves through the landscape. Carefully located gaps in planting open up vistas or frame a focus at just the right moment. Like a window or an archway, a frame of branches or foliage directs attention and focuses the mind on what is beyond it.
- A single specimen or small group of trees, on the other hand, itself acts as a focus. Being an isolated object, it occupies a small area in our field of vision and our eye tends to rest on it. A tree with a distinctive feature such as autumn colour or picturesque habit will make a particularly notable focus. Large tree specimens or groups have this effect at some distance and so provide foci and landmarks in the larger-scale rural landscape.
- When single specimens or small groups of trees accompany buildings the

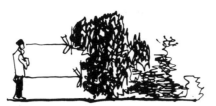

PLANTING TALLER THAN EYE LEVEL FORMS
BOTH A PHYSICAL AND VISUAL BARRIER.

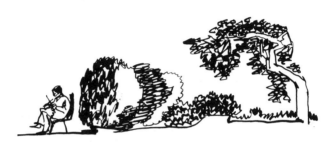

IT CAN GIVE PRIVACY AND SHELTER,

CAN PROVIDE A BACKCLOTH FOR DISPLAY PLANTING,

Figure 3.4a Tall shrub planting.

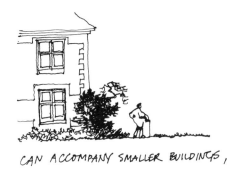

CAN ACCOMPANY SMALLER BUILDINGS,

CAN FRAME A VISTA OR LANDMARK,

AND CAN MAKE A SPECIMEN OR VISUAL FOCUS.

Figure 3.4b Tall shrub planting.

TREES

CAN FORM A BUFFER BETWEEN INCOMPATIBLE ACTIVITIES,

CAN SCREEN AND SEPARATE LARGER BUILDINGS,

CAN INTEGRATE THE LARGEST STRUCTURES,

CAN FRAME AND EMPHASISE LANDMARKS,

A SINGLE LARGE TREE CAN BE A
LANDMARK AND MEETING PLACE.

Figure 3.5a Trees.

TREES CAN COMPLEMENT BUILDING FORM

CAN INTEGRATE UNRELATED BUILDING STYLES,

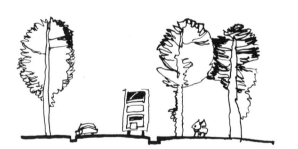

CAN GIVE VERTICAL CONTAINMENT TO ROUTEWAYS.

Figure 3.5b Trees.

TREE CLUMPS AND WOODLANDS CAN EMPHASISE TOPOGRAPHY,

OR DISGUISE INSENSITIVE EARTHWORKS

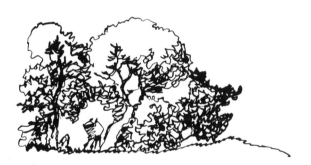

AND CAN CREATE A DISTINCTIVE WOODLAND
ENVIRONMENT WITHIN THEIR CANOPY.

Figure 3.5c Trees.

relationship between the form of the tree and of the building can be interesting. Humphrey Repton formulated a rule, in the picturesque tradition, prescribing which tree forms best accompanied different architectural styles. He recommended that buildings in the classical style with broad, stable proportions and shallow roof angles, be accompanied by the rising lines and upright forms of fastigiate trees such as spruces or firs. Conversely, the rising pinnacles and steep pitched roofs of the Victorian Gothic Revival would be complemented by stable rounded or horizontal spreading trees such as cedar of Lebanon, English oak or chestnuts.

- A further architectural role of tree planting might be the linking of varied building styles. A simple, regular line of one species can provide uniform frontage or a free-standing counterpoint to an architectural façade. Its continuity can bind together different building styles so that the architectural variety adds interest within a unifying green framework.

We have seen how the height and habit of plants determine many of their spatial functions. The control of vision and circulation is fundamental to spatial design. How we combine plants to create spaces of various characters and for various purposes provides the subject of the next chapter.

CHAPTER 4

Creating Spaces with Plants

When we arrive at a site for the first time and start to imagine its potential for design, one of the most immediate qualities to strike us will be its spatial character – whether it is expansive and exhilarating, bleak and open, confining and threatening, intimate and comforting, and so on. Space is a bit like colour in as much as we sense its basic nature almost instantaneously – we are aware of space, before we start to notice the details of a place.

Some of our first design ideas will include the scale and character of the place that we want to create. Imagining different qualities for a site is a good way to start design and once we have a basic understanding of spatial composition, these qualities can be interpreted in a framework for the site. (This is one way to overcome the perplexing problem of what to do on a blank sheet – more about designer's block later!) Starting to envisage and sketch out spatial qualities and relationships is fundamental to landscape design. It is a bit like the sketches a sculptor might make as he or she works on a concept for a piece.

Before we look at how the medium of planting can create landscape spaces with the kind of character and qualities that we want, we should first ask why spaces are so important for our experience of the environment.

The Experience of Space

Our experience of space is the result of the sensory perception of our surroundings. As Erno Goldfinger described in his early article 'The Sensation of Space' (1941) it is the product of all our senses. The smell and feel of the air; the quality of the sound of voices or birdsong, footsteps, car engines, the texture of the ground under our feet are all sensory qualities of space that contribute to our experience in addition to what we see.

These qualities are the result of physical size and form, surface patterns, textures and colours. Surface qualities give much information about where we are: for example whether it is a natural or artificial environment (such as a rock outcrop or city paving) and whether it is friendly or hostile (such as rolling pasture or desert sand dunes). Although the size and shape of spaces around us have a primary role in our experience, they are often overlooked. Perhaps this is because space is a holistic phenomenon rather than a separate object, and harder to define and grasp in a practical way. Edmund Bacon's urban design approach in *Design of Cities* (1974) emphasizes this: 'Awareness of space goes far beyond cerebral activity. It engages the full range of senses and feelings, requiring involvement of the whole self to make a full response to it possible.'

One explanation for our responses to spatial arrangements is offered by the geographer Jay Appleton's behavioural theory of prospect and refuge (Appleton 1986). His theory is one of the few in landscape architecture concerned with why, rather than how. It is based on the continuing influence of humankind's pre-agricultural relationship to its habitat. The habitat was a landscape where food needed to be hunted, gathered, or grown in small gardens but also a landscape where dangerous predators roamed. In these circumstances, an enclosure such as a cave offered refuge while a commanding viewpoint (for example, a hilltop) allowed danger to be anticipated or food to be identified. Because of this, an enclosed space felt safe and therefore relaxing whereas a prospect was stimulating and exciting. An exposed location such as the open plain, while allowing good vision, also meant that you could be seen and so would produce a mixture of excitement and caution.

Jay Appleton believes that our responses to the hunter-gatherer landscape were so essential for survival that they remain ingrained in the biological fabric of experience. Thus, exposure and enclosure and combinations of views and screening continue to elicit archetypal responses of anticipation and excitement, caution and anxiety, relaxation and safety, according to their archaic survival meaning. This unconscious meaning of spatial form helps to explain why some sizes and shapes of spaces feel 'right' and others do not. For example, too confined an enclosure or an unfamiliar place without a clear exit route is no longer safe but threatening, whereas a large expansive space is unsatisfactory if it is cluttered with objects that obstruct views and stop us from getting any clear prospect. The right combination of enclosure and outlook will give a balance of welcome refuge and pleasant prospect.

Prospect-refuge theory is useful for designers because it reminds us that when we design spaces we create experiences. Although it was developed mainly by reference to rural and natural landscapes, the theory can also be applied to complex urban spaces created by buildings, topography and vegetation. Its foundation in theories of hunter-gatherer behaviour is overlain with a diversity of social demands and opportunities that are the products of the specific cultural setting of our present day lives.

We can understand, then, our perception of space as an integrated whole, a *gestalt* built up from a variety of received sensory information that is interpreted in the context of our biological and cultural heritage. This helps us to understand why space is not simply the gap between objects – the absence that allows us to perceive the presence – but something with an impact and a meaning in its own right.

The Use of Spaces

Whether spaces are conducive to the activities taking place within them is determined not only by their functional provision but also by their physical composition. We must endow the space with aesthetic qualities that fit it for its purpose.

John Ormsbee Simonds reminds us in his classic textbook *Landscape Architecture* (1983) that 'a space may be so designed to stimulate a prescribed emotional reaction or to produce a predetermined sequence of such responses'. For example, it could be restful or dynamic, protecting or exhilarating. The responses could be more complex, involving emotions like gaiety, reflection, even awe. It is important that these responses are appropriate for the use of the space. Contrast, for example, the wonder that we feel at the soaring architecture of a cathedral with the personal insignificance or anxiety we might experience when

hemmed in by poorly designed high-rise. In the first case the scale and proportions of the space speak to us of inspiration and aspiration that transcend the personal, in the other we feel merely depersonalized.

In landscape design, including urban design, planting can play a primary role in creating spaces. These spaces are often described in the language of buildings. Outdoor 'rooms' can be enclosed by 'walls' of planting, 'floors' surfaced with grass or ground cover and a 'ceiling' can consist of a spreading tree canopy, climbers on a pergola, or simply the sky. 'Doorways' or 'gateways' give access to these spaces and 'windows' are formed by gaps in a foliage canopy or merely by the natural permeability of trees and shrubs with an open branching habit. The basic spatial form can be 'decorated' and 'furnished' with ornamental planting.

This building vocabulary can be useful to the planting designer for two reasons. Firstly, it reminds us that outdoor spaces, just like indoor ones, are designed to be used as well as to be enjoyable. Secondly, it identifies the structural/spatial aspects of planting that are important in the making of outdoor spaces.

The Elements of Spatial Composition

In *The Visual and Spatial Structure of Landscape* (1983), Higuchi analysed landscape space in terms of four aspects:

- Boundaries,
- Focus–centre–goal,
- Directionality,
- Domain.

His study encompassed all the elements of the landscape, including topography, water and structures as well as vegetation. We will interpret Higuchi's four aspects to identify those that are important for planting design.

Higuchi defines 'domain' as 'the total space that is brought together and given order by the conditions of boundary, focus–centre–goal, and directionality'. Domain also has a social connotation, it suggests ownership and territory. This is an important concept for design, but is a property of composite space, not a primary element of composition, so we will discuss it in the chapter on composite space.

'Boundaries' include both open boundaries enclosing edges. Open boundaries that allow free access may delineate territory but do not define space. All spatial boundaries are formed by some degree of separation and enclosure and so our first element of spatial composition with plants will be enclosure.

The 'focus–centre–goal' of a space can be anything important enough to be a visual focus, for example, a fountain, or a specimen tree, or it can be a natural centre such as an amphitheatre, or a goal such as a lookout or building.

'Directionality' is the sum of all the aspects of space that give orientation or directional emphasis. These include shape, proportion, focus, slope, even the direction of the wind and sunlight. Directional elements introduce dynamic qualities into space because they imply movement. So our third element of composition will be the dynamics of space.

Enclosure

Higuchi takes a rather limited, architectural view of the spatial envelope. He says that enclosure requires a barrier and 'to be effective a barrier must be difficult to penetrate. It must also shut the outside world off from view while at the same

time have a high degree of visibility within the domain it protects'. In other words it must enclose and separate from what is outside.

But enclosure need not be complete. It can be clearly defined without being impenetrable. Indeed, it is rare that full closure is needed in a landscape situation. As landscape architect, Barrie Greenbie, points out in his book *Spaces* (1981): 'The openings in the walls enclosing a space make the difference between … an enclosure and a prison'.

The design and location of these openings will articulate vision and physical movement within and between spaces. This is to do with communication and relationship within the spatial landscape and is essential to the design potential of landscape. By varying the placing, proportions and permeability of barriers we can orchestrate spaces for different uses and effects. In looking at types of enclosure we will take a systematic approach, but the intention is not to limit flexibility in application, only to establish basic principles as firmly as possible. These principles can then be employed with imagination and subtlety.

Degree of Enclosure

The degree of enclosure is the length of the perimeter that is enclosed by vertical planes. Different degrees of enclosure result in spaces that vary in character from introverted to extraverted.

ENCLOSURE ON FOUR SIDES/360 DEGREES This creates the most introverted character of space. It is appropriate if the site is surrounded by incompatible or hostile environments. For example the earliest gardens in the Middle East were fully enclosed to protect them from the inhospitable climate and surrounding landscape. The Old Persian word for garden or park, *Pairidaeza* is made up from *pairi*, meaning around, and *diz*, meaning mould. To mould around an area was the essence of garden making. The classical Chinese garden too, was completely separated from its surroundings – usually urban in this case – by high walls. This allowed the creation of a contrasting and special world within. A present-day counterpart would be a private inner city town garden enclosed by walls or hedges. Other examples could include forest clearings, play areas, outdoor classrooms, music rooms and theatres. Full enclosure is also important for land uses that are ugly or otherwise intrusive, in order to minimize visual, sound and atmospheric intrusion into the surrounding area.

Full perimeter enclosure can be extended to include overhead enclosure. This is found in places such as dense woodland or a small courtyard shaded by the spread of a large tree. Being so completely surrounded creates the most private kind of place. But care is needed because, depending on its proportions and the materials used, it can be pleasantly intimate or uncomfortably claustrophobic – a refuge or a prison.

ENCLOSURE ON THREE SIDES/270 DEGREES This gives a high degree of protection or separation to the space but also offers a directed outlook. It creates both refuge and prospect. The prospect significantly affects the character of the space by drawing attention beyond the limits of the space. A distant landmark or vista may become part of the identity and character of the space even though it is located beyond it.

Such a 'space with a view' would be appropriate for many gardens and play areas and also for seating in public areas, especially in parks and countryside. But note that there is a common problem of territory that occurs when small urban spaces are too enclosed and separated from the busy activity zone. Such spaces

Plate 38 Enclosing boundary tree planting creates a protected, warm, sheltered and attractive space for informal games, walking, sunbathing and other recreation in Golden Gate Park, San Francisco, USA.

Plate 39 Clipped beech hedging gives medium height enclosure for this circular lawn. Trees and buildings provide taller enclosure beyond (University of Canterbury, Christchurch, New Zealand).

can become taken over by groups who are then experienced by other people as threatening and the space becomes their territory. This can be commonly seen where groups of seats are set in enclaves away from thoroughfares in parks and city streets. This is a cultural issue as well as one of spatial layout. It tends to be less of a problem where the street and the urban public realm is seen as a social arena and not merely a route from A to B.

ENCLOSURE ON TWO SIDES/180 DEGREES The enclosing elements may be L-shaped or C-shaped and may define space half by delineation and half by implication. The full domain of the space will cover roughly the area of ground that would be enclosed if the two omitted sides had formed a mirror image of the actual sides. The space will have an outward looking, extraverted character with free access across half the boundary and a clear orientation towards a landmark, attractive outlook or simply towards the sun. Yet, a sense of place, a feeling of having arrived somewhere, is created by the limiting and sheltering function of the two sides. Such spaces can be welcoming.

Two-sided enclosure may be 'free-standing' rather than a condition of the edge of a larger mass. If it is free-standing in a flowing, wider space it will create a subsidiary domain. This combination of protection and orientation is made good use of by farmers in parts of Japan where L-shaped shelterbelts protect farm buildings from winter wind and snow.

Semi-enclosed spaces are frequently encountered in the form of niches or enclaves in the edge between open space and solid mass. They can be quite informal, occurring along the edges of forest or scrub where natural irregularity creates a serpentine or fragmented edge. Despite their unplanned nature, such enclaves are an important part of the spatial structure of informal or nature-like planting where they add smaller scale spatial variety to large-scale landscapes.

In the more formal setting of many urban landscapes a semi-enclosed enclave can provide variety and incident along the edge of a route or around the boundary of a larger, dominant space (the arena at Parc Guell in Barcelona provides a famous hard landscape example). In addition, seating areas, ornamental display planting, building entrances and gateways can all benefit from the protection combined with ease of access offered by this configuration.

Plate 40　Shrub and tree planting provides enclosure behind and over the seat giving shelter and shade, creating a delightful space while emphasizing the outlook (Singapore Botanical Gardens).

Plate 41　Planting forms seating enclaves along the edge of a route in Robson Square, Vancouver

OBJECT/FOCUS If enclosure is much less than 180 degrees, spatial definition is weakened and soon becomes ineffective. If the structural element is isolated rather than forming part of a structural continuum it will be experienced as a free-standing object rather than a space-forming enclosure.

Although no distinct spatial boundary is defined, such an object can create a field of influence around itself. There is a tendency to feel fully in its domain, when we are within a radius equal to the height of the object. This is only an approximate boundary but it can be useful to be aware of it when locating key objects. These objects behave as foci and their effectiveness is often greatest if the boundary of their influence is reinforced on the ground by some kind of physical definition so that they become a focus within a clearly established space.

To define the space that focuses on an object can help avoid the risks of the compound influence of separate objects. This can easily create a landscape which, as a whole, is formless and without boundary. For example, a series of 'island beds' or a scattered collection of specimen trees can be unsatisfactory as a spatial composition; they are objects that need to be located in spaces and play a role within a firm spatial structure.

Permeability of Enclosure

The framework of green spaces is constructed from plants of the different growth habits and canopy heights described in Chapter 3. They offer various combinations of visual and physical enclosure and openness. This is what we will call the permeability of enclosure and is as important for the composition and the character of space as is the degree of enclosure.

VISUALLY AND PHYSICALLY ENCLOSED Enclosure is complete. The boundaries of a space consist of impenetrable foliage to above eye level. This will consist of shrubs with a naturally close-knit canopy to near ground level, or clipped hedging. There are no significant gaps in the planting, at least not below eye level, and so complete separation is achieved.

The resulting space, if enclosed around more than half of its perimeter, will offer shelter, protection and seclusion. Attention will be focused on what is

4 SIDES -
INTROVERTED

3 SIDES -
PROTECTED

2 SIDES -
EXTRAVERTED

OBJECT -
FOCUS .

Figure 4.1 Degrees of enclosure.

within the space rather than what is beyond it unless any openings in its enclosure and perimeter are directed towards a notable view.

PARTLY VISUALLY ENCLOSED, PHYSICALLY ENCLOSED Openings that extend below eye level in the enclosing planting will form windows that allow visual penetration of the space. These may be small, allowing only carefully controlled glimpses out and in, or they may be more generous, giving a greater degree of connection between inside and outside.

Windows can be created by omitting tall planting in chosen positions to leave clear gaps, or they may be more loosely formed by trees and shrubs with an open habit that allow views through the tracery of their branches.

PARTLY VISUALLY ENCLOSED, PHYSICALLY OPEN Shrub planting is omitted so there is no barrier to movement but a narrow band or single line of trees clearly defines the boundary and their boles interrupt and frame views across the boundary. Trees form a canopy above head height and the spacing of the trunks will determine the amount of visibility between them. Comparatively dense tree planting at 1–2 metres apart eventually forms a frame around numerous tall and narrow 'doorways'. A line of trees at wider, regular spacing would form something more like a colonnade, the trunks becoming columns supporting an arching canopy of branches and foliage above.

The advantage of this kind of space is easy communication with surrounding areas combined with a strong sense of place, of being within.

VISUALLY OPEN, PHYSICALLY ENCLOSED Full visibility is achieved by planting that is mostly below eye level. Yet shrubs at knee to waist height form an effective barrier to movement. A space enclosed in this way by medium-height shrub planting will be clearly defined and separated from surrounding ground and yet allow an open prospect in all directions. It will feel open even if there is only one entrance. Because of the exposed nature of such a space it is often used as a subsidiary space within a larger, dominant enclosure that offers more shelter. Nevertheless, medium shrub planting creates a clear boundary and can effectively define a domain where territory must be identified and easy surveillance is required.

VISUALLY OPEN, PHYSICALLY OPEN A domain can be defined by low planting of knee height or below. This allows complete visibility and, though it discourages movement because the surface can be difficult to walk on, it does not altogether prevent it. Indeed, some groundcovers can tolerate a moderate amount of foot traffic. The role of low planting in this kind of space is not to separate but to link visually the distinct areas or zones, giving an uninterrupted flow of space between them.

Enclosure is one key element in the composition of spaces. Its degree and its permeability can be manipulated to control the linkages and inter-relationships between spaces. These relationships will be examined further in Chapter 5 on composite space and transitions. In addition to enclosure, the designer needs to understand the effect of its shape and relative proportions because these give a landscape composition much of its dynamic quality.

Dynamics

The dynamic qualities of space are those that create a sense of movement or rest within it.

PERMEABILITY OF ENCLOSURE

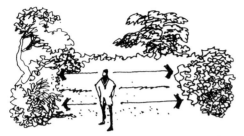

VISUALLY & PHYSICALLY ENCLOSED

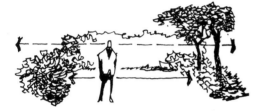

PARTLY VISUALLY ENCLOSED
PHYSICALLY ENCLOSED

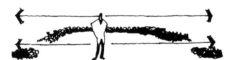

VISUALLY OPEN, PHYSICALLY OPEN

Figure 4.2 Permeability of enclosure.

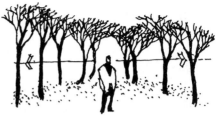

PARTLY VISUALLY ENCLOSED
PHYSICALLY OPEN

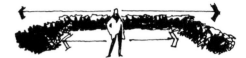

VISUALLY OPEN
PHYSICALLY ENCLOSED

Plate 43 Full visual and physical enclosure gives shelter and seclusion to a public garden at Birchwood, Warrington, UK.

Plate 42 Full visual and physical enclosure may be desirable around visually intrusive land uses such as this car park at Broadwater Business Park, Denham and will also provide shelter and a pleasant environment for the people using it. The trees are London planes (*Platanus* x *hispanica*), the tall shrubs bamboo (*Arundinaria* sp.) and the low shrub edge is composed of *Rubus tricolor*.

Plate 44 Partial visual and physical enclosure results when windows and doorways remain in a wall of planting. Here they frame views across Willen Lake, Milton Keynes, UK.

Plate 45 This line of trees in paving makes all the difference to the restaurant's environment in this new public space in Bristol, UK. They provide spatial definition, separating the dining area from the larger expanse of the public thoroughfare. They also give partial physical enclosure, while retaining easy physical access

Shape

The shape of a space, its horizontal proportions, affect its dynamics. An enclosure that is circular or square in its proportions suggests a place of arrival, a place for gatherings and focused activities, or simply for stopping. This kind of space is 'static'.

In contrast, a space that is longer than wide implies movement. It appears, like a street or corridor, to lead somewhere. It is dynamic, motive. The more elongated or attenuated the space and the less detail or variation along its length, the greater the directional emphasis or 'speed' of the space. A familiar analogy would be that of water in a pipe. Given the same water pressure, the narrower the pipe, the faster the flow of water. Space, like water, is fluid. Without containment it is formless and the shape and dimensions of that containment determine the dynamics of its flow.

The dynamics of an enclosure that is intermediate between static and linear can sometimes be ambiguous if the circulation is not defined by a path or other route. This kind of shape will have a quality of restlessness without leading anywhere in particular, but the uncertainty could be resolved by introducing a feature such as a specimen tree or other focus that creates a goal within the space.

Pattern and shape also influence the implied speed of movement. The artist Maurice de Sausmarez, in his book *Basic Design: the Dynamics of Visual Form* (1964), notes that, 'Rectilinear shapes and curvilinear shapes appear to have differing potentials in terms of suggested movement – in general the latter appears to move more swiftly than the former' though he recognizes that this is not always the case: 'For example, a star shape of a certain kind has as great an apparent speed as almost any curvilinear shape.' The star shape implies greater speed because it is made up of diagonals and acute angles. Elements of this kind of pattern are encountered in landscape in what Higuchi calls 'opening' and 'closing' spaces. An opening space has a clear beginning from which interest or movement is drawn out, an example would be the deeply cut head of a valley. A closing space funnels attention or movement in towards the apex that then becomes the focus of the space.

Static spaces are necessarily reasonably regular. Motive spaces may be regular and symmetrical, for example an avenue or boulevard. But unvarying, uninterrupted spaces such as tend to be grand and impressive, or dull and daunting depending on their scale, the views they frame and the detail encountered along their length. An example of grand formality is the double avenue in Windsor Great Park that leads, gently but purposefully, over undulating parkland to focus on the impressive statue beyond. Compare this avenue with the vistas at Versailles that seem to extend over more or less flat ground, almost to infinity.

Plate 46 A stopping and gathering place is most successful if its shape is of largely similar horizontal proportions, such as found in a square or a circle. This example is in museum precincts, Brussels, Belgium.

Plate 49 The course of this canal creates a linear space within dense woodland at Green Park, Aston Clinton, Buckinghamshire, UK.

Plate 47 A pond and clearing provides a natural stopping and gathering place in the woodland at Risley Moss, Warrington, UK

Plate 48 The shape of linear spaces express the functions of communication and movement. This photograph shows footpaths and carriageway firmly defined ansd separated by trees and shrubs (Singapore).

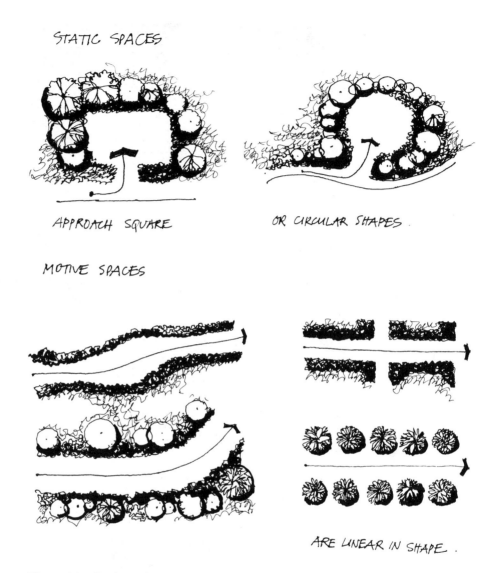

Figure 4.3 Static spaces and motive spaces.

Motive spaces can gain much of their dynamism from the tension set up by irregularities of shape. The enclosing sides may approach one another, then recede; they may be interrupted by sudden changes in direction or their density may vary along their length. This variation is like the rhythm of the space. It can be regular and simple, or more complex and varied, and it should carry you along.

The visual length of the space can be limited by bends, corners or changes in level. The concealment and anticipation that results creates a desire to explore and the shape of space can be designed to incorporate anticipation, incident, surprise and arrival.

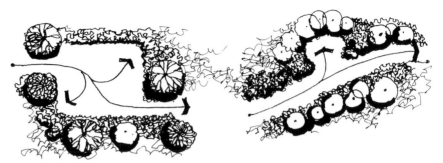

STATIC SPACES MAY BE LOCATED ON THE ROUTE OF LINEAR SPACES.

INTERMEDIATE SHAPES CAN BE AMBIGUOUS

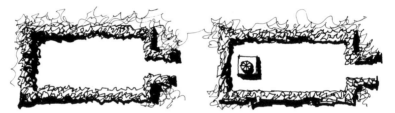

IF THEY HAVE ONLY ONE ACCESS THEY BENEFIT FROM A FOCUS OR GOAL.

Figure 4.4 Static and motive spaces may be combined.

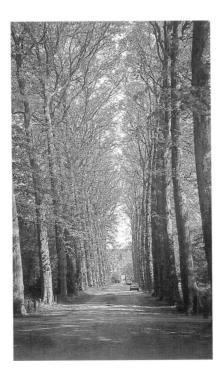

Plate 51 If an avenue is long with no focus it can be daunting for the traveller, especially if they are on foot. This avenue however, does make the ramp down to the underpass a more attractive and less claustrophobic space than it would be without trees (Milton Keynes, UK).

Plate 50 This mature avenue of plane trees (*Platanus*) leading to Castle Arenberg, Belgium is a grand and dynamic element of landscape structure.

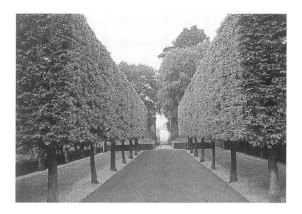

Plate 52 The gate at the end of this alley at Hidcote Manor, Gloucestershire, UK, provides a focus and also anticipates what lies beyond it. Hidcote Manor is a masterpiece of formal spatial composition and provides endless examples of spatial form.

Plate 53 Curving linear spaces create curiosity and anticipation by concealment. The gentle curve and flow of the landform are further enticements (Ashridge, Hertfordshire, UK).

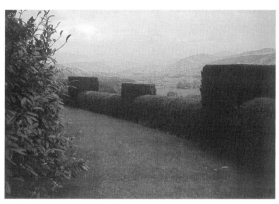

Plate 54 This hillside promenade is fully closed along one side but open to views over the distant landscape along the other side. The waist-high hedge screens foreground detail and the curving alignment draws us on (Muncaster Castle, Cumbria).

LINEAR MOTIVE SPACES ARE STRAIGHT AND SYMMETRICAL CAN BE GRAND AND IMPOSING.

IRREGULAR MOTIVE SPACES SET UP A DYNAMIC TENSION BETWEEN CONCEALMENT AND REVELATION.

Figure 4.5 Linear motive spaces.

Vertical Proportion

The height to width ratio of a space also influences its dynamics. If it is too low, physical containment and orientation are lost and the space and directional qualities are said to leak away. If it is too high, a claustrophobic, deep well or trench is created. A way of understanding this effect is to imagine that the pressure caused by the shape of the enclosure is multiplied by a factor that reflects the height to width ratio. The higher and narrower a linear space, the more urgent the sense of movement. Tall enclosing sides can also create strong motive forces in a static space and, although they may still be in balance, these forces have great potential energy. If the height to width ratio is too great the space is experienced as oppressive.

Empirical studies of the spaces formed by buildings have shown that, among those consulted, certain height to width proportions are generally regarded as the most satisfying. For a street, these tend to be between 1:1 and 1:2.5 and for a square or other static space, between 1:2 and 1:4 (Lynch, 1971; County Council of Essex, 1973; Greater London Council, 1978). There are, of course, exceptions to these rules such as the deep canyon-like streets of Florence and other Renaissance and medieval towns. These give pleasant shade from the summer sun and a sense of busyness combined with intimacy. Narrow streets like these are also a much-loved feature of historic cities like York, despite the colder, cloudier northern European climate. Perhaps the conclusion is that the 'classic' proportions are only one aspect of the character of a space and, although they do have an effect, they should not be rigidly adhered to.

Height to width proportions can also be applied to green spaces enclosed by vegetation. The ratios preferred in the studies mentioned above represent a range of proportions that feel inviting, and generally comfortable. The limits of comfort can be stretched in order to dramatize the contrasts felt between different spaces. For example, a feeling of claustrophobia in a dark narrow confined space would heighten the experience of relief on entering a generously proportioned, warm, sunlit space beyond. Conversely, the feeling of refuge in a warm and sheltered enclosure would be all the more welcome after a journey through an exposed expanse of featureless ground.

Slope

Steeply graded land may itself give enclosure and define space, but the slope will also effect the dynamics of a space that is defined by planting, buildings or structures.

Sloping ground introduces a directional quality. It may invite us to climb to a point of prospect or descend to a protected hollow. If the slope is steeper than about 1 in 3, easy movement will be restricted to the direction of the contours or diagonal paths across the slope. For this reason the directional emphasis of a steeply sloping site will tend to be perpendicular to the contours for vision while movement will follow the contours. The orientation of the ground plane is a dynamic element and needs to be considered along with the placing of the proportions and the shape of the space.

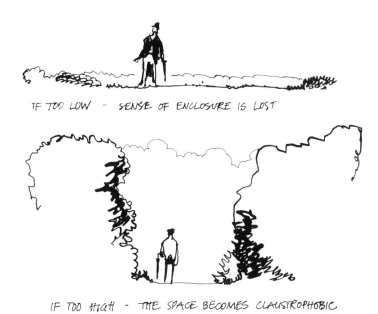

IF TOO LOW - SENSE OF ENCLOSURE IS LOST

IF TOO HIGH - THE SPACE BECOMES CLAUSTROPHOBIC

HEIGHT TO WIDTH RATIO OF A LINEAR SPACE:

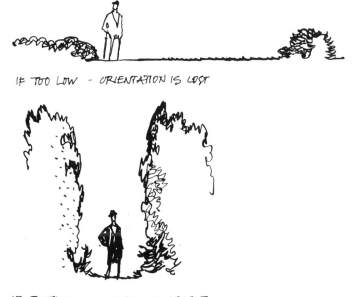

IF TOO LOW - ORIENTATION IS LOST

IF TOO HIGH - ESCAPE IS URGENT.

Figure 4.6 Height to width ratio of static and linear spaces.

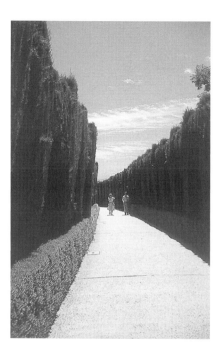

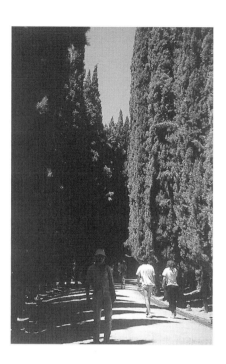

Plate 55 The ratio of height to width of a linear space influences its dynamic qualities. A ratio of 1:1 gives a strong, purposeful character (Generalife, Granada, Spain).

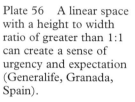

Plate 56 A linear space with a height to width ratio of greater than 1:1 can create a sense of urgency and expectation (Generalife, Granada, Spain).

Focus

The focus of a public, built space is often a dominant building, a sculpture or a water feature. In a space enclosed by planting, the focus could be any of these, or other structures such as a pergola or an arbour, or simply a notable tree. Whatever the focus is, it needs to be distinct from its surroundings and of a strong character. In fact, the character of the focus tends to dominate a space and define its identity.

At the large-scale a focus may become a local landmark. Lynch (1971) and Greenbie (1981) both report the significance of landmarks such as churches, old buildings and parks for the identity of districts or urban areas. A single, grand old tree can have equal presence and renown as a landmark. Foci have different roles and effects according to their position in a space. Some of these are as follows.

Symmetric Focus

A static space with an internal, more or less central focus that terminates sight lines is described as 'centric' (French, 1983). The symmetry of the space will be emphasized if the focus is near the intersection of the axes of symmetry.

In such a symmetrical space dynamic forces remain balanced and this gives a calm and often strictly formal character. This kind of arrangement is very simple but is found in some of the best-known examples of spatial design in history, for example, the Piazza of St Peter in Rome and the Islamic courts and gardens of southern Spain. Although the design of a formal, centric space demonstrates an apparent economy of effort, it is far from easy to accomplish. Inexperienced

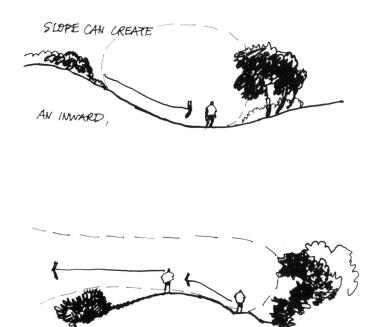

Figure 4.7 Slope can create an inward or an outward orientation.

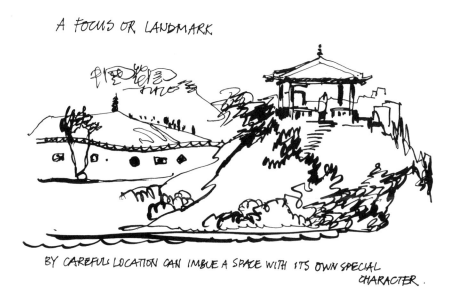

Figure 4.8 A focus or landmark.

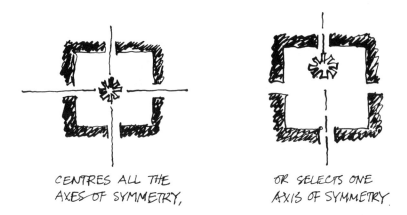

CENTRES ALL THE
AXES OF SYMMETRY,

OR SELECTS ONE
AXIS OF SYMMETRY.

Figure 4.9 A symmetric focus.

designers can easily place foci in the middle of a space with a result that is clumsy and prosaic. Good design of a centric, symmetrical space requires just as much flair and sensitivity as asymmetric, informal design.

Asymmetric Focus

When any object is located in a defined space, dynamic forces are brought into action between the object and the boundaries of the space. The strength of those forces depends on the distance from the boundaries and the overall geometry of the space. This principle is understood and used in the visual arts (de Sausmarez, 1964) and in architecture (Ching, 1996).

If the focus of a static space is located off-centre the sum of the forces introduces a dynamic, directional quality to the spatial composition. Another way of understanding this is to imagine the implied division of the space by its focus. An asymmetric focus implies division into unequal parts and so creates a progression through the sub-divisions, usually in order of their magnitude arriving at the focus itself.

So, an asymmetric focus introduces movement and rest within a space. This dynamic tension adds to the character of a space but is independent of the character of the focus itself. The dynamics of the space would be the same whether the focus is an obelisk, a coffee kiosk or a specimen tree.

Focus on the Boundary

The focus of a space can be located on the boundary or part of the enclosing edge. Enclosing framework planting that is spectacular in colour or form can provide the main eye-catcher and focus in the space. An entrance, because of its importance as an access point or because it allows glimpses beyond, could be the centre of attention. Indeed, in the absence of any other focus the main entrance is likely to be the focus of a space.

A focus that is located within or on the edge belongs to the space because it is an integral part of its composition and is chiefly visible from within. Such an internal focus emphasizes the feeling of arrival, of achieving the goal, of completeness.

AN ASYMMETRIC FOCUS

ADDS DYNAMISM TO A STATIC SPACE

OR ADDS TO THE DYNAMISM OF A LINEAR SPACE.

Figure 4.10 An asymmetric focus.

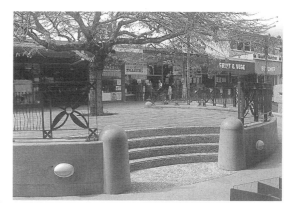

Plates 57 and 58 The focus of a space can be provided by a single specimen tree of sufficient stature. These urban spaces are in Brugge, Belgium; and Northcote, Auckland, New Zealand, and in both cases the trees also make an informal gathering place.

ON THE BOUNDARY.

BEYOND THE SPACE

THE ENTRANCE MAY
BE THE PRIMARY FOCUS

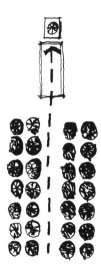

Figure 4.11a The focus may be located on the boundary.

Figure 4.11b The focus may be beyond the space.

External Focus

A prominent landmark that is visible from a space can act as its focus even if it is some distance away. It gives orientation along a visual axis and it can also give the space a particular identity, a sense of place, because it is visually included within it. The external focus will be part of the experience of the space.

An external focus can be used to emphasize the orientation that is inherent in the shape, enclosure or slope of a space. An example is the device of placing a monument beyond an avenue, where it terminates a long, straight vista.

So far, we have examined the composition of single spaces. But no space exists in isolation. It will always be part of a sequence through which we pass and that gives relative meaning to each particular space. In the next chapter we will look at how the relationships between spaces affect our experience of landscape as a whole.

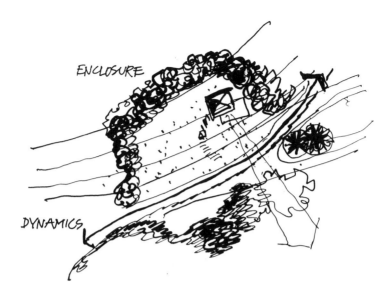

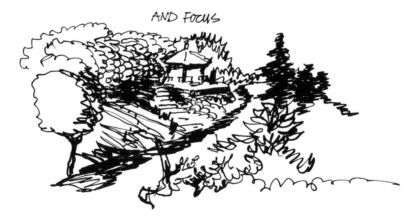

Figure 4.12 The character of any space is a product of its enclosure, dynamics and focus.

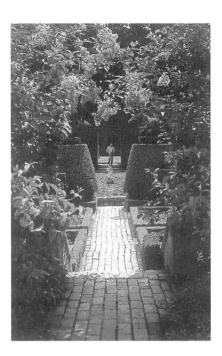

Plate 59 Focus beyond the boundaries of the space may be effective in both characterizing the space itself and creating momentum (Hidcote Manor, Gloucestershire, UK).

CHAPTER 5

Composite Landscape

Activity and movement are fundamental to our experience of landscape. To view a scene from a fixed position is the exception rather than the rule and tends to be a view experienced by the painter, photographer or tourist, rather than the dweller in, or user of a place.

The perception of landscape as scenery, as if it were a picture of a scene, requires a viewpoint that is separate from the scene being appreciated. This scenic perception is, in some ways, an abstraction from the experience of being or doing in a place that constantly changes as we engage with the environment. There are drawbacks to appreciating landscape primarily as something to be viewed. It can lead to the 'out of sight – out of mind' approach and to the detachment inherent in the idea of environment as mere decoration for living. Landscape can become a picture window to hang on the lounge wall or a video to be viewed through the windscreen of a motor car. This reflects a separation of scenic values from the every-day, utilitarian landscape. A good discussion of different modes of landscape appreciation can be found in Steven Bourassa's *The Aesthetics of Landscape* (1991).

In reality, interaction with the outdoor environment consists of a multitude of sensory events. These include the commonest of everyday sights, sounds, smells and sensations as well as surprise encounters. As we move through the landscape, we enter and leave spaces and our perception changes constantly, we pause to examine something, we encounter people, animals and plants. These events happen in a time sequence. The experience of landscape is a shifting perspective in time and in space observed in a way that Gordon Cullen (1971) called 'serial vision'.

The composite landscape is the sum of the spatial framework created by landform, vegetation and built structures. It controls our unfolding experience as we move through a sequence of spaces and transitions. Within this composite landscape, the relationship of a space to the others in the sequence will affect our experience of it and influence its character. So the design of composite, complete landscape involves the integration of space within an orchestrated and often complex whole. Edmund Bacon regarded this as one of the connections between architecture and other arts:

> Life is a continuous flow of experience; each act or moment of time is preceded by a previous experience and becomes the threshold for the experience to come ... When viewed in this way, architecture takes its place with the arts of poetry and music, in which no single part can be

considered except in relation to what immediately precedes or follows it. (Bacon, 1974)

Bacon's reference to architecture applies equally to landscape design. In the design process, we begin to synthesize ideas by exploring the spatial qualities that would enhance the site and engage the users. The next step is to understand the place of each space in the composite landscape, to consider its relationship with other spaces. There are two keys to this relationship, the kind of organization we adopt for a related group of spaces and the nature of the transitions between adjacent spaces.

Spatial Organizations

If we observe spaces as we move through the landscape we can see that there are a number of fundamentally different kinds of organization. The organization depends on the location of spaces relative to each other and to the circulation patterns that will link them. The architect Francis Ching in *Architecture: Form, Space and Order* (1996) described various types of organizations of rooms, courtyards, squares and streets. If we study these we see that three of his types: 'linear', 'clustered' and 'centralized' organizations, are primary; that is, they cannot be made up from or subsumed under any other type. All of these primary organizations can be found in landscape as well as architecture and they give us a means of analysing and understanding composite landscape space.

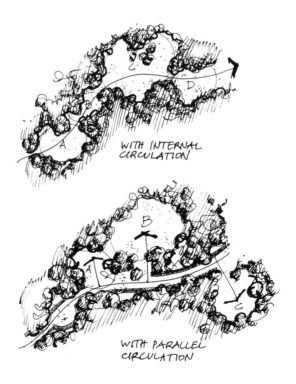

Figure 5.1 Linear progression of spaces.

Linear Organizations

A linear organization is a serial progression of spaces. It is associated with a single circulation route that can either pass through each space in turn or follow the line of spaces in parallel giving separate access to each space. The progression might be straight, angled, curved or irregular but the line is unbroken and with a beginning and an end.

Each space within the series can be similar, or their size, shape and enclosure could vary. The spaces at either end of the line will have a special importance because they start and finish the sequence, whereas the significance of the spaces in between is articulated by their composition and relative position. A linear sequence of spaces is experienced as a progression of places in a definite order and might build up to a climax or goal at some point within the line. This is often, but not necessarily, at the end of the sequence.

This kind of organization can make a good approach to an important place, particularly one with symbolic associations. It allows careful control of the design elements to create anticipation, excitement and a strong sense of arrival. Two English examples of how vegetation can achieve this are the wooded approach to the J. F. Kennedy memorial at Runnymede, near Windsor, and the sequence of spaces along the valley of the River Skell linking Studley Royal to the ruins of Fountains Abbey, in North Yorkshire. Both the outward and the return journey can, of course, include other incidents and interest but these should support rather than compete with the primary objective of the sequence.

Clustered Organizations

Ching shows how clustered spaces form a different kind of organization in which they are related mainly by their proximity to one another, to an entry point or to a path. He also describes the role of symmetry as a means of ordering a cluster. The axis of symmetry acts like a perceptual if not physical path linking as well as reflecting the spaces it divides.

Circulation among clustered spaces can take a variety of forms. If each space leads to only one other, the effect would be of a linear organization that has been compressed into a concentrated area. A more common and more useful arrangement is a network of paths connecting spaces. A primary path might give access to the main spaces and the remainder could be entered either by way of intermediate spaces or secondary paths. Another method is to create a major gathering and distribution space such as a city square or performance arena that, although static and not linear gives access to all the spaces adjoining its perimeter. The gathering space is often the largest and most important due to its strategic position and proximity to the others. A historic garden example is the Theatre Lawn at Hidcote Manor in Gloucestershire.

A clustered organization of spaces is suited to a range of related activities that require their own separate domains. An example would be private gardens, public courts, streets, play areas and neighbourhood parks within a residential neighbourhood. The circulation network should allow a choice of routes. This is different from a linear sequence, which would offer only one path and only one sequence of experience. Intricate and varied clustered courtyard type spaces are found, for example, in classical Chinese gardens where indoor, outdoor and intermediate, covered spaces are gathered together within the confines of the enclosing boundary wall. Japanese stroll gardens are marked by a much more fluid spatial progression. Nevertheless, part of their intrigue and delight is due to the variety of space experienced on the path through the landscape.

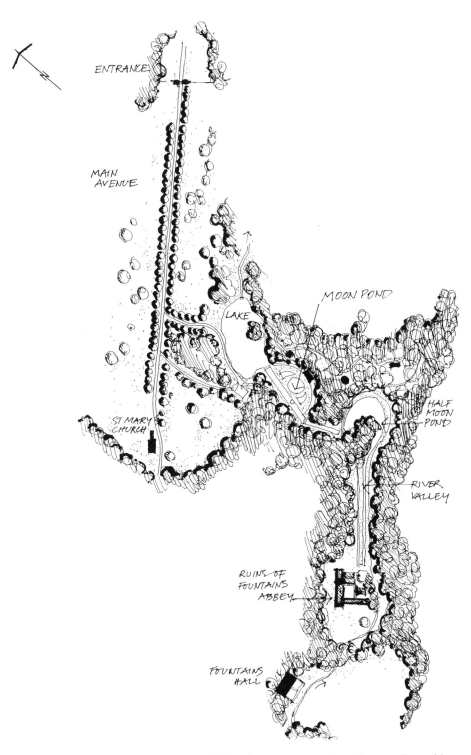

Figure 5.2 Studley Royal, North Yorkshire. A linear progression of spaces formed by tree avenues and woodland clearings along the valley of the River Skell, culminating in the ruins of Fountains Abbey.

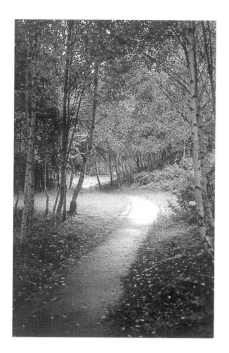

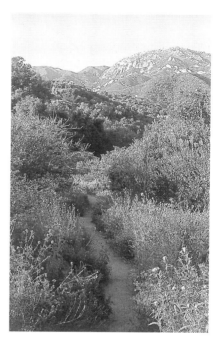

Plate 60 Woodland glades separated by groves of birch (*Betula pendula*) in a Bristol, UK, park form a linear progression of spaces linked by an internal sinuous path.

Plate 61 Again a sinuous path leads through a gently modulated linear sequence of spaces. This time it is formed by landform and vegetation. The sensitive arrangement of the path, the small scale for ground topography and the planting allow the large scale surrounding landscape to be included in the composition or (to use the classic term) to be 'borrowed' (Santa Barbara Botanical Gardens, California, USA).

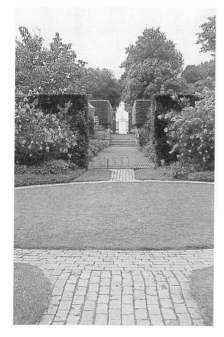

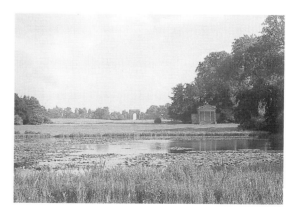

Plate 62 A strongly articulated linear sequence forms a main axis at Hidcote Manor Gardens, Gloucestershire, UK. The transitions are defined by clipped hedges and level changes.

Plate 63 The impressive view from the lawn in front of the house at Stowe, Buckinghamshire, UK, penetrates a series of three parkland spaces enclosed by belts and clumps of trees and focuses on the Corinthian arch on the horizon. The approach drive runs through the plantations to the side of the main spaces and so gives parallel circulation.

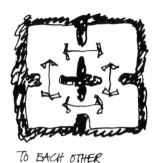
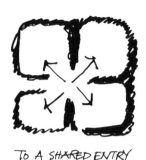
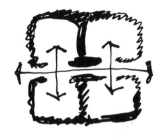

TO EACH OTHER

TO A SHARED ENTRY

TO AN ACCESS PATH

Figure 5.3 Clustered spaces related by proximity.

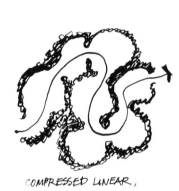

COMPRESSED LINEAR,

PATH NETWORK,

MAJOR GATHERING SPACE.

Figure 5.4 Circulation in clustered spaces.

Contained Organizations

One or more spaces can be contained within a larger, all-embracing enclosure. Ching's 'centralized organization' is one kind of contained organization. The contained spaces can themselves be fully enclosed and so separate from the surrounding space, or they can be only separate while still possessing a domain that is differentiated from the larger space. The tilt yard in the gardens of Dartington Hall, Devon, England provide such an example. This beautifully proportioned space is defined by grass terraces, clipped yew hedges and shrub planting, but lies within the enclosure of a belt of forest trees on rising ground that bounds and encloses the gardens as a whole.

A contained organization can be two-tiered (a space within a space), three-tiered, four-tiered and so on, although in practice it is rare to find contained organizations with more than three tiers out of doors. Any tier within the containing space can consist of more than one space. The organization can be concentric (a centralized organization), or the contained spaces can be distributed asymmetrically according to the requirements of circulation and other usage.

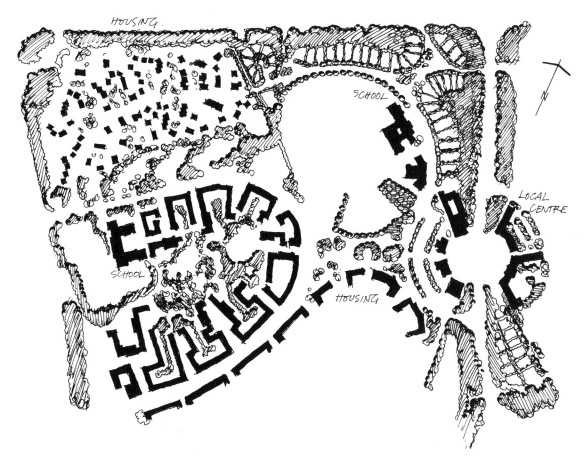

Figure 5.5 Neath Hill, Milton Keynes. Residential, park and garden spaces cluster around a central open space.

Unlike linear series and clusters of spaces, a contained organization relies for its effectiveness on the relative sizes of the constituent spaces. If a contained space is very much smaller than the containing space, it takes on the character and role of a focus of that larger space. It is perceived from the dominant space like an object rather than a second domain that can be entered and explored. On the other hand if the smaller space is too large, then the larger, containing space will have insufficient domain and will lose its separate and dominant identity. In this case, either the two sets of boundaries simply reinforce one another to form a double boundary, or a space of linear form is created between the boundaries that becomes an encircling path.

The experience of contained spaces is one of deepening involvement, of progressive penetration of boundaries, of gradual approach towards the centre or heart. Any of the spaces making up a contained organization can be dominant by virtue of the relative size, the strength of its enclosure, or the influence of the focus. However, it is often either the largest space or the innermost space that dominates – the largest space because of the extent and height of its enclosure, or the innermost space because it is the goal of the composition. The remaining spaces play a supporting role, adding diversity and incident, subdividing domains or offering a prelude to the innermost space.

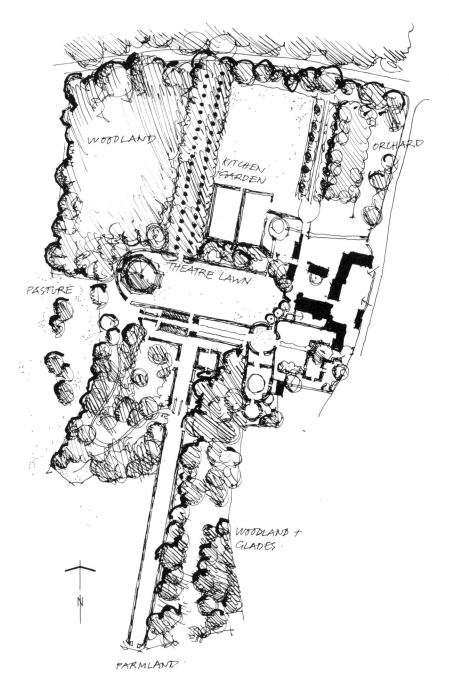

Figure 5.6 Hidcote Manor, Gloucestershire. A complex of spaces clustered around the Theatre Lawn and organized about two major axes at right angles.

TWO TIER

TWO TIER CONCENTRIC

TWO TIER ASYMMETRIC
MULTIPLE SUBDIVISION

THREE TIER

THREE TIER ASYMMETRIC
MULTIPLE SUBDIVISION

Figure 5.7 Types of contained spatial organization.

Hierarchy of Spaces

Linear, clustered and contained organizations will all have some degree of hierarchy in their constituent spaces. That is, there will be differentiation in the status and function of spaces. Like a hierarchy of positions within a company organization, a hierarchy of spaces can be 'vertical' or 'horizontal'. The number of levels in the hierarchy depends on the purpose and nature of the spatial organization.

Hierarchy According to Function

In his book *Exterior Design in Architecture* (1970), Ashihara described a hierarchical order of spaces by uses. He listed the following pairs of opposites:

exterior	interior
public	private
big groups	small group
amusement	quiet, artistic
sport	non-movement, cultural

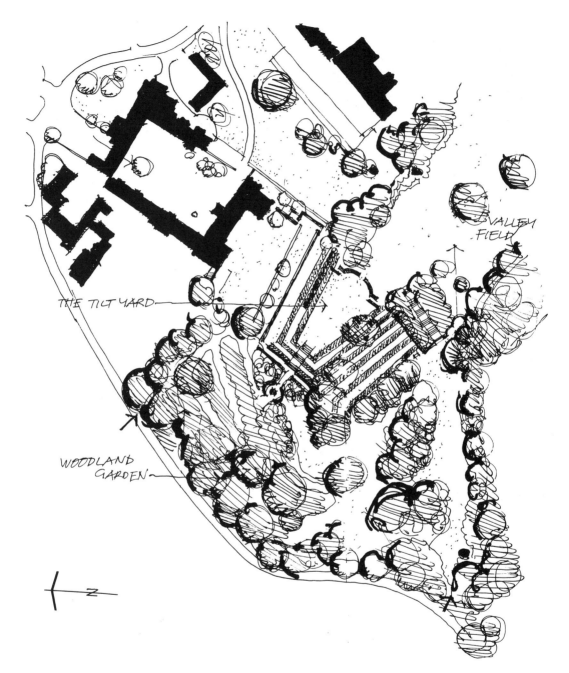

VALLEY FIELD

THE TILT YARD

WOODLAND GARDEN

N

Figure 5.8 Dartington Hall, Devon. The Tilt Yard is the focal space contained within enveloping woodland.

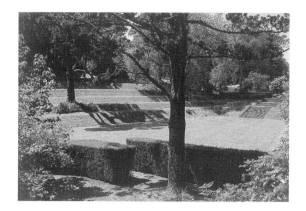

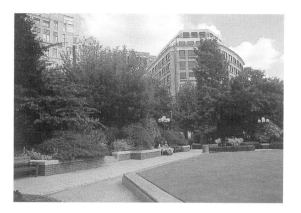

Plate 64 The Tiltyard at Dartington, Devon, UK, is defined by ancient terraces reinforced by tree and hedge planting. It forms the major gathering space around which a number of smaller garden spaces cluster. All are set within surounding woodland.

Plate 65 This park, constructed over a car park, was part of the London Canary Wharf development in the 1980s. It forms a protected green space within the larger spaces formed by the massive buildings and surrounding roads. The whole composition takes the form of a two-tiered contained organization.

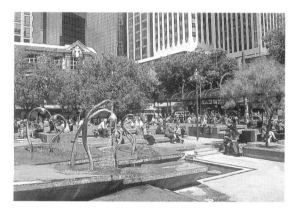

Plate 66 Midland Park, Wellington, New Zealand is a busy greenspace in the heart of the CBD. The simple line of small trees that surrounds it on three sides is vital to the spatial composition. They prove sufficient separation and definition to create a space contained within a larger space, enclosed by the continuous wall of high rise offices. This change in scale is vital to the relaxation and recreational function of the park.

Plate 67 Blocks of trees and groundcover, although rather regimented in arrangement, provide a sequence of smaller sitting spaces contained within the much larger architectural expanse of Millennium Square, Bristol, UK.

Any single space will occupy a position somewhere between these opposites and the successful design of composite space depends on understanding and articulating the position of constituent spaces in the hierarchy.

Between exterior and interior, outdoors and indoors, the hierarchy of space could be developed so that we pass through a sequence in which each space is more sheltered and enclosed than its predecessor. This would allow us to adapt gradually to the change or to choose a place that has just the right combination of indoor and outdoor qualities for our purpose. Classical Oriental gardens and buildings provide some delightful example of this kind of spatial hierarchy, with

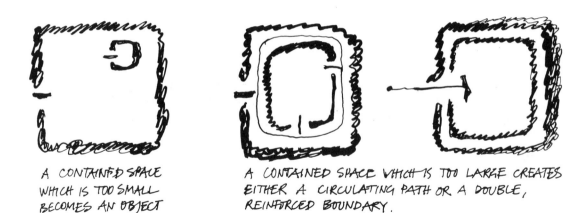

A CONTAINED SPACE
WHICH IS TOO SMALL
BECOMES AN OBJECT

A CONTAINED SPACE WHICH IS TOO LARGE CREATES
EITHER A CIRCULATING PATH OR A DOUBLE,
REINFORCED BOUNDARY.

Figure 5.9 Contained spaces.

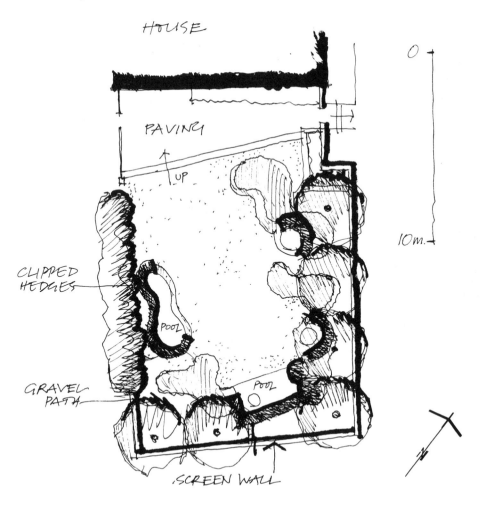

Figure 5.10 Garden at Newport Rhode Island by Christopher Tunnard, 1949. The lawn, enclosed by clipped hedges, is contained within the boundary wall and tree planting.

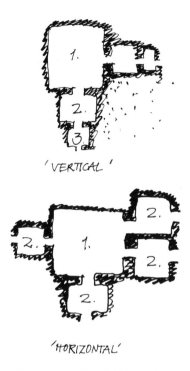

'VERTICAL'

'HORIZONTAL'

Figure 5.11 Spatial hierarchy.

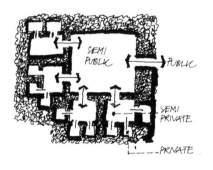

THE INEVITABLE DOMINANCE OF THE
CONTAINING SPACE IS EMPHASISED BY
ITS GREATER HEIGHT OF ENCLOSURE

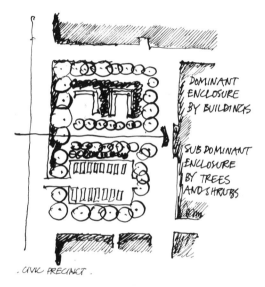

DOMINANT
ENCLOSURE
BY BUILDINGS

SUB DOMINANT
ENCLOSURE
BY TREES
AND SHRUBS

. CIVIC PRECINCT .

Figure 5.13 Hierarchy in contained organizations.

Figure 5.12 Hierarchy of clustered spaces.

verandahs, covered walkways, sheltered terraces, walled enclosures and roofed pavilions linking the larger outdoor spaces with indoor rooms. The inclusion of structures such as pavilions and open rooms has long been a feature of tropical gardens and parks where the shade and shelter from rain that they provide is essential for the enjoyment of outdoor spaces. Planting, either alone or in combination with built elements, fulfils some of these functions.

At the other extreme, the transition from an extensive, exposed, outdoor space to complete enclosure within a building might be made, literally, in one step. This simplest of hierarchies, containing only the two opposites, is be found, for example, in rural cottages and other buildings standing alone in an expansive

landscape. Although it lacks the variety of a multi-levelled hierarchy, a single threshold offers impact and drama.

The hierarchy of outdoor–indoor space is articulated primarily by variations in degree and permeability of enclosure. The extension of structures from a building to enclose the surrounding space is one effective way of creating 'semi-outdoor' spaces because the structures are obviously associated with the building. Plants are more strongly associated in our minds with the outdoors so, in the creation of intermediate spaces, plants can bring 'the outside' into a conservatory or other planted room. They are also very effective at creating shaded and wind-sheltered space that can make an effective transition from an indoor room.

The hierarchy of public–private spaces is a hierarchy of territories that belong to increasingly small numbers of people. It is expressed in its most elaborate form in urban areas where it can provide a framework for social interaction, a way of giving shape to and bringing together what Barrie Greenbie (1981) calls the 'community of strangers'. Entirely public places are found in city squares and shopping streets. Complete privacy is found in the home and its immediate, enclosed curtilage. A number of writers (primarily Oscar Newman in *Defensible Space* (1972)) have shown that positive social interaction and responsibility is facilitated by a spatial hierarchy that makes a staged transition between public and private. People need defensible space between their private domain and the anonymous crowd.

Although territorial hierarchies have been thoroughly discussed in an urban context, this type of spatial structure is also relevant to other situations and can be formed by planting as well as by built elements. As we have seen, planting can create boundaries with different degrees of permeability to suit the need for separation between spaces. The hedge, for example, is one of the oldest ways of marking the boundary of a territory.

Outdoor–indoor and public–private hierarchies provide two examples of how the form and location of spaces can clarify and facilitate purpose and use. Also essential to the functioning of such spatial hierarchies are the transitions between spaces.

Transitions

As we move through our environment we cross boundaries and entrances of one kind or another innumerable times. Many of these are so familiar to us that we take them entirely for granted; for example, in entering our own section or garden, turning into our own street or crossing a bridge over a river into our neighbourhood. Other boundaries assert their presence with more force. We think twice before crossing them or the experience of entering can be dramatic, such as finding ourselves in a quiet enclosed courtyard after a busy street or an exposed sunny meadow after the shelter and darkness of a forest.

The transition between one space and the next can take many forms and its precise nature will do much to influence our experience of the space we are entering. Our first view of a place, like our first impression of a person, sets the scene for an acquaintance. The basic form of the transition is created by the arrangement of the enclosing planes that separate the spaces. This will determine how much of the next space is visible before crossing the boundary and how quickly its full extent is revealed.

At one extreme, overlapping enclosure forms the most abrupt transition that completely hides the space until we have crossed the boundary and its domain is suddenly revealed. This creates suspense and surprise because we do not know

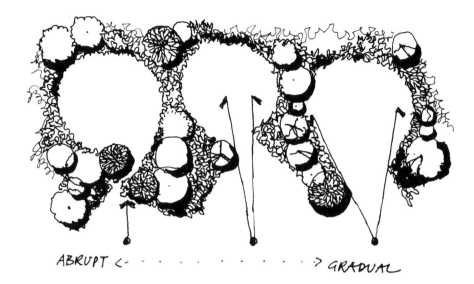

ABRUPT ‹- - - - · · · · · · ‹? GRADUAL

Figure 5.14 Transitions and entries.

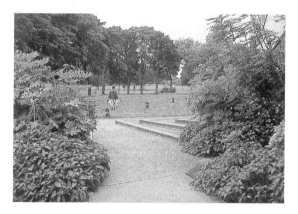

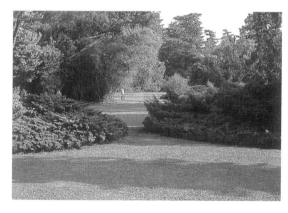

Plate 68 A gap in tall and medium shrub planting creates an informal but concise transition between intensively detailed building curtilage and the more extensive parkland beyond (Hounslow Civic Centre and park, London).

Plate 69 The planting comes so close in this concise transition in Huntington Botanical Gardens, Los Angeles, that there is real tension created between the two spaces.

what to expect. It offers unknown territory and requires curiosity and commitment on the part of the visitor. In contrast, one space might flow gently and gradually into the next so that most of the domain is visible before it is entered. The boundary between these spaces would be merely suggested and not strictly defined, so less intention is needed to enter. Between these two extremes we find a variety of transitions that are more or less abrupt, but in general, the more abrupt the transition, the more deliberate the act of entry must be.

The transition between two spaces will also vary according to what Francis Ching calls the 'relationship' between the two spaces. He identifies four conditions:

- a space within a space,
- interlocking spaces,
- adjacent (abutting) spaces,
- spaces linked by a common space.

The first condition is an example of a contained organization and the remaining three relationships can be understood as a type of transition between spaces. The shared domain of interlocking spaces plays the role of a transitional zone, the threshold between adjacent abutting spaces will be at the 'neck' between them, and a common space linking two other spaces is specifically transitional and analogous to the lobby or porch of a building. We shall now examine some of the possibilities that these spatial relationships offer for imaginative design.

Transitions between Abutting Spaces

This can be a simple gap in a hedge or other separating planting. It can be emphasized or elaborated by creating a 'gate' or 'archway' using planting. Changes in level on the ground can further articulate the transition, separating the two spaces by height as well as by enclosure. The width of the gap will determine how concise the transition is. A screen can be added that overlaps the entrance and prevents any view at all into the adjacent space. A very different approach would be to separate adjacent spaces with a permeable enclosure that allows visual and physical penetration over a wide area, but that still clearly distinguishes one domain from the other.

Transitions between Interlocking Spaces

The shared zone between two interlocking spaces can be defined by low planting in which case a gradual transition would be created allowing a view of both spaces. Because the two spaces overlap, not one but two boundaries would be crossed and we enter the domain of one space before we leave the other's, so the transition is staged. If the shared zone is defined by a continuation of the visual and physical enclosure that delineates the spaces proper, then an overlapping, screened entrance is created. If the size of the overlapping zone is large enough and it is clearly distinguished from its parent spaces, it would be a transitional space in its own right.

Transitional Spaces

An intermediate, transitional space is separated from the domains it links by some form of enclosure and has it own distinct character. Yet, because it is primarily a route and is subsidiary to the spaces it links, its character is often subdued and it prepares us for the next space, linking the two in our minds as well as physically. Together the three spaces form a linear organization, which include two entrances or subsidiary transitions.

Entrance Zones

Where a concise transition forms a distinct entrance it is usually a strategic and important part of a space. It is often a visual focus, and a gathering and meeting area for people serving a similar function to a main entrance into a building. The entrance to a larger space gives rise to zones where people come together close to the enclosing elements of the space. Because it comes under close scrutiny, the

OVERLAPPING ENCLOSURE GIVES COMPLETE SURPRISE

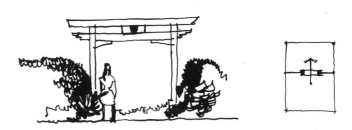

A NARROW GAP ATTRACTS INTENSE ATTENTION

ITS IMPORTANCE CAN BE ENHANCED BY OVERHEAD ENCLOSURE

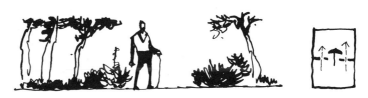

OR A GREATER VISUAL CONNECTION MAY BE DESIRED.

Figure 5.15 Entrances.

Plate 70 A simple narrow gap in an enclosing hedge overhung with the branch of a nearby tree provides a concise transition. The point of entry is precisely defined and a glimpse of what is within is revealed. This public park was once the Bundesgartenschau at Mannheim, Germany.

Plate 71 An overlapping entrance ensures complete surprise on entering the space (Bodnant, North Wales).

Plate 72 A gradual transition is made between two distinct spaces but dynamic tension is created by the sinuous curve of the grass path, by the gap which first narrows and then widens and by the locations of the clumps of trees being offset either side of the opening (Askham Bryan College, York, UK).

Plate 73 This transition is made in stages. As the observer skirts the lake at Stowe, Buckinghamshire, UK, new views are opened and the far paddock is revealed in carefully controlled sequence. Finally the focus of the space, the Palladian Bridge, will come into view.

detail of entrance zones should be given careful attention and can be designed at a more intimate scale than general boundary planting. Entrances and transitional spaces allow us to express the relationship between spaces and the relationship between the people that use them.

On a particular site we might be blessed with a landscape with a strong existing spatial structure and organization. This structure might need to be strengthened, modified or added to, so as to accommodate fully the proposed changes in land use. Many sites, such as derelict land and demolition plots, however, have little or no existing spatial structure. Here, new spaces have to be created and organized to help transform the site.

To meet the functional brief is only part of the design objective. The form and character of the site itself, the spirit of the place – these can suggest the uses and

Plate 75 A larger transitional space, enclosed by beech (*Fagus sylvatica*) hedges and pleached lime trees (*Tilia*), forms the entrance zone to a public park in Oakwood, Warrington, UK.

Plate 74 Trees and shrubs create a small but well-defined transitional space between the precinct in the foreground and the courtyard beyond the arch at Leuven, Belgium.

kind of spaces that will be right for the place. A location with a fine view would suggest an extraverted space, whereas a setting that was unsympathetic would need a more introverted, inward looking arrangement. A site with substantial existing tree and shrub cover would suggest a smaller scale organization that made use of the existing vegetation character and canopy structure. A steeply sloping site would suggest spaces of an elongated shape because this would allow development without the need for massive earthmoving and level changes.

Now that we have an understanding of spatial composition, we will return, in the next chapter, to the characteristics of individual plants and consider how the visual qualities of form, foliage, flowers and fruit contribute to the detailed textures and colours that clothe the skeletal framework of outdoor spaces.

CHAPTER 6

Visual Properties of Plants

Planting that is primarily structural, as well as creating space, will also endow that space with its decorative, visual qualities. The details of foliage, bark, flowers and fruit all contribute to the quality and character of the space, even though they are secondary to the basic structural framework.

There may also be other planting, within the structural framework, that takes on a specifically ornamental role, providing aesthetic highlights and special details. A display border within a hedged enclosure and courtyard planting in pots and beds are examples, and for this kind of planting it is the decorative, visual characteristics that are the key to success.

Before we examine these characteristics in detail, it should be stressed that decorative does not necessarily mean elaborate. Just as the decoration of a room can be plain and simple, even minimal, the decoration of an outdoor space might rely on the simplest of plantings for its effect. Although it is an exercise of design inspiration and skill in its own right, it reaches the highest expression only when the decorative aspects are integrated with the spirit and nature of the spatial composition. Then it becomes part of the space rather than a cosmetic finish.

Subjective and Objective Responses to Plants

We all have personal responses to particular plants and combinations of plants. As professional designers, however, we need a model of planting aesthetics that will help us design for the full range of people, places and functions that we will meet in the course of our work.

First, it is useful to distinguish our subjective responses from a plant's objective qualities. Tanguy and Tanguy (1985) describe the differences between what they call the 'objective plant' and the 'subjective plant'. Their 'objective plant' consists of all the features or physical attributes that can be described and agreed on by different people. People might have different interpretations and tastes but they will more or less agree on features such as habit, leaf shape and even, though perhaps to a lesser degree, colour.

The 'subjective plant', by contrast, consists of the observer's interpretation of the objective plant. Many plants have strong associations and symbolic meanings both for individuals and for groups of people with a common culture. For example, the red rose is given as a symbol of love. It has contrasting associations as a tribal or political emblem: the white rose of York, the red rose of Lancaster, the pink rose of the British Labour Party. This flower is one of the oldest of ornamentals cultivated in the western and middle-eastern world. Its association

with the rites and rituals of human societies probably dates back as far as the Minoan civilization in Crete around 2000 BC. Evidence of this was found in a fresco unearthed by the archaeologist Arthur Evans near Knossos. It showed ceremonial activity and included a rose resembling the Holy Rose of Abyssinia, a form of *Rosa damascena* (Thomas, 1983).

In classical Chinese gardens one of the most important functions of plants was their symbolism. The bamboo representing resilience, the pine virtue, and the apricot that bloomed on its withered old branches – these were the celebrated 'three friends of winter', but perhaps the plant of the Orient most saturated with symbolism is the lotus. For the Taoist, the lotus stands for friendship, peace and happy union, and for Buddhists it is 'the symbol of the soul struggling upwards from the slime of the material world, through water (emotions), to find final enlightenment in the air above' (Keswick, 1986). Even an individual tree can have a political symbolism. The single *Pinus radiata* that gave its name to One Tree Hill in Auckland, New Zealand, was severely damaged as an act of political expression, because of its cultural and political symbolism.

When we are dealing with the symbolic or expressive type of aesthetic experience, it is useful to distinguish between those aspects that are primarily personal in their meaning and those that have a wider cultural recognition. We could talk about the *personal* plant, the *cultural* plant and the *biological* plant – to apply the philosopher Dewey's three levels of aesthetic experience to landscape design (Dewey, 1934). The *biological* plant, like the 'objective' plant would embody those aspects of perception that are common to people of all backgrounds. The cultural associations and meanings of plants (the cultural plant) have the potential to influence the success of a project, and the designer needs knowledge and sensitivity in order to respond to and reflect the cultural aspects of planting preferences, especially if he or she is not of the same cultural group as the users.

An example of the power of association and of cultural change to influence people's choice of plants is provided by the common laurel. Cherry laurel (*Prunus laurocerasus*), Portugal laurel (*P. lusitanicus*) and Japanese laurel (*Aucuba japonica*), as well as other common evergreens like Holly (*Ilex aquifolium*) and the hardy hybrid group of rhododendrons, were much favoured by the Victorians for large private gardens and public parks in England. This was partly for the shade and seclusion that was fashionable at the time. Because of their resilience and especially their ability to tolerate the severe atmospheric pollution prevalent in industrial areas until the 1950s, these species survived in large numbers whereas the more choice flowering shrubs that had been planted with them have been lost. The unrelieved evergreen shrubberies that remain have a dark, gloomy atmosphere and have come to be associated with the melancholy aspects of Victorian culture. As a result, and because of a desire for more openness and sunlight, these species are now planted far less often than merited by their objective characteristics of growth and appearance.

Leaving aside the peculiarities of associations and trends, let us return to some of the physical attributes that attract people to plants – the rugged forms of wind sculpted trees, the wealth of colour in the greens of summer foliage, and the brilliant fruit and leaf colours of a deciduous autumn. The whole landscape is enlivened through the year by the changing weather and light and its green mantle is soothed by breezes and exhilarated by gusts of wind. In gardens and ornamental planting, we find spectacular species grown for their flower display and the extravagant creations of plant breeders. These ornamentals are celebrated for the beauty of their flowers, their powerful fragrance or the highly decorative qualities of their leaves and bark. Such ornamental highlights of flower

and fruit can be regarded as special effects because they are enjoyed for only a short period. More subtle, but no less delightful, are the sight and sound of plants moving in the wind and the changing patterns of shadows cast on walls and ground. These are especially welcome in built environments where they offer a living contrast to the unyielding geometry of buildings and engineering.

However delightful these transient effects and the ornamental impact of individual specimens, planting as a whole should be designed to look good throughout the year, regardless of the weather. The best way to achieve this is to create a permanent visual foundation using the enduring qualities of foliage, bark and habit. These essentials should form a successful composition in their own right as well as support the temporary displays of flowers, fruit and other special effects.

In planting design, a keen visual sense is needed to produce a composition that both brings out the best qualities of the individual plants and is effective as a whole. This sense can be partly intuitive, particularly with a good plant knowledge, but design intuition is strengthened and further developed by systematic study of what to look for in plants and how to make effective use of these qualities in composition.

The Analysis of Visual Characteristics

The appearance of an individual plant or a plant group can be analysed in terms of the visual properties of form, line, texture and colour. Although they are more abstract than special effects like flower, fruit and autumn display, these properties are fundamental to understanding composition, and essential if we are to combine plants to form a visually effective whole. We will examine each element in turn. Please note that the examples of species given to illustrate different visual characteristics are chosen from a range of horticultural regions and ecological contexts, and should not be used without checking their suitability for the proposed location.

Form

The form of a plant is its three-dimensional shape. It can be seen from various directions and distances and these different viewpoints and scales affect our comprehension of the form. A plant's form can be explored at close quarters, or rather, the space around the form of the plant can be explored. This space can become intricate and entangled with the solid form of the plant.

For example, a mature oak in an open area would appear, from a distance of about five hundred metres, as a spreading dome with some gentle irregularity in the outline and with part of the bole visible below the canopy if the lower branches have been removed. At a medium distance, say one hundred metres, the sheaves of foliage arising from the main limbs will be visible as more or less distinct, projecting parts of the canopy and the main branches within will be discernible in places. From this distance, the form will appear as a rough dome with an undulating surface penetrated by gaps. If we approach within a few metres of the tree or go under the canopy, the form of the oak will be perceived to be more complex than seen from afar and to include quite different shapes and qualities. The rugged, cylindrical bole and branches will appear as the dominant forms and the shape of the spaces inside the canopy will form an important part of the character of the tree. Details such as the shape of a leaf or the pattern of bark will be more clearly seen than the overall shape of the tree.

Form is an important aesthetic criterion for species selection. Florence

Colour section

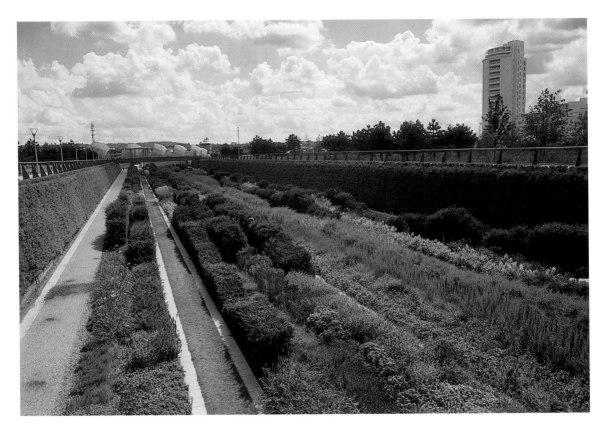

89 Trained and clipped form can be treated as sculpture in the landscape. Yew are being clipped to form green waves in this sunken 'dry dock' garden at Thames Barrier Park in London.

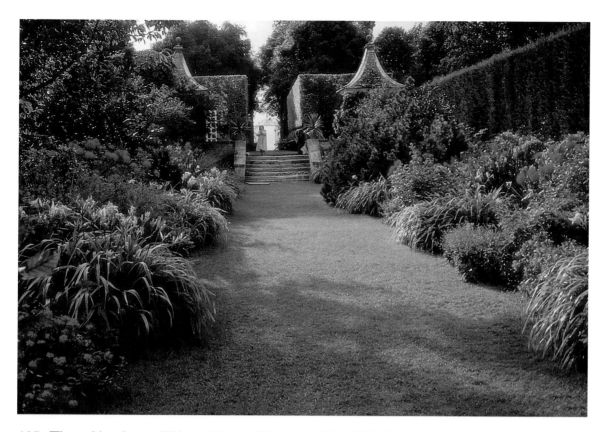

105 The red borders at Hidcote Manor, Gloucestershire, UK, show the powerful qualities of the colours red and orange. These colours are unusual in cool temperate climates. (Photo: Owen Manning)

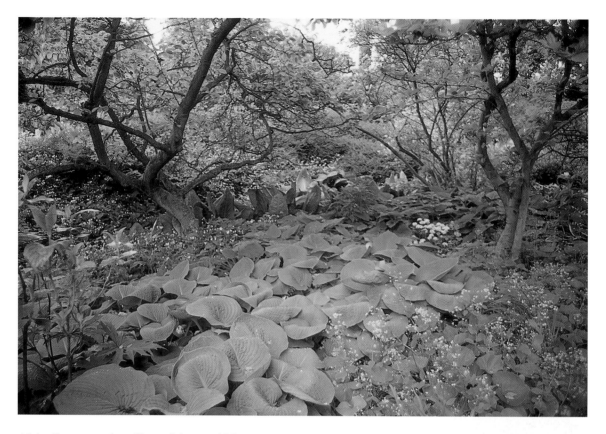

106 Compare the effect of the cool blues and greens in this planting, also at Hidcote Manor, with the hot colours of the red borders.

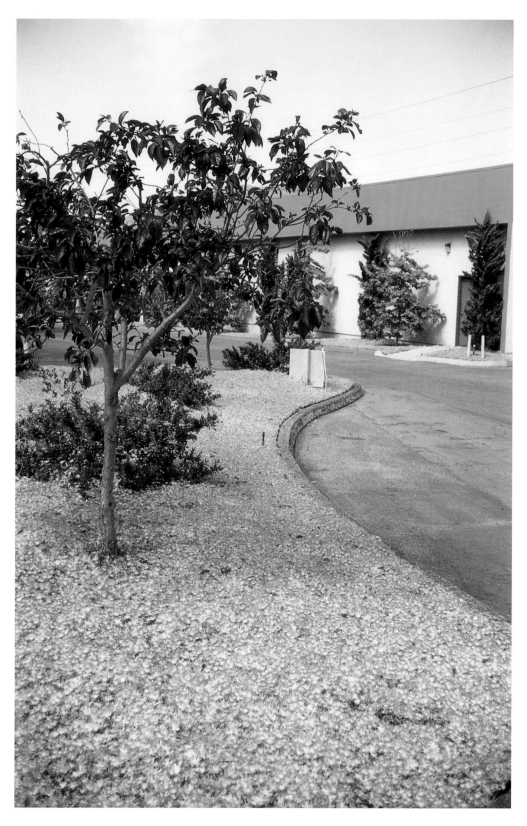

107 Pink at a business and industry park, San Luis Obispo, California.

111 The visual qualities of plants can be delightful when related by harmony and contrast to hard landscape materials. In this example the rectilinear geometry of the hedge and brick edgings contrast with organic forms of the plants while the texture and visual 'softness' of the pebble groundcover provides a link between 'hard' and 'soft' materials (Hounslow Civic Centre, London).

122 This restrained planting at Dartington Hall, Devon, UK, shows mutual enhancement of complementary hues, combined with harmony of the purple flowers, grey foliage and the stone in wall and path.

132 The development of a hotel and conference centre in an old quarry at Hagen, Germany, provides the opportunity for naturalistic planting which reinforces the sense of place. (Photo: Owen Manning)

Robinson considered form, along with the other visual properties, in considerable depth, in her book *Planting Design* (1940). She reminded us that 'form is built upon line or direction, and both are bounded by line or silhouette. Thus mass and form, line and silhouette must be considered together'. The plant forms that we will consider link the visual phenomena of mass and line with the biological properties of growth form and habit.

Although plant form is wonderfully varied, it is possible to describe major types, and each of these can have a particular role in planting composition. These types will be described with a view to their design potential rather than as a rigorous horticultural classification of plants. However, while authors in the landscape architecture field, such as Florence Robinson (1940) and Theodore Walker (1990), have often treated form as a purely visual property, its horticultural role is at least as important to the success of plant combinations. We will highlight both the aesthetic potential of plant form and how it helps plants grow together.

Habit and form are very much a part of the ecology of a species, and this can also inform design. The compact, dome-shaped medium sized shrub form that is so useful for low-cost, large scale groundcover in towns is, in fact, an adaptation to a natural habitat quite different from those urban conditions. To find this shape in nature we must go to the windiest places such as coastal cliffs or exposed mountain sides. Here we will find shrubs like *Hebe, Cistus, Olearia, Convolvulus cneorum, Cotoneaster microphyllus* and *Coprosma repens*. But a low compact dome shape is not the only way that plants cope with persistent high winds. The long, linear and very tough leaves of harakeke (*Phormium tenax*), wharariki (*Phormium cookianum*), ti kouka (*Cordyline australis*) and nikau (*Rhopalostylis sapida*) are all very resilient and remain undamaged in strongest winds. Their natural strength is reflected in the use of harakeke and ti kouka as a source of fibre.

Lastly, we should always keep it in mind that a plant's inherited form can be dramatically affected by environmental factors, including the presence of other plants and especially light levels and wind exposure. For our descriptions of form, we will assume average, favourable growing conditions and a reasonably sheltered but not crowded location.

Prostrate and Carpeting Forms

PROSTRATE PLANTS A number of shrubs and perennial herbaceous plants have a distinctly prostrate or flat spreading form. These include ground-hugging creeping species that spread by the layering, or rooting, of their prostrate stems at intervals and that rarely produce ascending stems (for example, *Fuchsia procumbens, Grevillea* x *gaudichaudii, Convolvulus sabatius, Muehlenbeckia axillaris, Hebe odora* prostrate form, *Hedera* sp.). There are also a number of shrubs that produce woody stems held above ground level but that constitute low, horizontally spreading masses of foliage (*Coprosma* x *kirkii, Grevillea lanigera* 'Mt. Tamboritha', *Juniperus horizontalis, Cotoneaster horizontalis, Prunus laurocerasus* 'Zabeliana'). With age, prostrate plants can often develop foliage gaps in the middle, because their main growing points are distributed around the perimeter of the canopy. For this reason, they may need cutting back or replanting after a number of years.

CARPETING PLANTS By carpeting plants we mean those with a neat, dense canopy of constant height, close to ground level (for example, *Gazania* sp.,

Plate 76 The spreading form of this Juniper (*Juniperus* sp.) provides a base to the white trunk of these birches (*Betula* sp.) at the University of Waikato, Hamilton, New Zealand.

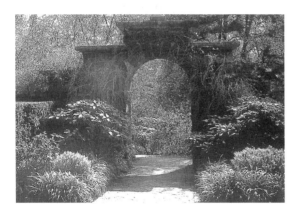

Plate 77 Prostrate dwarf shrubs such as this *Cotoneaster adpressus* hug the ground and follow the shape of whatever they cover (Askham Bryan College, York, UK).

Plate 78 The hummock and dome forms of herbaceous plants such as *Liriope muscari* and shrubs such as *Hebe rakaiensis* and *Viburnum davidii* anchor this gateway, reflect the curve of its arch and contrast with its rectilinear outline (Bodnant, North Wales).

Pachysandra terminalis, Lamium maculatum, Scleranthus biflorus, Parahebe catarractae). Many carpeting plants are fast spreaders, increasing by means of vigorous underground stems (see Chapter 8). The shoots of carpeting plants are mostly hidden by their leaves and the plant presents a dense plane of foliage that follows the surface of the ground. As carpeting plants decline in vigour with age, many can be rejuvenated by clipping them over, or 'mowing' them to near ground level with a rotary cutter or flail. In Europe and North America resilient groundcovers like *Hypericum calycinum* are commonly treated in this way.

Prostrate, and especially carpeting, forms hug the ground surface and express, rather than hide its micro-topography. They can be used to emphasize detailed ground modelling and their low stature makes them a successful foundation allowing taller, upright plants to grow through to form striking plant forms and tall specimens.

Hummock, Dome and Tussock Forms

Many low-growing plants develop by means of a gradually increasing rootstock (see Chapter 8) rather than by vigorous, searching, propagating stems. They form enlarging clumps that, if planted as a monoculture, will eventually unite or

Plate 79 Many trees ultimately develop a spreading dome-like form if allowed to grow unhindered in an open location and free from environmental stress. This photograph shows a specimen of Moreton Bay fig (*Ficus macrophylla*) with a canopy spread of more than 40 metres. For scale, note the Norfolk Island pines (*Araucaria heterophylla*) to the side of the photo (Northland, New Zealand).

Plate 80 The unusually erect form of horoeka or lancewood (*Pseudopanax crassifolius*) allows it to be planted so close to this hotel unit that it grows through the balcony rail (Christchurch, New Zealand).

abut. These clumps are often rounded in form and create a tussock hummock or domed mass canopy.

HUMMOCK FORM The term hummock is useful to refer to clump-forming herbaceous plants and smaller shrubs, and dome to larger shrubs and trees that have a similar shape of canopy. Common examples of hummock form include *Geranium* species and *Nepeta faassenii*). A similar groundcovering hummock form is typical of many sub-shrubs (plants with a woody stem base below herbaceous growth that may die back in a cold winter) and dwarf shrubs. These spread by lateral growth of branches from the main stems or, in some cases, propagate new plants by the layering of these stems (for example *Lavandula spica*, *Erica* species and the *lapponicum* rhododendrons).

DOME FORM This is a larger version of the shape of the hummock plants. Perhaps the classic domed shrub group is the shrubby veronica. In fact, this shape is very common among both trees and shrubs of all sizes in the New Zealand flora because of its ability to withstand the severe winds in exposed habitats that characterize the islands' climate. Other familiar dome-shaped, low or medium shrubs include *Pachystegia insignis*, *Viburnum davidii*, *Cistus* species, *Coleonema* species, and some *Brachyglottis* species such as *B. monroi*, *B.* Dunedin hybrids.

A domed, rounded form is perhaps the most frequent among larger, broadleaf shrubs and trees. In the case of trees, this dome is normally supported on a single

massive bole from which lateral branches arise. The canopy of a shrub normally develops from a number of main stems arising at, or close to, ground level. A dome is often the mature form of species that display an upright habit in juvenile growth phases. In forest, the canopy domes of tall trees are held high above the ground because of suppression of the lower branches. In urban settings, where the crown has been raised to allow circulation below, a similar shape can be seen. An asymmetrical dome can result from competition for light or exposure to wind.

Among the trees with distinctly dome-shaped mature canopies we find *Acer palmatum*, *Acer cappadocicum*, *Sorbus aria*, *Metrosideros excelsus*, *Vitex lucens* and pendulous species such as *Salix babylonica* and *Pyrus salicifolia*.

TUSSOCK FORM Also known as bunch form, this shape is common among monocotyledonous plants, including many grasses and sedges, such as some of the fescues (for example, *Festuca ovina*, *F. glauca*, *F. coxii*), purple needlegrass (*Stipa pulchra*) toetoe and pampas grass (*Cortaderia* sp.), snow tussocks (*Chionochloa* sp.), rainbow tussock (*Anemanthele lessoniana*) and many sedges (*Carex* spp. such as *C. testacea* and *C. buchananii*). The overall outline is similar to a hummock, being rounded, but the foliage arises in a tight bunch from the ground and arches outwards. In this respect, it is similar to the erect and arching forms described later in this chapter. The smaller cultivars of harakeke and wharariki (New Zealand flax – *Phormium tenax* and *P. cookianum*) and *Astelia* species (bush lilies) could be included here, being a bolder version of the grass and sedge tussocks.

Hummock and dome forms are useful for their visual stability. They can be used as anchors, balancing and stabilizing more lively and dramatic forms. They have been traditionally used as 'full stops' at the end of a border or planting that needs containment or conclusion. Because of their compact canopies, small dome shrubs like Hidcote lavender and Spanish lavender form a good edging. Tussocks are more ascending and therefore energetic in their visual character. These forms often leave small spaces between the plants in their natural growth communities and these niches are usually filled by smaller plants that benefit from the partial shelter and shade between the larger plants. These forms have, in many cases, evolved in exposed environments, such as sub-alpine or coastal, and their compact form is a response to the effects of wind. Some species (such as many of the tussock habit plants) retain their form well in shaded or crowded situations while others (such as lavender) are drawn into a more irregular habit if mixed closely with other plants. The latter group should be planted with sufficient space around them.

Erect or Ascending Form

Whereas domed, rounded trees and shrubs produce a high proportion of spreading and low angled branches, erect, ascending form is characterized by a majority of vertical or sharp-angled main stems and branches. Erect shrubs are often multi-stemmed with any side branches being comparatively short and wide-angled. This habit gives the plant an overall shape that is upright with a strong component of ascending line. The appearance can be rather stiff with the mature canopy held aloft. Examples of notably erect or ascending form include *Mahonia lomariifolia*, *Aralia elata*, *Cordyline terminalis*, *Plagianthus regius* (juvenile form), *Musa acuminata* and many bamboos. One of the most unusual ascending growth forms is the single, slender erect stem of juvenile lancewoods (horoeka – *Pseudopanax crassifolius* and *P. ferox*).

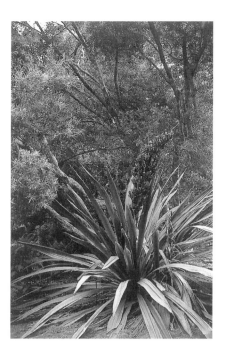

Plate 81 The Australian perennial giant *Doryanthes palmeri* has such large linear, striking leaves that it can dominate any plant grouping.

As they mature, erect shrubs tend to either remain rather separate in their appearance or, if they have a suckering habit, form dense thickets over large areas (for example, banana and the stoloniferous bamboos). In the case of some tree species, the adult form is surprisingly different from that of the juvenile. Both lancewoods and *Plagianthus regius* (ribbonwood or manatu) illustrate this. Because of their ascending habit, erect forms can be a forceful, assertive element in composition and if combined with other eye-catching qualities such as bold leaves, the plant can provide a focal point in the planting.

When planted en masse shrubs with erect form create a small dense forest of stems and these can be quite 'leggy' and bare as they are drawn up towards the light. Under these conditions, the plants lose many of their specimen qualities and become mere space fillers at the canopy level, leaving bare stems and bare soil below. Even if used singly or in small groups, erect growing plants benefit from close planting of lower species to use the space left around the base, if it is not needed for circulation or hard landscape.

Erect, ascending form is found at a smaller scale among the foliage of some herbaceous plants and sub-shrubs and is most effective when the leaves are large or sword shaped. Examples include species and cultivars of *Strelitzia*, *Doryanthes* *Phormium*, *Agave*, *Yucca* and *Iris*. Even the smaller yuccas and *Phormium* cultivars can have such a striking appearance that they become the focus of a plant group, despite their small stature.

Trees with narrow, ascending branches will be described later in the oval or fastigiate form categories.

Arching Form

Many shrubs make vigorous erect stems that, after their initial burst of growth, produce lateral branches and arch over under their own weight. The overall shape is like a sheaf of wheat with the stems gathered in at the base but sprayed out towards the top. The initial vigour of the stems helps the plant 'forage' for light,

then arching and lateral branching produce a broad, elevated canopy to exploit this light. Examples of shrubs include *Buddleja* species, *Cotoneaster salicifolia*, bamboos such as *Arundinaria nitida* and *A. murieliae* and shrub roses such as *Rosa* 'Nevada' and *R.* 'Canary Bird'.

The arching form is also common at a smaller scale among herbaceous plants where the stems or linear leaves adopt this configuration. To some extent this form overlaps with the tussock habit but examples that are more upright and notably arching include *Polygonatum multiflorum. Dierama pulcherrimum Hemerocallis* species, *Arthropodium cirratum*, and the classic arching, vase shapes of ferns such as *Blechnum discolor, Polystichum vestitum* and bromeliads such as *Aechmea* and *Billbergia* species. Arching form is not common among trees; they generally produce sturdy branches that strengthen as they grow, rather than leaning or drooping under their own increasing weight. Some aspects of the arching habit are expressed in weeping trees such as *Betula pendula* 'Youngii'.

Arching shrubs and herbs can play a similar, accent role to that of erect shrubs, though often with a little less contrast because they have a rather looser habit. They are valuable as single specimens of all sizes or where a canopy of foliage is required at an elevated level leaving a space below. As with erect and tussock forms, this space should not be left to bare earth and weeds but used either for lower planting or for a different visual element such as pebble, paving, rock and so on.

Palm Form

This form is, in some ways, similar to the arching habit described above but distinguished by the clear stem that can rise up to twenty or more metres. It is found almost exclusively among the members of the palm family and tree ferns. It consists of a tall straight main stem or stems with all leaves arising in a rosette from the single growing point at the stem tip. This gives various umbrella type shapes that can be boldly sculptural and are usually striking. Some of the best known palms for landscape work in warm temperate areas include *Phoenix* canariensis, *Syagrus romanzoffiana* and *Rhopalostylis sapida*. Tree ferns include *Dicksonia* and *Cyathea*. The Ethiopian banana *Ensete ventricosum* is a plant of a different family that has a somewhat similar form. Similar palm-like forms are also found among some species of *Cordyline*, the *Strelitziaceae* and the larger *Yucca*.

Species with a palm habit have a big impact in planting because of their statuesque, evocative form. They also cast a light shade and many have compact, undemanding root systems that make them particularly good neighbours for other plants. Others, including *Dicksonia squarrosa* (wheki), naturally spread in dense colonies, excluding other plants partly by the quantity, size and toughness of their leaf or frond debris.

Succulents and Sculptural Form

Rather like palms and tree ferns, many succulents form a group of plants that have a very distinctive range of form. This could perhaps be described as 'sculptural form' because the plants have a singular strength of three-dimensional shape that immediately makes them the focus of attention. Some of the most striking are species like the fan aloe *Aloe plicatilis*, the spiral aloe *A. polyphylla*, the dragon tree *Dracaena draco* and *Agave attenuata*.

Used singly and in small groups, they should be handled like sculpture. Planted in large numbers, they create a landscape wholly distinct from the

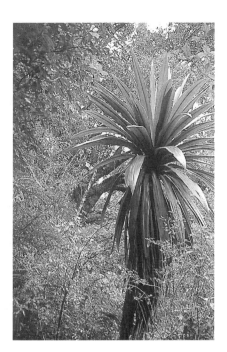

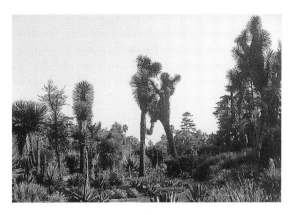

Plate 83 Some succulents display strongly sculptural form, such as these at Huntingdon Botanic Gardens, California.

Plate 82 Palm form is seen not only in members of the *Palmae*, but also in plants such as this toi or mountain cabbage tree (*Cordyline indivisa*), seen here in its natural habitat of mountain forests at Te Urewera, New Zealand.

everyday human surroundings, and that brings an exhilarating atmosphere of the arid, often hostile, environments from which they originate.

Oval Upright Form

A number of shrubs and trees have a generally erect habit of growth but a crown that also spreads laterally and, unlike erect and arching forms, is consistently furnished with side branches and foliage to near ground level. The form that results is oval or egg-shaped. It is seen more often in selected cultivars than in wild species, largely because an oval upright form is desirable in many urban and garden locations where lateral space is restricted. Examples include *Carpinus betulus* 'Fastigiata', *Acer platanoides* 'Columnare', *Malus tschonoskii*, and young and early mature plants of *Pittosporum tenuifolium* and *Hoheria sexstylosa*. This shape is less common among shrubs than trees mainly because shrubs, being generally multi-stemmed, take on a broader habit.

Oval form brings a rising element to composition. It has some of the qualities of erect form but, because of its more rounded outline, it is more contained, and less straining and soaring than the spires and columns of fastigiate forms. Oval form can punctuate less regular masses and, like the related dome shape, can make a clear stop to a run of mixed planting. The canopy of an oval upright tree or shrub is less closely associated with the ground than the hemispherical dome, so it may need anchoring with a lower dome or other planting with visual weight.

Plate 84 *Lophostemon confertus*, the Brisbane box, is an example of a tree with an oval upright form. Its restricted spread makes it convenient for planting next to roads, especially those that carry high vehicles (Mayoral Drive, Auckland, New Zealand).

Plate 85 The distinctive conic form of Norfolk Island pine (*Araucaria heterophylla*) provides a strong contrast to the horizontal masses of the building and the gentle sweep of the ground at Auckland airport, New Zealand.

Conical Form

Conical form is frequent among conifers but is also found in some 'broadleaf' species. A conical crown is generally tall and tapers from the base to a sharp apex. It is the product of a regular branching habit. A single straight bole gives rise to a comparatively larger number of first order branches (those arising directly from the bole) and these are regularly arranged in whorls or in a spiral with regular vertical intervals between nodes. In many cases, the branches are nearly horizontal and thus the cone is made up of horizontal tiers of diminishing diameter towards the top of the crown. Good examples of conical trees are *Picea omorika, Pseudotsuga menziesii, Sequoiadendron giganteum*, young trees of *Agathis australis* and *Dacrycarpus dacrydioides* and *Corylus colurna*.

The effect of conical form is similar to that of oval and erect forms. The main difference lies in the sometimes sharply pointed crown. This gives it more dynamic, ascending qualities, although the effect can be austere. A strongly conical form can make a striking accent in planting composition. When whole forests are composed of conical, spire-shaped trees, the effect can be quite extraordinary. The groves of giant redwood (*Sequoiadendron giganteum*) in the American Sierra Nevada and the old growth forests of Californian coastal redwood (*Sequoia sempervirens*) both have serene, cathedral-like qualities due to the rising crowns of the younger trees, the massive tall trunks and the sheer scale of the spaces created.

Fastigiate and Columnar Forms

The narrowest of upright crowns are normally referred to as fastigiate or columnar. This form is rare in the wild state and most fastigiate trees and shrubs are selected clones. The crown of fastigiate trees is usually made up of many short, ascending branches that form a dense, well-defined crown. When this habit produces a narrow cylindrical shape it is often referred to as columnar. The top may be more or less pointed (as in *Juniperus* 'Skyrocket') or flattened (as in *Libocedrus decurrens* and young *Taxus baccata* 'Fastigiata'). Examples of shrubs with a fastigiate canopy are less common than trees, but include *Juniperus communis* 'Hibernica', and *J.* 'Skyrocket'. The best known of fastigiate trees

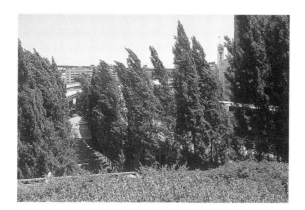

Plate 86 Trees like Lombardy poplar have a narrowly fastigiate or columnar form. They were used in the Pacific Gateway Project in San Francisco because this form can be accommodated in the narrow spaces between freeway ramps.

Plate 87 The ascending flower raceme of mullein (*Verbascum*) has, on a smaller scale, a similar effect to a fastigiate or columnar tree canopy (Hagen, Germany).

include Italian cypress (*Cupressus sempervirens*), incense cedar (*Libocedrus decurrens*) and Lombardy poplar (*Populus nigra* 'Italica').

Fastigiate form has an uncompromising visual character and can easily be the dominant element in a plant group. Trees such as rewarewa (*Knightia excelsa*), Lombardy poplar (*Populus nigra* 'Italica') and Italian cypress (*Cupressus sempervirens*) appear like exclamation marks among other vegetation. They rise out of the mass in a dramatic way. The smaller the number of fastigiate trees the more they draw attention to themselves so, to be highlights or foci of a scene, their numbers should be restricted. On the other hand, there are landscapes where large numbers of fastigiate trees are common and give the regional landscape much of its distinctive character. These include some of the Mediterranean lands, where Italian cypress is characteristic, and the dry hill country of eastern New Zealand, especially around Hawke's Bay where Lombardy, as well as other erect growing poplars, have been extensively planted for land stability.

Lombardy poplar, because of its rapid growth and narrow crown, has been thoroughly exploited as an 'instant' screen tree, particularly in urban areas where space for lateral spread is restricted. Unfortunately, a single row does not provide a very good screen, especially in winter, as it has a rather thin crown and foliage. The visual effect of a 'screen' of Lombardy poplars, regardless of spacing, is like a rank of stiffly upright sentries standing guard over an ugly installation – it draws attention to what it screens.

In our discussion of fastigiate form, we should include a number of shrubs and herbaceous plants that have a distinctive vertical flower spike or raceme. Examples of these include *Yucca recurvifolia*, *Acanthus mollis* and *Verbascum nigrum*. They make a good temporary accent or emphasis within ornamental planting.

Plate 88 Tabulate form is seen in the spreading branches of trees such as this young deodar (*Cedrus deodara*) and Japanese maple (*Acer palmatum*) which give a serene quality to this composition in Sheffield Botanical Gardens, UK.

Tabulate and Level Spreading Form

Many trees and shrubs have habits of branching in which foliage is held in horizontal layers. In some species and cultivars this is particularly well developed and creates distinctive horizontal 'tables' of foliage. Such trees include *Cedrus libani* and *Acer japonicum* 'Aureum'. The effect may be accentuated by a display of eye-catching flowers on the tabulate layers of shrubs such as *Cornus kousa* and *Viburnum plicatum* 'Mariesii'.

Some trees and shrubs have noticeably spreading branching patterns and a flattened silhouette without the separate layering of foliage. The silk tree, *Albizia julibrissin*, and a number of the tropical leguminous trees are examples of this spreading, umbelliferous form.

Tabulate and spreading forms give trees and shrubs a stable quality, but with lightness rather than weight in character, because the tiers of foliage are held high and admit light and air between the branches. The contrast between tabulate and fastigiate crowns can be spectacular. The distinct form can be easily lost if these plants are associated closely with others and is most effective if the tabulate trees or shrubs are allowed sufficient space to extend their canopies to the full.

Open Irregular Form

In the descriptions above species have been chosen that show the clearest expression of a particular type of form. Many plants, especially when growing in the wild, only approximate to these types due to environmental factors and can be more or less irregular in form as a result of environmental factors.

There are some species that inherit rather than acquire what we will describe as open irregular form. Their overall shape is irregular and unpredictable, the crown does not produce a well-defined outline nor a dense, leafy surface. The most distinctive feature of such plants is often their strong growing extension shoots that thrust out in various directions, carrying with them smaller side branches and clusters of foliage but leaving considerable space between them. These gaps in the canopy are exploited by other plants in their search for light, and so open irregular plants tend to be gregarious in their character, growing well among other species to form a mixed canopy. Trees include *Populus alba*, *Sorbus* 'Embley' and *Prunus* x

yedoensis. Shrubs with this kind of form include *Pyracantha rogersiana*, *Hippophae rhamnoides*, *Coriaria arborea* and *Clianthus puniceus*.

Trained Form

Not only do plants grow spontaneously into a wide range of forms, but many species lend themselves to the sculpting of quite unnatural shapes by training, trimming and clipping.

The most common green sculpture is the clipped hedge. In addition to its functional purpose, a formal hedge brings an element of control and precision to visual composition that cannot otherwise be achieved with vegetation. The elementary form of the rectilinear slab can be clipped from a tree or shrub and can be elaborated with variations in height and width. The whole slab or clipped 'box' may be raised above the ground as in the traditional pleaching of trees such as lime (*Tilia* sp.) and hornbeam (*Carpinus betulus*). Other angles and shapes can be created, such as castellations or curves in profile or in plan. A memorable example is the serpentine beech hedges (*Fagus sylvatica*) at Chatsworth, Derbyshire, England.

The most curious shapes are those created by topiary – a practice that dates from Roman gardens. This includes the sculpting of birds and other animals as well as abstract geometric shapes out of bushes of yew (*Taxus baccata*), box (*Buxus sempervirens*), or cypress (*Cupressus* sp.). Traditional topiary plays an important role in historic garden management and sometimes as an occasional feature in prestige planting schemes for which a generous maintenance budget is available.

Suitable species for clipping are those that respond to frequent light pruning by producing dense twiggy growth at an even rate over the whole canopy. This allows the creation of an even surface to the desired shapes. Smaller leaved species are ideal because the damage caused to the leaves themselves is less noticeable and evergreens are preferable because of their ability to retain the sculpted surface throughout the year. Traditional hedging and topiary species include *Taxus baccata*, *Buxus sempervirens*, *Lonicera nitida*, *Fagus sylvatica*, *Ilex aquifolium*, *Cupressus sempervirens* and *C. macrocarpa*, and *Laurus nobilis*. Less well known, but very successful, species for close clipping include *Podocarpus totara*, *Corokia* × *virgata*, *Coprosma repens* and *Coprosma parviflora*.

Other traditional practices including pleaching, and the training of fruit trees as a cordon, espalier, fan and palmette. Vine crops such as hops, grape and kiwi

Plate 89 Trained and clipped form can be treated as sculpture in the landscape. Yew are being clipped to form green waves in this sunken 'dry dock' garden at Thames Barrier Park in London.

Plate 90 The topiary at Levens Hall, Cumbria, UK, creates an intriguing interplay of form and space.

fruit are grown commercially by training on wires and pergola type supports. Many of these offer interesting possibilities for design interpretation using either the same species, or ornamental cultivars, or adapting the training method to different species and modified structures.

Because of its precision, trained or clipped forms introduce a strong sense of imposed order to composition. They can give cool regularity to contrast with the abundance and unpredictability of free growing vegetation.

Line and Pattern

Line is closely related to form, being the two-dimensional effect of edges. To this extent, it is an abstraction from the three-dimensional reality. The edges that create line can be the edges of a whole plant mass (its silhouette), or of its branches, stems, leaves, or petals, or the edges between different materials or colours and between light and shadow falling on the surfaces of plants.

Composite patterns of line are formed on the surfaces of things and, although these surfaces may be curved or bent, they can be perceived from one viewing point as if they were on a two-dimensional plane. A pattern of lines can, by means of perspective, convey information about the three-dimensional shape of objects but this requires interpretation of the two-dimensional pattern based on experience of moving through space.

The essence of line is direction, being the result of the movement of a point in space. In visual composition, the primary effect of line is to lead our eyes and direct our attention. Although we do not necessarily follow each line faithfully to its end, our vision will nevertheless tend to move backwards and forwards along the stronger lines and follow the compounded direction of weaker and shorter lines. Our attention will tend to rest at the places where lines converge. So, line can be used to direct the visual exploration of a scene.

Different directions of line, as found in different patterns and in different

Plate 91 This planting composition depends for much of its impact on the form of the trees and shrubs. The tabulate branches of *Viburnum plicatum* 'Lanarth' are emphasized by brilliant white flower heads and give a striking contrast to the dark fastigiate yew (*Taxus baccata* 'Fastigiata') and the ascending branches of *Nothofagus dombeyi* in the background. These strongly expressed forms are set within a softly flowing mass of informal foliage that saves the composition from stiffness (Bodnant, Wales).

Plate 92 Line can be a dominant element in planting composition especially when we can see the branch and stem outlines or the silhouettes of plants. This avenue of plane trees near Napier, New Zealand, demonstrates the impact of line and outline in composition. Note that it is through line that we recognize perspective, and that this perspective gives avenues their dramatic quality.

Plate 93 The ascending outlines of these fastigiate junipers (*Juniperus* 'Sky Rocket') punctuate and regulate the soft billowing masses of roses and herbs below (The garden of old roses, Castle Howard, Yorkshire, UK).

Plate 94 Vertical line is also common in the ascending linear leaves of monocotyledons such as *Iris* and rushes (*Juncus*), here contrasting with the horizontal slab of the stone bridge at Wisley, Surrey, UK.

Plate 95 Pendulous line is found in the hanging branches of weeping willow (*Salix* '*Chrysocoma*') over the River Avon, Christchurch, New Zealand.

plants, have intrinsic aesthetic qualities that can be deliberately exploited in planting composition.

Ascending Line

Ascending or vertical line is expressed in the outlines of plants with columnar or fastigiate shapes (e.g. *Juniperus communis* 'Hibernica' and *Cupressus sempervirens*), in the trunks of strong growing trees (e.g. *Poplar* and *Betula* species, *Pseudopanax crassifolius* and many palms), in the vigorous stems of shrubs and herbaceous plants (e.g. *Perovskia atriplicifolia* and hard-pruned *Cornus alba* and *Rubus cockburnianus*), in the shapes of flower spikes (e.g. *Furcraea foetida, Puya alpestris, Verbascum nigrum* and *Stachys lanata*) and in the 'sword' shaped leaves of some monocotyledons (e.g. *Astelia chathamica, Typha australis* and *Crocosmia paniculata*).

The character of ascending line is assertive and emphatic and can be stately or grand if of sufficient scale. Ascending line is prominent because it opposes the direction of gravity. Yet, a vertical line by itself exists in a state of tenuous balance and the least movement in any lateral direction will offset its alignment and release its considerable potential energy. This sense of delicate balance gives an air of achievement to strongly expressed vertical line, but if it is used without discretion and order, it can be restless and overbearing.

Pendulous Line

Pendulous or descending line is found in the branches of weeping trees (such as *Salix babylonica, Pyrus salicifolia* 'Pendula' and *Betula pendula* 'Tristis'), in shrubs with trailing and hanging stems (such as *Rosmarinus officinalis* 'Prostratus', *Buddleja alternifolia*, and *Myrsine divaricata*), and in plants with hanging leaves or flowers (such as *Viburnum rhytidophyllum, Wisteria* sp., *Garrya elliptica* and *Carex pendula*).

Pendulous line is characteristically restful, bringing a peacefulness to the scene. This is because it suggests some letting go of the struggle with gravity – weeping branches hang in a position of minimum effort. Perhaps because there is less resistance, less vitality in their habit, pendulous plants can reflect a melancholy mood that might be particularly strongly felt if it is combined with sombre, dark colours. The atmosphere created by the delicate, sparkling foliage of *Betula pendula* 'Tristis' or the golden yellow twigs and wispy foliage of *Salix* x *sepulcralis chrysochoma* is lively while still gentle. *Picea breweriana* can suggest very different moods; in grey mists it may have a mournful aspect, in sunlight it can glisten like a green cascade.

Weeping foliage or branches draw our attention down to the ground and this can give a sense of weight, so the presence of a contrasting light, lively element, such as water, below the canopy is the perfect complement to a weeping tree or shrub. There is also an affinity between the character of water and the flowing, cascading forms of weeping trees, hence the traditional association between the two.

Horizontal Line

Horizontal line is seen in spreading branches and foliage (such as in *Albizia julibrissin, Coprosma parviflora Cedrus libani, Cornus kousa* and *Viburnum plicatum* 'Mariesii'), along the tops of clipped hedges, in the browsing line that forms the base of tree canopies in grazed parkland pasture, and in level ground surfaces articulated by grass or groundcover.

This direction line represents a state of stability. Its character is passive, like a reclining figure, and it contains little potential energy and so implies little movement or effort. Because of its visual stability, planting with strong horizontal line can act as a foundation that will support the more active elements of

Plate 96 The tabulate branching cedar of Lebanon (*Cedrus libani*) produces a strong horizontal component and reflects the lines of the brickwork pattern and building eaves (Reigate, Surrey, UK).

Plate 97 Dynamic diagonals are strongly expressed in the linear leaves of New Zealand flax (*Phormium tenax*), seen here in its natural wetland habitat on a South Island lake margin. It contrasts dramatically with the pendulous line of the rimu foliage behind.

Plate 98 Much of the line found in nature is lively and more or less irregular in character. The stems and branches in this picture express both inherent patterns of growth and the influence of an exposed environment (coastal forest at Kohi Point, New Zealand). The simple vertical line of the mamaku tree fern provides a contrast.

Plate 99 Line can be crucial to composition: the crossing of horizontal and vertical lines is one of the most dominant aspects of this view (Bodnant, Wales).

composition. Indeed, without these to lift it the planting can appear featureless and lifeless. This is why the stable simplicity of a clipped hedge is most effective when it acts as a foundation or background to exuberant planting or other features, but rather severe or dismal when only for the sake of its own geometry.

Diagonal Line

Diagonal line is seen in sharply rising branches found occasionally in many trees and shrubs but more consistently in a few species and cultivars such as *Prunus* 'Kanzan' and *Sorbus sargentiana*. The stiff linear leaves of some monocotyledons are held at a strong diagonal although they are usually spread over a range of angles (examples include *Furcraea selloa*, *Phormium tenax* 'Goliath', *Yucca gloriosa* and palms such as *Rhopalostylis sapida*).

Diagonal line is energetic, dynamic and exciting. It expresses tension and high potential energy. It is thrust out against gravity, moving upwards and forwards and this forceful quality makes it a powerful element in composition that is seen at its most effective when used in contrast to more stable elements. Too many strong diagonals would cause disintegration of the composition and a solid foundation is needed to support the dynamic nature and eye-catching qualities of diagonal line.

The Quality of Line

Because the medium of design that we work with is living vegetation, it is rare to find pure line direction except where the maintenance has imposed simple and geometrical form on planting. Geometric line that is quite straight or evenly curved is perceived as 'formal' and controlled. It demonstrates conscious intent rather than the forces of nature. The majority of form and line found in nature, although directional qualities are clearly discernible, is more varied and irregular in its character.

A meandering or irregular line, whatever its overall direction, can have a spontaneous and playful quality and this is expressed in the darting, weaving

Plate 100 The fine, even texture of the *Libertia peregrinans* (miikoikoi) is notable in this simple planting, and reflects the fine textured surface finish of the concrete wall (University of Canterbury, New Zealand).

Plate 102 The bold foliage of *Acanthus* draws attention to the steps and balustrade and harmonizes with the similar, coarse texture of the stone work.

Plate 101 Grasses and ti kouka (cabbage tree) both have a fine visual texture that add to the feeling of spaciousness in this New Zealand courtyard.

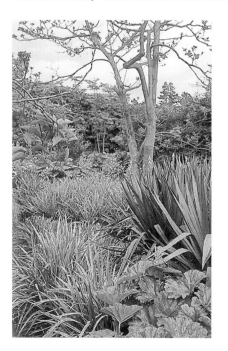

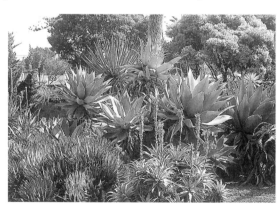

Plate 104 The elegant sculptural form and bold texture of *Agave attenuata* stand out in this planting of succulents. Also important are the consistency of line and the accenting of the vertical flower spikes of aloe in the foreground (The Sunken Garden, Napier, New Zealand).

Plate 103 This plant grouping at Newby Hall, North Yorkshire, UK, combines a wide range of textures and forms. Strong leaf form, dynamic line and textural contrasts create an eye-catching effect.

growth of branches and twigs as they seek the light. Indeed, some cultivars have been selected specifically for their unusually twisted and picturesque branch habit (for example, *Salix matsudana* 'Tortuosa' and *Corylus avellana* 'Contorta').

Texture

Plant texture can be defined as the visual roughness or smoothness of any part of the plant. It is akin to the texture of a painting, the grain of a photograph or the consistency of materials such as fabric, stone, brick or wood. Texture is a function of the scale of differentiation and division within a material. It may be the result of a pattern of lines but, if so, it is determined only by the scale of the pattern and not by the direction of the lines. A plant is commonly referred to as having coarse, fine or medium texture.

Texture, like form, depends on viewing distance. When seen from a moderate distance a plant's visual texture is the result of the size and shape of its leaves and twigs. The larger the leaves and the more stout the twigs, the coarser the texture. The petiole also affects texture because a long and flexible petiole allows more movement of individual leaves in a breeze and this tends to break up the outlines of the leaves and give the foliage a softer appearance (such as the many species of poplar).

If we move far enough away the visual effect of individual leaves and twigs will be lost and the canopy will appear to be made up of clusters or sprays of foliage. In this case it will be the size and arrangement of these clusters or branches that determines texture. Plants made up of large, clearly differentiated branches will appear more coarsely textured. If the viewing distance is so great that the only visible differentiation of vegetation is between whole plants or between clumps of trees or shrubs, texture will depend on the spacing of individual shrubs and trees or clumps. Widely spaced clumps and separate canopies will give the landscape a coarser grain than even, interlocking canopies, which will appear more finely textured.

Under the closest inspection, it will be not the combined mass of foliage or stems that give texture but the surface of the leaves and bark. Some species have coarse textured leaf surfaces (e.g. *Rosa rugosa*, *Viburnum rhytidophyllum* and *Elatotema rugosum*) and some have rough bark (e.g. *Quercus suber Podocarpus totara* and *Sequoia sempervirens*) while others have particularly smooth leaves (e.g. *Hymenosporum flavum*, *Corynocarpus laevigatus*, *Fatsia japonica*) or smooth bark (e.g. *Fagus sylvatica*).

Texture, like form and line, has specific visual effects and plays an important role in composition. In the discussion that follows, we will concentrate on the textural effects of plants viewed from medium distances (about 2–20 metres) because it is from these distances that the detailed composition of most ornamental planting is fully appreciated.

Fine Texture

The finest textured plants are those with the smallest leaves or leaflets and the finest, most closely packed twigs. These include most species of *Erica*, the small-leafed *Coprosma* and *Dracophyllum* species, many *Genista* and *Cytisus* and many grasses, rushes and sedges. A number of trees also have comparatively fine texture, for example *Taxus bacatta*, *Cupressus species* and *Pinus*, especially those with slender needles such as *Pinus patula* and *P. coulteri*. Fine-textured broadleaved trees include *Betula pendula*, *Pittosporum tenuifolium* 'Silver Sheen' and *Sophora microphylla*.

Fine-textured plants tend to be easy to look at, that is, relaxing rather than stimulating. They can give the impression of being at a greater distance than coarse-textured plants and are said to recede in the field of vision. As a result, a high proportion of fine-textured plants increases the sense of spaciousness within an enclosure, rather like the effect of fine-textured or small-patterned wallpaper in a room. Their character is light and airy, expansive and soft.

A further effect of fine-textured foliage is that the overall outline and form of the plant is strongly expressed and easily traced. The shape of the whole plant will usually dominate the shapes of individual leaves and stems. For this reason fine-textured plants are valuable in formal composition where strict control of pattern is the essence of design. Here, the outlines of planted areas, the planting of geometric patterns and the shaping of hedges and clipped specimens are all expressed with the greatest precision by fine-textured species. In classical formal gardens the plants used were yew (*Taxus bacatta*) and box (*Buxus sempervirens*) but there are many more suitable plants and some of these are listed on p. 97. Another major component of pattern making in formal landscapes is the lawn. The fine, even texture of mown grass plays a similar role to yew and box, but on the ground plane.

Coarse Texture

The largest leaves and the thickest twigs have the coarsest, or boldest, visual texture. These include the huge rough leaves of *Gunnera manicata* which can be up to 2 metres across, the broad, lobed foliage of *Rheum alexandre* and *Peltiphyllum peltatum*. Other species with bold foliage and coarse texture include trees such as *Catalpa bignonioides*, *Meryta sinclairii* and *Acer macrophyllum*, shrubs such as *Rhododendron sinogrande* and *Fatsia japonica*, and herbaceous plants such as *Myosotidium hortensia*, *Bergenia cordifolia* and *Cynara cardunculus*. In winter, the sturdy stems of *Aralia elata* or coppiced shoots of trees such as *Catalpa* and *Paulownia tomentosa* provide coarse texture among the deciduous plants.

Plants with bold foliage and stems are, primarily, attention grabbers, perhaps because the form and detail of their foliage is clearly visible from a distance, perhaps simply because of their size. Indeed the shapes of individual leaves tend to break up the outline of the plant and distract attention from overall form. In this case, the plant's qualities of line arise from the edges of leaves and twigs rather than from the mass of the canopy.

The boldness of coarse-textured plants makes them appear to advance in the field of vision. This effect can be employed to increase the sense of depth in planting composition if coarse textures are placed in the foreground and finer textures kept mainly to the background. In a confined area, however, too much bold, advancing foliage can create a claustrophobic atmosphere, so care is needed when using coarse texture in small spaces.

The large leaves of coarse-textured plants throw big shadows and create striking patterns of light and shade. If the plant has glossy leaves – puka (*Meryta sinclairii*) for example – areas of deep shade contrast strongly with the reflected light and this adds to the visual impact of bold foliage and helps make it a fine specimen plant. Coarse-textured specimens create an accent or emphasis within a composition, particularly if bold foliage is combined with ascending line (for example, *Phormium tenax* and *Agave* sp.). With their eye-catching character, accent plants such as these become a visual goal and can provide markers to identify key locations within a composition.

In addition to the energetic qualities of coarse-textured plants, their substantial foliage and sturdy stems give them visual weight and solidity. This

allows them to act as 'anchor' plants in composition, the role of which is to stabilize or 'ground' the more insubstantial, fine-textured plants. The most effective anchors combine coarse texture with the stability of domed, hummock or prostrate habit. *Viburnum davidii* and *Fatsia japonica* are good examples, *Bergenia cordifolia* with its spreading habit, is often used as a low edging or sometimes as a solid foundation to taller planting. *Hedera canariensis, H. colchica, Brunnera macrophylla* and many hostas can also create a coarse textured carpet. They do this best when there is a contrast in texture between the weighty lower layer and the higher canopies that it supports. Thus *Bergenia* is successful as an edging to mixed foliage and flower borders and the excellent groundcovering properties of *Hedera* help it to create a firm visual foundation that will support and unite areas of taller more varied planting.

Medium Texture

Between the textural extremes of plants such as *Gunnera manicata* and *Erica arborea* there are many that can be described as of medium texture. Even among these, noticeable contrast can be achieved between relatively fine and relatively coarse texture. The starkest contrasts are not always the most effective and some linkage to bridge the gap between the coarsest and the finest foliage will generally help a composition. Such intermediate textures allow our eyes to absorb the range more easily by making a progression rather than too sudden a variation.

Colour

The development of modern colour theory began in a systematic way with Goethe's *Theory of Colours* (1840). Certain scientific principles are generally accepted although some aspects of the perception of colour remain enigmatic. We will not attempt a full explanation of colour theory but confine ourselves to principles of most practical use to the planting designer.

As Michael Lancaster (1984) reminded us, 'colour is light'. Differences in colour are differences in the properties of light, mainly wavelength, amplitude and energy. These differences are caused both by the nature of the light source and the reflection, refraction and absorption of the light before it reaches the observer's eye. The colour of light can be described in terms of its three fundamental qualities: hue, value/tone and saturation.

Hue

Hue is the quality that is popularly referred to as colour, that is, whether an object appears red, blue or yellow and so on, and is determined by the wavelength of the light. The natural spectrum is conventionally perceived to have seven hues: red, orange, yellow, green, blue, indigo and violet although on close inspection each is seen to grade continuously into its neighbours through intermediate hues. The hues of the spectrum are as pure as can be observed within the Earth's atmosphere because they arise from the refraction of the sun's light rather than from absorption by pigments.

The colours of plants and other natural materials are the result of absorption by pigments contained in these materials. The wavelengths of light that are not absorbed are reflected back from the surface and nearly always contain a mixture of hues. Plant colours are also modified by the other two qualities of value and saturation.

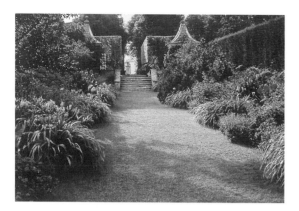

Plate 105 The red borders at Hidcote Manor, Gloucestershire, UK, show the powerful qualities of the colours red and orange. These colours are unusual in cool temperate climates (see colour section).

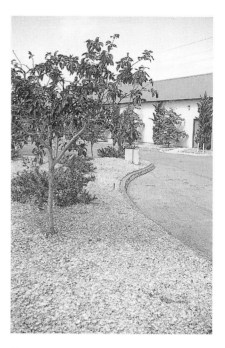

Plate 107 Pink at a business and industry park, San Luis Obispo, California (see colour section).

Plate 106 Compare the effect of the cool blues and greens in this planting, also at Hidcote Manor, with the hot colours of the red borders (see colour section).

Value

Value, often referred to as 'tone', is the quantity or 'luminosity' of the light reflected back from a coloured surface. This is most easily understood as the lightness or darkness of the colour. A black and white photograph shows the differences only of value and not of hue or saturation; it is therefore a study in 'tone'. The brightest, most reflective surfaces have a high value or light 'tone' and the dimmest, or least reflective have a low value or dark 'tone'.

If we consider the possible variation in tone of a single hue – say red – we notice that if the red pigment is diluted with white (that is, one reflecting all hues equally) the total quantity of light reflected is greater, the red is a paler tone and its value is higher. As more white pigment is added, the red pigment becomes less perceptible and the colour would eventually become almost pure white. Conversely, if the red pigment is mixed with black (one absorbing all hues equally) the total quantity of light reflected is less and the colour becomes a darker tone, its value is reduced. As increasing proportions of black pigment are added, almost all red light would eventually be absorbed and the colour would become indistinguishable from black.

It is interesting to note that some hues are intrinsically paler in tone than others, having a greater luminosity or higher value; the palest is yellow.

The values or tones of colour seen in the landscape depend on the pigmentation of materials but also on the amount of light available. In areas of shadow or as dusk approaches all tones will be darker and the apparent difference between tones will be reduced because of the reduction in the reflected light.

Saturation

Given the same hue and a constant value, variation in colour could still be perceived. This would be a variation in the 'saturation' of the hue, that is, in the degree of redness or blueness of the colour. Saturation gives us a measure of relative colourfulness. A bright red and a dull red may have the same value but the bright red will be distinguished by its greater saturation. The spectral hues are pure, fully saturated colours, but the majority of colours we see in nature are more or less muted, or dull. In these colours, the pure hue is muted with a proportion of greyness *of the same value* as the pure hue. This reduction in saturation could be pictured as the red hue in a colour photograph gradually fading to the grey of identical value that would represent it in a black and white photograph.

Terminology in colour theory can at times be ambiguous or confusing. Saturation is also known variously as intensity, purity and chroma. The term saturation might be preferred because it suggests the origin of this quality of colour: saturation is the proportion of reflected light that is made up of the hue in question. In the case of a coloured object this results from the degree of saturation of the surface of the object by the pigment.

Ambiguity can also arise from the use of the word tone. It has been used to describe degrees of saturation as in the expression 'to tone down a colour'. It is more commonly understood, however, to refer to the quality of lightness or darkness, to distinguish tints and shades: thus, tone is taken as synonymous with value.

The three qualities or dimensions of colour: hue, value and saturation, allow us to fully describe any colour. For example, a dark, dull, red or a pale, bright, green. They also help us to understand the visual effects of colour and to employ these with awareness in design.

Colour Perception

The actual colour observed, that is, the characteristics of the light reflected from an object, depend on the light source and, if this is the sun, on the weather. For example, in the soft bluish light of humid, cool temperate climates, pale and muted colours can be fully appreciated and intense, saturated, vibrant colour can appear garish. By contrast in the stronger sunlight of lower latitudes, especially where air quality is clear, subtleties of pastel shades are lost and it is the saturated, brilliant, colours that are seen at their best. Furthermore, no colour exists in isolation. The perception of colours is greatly influenced by their context. 'Colour behaviour is relative' explains garden designer Penelope Hobhouse (1985) 'depending on neighbouring colours and the quality of light'. She describes the phenomenon of simultaneous contrast:

> Juxtaposing two hues has the optical effect of exaggerating the difference between them and 'driving them further apart'. Each colour appears to be tinged with the complementary of its neighbour; paired complementaries seem more brilliant. The other two dimensions, value and intensity [saturation], further affect the apparent changes in the pairs of pure hues.

The vast majority of natural objects, including plants, possess a mixture of hues, a range of value and varying degrees of saturation. Because of the complexity of colour, it is unwise to attempt to draw up rules for its use in design. A number of aesthetic effects, however, can be identified and these will influence the choice and combination of colours in planting.

Colour Effects

It is mostly accepted that colour hues produce reasonably predictable effects on the observer (Birren 1978). Indeed, the meaning of colour is reliable enough to have been used as an effective measure of exploring personality, as in the Lüscher colour test (Scott, trans. 1970). Thus, colour hues can be understood as aesthetic materials, rather like different sculptural media or different paving materials. What follows is a summary of some of their main characteristics.

- Red is the hottest colour. It is energetic and powerful, often dramatic and can be exciting or even alarming. Because of its energy it is advancing and is perceived instantly, even when present in small patches among other hues.
- Orange is also warm and advancing. It is lively and vital, possessing some of the energetic quality of red but tempered by the yellow it contains.
- Yellow is warm but without the passion of red. It is stimulating but gentle and tends to advance when combined with recessive hues. It has a clear, fresh and cheerful character.
- Green is a neutral colour in many ways. It is neither warm nor cool, neither receding nor advancing. It is soothing and balancing, but also stimulating. Green light is the most easily focused by the eye and so to look at green objects requires the least effort by the ocular muscles. Green allows the sharpest distinction of contour and outline.
- Blue is the coolest hue and the most recessive in our field of vision. It is calming and serene but also expansive and inspiring. It can be airy and even ethereal.
- Indigo and violet contain both blue and red. Like blue, they are cool and receding but less so than pure blue. The power of red gives them an uplifting quality and they can be quite mysterious.
- White is the equal combination of all the hues of the spectrum. It is neutral, favouring none of its composite parts; it is neither advancing nor receding and neither warm nor cool but, because a pure white surface would reflect all the incident light, it takes on the qualities of that light. A white flower would appear warm and advancing in the golden or red light of sunrise and sunset, but cool and receding in blue twilight.

Intermediate and mixed hues have combined qualities according to their composition and hues mixed with white to produce tints show a moderation or refinement of the qualities of the pure hue.

The effects of colour depend on value and saturation as well as hue. Saturated colours and dark shades tend to advance, like warm hues, whereas dull colours and pale tints tend to recede, along with cool hues. So dull, pale and cool colours provide good backgrounds while saturated, warm and dark colours make highlights. Dark shades, rather like coarse textures, are comparatively heavy in their character and so anchor or stabilize large areas of pale tints and cool, recessive colours that might otherwise appear insubstantial and floating.

Warm, saturated colours, because of their intensity and energy, tend to distract attention from form or texture and so dominate composition. An example of this

is the intense red of the common field poppy that, especially when exaggerated by juxtaposition with complementary green foliage, can make the flowers appear disembodied and formless, mere splashes of colour. The outline and size of the poppy flowers and their exact location in space are difficult to establish under these conditions.

Visual Energy

We have seen that the aesthetic characteristics of line, form, texture and colour are all capable of producing related effects. Diagonal line, fastigiate form, bold texture and bright colours all, to some extent, share properties of dynamism, drama and stimulation and can produce eye-catching, striking effects, whereas, horizontal line, prostrate or dome form, fine texture and dull colours are all characterized by restful, unimposing qualities and so play a more recessive, quieter role in composition.

These connections between these effects can be understood with the help of Nelson's concept of visual energy (Nelson, 1985). Active characteristics have a higher visual energy than passive characteristics. The idea of visual energy also helps to explain why too many saturated colours in one place or too much bold texture and diagonal line creates a composition that can be chaotic and tiring. These high energy elements will all fight for attention and struggle among themselves for dominance. To gain the full impact from a specimen plant and to appreciate its unusual qualities, its visual energy needs to be complemented with areas of quieter, visually undemanding planting.

Planting can be designed for high or low visual energy overall. The choice is influenced by the setting and purpose of the planting. For example, in a quiet meditative garden, or in borders that complement fine architectural detail, much of the planting could be of low visual energy, whereas a display garden in a park, or a dreary urban setting, may need high energy to lift it above the ordinary.

Combining Plants

A particular plant may be of attractive appearance and easy culture. But, when we combine it with others, these recommendations will come to little if it is placed where its beauty is eclipsed by conflicting demands on our attention, or it is quickly overgrown by invasive neighbours. The next two chapters will deal with different aspects of plant combinations. Chapter 7, Principles of Visual Composition, will discuss how we combine the characteristics of form, line and pattern, texture and colour to achieve successful visual composition. Chapter 8, Plant Assemblages, will examine the effects of growth habit and horticultural needs on plant combinations. We will see how shoot and root habits, soil and climate, mode of spread, speed of growth and longevity all help determine a plant's ecological compatibility with others and, therefore, its ability to form part of a balanced plant association.

Principles of Visual Composition

Our analysis of the aesthetic characteristics of plants has given us a basic visual vocabulary. When this is put to work in a planting design it will convey a visual message of one kind or another. So, composition could be regarded as the visual grammar of planting design.

Five Principles of Visual Composition

Painting, photography, sculpture and other visual art forms can all be analysed by composition and some principles are common to them all. In planting, the most important are the principles of harmony and contrast, balance, emphasis, sequence and scale. An understanding of these will allow us to analyse the visual grammar of any plant association and help us with both design method and creative inspiration.

Harmony and Contrast

Harmony is a quality of relatedness. It is found between similar plant forms, similar textures, similar characters of line and closely related colours. The closer the relationship between the aesthetic qualities of associated plants, the greater the harmony. As it becomes increasingly close it approaches identity, but, in identity, harmony would be lost because it depends for its aesthetic impact on the simultaneous perception of both similarities and differences. The pleasure of harmony rests not only in the similarities between things but in the balance between identification and differentiation. The experience of identity and of difference is of primal importance in the human psyche. We understand everything we perceive in terms of similarity or difference to the familiar – to make sense of the world we pick out a pattern of similarities as different from its background, or conversely, a pattern of differences arising from the undifferentiated. So harmony and contrast go together, they are not mere polarities and neither can exist without the other.

Contrast is found between different plant forms, different qualities and directions of line, texture and colour. Contrast does not necessarily imply conflict – it may be an attractive, happy contrast coming from a complementary, mutually supportive relationship between widely different characteristics. Conflict is only perceived when the contrast creates strain, when it is not contained within order and aesthetic purpose. Indeed, without a binding, unifying aesthetic purpose contrast is likely to create at least confusion.

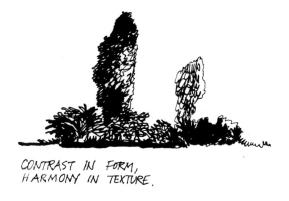

CONTRAST IN FORM,
HARMONY IN TEXTURE.

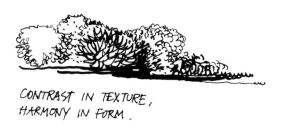

CONTRAST IN TEXTURE,
HARMONY IN FORM.

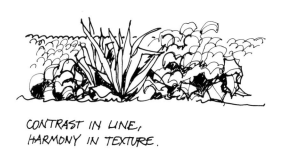

CONTRAST IN LINE,
HARMONY IN TEXTURE.

Figure 7.1 Contrast and harmony.

In planting composition, we aim to achieve the right balance of harmony and contrast. Contrast between two species will be more visible and have a greater effect if there is also a measure of harmony. This arrangement works well when a contrast in one characteristic such as leaf texture is combined with harmony in another, such as leaf colour. Similarly, harmony in flower colour appears more satisfying if it is used to link varied and contrasting form and texture.

Too much contrast is illegible, because there are too few related elements and we cannot perceive a pattern in the whole. A combination of plants with strong

Plate 108 Visual harmony can be found among natural forms as diverse as trees and clouds (Avon, UK).

Plate 110 The close relationship of colours and textures shown by the ferns in this forest at Te Urewera, New Zealand, emphasize the contrasting form of the large-leaved tree ferns.

Plate 112 On the Victorian Italinate terrace at Tatton Park, Cheshire, UK, the strictly symmetrical layout of grass and floral bedding denotes absolute control of form and articulates the central axis of symmetry.

Plate 109 Harmony of leaf form and colour supports the strong contrast in texture between *Bergenia* and *Saxifraga* (Hidcote Manor, Gloucestershire, UK).

Plate 111 The visual qualities of plants can be delightful when related by harmony and contrast to hard landscape materials (see colour section). In this example the rectilinear geometry of the hedge and brick edgings contrast with organic forms of the plants while the texture and visual 'softness' of the pebble groundcover provides a link between 'hard' and 'soft' materials (Hounslow Civic Centre, London).

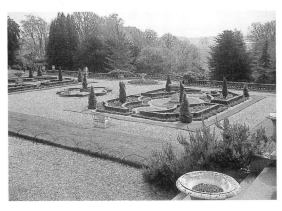

contrast in all its aesthetic characteristics would appear chaotic and we would find it difficult to appreciate the qualities of individual plants and the composition as a whole. Indeed, the restlessness of such a composition would cause constant distraction. This is why restraint is one of the qualities in enduring and refreshing design.

Balance

Balance comes from the relationship between vegetation masses. It depends on their magnitude, their position and their visual energy.

The possibility of visual balance implies two things, that the parts of a composition have visual force or energy, and that there is a fulcrum or axis about which that force acts. This fulcrum or axis is brought into being, and given importance, by the way in which plant masses and other elements are placed around it. Because of its vital role of attracting and ordering surrounding elements, the axis may become the focus of the space or composition.

The simplest expression of balance is bilateral symmetry where the arrangement of planting on one side of an axis is repeated in its mirror image on the opposite side. There are often one or two axes of symmetry within a composition, but there can be any number (a circle possesses an infinite number of axes of symmetry).

Symmetry has long been associated with strict formality in design. Its abstract, ordered patterns are an expression of rational thought and the control of form is a demonstration of the power of human technology to shape the materials of the landscape. Symmetrical form is remarkable because it contrasts with the natural, organic forms that develop when no conscious plan is imposed. Yet, pure symmetry can be seen to emerge from natural forms. It is an intellectual refinement of the underlying patterns of the microscopic world and of the elements of the more relaxed symmetry found in living things.

Balance can also be achieved without symmetry. In this case, visual stability arises not from replication but by the balancing of the energy of different qualities about the axis or fulcrum. Prominent form may balance coarse texture and assertive line may balance intense colour. In addition, a small quantity of one prominent characteristic may balance a greater quantity of the same characteristic that is less strongly expressed. For example, a single plant with striking, sword-like leaves would balance a group of three or five smaller plants with ascending linear leaves of similar shape but finer texture. The energy of balanced elements may be the potential energy that results from the positioning of the plant masses. This potential energy is a product of both the mass itself and of its relative height or prominence and allows a smaller plant mass in a dominant location to balance a larger mass in a subordinate position.

When planting is balanced about an axis or centre, either by symmetry or by equality of energy, a state of visual stability is achieved. It may include dynamic elements and exciting contrasts, but its parts are held together in a unified whole. These mass or energy equalities and stable, non-symmetrical arrangements are sometimes said to have occult balance.

Emphasis and Accent

Important things and places can be emphasized by associating them with planting of high visual energy. This is often called accent planting and it can be used to draw attention to elements like entrances, steps, seating or water. Sometimes the planting itself provides the focus of a space and accent planting

SYMMETRICAL BALANCE

ASYMMETRIC BALANCE

PROMINENT FORM BALANCES COARSE TEXTURE

SINGLE STRONG FORM BALANCES SEVERAL
WEAKER FORMS .

PROMINENT POSITION — BALANCES — GREATER MASS .

Figure 7.2 Balances.

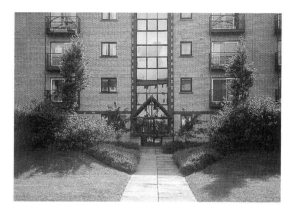

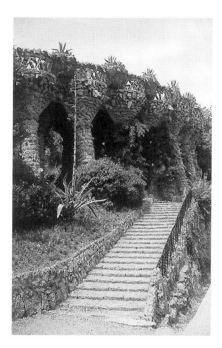

Plate 113 Symmetry is observed in the ground modelling and the repetition of trees and shrubs either side of the path. By emphasizing the axis of symmetry generated by the building the planting helps focus on the entrance to these apartments at Kingston Dock, Glasgow.

Plate 114 The drama of a single *Agave* brings a point of emphasis to the remarkable stonework of viaduct and steps at Parc Guel, Barcelona, Spain.

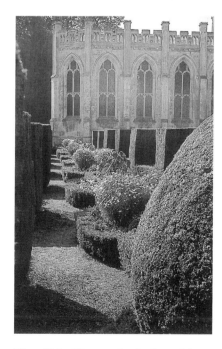

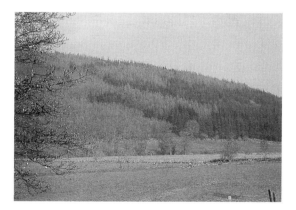

Plate 115 The steady rhythm of the yew bastions reflects the buttressing of the church at Ashridge, Hertfordshire, UK.

Plate 116 The forestry planting on the distant hillside includes drifts of different species that are in scale with the patterns of the vegetation and landform in the surrounding landscape (Snowdonia, Wales).

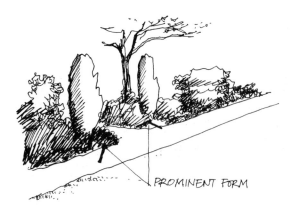

PROMINENT FORM

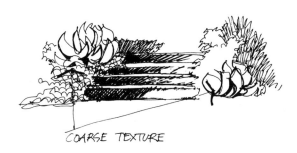

COARSE TEXTURE

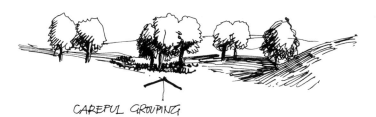

CAREFUL GROUPING

Figure 7.3 Emphasis can be given by prominent form, coarse texture or careful grouping.

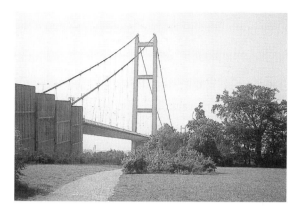

Plate 117 The largest structures in the landscape, such as the Humber Bridge, near Hull, UK, require plantations and tree clumps of generous size to maintain good generic scale relationships.

is essential for the creation of a visual rhythm and the division of the full extent into comprehensible sections.

Emphasis and accent planting can be effective by virtue of its intrinsic striking qualities or by careful arrangement and grouping which brings the eye to rest at the chosen location. It is closely related to contrast because any strong contrast or sudden change of appearance will attract attention. So a single plant of form contrasting with its setting will create and accent.

Sequence

Sequence is the way that the appearance of a planting composition changes or unfolds before the observer. Sequence may be visible from one observation point, as in a build-up of colours, textures or forms within a single vista, or it may be experienced as a progression of scenes that unfold as we move through the landscape.

Sequence is essential to the dynamic qualities of composition. It is an expression of change. It relates the parts to the whole, not only within a static picture, but also over time. Sequence in visual composition can be likened to rhythm in music or meter in verse; it provides a temporal structure to the composition. Just as with musical rhythms or poetic meter, planting sequence may be ordered simply and with regular accent or it may be more complex, including overlapping patterns of repetition. It may be deliberately chaotic or arbitrary, giving expression to forces of disorder.

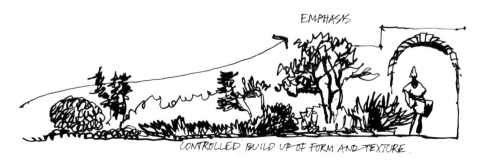

Figure 7.4 Sequence.

Scale

Scale can be understood most simply as relative size. Ching (1996) defines scale as either 'generic', that is, '... relative to other forms in its context' or 'human', that is, '... relative to the dimensions and proportions of the human body'. In landscape design generic scale refers to the size relationships between the various parts of a whole space and within a plant association. The relative sizes of single plants and of plant groupings determine the generic scale of the composition. These are the aspects of scale that tend to be seen as separate from the observer. Human scale, on the other hand, refers to the relationship between the size of composition and the observer. Because we are designing for people we must take account of the human-scale relationships of landscape and allow for the effects of different patterns of engagement.

The amount of detail that we can perceive depends on the viewing distance. As distance increases so we see less detail but a greater area and although the

AT THE SCALE OF A BUILDING COMPLEX THE MASSING OF TREES DOMINATES

AT THE SCALE OF A SINGLE BUILDING, INDIVIDUAL TREES AND THE MASSING OF SHRUBS DOMINATE

AT AN INTIMATE HUMAN SCALE INDIVIDUAL SHRUBS AND SMALL GROUPS OF HERBACEOUS PLANTS DOMINATE .

Figure 7.5 Perception of plant groupings depends on viewing distance.

content of our view changes the amount of information that we can assimilate stays about the same. Close to, the finer characteristics of foliage and flowers and the textures and forms of smaller plants hold our attention. At a distance of about 25 metres these details will be barely visible but the form of larger individual plants and groupings of colours and textures will dominate the composition. If we move back to 100 metres, only the trees will be appreciated as individuals, and smaller plants as part of the combined mass of woodland, shrubbery or meadow. The different scales inherent in a plant association cannot all be perceived at once. Our attention tends to focus on one scale of patterns at a time and so, in design, we must understand the different scales that predominate from different viewing positions or regions.

Viewing scale is reliant not only on distance but also on movement. The rate of travel through a landscape determines how much is visible within a given time and the amount of information that can be absorbed from an area. Because of this, the planting scale should reflect the observer's speed of travel. Planting to be seen repeatedly from a fixed vantage point and studied at leisure will do justice to a smaller scale and greater diversity than planting that will receive only brief glances from passing vehicles.

Unfortunately, it is common to see planting design that is either too complex or too simple for its setting. In the first situation, the designer may be well motivated but is misguided in trying to provide too much richness and diversity within a restricted area. He or she might be trying to compensate for poverty of planting elsewhere, or to relieve the dullness of the surroundings, but diversity is wasted if it cannot be appreciated from the normal distance and in the normal period. Further, the generic scale relationships of planting to space and to architecture and hard landscape are sometimes ignored in the desire to plant for planting's sake. Too much diversity in planting wastes much of the care and thought that has been put into other aspects of composition.

At the other extreme, we find large expanses of shrub monocultures in pedestrian areas. These can appear monotonous, even depressing, because they offer too little diversity to satisfy close inspection or maintain any interest while we walk alongside. They have only two scales of interest: the minute detail of leaf, flower or fruit and, at the generic scale, the contribution that they make to the site development as a whole. This mistake is common when the designer is over concerned with the greater concept at the expense of the materials and details of design.

These are fundamental failures and they can overshadow other attractive qualities the planting may have. When working on the drawing board, we need good imagination to anticipate the effects of scale relationships.

Movement and Viewing Angles

The designer must also take into account the angles at which planting will be seen. These are affected by movement through the landscape and while we are in motion our range of focused attention is more restricted than when static. The greater our speed of travel, the narrower this range will be. For example, the attention of pedestrians walking purposefully will be confined within a horizontal spread of about ninety degrees. For a motorist on a fast road this angle will be further reduced to about 45 degrees because of the need to keep close attention on a small, but rapidly changing, visual area. These angles refer to the general spread of focused attention allowing for head as well as eye movements. It is not the same as the commonly quoted 60 degrees 'cone of vision' (e.g. Dreyfuss, 1967) that is determined by the

Plate 118 Planting in a garden, whether public or private, should be of sufficiently small scale to invite prolonged observation and enjoyment (Stoke, UK).

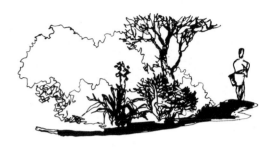

AT A LEISURELY WALKING PACE INDIVIDUAL TREES AND SMALL GROUPS OF SHRUBS CAN BE APPRECIATED

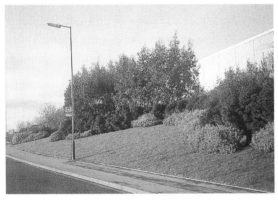

Plate 119 When vehicles are passing at moderate speeds more variation in shape and smaller groups of species can be appreciated (Swindon, UK).

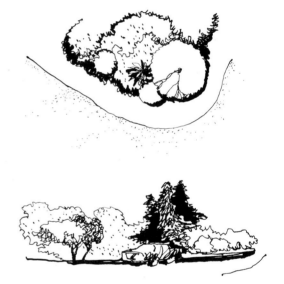

AT A MODERATE VEHICULAR SPEED GROUPS OF TREES AND SHRUB MASSING CAN BE APPRECIATED.

Plate 120 Only tree and shrub groups of sufficient scale will be perceived from fast moving vehicles on a fast road. Note the contrasts between the forestry plantation in the background, the edge of regenerating native bush, and the varied herbaceous flora at the road side (Bay of Plenty, New Zealand).

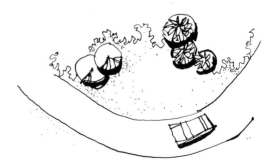

Figure 7.6 The scale of plant groupings should reflect the speed of movement of the observer.

Plate 121 This planting of sedges, *Astelia chathamica* and *Libertia*, together with paving and pebbles, is of a scale that invites movement and reinforces the drama of the distant landscape. An intricate foreground would have been out of place here (Hamilton, New Zealand).

Plate 122 This restrained planting at Dartington Hall, Devon, UK, shows mutual enhancement of complementary hues, combined with harmony of texture and form. Note the colour harmony of the purple flowers, grey foliage and the stone in wall and path (see colour section).

optimum angle of eye rotation of 30 degrees either side of the horizontal axis of the head.

We most often see planting by the side of a path or road from an acute angle, and so its apparent dimensions will be foreshortened. Just as road markings are painted on the road surface in an elongated shape to give the appearance of normal proportions, so plant arrangements should be stretched along the axis of movement to achieve the scale that is desired.

Unity and Diversity in Planting Design

Unity and diversity are sometimes treated as principles of design. However, they are better understood as an objective underpinning the principles discussed above. They are fundamental to all design and all expression. The desire for unity needs little explanation. Wholeness, completeness, are an essential motivation for the human psyche and the perception of unity in the outer world is intrinsically satisfying. Principles of composition can be seen as a guide towards unity and variety in design. Unity can arise from a pervasive harmony of aesthetic characteristics; from an overall balance of composition that binds the various parts into a whole; from the emphasis of linking elements in the composition; from an ordered sequence of spaces and planting; and from a choice of planting scale that links the scales of its landscape setting to that of its human participants.

Diversity is easier to provide than unity. The range of plant species and cultivars available includes all the variety we are ever likely to need and more. Even a single plant can show great variation as it develops and changes through the seasons. It is achieving unity that is the designer's greater challenge.

Planting Ideas

Over and above the binding function of composition, unity can be achieved by the presence and clarity of a planting idea or theme. This can be of great value

to the designer because once chosen, it gives both inspiration and a conceptual framework for the development of detailed design. Further, it can help reduce the array of possible plant species to a manageable palette.

A theme may be historic, that is, based on the interpretation of the past character and events of a site, or the incorporation of historic references in contemporary design; a theme can be inspired by how people use the landscape, or it may simply reflect a central design concept or idea that informs all aspects of the landscape architecture of the site, including the planting. It is always important that the planting design contributes to the overall design concept and objectives, and this is achieved by the spatial design and by the themes employed in detailed planting composition. Planting themes are many and diverse but can usefully be divided into those based on the aesthetic characteristics, on taxonomic relationships or ecology.

Plate 123 This sunken garden at Thames Barrier Park in London, UK, is a good example of planting that reflects a central design concept. The dockland history of the area is expressed in the form of the garden and in the wave-like shapes of the yew hedges. The planting is contained in long strips between the hedges and narrow paths. This is an innovative development of the traditional mixed border with hedge backing.

Plate 124 The icon of the New World city grid has been applied, with a sense of humour, to the planting in this San Francisco, USA, plaza to represent the pervasive idea of the city as geometry.

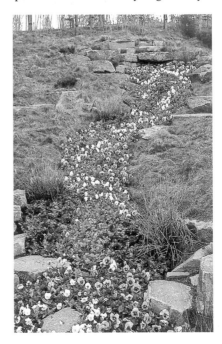

Plate 125 The inspiration for this planting is made explicit. A stream of blue, white and purple pansies (*Viola* hybrids) tumbles down an artificial hillside at the Stoke National Garden Festival, UK. The moorland grasses and rushes not only reinforce the suggestion of an upland stream but their subdued browns and greens provide a complement to the brighter colours of the pansies.

COLOUR Many beautiful garden and landscape plantings have been created by restricting colours of flowers, fruits, stems and foliage to a limited, related range. For example, colour theme borders, especially of white flowers and grey and silvery foliage, were very popular in the Arts and Crafts, 'English country garden' of the early twentieth century. These are well preserved or recreated at, among many others, Newby Hall in North Yorkshire, Hidcote Bartrim Manor in Gloucestershire, Sissinghurst Castle in Kent and Hestercombe House in Somerset. The control of colours in these borders creates a pervasive mood stimulated by the character of hues. In addition, many subtleties of tone, tint and intensity can be appreciated that might be lost in a more diverse colour scheme. Walking in the white garden at Hidcote allows us to appreciate the diversity of colour that exists simply among whites, creams, greys and silvers. The contrast with the red borders of the same garden is dramatic. Here we find a sultry, sub-tropical extravagance. The intense, rich reds of hardy and tender flowers melt into the bronzes and purples of foliage and the whole effect is strangely unfamiliar in the subdued, English light.

Other single colour themes have been used to great effect, yellows bring vitality in the shade of buildings and many yellow flower and foliage plants prefer the low light of such locations. Most blue flowered and silver or grey foliaged plants, on the other hand, need full sun and warm conditions to grow well and develop their most effective foliage colours. This is because the grey or silver leaf colour that arises from a woolly or tomentose leaf surface is usually an adaptation to moisture stress or intense sunlight in the plant's natural habitat.

On the subject of single colour themes, painter and planting designer Gertrude Jekyll was cautious:

> It is a curious thing that people will sometimes spoil some garden project for the sake of a word. For instance, a blue garden, for the beauty's sake, may be hungering for a group of white lilies, or for something of palest lemon-yellow, but it is not allowed to have it because it is called the blue garden, and there must be no flowers but blue flowers. I can see no sense in this; it seems to me like fetters foolishly self-imposed. Surely the business of the blue garden is to be beautiful as well as blue. My own idea is that it should be beautiful first, and then just as blue as may be consistent with its best possible beauty. Moreover any experienced colourist knows that the blues will be more telling – more purely blue – by the juxtaposition of rightly placed complementary colour. (Jekyll, 1908)

Well-balanced, dual colour themes can also unify a planting scheme. The contrast and mutual enhancement of complementary colours is displayed most powerfully when each hue is restricted to a narrow range. Yellows and purples offer a striking complement of hue, and also a contrast of value, because yellows are lighter and fresher than purples of a similar intensity. Blue and orange is often less successful, perhaps because the contrast in value is less, and both colours can appear rather heavy in the presence of their complement. It is hard to say why this is so. It is a matter of perception and experience. Colour themes can be based on value and intensity rather than only on hue. For example, a planting of pastel flower colours and grey or silver foliage is given a sense of unity by the grey or white that unites the various hues. Pale pinks and pale purple blues can make a particularly effective pastel colour scheme.

Some colour combinations have had a bad press. Pink and orange are traditionally thought to clash, but this is due to lighting conditions and cultural preferences. In tropical countries such as India, these two colours are commonly combined in fabric and other design, so why not in planting?

An important reason for the success of the more restricted colour themes is that a degree of variety and contrast will inevitably be provided by the colours of plant foliage. This contrast is strongest for a red colour theme in which the flower hues will be complementary to the foliage greens, but in other colour themes there will still be enough to enliven the composition as a whole. It is particularly helpful to include a proportion of dark green foliage to anchor the pale and pastel colours.

TEXTURE, LINE AND FORM Texture may provide the aesthetic theme for composition but care is needed with the balance of harmony and contrast. An association consisting largely of bold textured plants can be overbearing unless relief is provided by other elements. Bold texture can provide an exciting theme in a space large enough to avoid feeling claustrophobic, and provided that contrast in line, form and colour is also included. 'Sub-tropical' and foliage gardens have been created in this way to give an atmosphere of luxuriant rainforest vegetation but using temperate species.

Use of bold textures is also traditional in association with modern buildings. This is sometimes called 'architectural planting', perhaps because the species used have a bold form and consistent habit that echoes the boldness of form in modern architecture. A theme of fine plant textures would, on the other hand, risk appearing weak and empty unless the lack of stimulation provided by the plant texture was compensated for by strong form, pattern or colour. The use of fine textures is common in formal historic landscapes, especially in parterres, hedging, pleaching or topiary.

SEASONAL THEMES When it comes to seasonal change, we can identify contrasting approaches. The first could be called the 'architectural approach'. In this, the aesthetic objective is abstract and formal: it aims to maintain carefully planned visual qualities in a state of constancy, almost as if the planting were made of building materials. It usually relies on evergreen foliage species, in order to keep the same texture and form throughout the year and tends to avoid plants

Plate 126 Use of bold foliaged species can create a jungle-like character in temperate regions by echoing the large-leafed characteristic of tropical rain forest (Newby Hall, Yorkshire, UK).

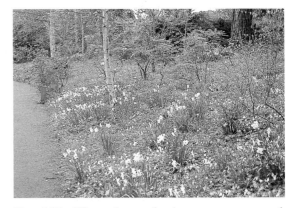

Plate 127 The spring garden is a common seasonal theme. This woodland walk at Dartington Hall, in Devon, UK, designed to be at its peak in spring with carpets of naturalized woodland flowers and shrubs such as *Camellia* and *Magnolia*.

that look messy or uninteresting at a particular season. The classic example is the groundcover and accent planting common in corporate landscapes.

Another is the 'horticultural approach', which tries to achieve diversity and highlights through as much of the year as possible. This approach emphasizes seasonal change and deals with the 'down time' of a particular species by planting another that will occupy the aesthetic gap. A good example of this approach is found in the home garden where people plant for year-round colour. A horticultural approach is growing in some areas of professional landscape design, and designers such as Piet Oudolf (1999) and James van Sweden (Oehme and Van Sweden, 1990) are using herbaceous plants to great effect in large-scale public and corporate projects with much attention to their ephemeral qualities and seasonal contrasts. Some new urban parks, such as Thames Barrier Park in East London, are reinterpreting traditional methods of horticultural display, both to extend the period of horticultural interest and to express the contemporary design themes of the whole development.

A third approach is to concentrate horticultural resources in one season, and thereby create an intense, transient, but memorable seasonal 'event'. In plantings like this, most of the plants to be used would be selected to be at their peak in the chosen months. This seasonal approach was much used in large private gardens especially those of the Arts and Crafts movement (such as Knightshayes Court, Dartington Hall, Hidcote Manor), but it can be adapted to public and corporate landscapes today, provided that the intensity of use is low enough to allow some areas to be below their best for part of the year. The periods that are most successful for seasonal displays are early spring (for bulbs and early flowering shrubs), late spring/early summer (for tree and shrub flower), high summer (for herbaceous perennials and tender plants), autumn (for fruits and foliage and, in some climates, a second flush of flower) and winter (for coloured stems and winter flowering plants). Each has its own distinctive charm.

SCENT, SOUND AND TOUCH Non-visual aesthetic qualities may also provide a theme for planting. Emphasis on scent, sound and touch is normal in planting for people with visual disabilities, but any of these could also provide a unifying theme in less specialized plantings.

The fragrance of flowers and aromatic foliage is a source of delight and planting that is carefully planned to provide an attractive blending and continuity of scents throughout the year would have great distinction and character. Blending of scent is no easier than combining colours, and a garden of scents would require as much skill and sensitivity as one based on a colour theme.

Sound and touch are less obvious characteristics of plants. Sound is dependent on the wind or rain to sway branches, rustle leaves, or clatter stems. The physical feel of plants requires our participation and so is less often appreciated. However, either, if used boldly, could provide an exciting and unusual theme for planting that would be appreciated by the more imaginative observer. Plants can heighten our sense of the weather and broaden our sensory experience with the sound of rain on foliage. Indeed different plants produce remarkably different sounds in the rain. The large leaves of species such as *Fatsia japonica* and *Phlomis russeliana* amplify the impact of raindrops; hard leaved plants like *Epimedium perralderanum* and *Hedera* echo with a clattering sound and smaller, softer leaved shrubs like *Symphoricarpos* 'Hancock' and *Caryopteris* produce a swishing noise. If you want to experience this, stand with your eyes closed in heavy rain near to plants with different leaf sizes and textures and see if you can identify the different sounds they make. If you prefer not to get wet, try watering your garden with your eyes closed.

TAXONOMIC THEMES In many botanic gardens and horticultural collections, plants are arranged by genus, family and order. Taxonomic themes also provide inspiration for purely ornamental purposes; the prime example is the rose garden, but other genera and groups of related genera are sometimes displayed in their own separate garden, beds or spread throughout an area. Woodland gardens featuring magnolias or rhododendrons/azaleas are common, as are collections of camellias. Other examples include *Iris, Aloe, Protea, Cistus* and *Fuchsia*. The close taxonomic relationship between the species gives a unity and sense of identity to the planting. Collections of plants of a single family are also brought together, usually by enthusiasts. Examples include orchid collections, bromeliads, *Asteraceae* (daisy family) borders, *Proteaceae* collections and heather gardens. Grass gardens, succulent gardens, conifer gardens and fern collections bring together a wider range of plants, though they are still related, and these can be very effective in creating a strong, distinctive planting character.

Taxonomic relationships can provide a theme to help both inspire and unify a planting design. They are most appropriate when the environmental conditions are particularly well suited to a genus or family that includes a range of species all adapted to a habit found on the site. A *Cistus* (rock rose) garden would only be really successful on a hot, dry, sunny bank, and an iris collection would be best if both dry and wet ground were present to allow a full range of dry-land and aquatic species to be grown.

One significant risk with extensive planting of closely related species, however, is that of pests and diseases. Not only is a large proportion of the species likely to be vulnerable to the same infestations, but its spread will be more rapid than if the host species were more widely distributed among resistant plants. Fireblight on *Rosaceae* and hypericum rust are diseases that demand caution in the planting of those plant groups.

HABITAT THEMES Natural habit is a common organizing principle in planting design. Rock and scree gardens, alpine gardens, dry river beds, wall plantings, wildflower meadows, woodland gardens, bush gardens, water and marginal plantings are all ways of displaying a variety of species that are perceived to

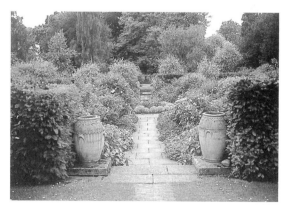

Plate 128 Rose gardens are traditional examples of planting on a taxonomic theme. This one at Newby Hall, Yorkshire, UK, features shrub and species roses.

Plate 129 An artificial boulder scree with acid soil provides a habitat for planting design at the Glasgow Garden Festival, Scotland. Heathers (*Calluna vulgaris*), heaths (*Erica* sp.) and birch (*Betula* sp.) not only grow well but also look at home in this kind of terrain.

Plate 130 This classic example of a planted drystone retaining wall is at the restored Jekyll and Lutyens garden at Hestercombe in Somerset, UK.

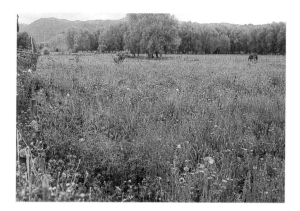

Plate 131 The wildflower meadow is a common habitat theme. This example is near Whakatane, New Zealand and most of the flowers as well as grasses are introduced species but are none the less attractive in this rural setting.

Plate 132 The development of a hotel and conference centre in an old quarry at Hagen, Germany, provides the opportunity for naturalistic planting which reinforces the sense of place (see colour section).

Plate 133 A waterside theme may be adopted even when the soil is not in contact with a water body by planting species such as *Alchemilla mollis* and *Salix matsudana* 'Tortuosa' which we associate with water but which do not require permanently moist soil (Lincoln County Hospital, Lincoln, UK).

Plate 134 The woodland habitat is well suited to ornamental planting and, in many large gardens and parks, provides a theme for collections of shade and shelter loving plants such as smooth Japanese maple (*Acer palmatum*) (Bodnant, Wales).

belong together. This is because a shared adaptation to similar environmental conditions often results in similar morphological characteristics, or because we associate these plants together from our knowledge of wild and semi-natural landscapes.

The limitations on species imposed by a particular habitat, especially if it is a difficult one for plant growth, allows the designer to introduce contrast and variety in aesthetic qualities without losing the sense of natural affinity between the plants. That affinity and the character of a distinctive habitat will help to create a strong sense of place and a natural logic to the choice and arrangement of plants.

No single habitat, however distinctive, is completely isolated from others. Forest grades into scrub or meadow or sub-alpine communities; open water adjoins emergent marginal plants or swamp, and so on. Likewise when we create artificial habitats for planting or establishing particular communities we can build a sequence of related conditions, an ecotone, and encompass more diversity within our planting theme. We might even go so far as to represent a whole landscape in microcosm from rocky peaks and tumbling streams to still lakes and tranquil pastures.

A planting idea related to that of the habitat-as-theme, is the 'plant signature' (Robinson, N., 1993). This is the use of a carefully chosen grouping of plants that refers to, or signifies, a distinctive plant association or community. The signature grouping is one that is commonly found in that plant community and so can be used to refer to it or identify it. This gives us the chance to do two things: to bring the ornamental qualities of a natural community into planting design (without the need to create and manage new habitat) and, secondly, to refer to a particular place. Note that it is the signature of the plant community and not the signature of the designer!

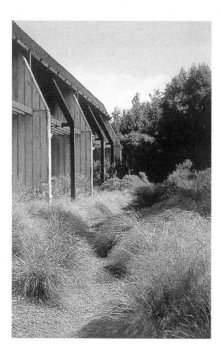

Plate 135 This grouping at the University of Canterbury, New Zealand, consisting of gossamer grass (*Anemanthele lessoniana*) and tawhai or beech (*Nothofagus* sp.) forms a plant signature referring to the typical forest edge/glade communities of the dryer Canterbury mountain forests.

Inspiration

The principles of composition consist of an ordering of visual phenomena. These effects can be perceived by anybody, regardless of culture and personal experience. The ability to distinguish harmony and contrast, to experience sequence and to respond to scale are fundamental to human interaction with the environment.

This understanding of the visual environment does not, by itself, lead us to manipulate that environment; to create and recreate the cultural landscape around us. To design requires stimulus and inspiration. The stimulus may be a functional necessity such as the need for food or shelter; or it may be a more sophisticated aesthetic need. What gives rise to an aesthetic need? What inspires the people to manipulate the elements of composition with aesthetic purpose?

The inspiration for design arises from three major sources. First, the ethos of a particular time and place is an inescapable influence that underpins the work of individuals. Such cultural influences may be unconscious, as is the case with much popular design, but trained designers should have studied and developed an understanding of the philosophy of design both in their own and also in other cultures and periods. This kind of cultural inspiration marks all the great movements and styles of landscape design. The English Landscape movement of the eighteenth century was inspired by a new appreciation of nature and influenced by the paintings of artists such as the Italians, Rosa, Poussin and Claude Lorrain. These portrayed a harmony between human activity and natural forces and a benign, pastoral landscape populated with architectural symbols of European humanist culture. The Gardenesque, in the mid-nineteenth century was inspired by the array of exotic species being introduced at that time and also influenced by the Victorian penchant for orderliness. Modernism was inspired by the machine age. The landscapes that resulted, reflected the conditions and the mood of their time.

Individuals have been crucial in propagating new ideas about design, which we now identify with their contemporary culture. But, designers such as Lancelot Brown (1715–83), John Claudius Loudon (1783–1843), Thomas Church (1902–78) and Martha Schwartz (b.1950) were not only vehicles for the birth of embryonic ideas but they also brought their own personal experience and inspiration to design. Their own individuality is stamped on their work.

The value of the individual is enshrined in western humanism, and the expression of personal freedom and values became a particularly powerful motivation in design in the late twentieth century. It has perhaps become an end in itself and, whether we believe this to be enriching or superficial, we can consider individualism to be a distinctive inspiration of the age. The mark of individuality, although it may be quite conspicuous, is more superficial than the underlying cultural generators of style. Although the designer's personal initiative and ideas may lead to a design with a strong identity, there is a risk that it becomes too contrived, too mannered, to carry real conviction. This can happen if designers try to impose their own will on the site and the result can appear 'over-designed'.

This brings us to the third source of inspiration – the site itself. The *genius loci* or 'spirit of the place' is recognized as something that should be deeply considered in design. The term was first coined by the writer and gardener Alexander Pope in 1731 while advising on the layout of landscape gardens, most of which would be located in a rural setting. However, the spirit of the place can be just as strong in urban landscapes or small private gardens. If we seek to express this essential nature of the site then the resulting design may be quite

unassuming. It may simply build on the best elements and character of what already exists and it may be difficult for the untrained observer to detect the work of a designer at all. Indeed, some of the best landscape architecture conceals the influence of the designer not by deliberate disguise but because imposed ideas and personal touches are not necessary. In such cases, one could say 'the site has designed itself'. The risk with site generated design is that it can have a feeling of dull inevitability about it. It can lack freshness and surprise. If we look deeply enough into the site and its natural and human history we do, however, often find the source of transformational design ideas. The *genius loci* can be sought in the local library archives, the stories of local people and in our own subconscious perceptions, as well as in the nature of the physical landscape.

CHAPTER 8

Plant Assemblages

This chapter will examine some of the key ecological and horticultural factors that determine the success of plant assemblages. Understanding these technical aspects will ensure that the planting develops to become what we imagined, and can be sustained without excessive demands on maintenance resources.

Plant Communities

In spontaneous, that is 'natural' or 'semi-natural' plant communities, each plant maintains itself by its ability to find the light, moisture and nutrients that it needs. Each species is equipped to live in a particular ecological niche, but interacts directly or indirectly with the other members of the community.

Let us take mature forest as an example. One characteristic that typifies and distinguishes plant communities found in forest is the way that they occupy the physical space above the ground. The species present are distributed in two ways – they occupy different areas of ground (they are distributed horizontally), and their canopies occupy different levels above the ground (they are distributed vertically). Distribution in the horizontal plane is largely determined by ground conditions, especially soil nutrients and moisture, and by atmospheric conditions, that is, wind exposure, light and precipitation. The vertical distribution is largely determined by inherent growth form combined with atmospheric conditions.

Forest Structures

It is interesting to compare two structurally different forest types with design objectives, rather than pure ecology, in mind. This will give us some insight into how different canopy structures can be suited to different design purposes. Forests from different climatic zones have characteristic stratification and growth forms that, as much as the particular species present, tell us where we are in the world. We will imagine ourselves suspended, simultaneously, above a New Zealand lowland rainforest and a forest in lowland Britain and then descend through the layers of the forest canopy. As we do so, we will explain the differences between the two forests and how they might suggest different design opportunities. The New Zealand rainforest provides an interesting contrast with the British forest because, although both are found in temperate climates, the New Zealand bush has many affinities with tropical rainforest.

The New Zealand forest is a kind of podocarp-broadleaved forest characterized by emergent podocarps above a canopy of broadleaved trees, this

was common in lowland and the lower montane areas before its destruction by logging and burning and conversion to pasture. At a height of about 30–40 metres above the ground, we would find ourselves among the tops of the tallest trees of this forest. These form a discontinuous layer consisting of podocarps (an ancient family of conifers) such as rimu (*Dacrydium cupressinum*), matai (*Prumnopitys taxifolia*), miro (*Prumnopitys ferruginea*) totara (*Podocarpus totara*) and kahikatea (*Darcycarpus dacrydioides*) together with the epiphytic giant, northern rata (*Metrosideros robusta*). They emerge above a denser canopy below, and provide a host to many epiphytic species, which benefit from the high light levels.

It is not until we have descended to between 20 and 30 metres above the ground that we encounter a complete tree canopy. This happens in both the New Zealand and the British deciduous forest. In the latter, the tallest trees, which form the forest canopy, are pedunculate oak (*Quercus robur*) perhaps mixed with ash (*Fraxinus excelsior*), sycamore (*Acer pseudoplatanus*) or alder (*Alnus glutinosa*). The mix depends on local ground conditions and where these become extreme (e.g. waterlogged or alkaline), other species may replace the oak altogether to form specialized communities. These trees can form a tightly knit canopy, broken only by gaps left by fallen trees. The upper surface of the forest canopy is often gently undulating or mounded, reflecting the shapes of the individual trees, or in some places (especially where exposed to strong wind) smooth, as though planed off.

In the New Zealand forest the broadleaved canopy is evergreen, not deciduous, and includes trees such as tawa (*Beilschmiedia tawa*), hinau (*Elaeocarpus dentatus*), kamahi (*Weinmannia racemosa*) and rewarewa (*Knightia excelsa*). These canopy trees also provide support to many lianes (tall vines) and perching epiphytes. Lianes include the native passion flower (*Passiflora tetrandra*) and puawhananga (*Clematis paniculata*), and epiphytes comprise both herbaceous plants, such as the perching lilies (*Collospermum hastatum* and *Astelia solandri*) that form 'nests' in the forks of branches, and epiphytic trees such as puka (*Griselinia lucida*) and northern rata (*Metrosideros robusta*).

This mixture of tall forest trees forms the main canopy, the first complete layer of foliage to intercept the sunlight. In dense forest, this layer may be only several metres deep, although it is often carried between 20 and 30 metres above the ground. Below this, smaller trees form an intermittent, sub-dominant tree layer in places where light levels are sufficient to support trees that cannot attain the same height as the canopy dominants. In the oak woodland the sub-canopy would include species such as field maple (*Acer campestre*), rowan (*Sorbus aucuparia*) and holly (*Ilex aquifolium*). Again, they are mostly deciduous and holly is the only common evergreen in this kind of woodland. In the podocarp-broadleaved forest it is, as the name suggests, mainly broadleaved rather than coniferous trees that make up the sub-canopy. They are almost entirely evergreen and include many species of *Pittosporum*, *Pseudopanax*, *Coprosma* and the tree ferns, as well as mahoe (*Melicytus ramiflorus*), kohekohe (*Dysoxylum spectabile*) and nikau palm (*Rhopalostylis sapida*).

Below this, we find an 'understorey' or 'shrub layer' that, in both forests, varies considerably in density. Where sufficient light gets through the foliage above, this layer can be diverse and luxuriant, difficult to penetrate in places, but in dark areas it becomes thinner or disappears altogether. The main difference between the two forests is that the podocarp-broadleaved forest is never both open and well lit. Because the climatic conditions are so favourable for plant growth, any gaps that appear are very quickly occupied by growth. The open areas that we do find within the forest are mostly very dark and often thick with the closely spaced

stems of trees and vines that have been drawn up to the light above. In oak woodland, there can be areas where the density of the summer tree canopy is enough to restrict growth of the shrub layer, and the inside of the forest becomes like a room with its roof supported on widely spaced pillars. In late autumn, winter and spring, when the foliage is not fully developed, this space can have a light and airy atmosphere.

Understorey species include shade tolerant shrubs such as, in oak woodland, hazel (*Corylus avellana*), midland hawthorn (*Crataegus oxycantha*) and elder (*Sambucus nigra*). In the podocarp-broadleaved forest species would include species of *Coprosma*, *Olearia rani*, tree ferns and the young plants of tree species. Root-clinging vines such as the rata vines and climbing ferns are also common at this level in the canopy.

The next stratum down is known as the 'herb layer' or 'field layer'. It comprises herbaceous and woody species that commonly grow up to about 1 metre in height, though often lower. Like the understorey layer, the herb layer's depth and density will depend on the light that is able to come through the upper storeys. Trees and shrubs also affect the plants below by other means, such as root competition and leaf litter (see Sydes and Grime, 1979, for more information on this).

In oak woodland, the herb layer species include shade-tolerant prostrate shrubs and climbers, such as ivy (*Hedera helix*), honeysuckle (*Lonicera periclymenum*) and bramble (*Rubus fruticosus*); herbaceous plants such as dog's mercury (*Mercurialis perennis*), lords and ladies (*Arum maculatum*) and ground ivy (*Glechoma hederacea*); and the seedlings of tall-growing woody species. Because the forest canopy is deciduous, and oak comes into leaf relatively late in spring, there is an opportunity in the herb layer for plants that complete most of their life cycle in spring. These are called vernal herbs. They flower and make most of their growth between March and June, before the tree and shrub canopies have reached their greatest density. Wood anemone (*Anemone nemorosa*), bluebell (*Endymion non-scriptus*) and primrose (*Primula vulgaris*) are examples of oak woodland flowers that take advantage of this seasonal 'window of opportunity'. Vernal herbs are often less well developed in beech woods because the tree canopy comes into leaf earlier in the spring and casts a heavier shade. In ash woods, the amount of light getting through the tree canopy is greater and this allows a denser shrub layer to develop and to restrict the growth of the field layer.

The herb layer in podocarp-broadleaved forest includes a great range of ferns together with some sedges and other flowering plants. By far the main component is the ferns, which reflects the low light levels that predominate near the ground throughout the year. Common species are crown fern (*Blechnum discolor*), hound's tongue (*Phymatosorus diversifolius*) and hen and chicken fern (*Asplenium bulbiferum*). Also frequent, trailing along the ground, are the stems of small white rata (*Metrosideros perforata*) and thread fern (*Blechnum filiforme*).

Two Principles

We have sketched only the briefest outline of forest structure, but it is enough to highlight two principles that can be applied to the design of planted assemblages of all kinds.

The first is the groundcover principle: that complete cover of the ground area at one or more levels is a sign of a well-developed plant community growing under favourable conditions. The ground surface is covered throughout the year either by living vegetation or by a thick layer of leaf and twig litter and other

debris. Bare soil, on the other hand, indicates a high degree of stress in the growing environment. This may take the form of low levels of water, soil air, available nutrients, toxicity, excessive compaction or frequent disturbance.

The second is the complexity principle: that plant communities in favourable environmental conditions tend to become more complex as they develop over time. This complexity may be reduced by interference of one kind or another, either natural or human, and the process of development is set back or begins again. Complexity can be assessed by three main criteria:

1. the variety of species present: **species diversity** (this is equivalent to local bio-diversity),
2. the number of canopy layers present: **structural diversity**,
3. diversity through the seasons: **seasonal diversity**.

Species and structural diversity act as a buffer against environmental pressures such as climatic or microclimatic change and variations in biotic factors including disease, grazing and human interference. A wide range of species offers potential for adaptation to environmental change and a well-developed physical structure tends to ameliorate the severity of climatic and soil factors.

Designing with Canopy Layers

Too much planting design is done on plan alone. No less attention should be given to the vertical, spatial arrangement of plants than to where we put them in the horizontal plane. After all, it is the elevations of plant groups that we see most often. It is unusual to view planting from much above normal eye level and most people never see it from above. It is also important for designers, who are creating places for people, to understand the effect of the spatial structures of plant communities. This will help them to realize more of the potential of their

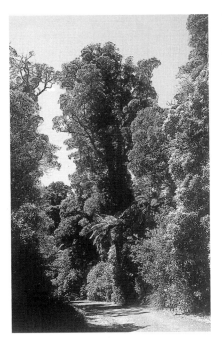

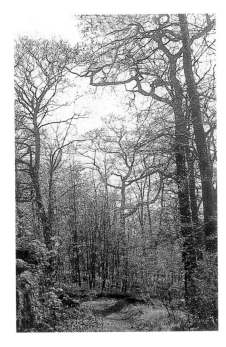

Plate 136 New Zealand podocarp-broadleaved forest at Kaitoke near Wellington showing massive emergent northern rata above a dense evergreen broadleaved canopy and some shrubs and tree ferns below.

Plate 137 Typical British oak woodland in spring, showing understorey of regenerating tree species as well as small trees and shrubs. The herb layer is partly dormant but grass is vigorous in lighter areas (Sheffield, UK).

unique design medium. To illustrate this, let us compare a journey on foot through two contrasting forest types.

In the New Zealand lowland rainforest of the kind described above, there is a strong sense of the abundance and power of growth. Indeed the main tree canopy, at its most vigorous growth stages, can be so dense that few plants can survive at all in the feeble light below. Where more light is able to penetrate, however, saplings quickly spring up; or shade tolerant shrubs and ferns luxuriate in the dappled sunlight and moist shelter. Even where there is little understorey, the bush interior is a tangled mass of stems, lianes and fallen debris that make it both a visual and a physical barrier. So, if we possibly can, we will find our way round the perimeter or keep to well-trodden paths within it. If we do venture into the dim interior, we find ourselves in an unfamiliar world where we feel clumsy and easily disoriented. In the places where shafts of bright sunlight penetrate, the foliage of the shrubs and ferns is lit up and seems to glow, jewel-like, in the darkness.

In the New Zealand montane beech forest, the character is quite different: serene and mysterious. Overhead is a feathery, even canopy of foliage raised on trunks lightly clothed with lichens. On the ground below is spread a mantle of mosses, ferns, bush lilies and other low growing plants. The 'shrub layer' is formed mainly by vigorous thickets of regenerating beech in the lighter areas, rather than specifically shrub species. Otherwise, the space is comparatively open, allowing views into the surrounding forest and letting enough sunlight through to create varied and beautiful patterns of illumination on the trunks of the trees and the forest floor. This is an inviting space to explore.

To the designer, these spatial structures offer both the means to different moods, and to different practical functions. The comparative openness and accessibility within the mountain beech forest creates the kind of spaces that suit human participation, particularly recreational activities. People will walk, play, cycle, park their cars, sit and eat their lunch within this kind of space if they are given simple facilities and sensitive management. On the other hand, the density of lowland bush deters entry and makes it an effective means of separation and enclosure. If we need maximum shelter, a solid screen or the concise definition of a spatial edge, this kind of planting structure would serve the purpose.

Complex mature forest structures of the kind outlined above are one possibility for design. However, it is important to remember that these can be difficult and slow to establish in a cleared area or in grassland. For a full treatment of the technical aspects, the reader is referred to the literature on establishing forest communities and plant habitats, such as B. Evans's *Revegetation Manual* (1983) and G. P. Buckley, *Biological Habitat Reconstruction* (1990). In the long term, a mature forest structure may be the objective, but there are many projects where simpler canopy structures would be the only realistic option for an early objective.

Some Typical Canopy Structures

In the examples that follow, the spatial canopy structures listed are based on some familiar plant communities, both natural and modified, found in temperate regions. The list is not a classification of plant communities, only a description of the potential of canopy structures for landscape design.

The list is in two parts: the first describes cool temperate deciduous woody plant community structures that are common in Britain, Europe and parts of North America, and the second describes evergreen structures found in temperate to warm-temperate climates such as New Zealand. In the

descriptions, the names of the layers are separated by /, and poorly developed layers are shown in brackets.

Deciduous Cool Temperate Communities (Europe and North America)

Three-layer Canopy Structures

TREE CANOPY/(SUB-CANOPY)/SHRUB LAYER/HERB LAYER This kind of multiple layer woodland develops where the ground provides sufficient moisture, nutrients and root anchorage and where conditions of exposure and temperature allow. Little remains of the original great forest of Europe but a related type is found in planted and managed woodlands and in spontaneous secondary growth. Small areas of woodland, copses and spinneys are much more common than extensive forest because they can occupy pieces of land not big enough to be put to more financially rewarding uses, or not suitable for development. Such woodland may be spontaneous in origin, the result of secondary succession in areas released from human interference, or it may be deliberately planted.

This provides the model for ornamental, exotic vegetation with related canopy structures. This tends to be found in woodland gardens and in beds of exotic tree, shrub and herb layer planting throughout the amenity landscape. These pockets of ornamental woodland – 'exotic groves' – occur in parks, gardens and other urban planting, but they are mostly scaled down versions of the native forest, using scattered trees of 8–12 metres height rather than 20–25 metres as found in the forest canopy. This is like leaving out the dominant forest trees and planting the sub-canopy. In area, they may be as small as 100 square metres but still show the distinctive canopy structure of three or more overlapping, but not necessarily continuous, layers.

Multi-layer forest or woodland structure is valuable for shelter, wildlife, visual improvements, environmental education and informal recreation. Whether naturalistic or ornamental, it offers a great diversity of plants and an aesthetic richness. It gives the best plant value per area because it makes full use of the space above the ground, allowing trees to grow above shrubs that grow above perennials and bulbs and groundcover.

Unfortunately, many opportunities for this kind of planting are ignored. There are a number of reasons for this; the commonest is traditional ideas about how to grow and display ornamental plants. These originate partly from the Gardenesque style of J. C. Loudon (quoted in Turner, 1987) and encourage the growing of plants as separate discrete objects of ornament rather than as components of a composition. It needs imagination and horticultural experience to see the possibilities for richer, more complex planting associations.

TREE CANOPY/SUB-CANOPY/SHRUB LAYER/FIELD LAYER: EDGE OR MARGIN The edge of woodland and forest margins are often characterized by a gradation in canopy heights from high woodland canopy through smaller trees and shrubs, dense tall herbs with dwarf or prostrate shrubs, down to grassland, herbfield or open ground. This edge may be fixed by climate, topography or the management of adjacent land. The edge may advance as the woodland or forest colonizes open land, or it may recede as incursions are made by human activity of natural destructive events. In all cases, however, its canopy structure and constituent species respond to the higher light levels and the greater exposure at the edge than within.

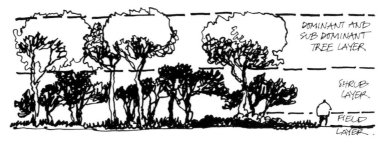

LAYERS IN MATURE OPEN WOODLAND.

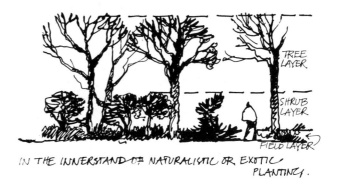

IN THE INNERSTAND OF NATURALISTIC OR EXOTIC PLANTING.

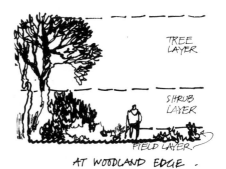

AT WOODLAND EDGE.

Figure 8.1 Three-layer canopy structures.

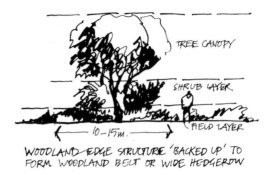

WOODLAND EDGE STRUCTURE 'BACKED UP' TO
FORM WOODLAND BELT OR WIDE HEDGEROW

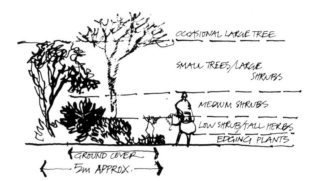

MAXIMUM DEVELOPMENT OF EDGE STRUCTURE USED TO
DISPLAY ORNAMENTAL PLANTING.

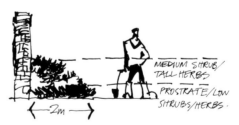

MINIMUM EDGE STRUCTURE REQUIRES 2m.

Figure 8.2 Edge structures.

The canopy layers at the edge are extensions of those within the core, but because there is less shading, they are usually denser. Many plants species are common to both edge and core, but will flower and fruit more abundantly in the light and warmth of the edge, especially if they face the sun. In addition, the edge can contain species that are more light-demanding. It is this diversity of species and their arrangement and the consequent range of wildlife habitat that makes woodland edges and forest margins valuable for conservation. The forest margin or woodland edge can also have a protective function. It helps create the conditions of shade and shelter that typify the interior and are necessary for the shade-demanding forest floor species. Without the dense edge, these plants would be restricted to a smaller area.

This edge structure is also a common model in artificial plantings. It may form an edge to high woodland plantation or woodland gardens or it may stand alone, a linear community divorced from the woodland proper. When planted like this, a woodland edge still offers valuable ecological, spatial and visual diversity. This kind of canopy structure is valuable for screens and shelter belts where the planting width available would not be sufficient to allow the development of high woodland. A woodland edge or forest margin needs to be at least five metres wide to be effective, to allow the space occupied by the plants in each canopy layer.

A woodland edge canopy structure can be developed using exotic and ornamental species and the gradual build up of height from front to back allows each layer in turn to be displayed. In ornamental associations we often want to accommodate a larger number of layers, perhaps including bulbs and herbaceous plants of various sizes and sub- and dwarf shrubs below taller species. This would need a more gradual build-up in height and a greater width to be effective. A typical ornamental edge structure with graduated height would consist of:

1. front edging and groundcover of prostrate shrubs or low herbs, perhaps with spring and autumn bulbs and other small herbaceous plants emerging through them at various seasons;
2. low shrubs, sub-shrubs and tall herbaceous perennials;
3. medium-height shrubs and, behind and above these:
4. tall shrubs;
5. small trees;
6. medium to tall trees.

Small- and medium-height trees might be grouped or scattered through the various layers, noting aspect and sun direction, and taking care to avoid casting heavy shade that would suppress layers below. Tall forest tree species would be confined to the back of the edge in order reduce the shade cast by their extended canopy.

Layers 1, 2 and 3 can be designed to give groundcover, that is, to provide a continuous dense canopy down to near ground level that will prevent most weed growth below it. The tall shrubs in layer 4 are likely to have a more upright habit with less foliage near ground level but their bare stems and the ground below them will be effectively hidden by the lower foliage canopies in front.

The width of each layer can vary along the length of the bed and some layers may appear only intermittently or not at all. Because of the greater control that we can exercise over the height and spread of exotic species in an ornamental association, it is possible to reduce the width of a graded edge type of planting to as little as 2 metres. In this case, however, there would only be space for two layers, a front edging of carpeting or low shrubs with medium or tall shrubs behind.

The graduated height structure is a model that is generally understood and commonly used in planting design, particularly in ornamental shrub planting, herbaceous and mixed borders. An early advocate of this type of planting for private gardens was Michael Haworth Booth (1983). This was at a time when most private gardens no longer had the space or resources to maintain the more labour intensive herbaceous borders. Like a multiple layered woodland core, a woodland edge planting is a way of making the most of a limited area by including different canopy layers within it. Either multiple layer woodland or edge type of structure is likely to be a good way of achieving structural and ornamental interest in a wide variety of planting schemes. However, for functional or aesthetic reasons, we may want to create a simpler kind of structure that contains one or two canopy layers.

Two-layer Canopy Structures

TREE CANOPY/SHRUB THICKET This combination typically occurs where the tree canopy is sufficiently open to allow a dense and continuous shrub thicket to develop in the understorey. The shrub thicket often includes species that spread by vegetative means to form colonies of dense 'undergrowth' and prevent the establishment of a significant field layer.

In planted associations, a version of this may be created using native shrubs like blackthorn (*Prunus spinosa*), blackcurrant (*Ribes nigrum*), bramble (*Rubus fruticosus*) or snowberry (*Symphoricarpos albus*) below a scattered tree canopy of species such as oak (*Quercus robur*), rowan (*Sorbus aucuparia*) or ash (*Fraxinus excelsior*). Beneath trees that cast a heavier shade, such as beech (*Fagus sylvatica*) and horse chestnut (*Aesculus hippocastanum*) only the most shade-bearing understorey species would survive; box (*Buxus sempervirens*), yew (*Taxus baccata*), holly (*Ilex aquifolium*) or mountain currant (*Ribes alpinum*), for example.

The ornamental equivalent of this is a common planting idiom in large-scale public and corporate landscape. Its popularity derives mainly from its low cost: the ground is covered effectively with a small number of vigorous thicket-forming shrubs that, once established, require only a minimal level of maintenance. Species need to be reasonably shade tolerant but also able to establish in more open conditions and these include dogwoods (*Cornus alba* and *C. stolonifera* and cultivars), cotoneasters (such as *Cotoneaster conspicuus*, and *C. microphyllus*), barberries (*Berberis candidula*, *B. verruculosa* and others), the smaller laurels (*Prunus laurocerasus* 'Zabeliana', *P. l.* 'Otto Luyken' and others) and boxes (*Buxus* species and cultivars). Trees are scattered in drifts, groups or individually through the shrub thicket and eventually form a continuous or broken tree canopy above the dense undergrowth.

TREE CANOPY/FIELD LAYER This occurs naturally in areas where a dense upper canopy precludes the growth of a significant shrub layer but allows a field layer of shade tolerant herbs to develop that may include 'shade dodging' vernal herbs. It is also found where the growth of trees and shrubs is limited by an arid climate and savannah woodland develops. However, this structure is probably more common in semi-natural associations. Wood pasture occurs where grazing of the herbs and shrubs has prevented the re-establishment of woody seedlings, opened up the woodland, and favoured grasses in the field layer. Parkland has a similar structure, but has been created by planting widely spaced trees in existing pasture to form an assemblage not unlike savannah woodland.

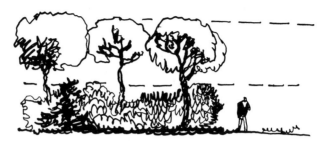

TREE CANOPY - SHRUB THICKET

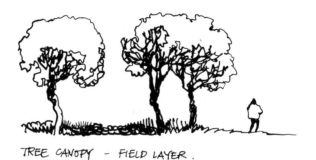

TREE CANOPY - FIELD LAYER.

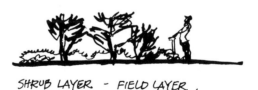

SHRUB LAYER - FIELD LAYER.

Figure 8.3 Two-layer canopy structures.

This kind of arrangement is useful in artificial plant associations where an open aspect is wanted. Space is defined by a tree canopy above and the floor is clothed by the field layer. The interior of the association would be open to views from its boundaries and to physical access and circulation. The canopy may be dense and unbroken, creating a continuous ceiling, or it may be more scattered giving lighter and more varied conditions within, while still having a distinct ceiling of foliage. The field layer could be a simple shade tolerant groundcover such as ivy (*Hedera* sp.), *Pachysandra terminalis* or rose of Sharon (*Hypericum calycinum*). It may, if the shade is not too dense, consist of a grassy meadow including wildflowers and meadow perennials, or simply a mown grass sward. The latter is the ornamental equivalent of wood pasture or parkland.

Trees scattered across mown grass are such a common sight that this could easily be taken to be the standard way to plant amenity trees. It is an effective combination where we want free circulation and a modest establishment cost, but it is slow to take effect and low in visual and ecological interest. Its widespread use comes from adherence to one particular idiom, that of the 'English Parkland', popularized as long ago as the eighteenth century by the English Landscape movement. Admiration for the generous sweeps of grassland and noble spreading trees of the eighteenth century is understandable, but the parkland idiom is less appropriate to small-scale urban locations, where factors such as low level shelter, visual screening and aesthetic diversity should be among the chief design objectives.

SHRUB LAYER/FIELD LAYER In nature this structure is found, for example, in coastal and sub-alpine communities, where the tree layer is absent because of climatic factors, and in scrub and shrubland, where succession has not progressed to an arboreal stage because of grazing or human interference.

A similar structure is adopted in artificial plant associations where trees are not appropriate for reasons of scale, space, light or views. Shrubs form the dominant canopy at between 1.5 and 3 metres in height and are under-planted with low, groundcover species. The shrub layer can be more or less dispersed, but this kind of canopy structure requires shrub species that have a more erect or open habit than would normally be used to form a closed, weed suppressing thicket. The shrub canopy must allow enough space and enough light below for the field layer planting to thrive.

Shrub and groundcover associations are common in small ornamental areas of parks, gardens and courtyards, in planting close to buildings and where overhead or underground services preclude tall growing or deep rooting trees. It is a good method of displaying specimen shrubs, alone or grouped, because the groundcover avoids the need for close planting of taller shrubs. Even slow growing specimens such as the cut leaved Japanese maples (*Acer palmatum* and *A. japonicum*) will have the chance to develop their full spread and mature form while the groundcover reduces weed competition. Exotic shrubs planted as specimens in mown grass represents another example of an artificial shrub/field layer association although one that has horticultural disadvantages. Traditional lawn specimens such as magnolias, buckeye (*Aesculus parviflora*) and lilacs (*Syringa* sp.) grow more vigorously and show off their flowers and form as well, if not better, above a carpet of groundcover than in a lawn. Grass competes more strongly with shrubs for soil moisture and nutrients than does groundcover.

Single-layer Canopy Structures

TREE CANOPY Tree growth without associated shrubs or herbs is unusual in nature, but not unknown. On thin, dry soils, xerophytic species may be the only ones capable of exploiting ground water at great depth. Under these conditions of extreme moisture stress, individuals are usually widely spaced, occupying the ground at a density determined by the quantity of water available. Another example can be found on screes and boulder falls where trees may be the first plants to colonize. Their rapid extension growth at the seedling stage allows the stem to extend into the sunlight from the deep crevices that retain the small amounts of soil and moisture needed for their seedlings to establish.

It is unusual to see trees planted alone in bare ground except during the early stages of establishment of mass tree planting, in paved urban areas. In both these

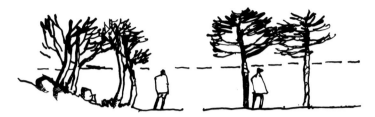

TREE CANOPY ABOVE BARE GROUND OR PAVEMENT

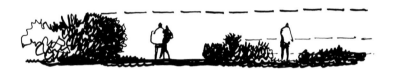

TALL OR MEDIUM HEIGHT SHRUB THICKET, OR FIELD LAYER
GROUND COVER.

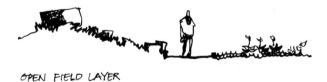

OPEN FIELD LAYER

Figure 8.4 Single-layer canopy structures.

cases, it is human rather than climatic induced stress that prevents the growth of the field layer. Planting trees in pavement areas is a common and valuable means of introducing vegetation to streets, squares, precincts and car parks where space at ground level is limited and pedestrian or vehicular traffic is intense. The spatial structure of this combination is similar to that of trees planted in grass but the ground surface can take much heavier traffic. The effect is to create a foliage canopy overhead, that defines and partly covers the space but does not significantly restrict vision or circulation at ground level.

SHRUB THICKET A shrub thicket is a shrub layer that is continuous and dense enough to suppress the growth of a significant field layer. This type of community is common in landscape plantings where it is cheap to establish and easy to maintain. In nature, a shrub thicket is usually the sign of the early vigorous

stage in colonization of an open area by woody plants, before a differential age and height structure develops. It can also be found where extreme climatic conditions prevent the growth of taller plants such as beyond the tree line in sub-alpine scrub, but here it is rare for there to be no herb or ground layer at all.

In amenity and ornamental planting, shrub thickets are used where groundcover and height are wanted simultaneously. They are best created using closely planted shrub species of spreading or domed form with dense foliage down to near ground level. Common species include *Viburnum tinus, Cotoneaster microphyllus* and many barberries such as *Berberis verruculosa* and *B. darwinii*. It is of course possible to use more light-demanding shrubs than would grow beneath a tree canopy. Examples of these include coastal and sub-alpine *Hebe* species, many of the smaller *Olearia* species, *Brachyglottis* (syn. *Senecio*) species, rock roses (*Cistus* sp.) and shrubby cinquefoil (*Potentilla fruticosa*).

The width of a shrub thicket need not exceed about 3 metres. This width will be enough to provide any necessary separation and enclosure. Because of its density and height, views into and over it are limited, and any planting beyond the first 2 to 3 metres is largely out of sight and contributes little to the composition.

Finally we should note that single layer, widely-spaced shrub planting with bare soil between, although common in traditional Gardenesque ornamental beds, is laborious to maintain and rarely attractive. Because the well lit, bare ground provides ideal condition for colonization, there is a continuing need to suppress the natural establishment of a field layer. Long-term herbicide application is not really a solution, merely a substitute for adequate planting design. Groundcover mulches such as bark and woodchip have become more adaptable with the development of weed mat fabrics that can be laid beneath them. This prevents growth up through the mulch. Coarse bark or shingle are often used but the visual qualities of any groundcover mulch should be considered just as carefully as those of a groundcover plant. Also, this system prevents the spread of some desirable species by seed and by vegetative means.

HERB OR FIELD LAYER Field layer vegetation with nothing taller than prostrate or dwarf shrubs is found naturally in tundra, alpine and desert communities where plants of greater stature are prevented from growing by the harshness of the environment. Field layer alone is also common where grazing, burning, soil degradation or other biotic factors limit the establishment of trees and shrubs, such as in meadows, heaths and moorlands. As climatic or biotic pressure approaches the limit of what plants will tolerate this ground layer vegetation becomes more open and bare ground appears between plants.

An open community of dispersed low shrubs and herbs is a common sight in traditionally maintained parks, gardens and urban plantings. In this case, the environmental stresses that prevent the canopy from closing are the frequent disturbance of the ground surface, pruning and trampling.

Extensive swathes of uninterrupted low groundcover are seen in landscape plantings where visibility is critical (for example, highway visibility splays) or to achieve a simple but striking spatial effect. A mown lawn is the ornamental version of a grazed meadow. Its uniformity can be an aesthetic benefit and its durability under pedestrian traffic gives it the important functional role of a circulation surface. A field layer of low shrubs requires carpeting species with similar form and habit to those associated with the tree canopy/field-layer structure, but thrive in conditions of full light where there is no tree or shrub canopy. Some examples of these include *Carex* species, *Coprosma acerosa* hybrids

and cultivars, *Erica* species, *Cotoneaster dammeri*, *Hypericum calycinum*, *Hedera canariensis*, *Coprosma acerosa* and *Lantana montevidensis*.

More intensive maintenance is normally needed if we want to keep low groundcover free from taller shrubs and trees than is necessary to preserve the canopy structure of the other associations. Even the densest of carpeting groundcovers such as ivies (*Hedera* sp.) and *Rubus tricolor* will soon become invaded by elder (*Sambucus nigra*), sycamore (*Acer pseudoplatanus*), ash (*Fraxinus excelsior*) and other prolific seeding trees and shrubs, and will begin to develop shrub and tree layers.

Evergreen Temperate Communities (New Zealand)

Emergent Trees/Tree Canopy/Sub-canopy/Shrub Layer/Herb Layer

Podocarp-broadleaved forest of the kind already described is an example of this five-layer structure. It has similarities to the structure of tropical forest with very tall emergent trees rising above a more or less dense bush canopy of mainly broadleaved trees. Sub-canopy trees, shrub and field layers are strongly represented in gaps where sufficient light penetrates, but otherwise tend to be weakly developed.

There is considerable planting potential for this structure in large-scale framework planting for full screening, shelter, boundary definition and allowing limited interior access. Establishment generally has to be staged because many of the final species require a nurse period where pioneer trees and shrubs provide a sheltered, partly-shaded environment. The emergence of the podocarps is only a very long-term objective. However, there are very good reasons for managing plantings to assist the establishment of the top tier of podocarps. Examples exist where early plantings of podocarps are now beginning to mature in revegetation projects. The totara, miro, matai and kauri that were planted in the early years of the twentieth century at Otari and Wilton's Bush reserve in Wellington is one.

Tree Canopy/Shrub and Sapling Layer/Herb Layer

An example is lowland mixed beech forest. Various *Nothofagus* species, and associated forest trees form a high canopy that is usually less dense than that of broadleaved bush canopies and so allows a fuller development of lower strata, especially in glades and at edges. This structure is similar to northern hemisphere temperate deciduous woodlands and has potential for large-scale framework planting for screening, shelter and boundary definition; informal access trails, siting for car parking, camping, or small buildings within the inner-stand. A narrower belt of this structure with a more open shrub layer could provide effective separation with partial screening.

Bush Canopy/(Shrub and Sapling Layer)/(Field Layer)

Lowland secondary forest, in its early stages of development, goes through a thicket stage that is dense and impenetrable in places. It can be explored where trees and shrubs have developed raised canopies or are more widely spaced. Understorey and field layers may be present where sufficient light penetrates the tree canopy. This is similar in composition to the forest layer in the first type, but is often more dense. It may contain colonies of distinctive trees such as tree ferns and nikau palm that create a notable variation in form and spatial quality.

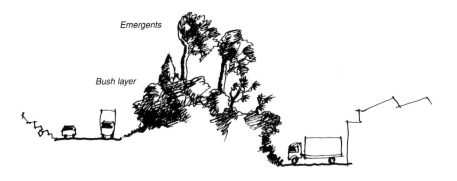

Emergent/bush.

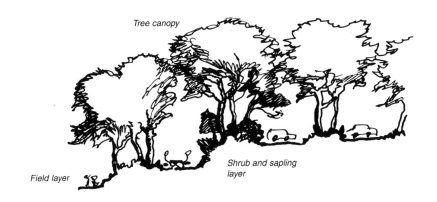

Tree/shrub/field layer.

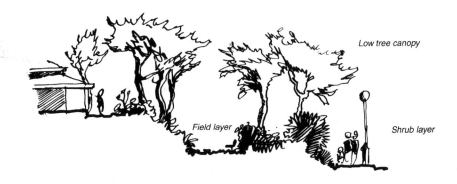

Low woodland.

Figure 8.5 Evergreen temperate communities.

It could provide quick establishing planting for medium- and large-scale framework planting, lower level screen and shelter, boundary definition, roadside planting, margins of commercial forestry plantations, nature study and wildlife areas in school grounds and urban parks and reserves.

Low Tree Canopy/Shrub and Sapling Layer/Field Layer

This is a pioneer community such as kanuka woodland with, at its mature phase, an open canopy allowing the development of a moderate to dense lower strata of bush and forest species. These will succeed the kanuka once its canopy becomes higher and thinner and a shade tolerant field layer will develop.

This type of community can provide quick establishing planting for medium- and large-scale framework planting; shelter and screening; boundary definition; nature study and wildlife areas in school grounds and urban parks and reserves; roadside planting and margins of commercial forestry plantations; siting for car parking and camping; a nurse for trees that need a protected environment during the establishment phase and a canopy for woodland gardens and other shade and shelter loving ornamental planting; and shade and visual accompaniment for buildings.

Shrubland Communities

SHRUB THICKET/(FIELD LAYER/GROUND LAYER) Sub-alpine scrub can create a shrub thicket from above head height to little more than knee height depending on altitude and exposure. The more open scrub canopies shelter scattered lower layers of sedges, grasses, ferns, mosses, lichens and small herbs as well as some prostrate sub-shrubs. A second example is provided by coastal scrub thicket that can be especially dense due to numerous scrambling plants such as kiekie and pohuehue.

The planting potential of this type includes medium- and small-scale framework planting for localized screening, shelter, enclosure, boundary definition and sub-division of space in estates, parks and gardens; nature study and wildlife planting in school grounds and urban parks and reserves; roadside planting, margins of commercial forestry plantations; background to specimen and decorative planting; and furnishing of building curtilage. Low and medium-height shrub thicket can be established in urban landscapes such as car parks and streets where the ground area is limited. More open shrub canopies can provide sheltered and partly shaded niches for smaller shrubs and herbaceous plants in amenity and ornamental planting in public or private landscape.

Herb-dominated Communities

HERB LAYER/GROUND LAYER Tussock grassland illustrates this structure. It is dominated by tussock-forming grasses and sedges and also includes some small herbaceous and shrubby species. A ground layer of mosses and lichens and other dwarf prostrate plants may also be present.

This type of planting may be used in the demarcation of space and territory without visual obstruction in small and medium-scale landscape development; nature study and wildlife planting in school grounds and urban parks and reserves; roadside planting, margins of commercial forestry plantations;

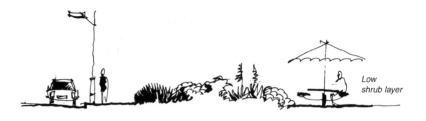

Shrub thicket.

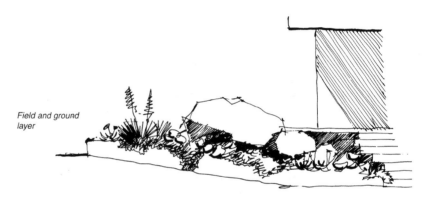

Herbfield.

Figure 8.6 Shrub thicket and herbfield.

ornamental grassland and mixed grass and herbaceous planting in parks, gardens and civic spaces.

Design Interpretation

What is described and suggested in the examples above is the canopy structure of the association rather than the precise species that make it up in its natural habitat. We could, for example develop a low shrub thicket canopy structure using adaptable native and exotic shrub species that will grow satisfactorily in the different site conditions and yet still form a typical canopy structure. We could even include the field layer or ground layer and make an indigenous design idiom.

To take another example, the tussock grassland community is strongly identified with some regions of New Zealand and California (where it is called bunch grass) and native, tussock forming grasses and sedges have enjoyed widespread planting in all types of landscape projects largely because, they are associated with local character. If we look at tussock grasslands closely, we see that they include many sub-shrubs and herbs such as (in New Zealand) *Pimelea, Celmisia, Bulbinella* and *Wahlenbergia*. These naturally associated flowering plants could be included with tussock grasses and sedges in planting projects in suitable soils and climates. We

could also use a tussock grassland structure in urban locations, but substitute some exotic herbaceous plants and dwarf shrubs. *Gazania repens, Eschscholzia californica, Iris unguicularis, Zauschneria californica, Phlox Felicia amelloides* and *Penstemon barbatus*, are herbaceous plants with natural habitats that include open grassland of similar structure to the New Zealand tussockland, and could be cultivated in the spaces between tussock forming grasses and sedges. Such an association of herbs and sub-shrubs spreading freely among a matrix of tussock would be a horticultural interpretation of the natural tussockland or bunch-grass meadow canopy structure and could be suited to urban planting sites.

The idea of 'ornamental meadows', consisting of an ecologically balanced community of grasses and exotic flowers, has been explored by the German landscape architect Richard Hansen. He created plantings of herbaceous perennials in established meadows and found that some would spread without intensive management (Ward, 1989; and Hansen and Stahl, 1993). The distinctive structure of New Zealand tussockland and the similar Californian bunch-grass communities, appears to be especially well suited to this kind of association – probably better suited in fact, than the European meadows of carpeting grasses with which Hansen works.

These examples and ideas are intended to suggest how the spatial characteristics of natural plant communities could provide distinctive, local idioms for planting design. They show that planting structures can help create this whether they employ only native or include exotic species. Because such planting structures are based on the indigenous and familiar vegetation, they offer a way to work with the distinctive character of the land to create planting design that truly belongs in its landscape.

Horticultural Factors in Plant Associations

The scope of planting design ranges from revegetation of disturbed and degraded areas through the creation of naturalistic plant communities to intensive gardening with choice and exotic ornamentals. The aim of revegetation is to re-establish the plant community that previously existed on the site. It is instructive to compare this objective with the related but different approach of naturalistic planting: this employs species that are well adapted to the existing conditions but also increases bio-diversity by deliberately extending the range of micro-habitats. At the other extreme, amenity horticulture adapts the soil and the microclimate to suit plants that would not otherwise grow. This approach results in the gradual transformation of a diversity of soils towards the horticultural ideal of a neutral or slightly acidic, moist but well drained deep loamy topsoil.

The difference between choosing the species to fit the site and modifying the site to fit the species is not necessarily the same as the difference between native and exotic planting. Exotic species may be planted, or they may naturalize in naturalistic planting schemes. In Britain, for example, larch (*Larix* sp.) and false acacia (*Robinia pseudoacacia*) grow successfully in many naturalistic woodland plantings and exotic herbaceous species such as winter aconite (*Eranthis hyemalis*) can be encouraged to naturalize in woodland gardens. Conversely, native species may require just as much horticultural care as exotics if they are to be grown in a location with different soil or microclimate – note the care lavished on heathers and heaths (*Calluna vulgaris* and *Erica* sp.) in gardens throughout Britain, where they are planted regardless of soil type. In New Zealand, the conditions that many natives need to establish are so different from the average garden or paddock that, in the early stages, they can require considerably more care and management than many exotics.

The planting designer must, at an early stage in the design process, consider the kind of site preparation and the level of aftercare that will be needed to establish and sustain the desired plant association. In most cases, the aim is to gain maximum functional and aesthetic benefit in return for the minimum input of costly resources. To do this we need to choose species that will grow and develop together to form a sustainable plant community. Whether a species will do this depends on a number of its characteristics – its growth requirements, relative competitiveness, means of spread, habit and longevity.

Growth Requirements

Each species used in a planting scheme must be well enough suited to the site conditions for it to grow strongly and remain in good health. In some situations, it will be an advantage if the plant is able to spread, either by setting and disseminating viable seed or, as is more common, by vegetative means of increase. This would be desirable, for example, where an unregulated mixture of naturalizing species is required. In many planting schemes, however, it will be sufficient if the component plants are able to grow strongly and establish quickly in the locations where they are planted. A plant that would struggle to survive because it was planted near the limit of its environmental tolerance would be wasted. It is much better to choose a plant that is well suited to the place. There are numerous references on growth requirements and, unless the designer is familiar with the species, a selection of these should be always consulted. In addition, it is important to supplement and confirm the advice of others with our own observation.

Relative Competitiveness

Vigorous and healthy growth is important for a robust and attractive scheme but the competitiveness of plants grown in close proximity must be carefully matched to avoid the more aggressive species overrunning the others. These trees, shrubs and herbs are capable of very rapid extension of the foliage canopy – they 'forage' for light, searching it out and shading and suppressing their neighbours in the process; so they need to be placed in order to ensure that they do not suppress slower growing neighbours.

Some herbaceous plants show very rapid growth rates over short periods with their canopy extension reaching its peak in late spring. This is possible because they collect large food reserves during the previous growing season that they store in perennating organs over the dormant period in preparation for the next growing season. Nettles (*Urtica* sp.), *Astrantia major, Geranium ibericum* and many grasses are familiar examples of foraging competitors.

Shrubs with particularly rapid canopy extension include poroporo (*Solanum laciniatum*), tutu (*Coriaria arborea*), elder (*Sambucus nigra*), sallows (*Salix caprea* and *S. cinerea*) and vigorous climbing or rambling species such as wisteria, clematis, honeysuckle (*Lonicera* sp.), Russian vine (*Polygonum baldschuanicum*) and many *Rubus*. These very vigorous, shade-casting shrubs must, like the herbaceous competitors, be carefully located or managed. They are best associated with species of similar vigour, or planted where there is enough free space for their canopy to extend without interfering with adjacent species. It is also important to consider whether they might become invasive weeds in the surrounding land if they were to spread from the planting area.

Although shading is the commonest way that dominance is achieved, competition for water and nutrients can also be significant at the establishment stage. Many grasses, for example, develop extensive root systems that are very efficient at extracting soil moisture and significantly reduce the water available to other plants that share the same soil volume. The effect of this can be seen in the poor performance of trees or shrubs planted in a grass sward or lawn. Their establishment and growth is much slower than the same species growing in mulched or bare ground. It is interesting to note that trials have shown mown grass swards to reduce tree growth even more than uncut grass. The common compromise is to keep an area around the base of the tree free of grass and weeds.

The growth check experienced by trees and shrubs growing in grass is reduced once their canopies begin to cast shade and shed leaf litter on the grasses below. At this stage, the trees start to exert their natural dominance. Mature trees and shrubs suppress the growth of plants below them by shading, leaf litter and by competition for soil moisture and nutrients. Only shrubs and herbs adapted to these conditions can thrive in this niche.

Mode of Spread

A plant's success in association with other members of a community will depend not only on the growth rate and ability to exploit soil water and nutrients but also on its mode of spread. Once established, plants that are well suited to the local conditions will begin to propagate themselves either by seed or vegetative means.

Increase by Seed

Both natives and many exotics may propagate themselves by seed from established plantings. Sycamore (*Acer pseudoplatanus*), Norway maple (*Acer platanoides*), *Buddleja davidii* and Spanish broom (*Spartium junceum*), plume albizia (*Albizia lophantha*), Darwin's barberry (*Berberis darwinii*) and *Cotoneaster* species are examples of species that naturalize freely by seed from plantings. This can be either a benefit or problem, depending on the site and the design objectives. Sycamore and plume albizia are often unwelcome colonists due to their prolific spread and tendency to exclude the majority of other species by rapid growth and shading. Self-sown shrubs, such as *Hebe*, *Coprosma*, *Buddleja* and Spanish broom (*Spartium junceum*), can contribute to the same landscapes with their wildlife benefits, attractive flowers and ability to colonize inhospitable places such as demolition sites and neglected land, where plant establishment by conventional means is difficult.

Vegetative Increase

In the majority of exotic plantings it is the different modes and rates of vegetative spread that are most likely to affect the composition of the association. The common methods are by stolons, runners, rhizomes, suckers and rootstocks.

STOLONS Many of the common groundcover plants owe their effectiveness to their ability to spread rapidly and produce a low dense canopy that excludes most weeds. The fastest spreaders include *Rubus tricolor*, *Rubus* × *barkeri*, *Hedera* 'Hibernica', *Cotoneaster dammeri* and *Vinca* species, all of which propagate themselves by sending out vigorous, long shoots that root where they touch the ground. These creeping stems are either true stolons (arching stems that curve down to the ground and root), for example, *Cotoneaster* 'Skogholm' and *Vinca*

major, or trailing stems that root at intervals along their length as in the case of *Hedera*.

In both cases, the plant has the ability to grow rapidly into new areas of ground. New roots and shoots are fed in the early stages by the parent plant and this allows them to establish quickly, even among competing vegetation, so stoloniferous spreaders are well equipped to invade other field layer vegetation by scrambling and 'leapfrogging' over the competition. This is a useful habit if the object is to achieve impenetrable groundcover, or if an intermingling or *mélange* of plants is desired. If, on the other hand, we want to maintain clear and constant boundaries between the territories of different species, such rampant invaders need regular curtailment to keep them within their allotted space.

RUNNERS Species that spread by runners show a similar ability to build up a dense and extensive foliage carpet. Runners are a special form of stolons that consist of an aerial branch or shoot that roots at its end to form a new plant. The main function of a runner is to propagate the plant rather than to make 'feeding' growth. Runners are a feature of herbaceous plants such as the strawberry (*Fragaria vesca*) and foam flower (*Tiarella cordifolia*).

RHIZOMES Rhizomes are underground stems that act as means of both perennation and propagation. They are usually horizontal in their growth and may be short and fleshy food stores, as in the common flag iris (*Iris germanica*) and Solomon's seal (*Polygonatum multiflorum*) that spread gradually outwards to form broad clumps. Some herbaceous plants and shrubs produce vigorous long branching rhizomes that enable them to spread rapidly into adjoining ground. These rhizomes are often mistaken for true roots, but can be distinguished by the presence of nodes and internodes. The rhizomes produce branches at the nodes. These appear above ground as new shoots and they are accompanied by a new root system. Couch grass (*Agropyron repens*) and horsetail (*Equisetum arvense*) are familiar examples and are difficult weeds to eradicate from planting because of the extent of their rhizomes.

Rhizomatous shrubs include rose of Sharon (*Hypericum calycinum*) and some bamboos such as *Arundinaria pygmea* and *A. anceps*. This habit enables them to form a dense mat of groundcover that expands rapidly over new ground and brings similar benefits and problems to those experienced with vigorous stoloniferous species. Rhizomatous plants can be even more difficult to keep in check, because pulling them up usually leaves pieces of the rhizome below the ground that quickly grow into new plants.

SUCKERS An ability to throw up vigorous shoots at some distance from a parent plant is a characteristic of suckering trees and shrubs. Suckers are shoots that arise from adventitious buds on the roots of woody plants. Cherries (*Prunus* species), common lilac (*Syringa vulgaris*), snowberry (*Symphoricarpos albus*), aspen (*Populus tremula*) and stag's horn sumach (*Rhus typhina*) are well known by gardeners for their persistence in producing suckers despite efforts to eradicate them. Indeed, disturbance of the roots while removing suckers stimulates further sucker shoots and so can be counter-productive. When choosing and combining plants it is worthwhile remembering that vigorous suckering shrubs like snowberry are difficult to manage in mixed planting, and that it can be difficult to maintain individual specimens of suckering shrubs like *Rhus* or *Syringa* free from ancillary stems.

ROOTSTOCKS The rootstock habit is common among herbaceous plants. The plant has a short upright underground stem that gives rise to fresh aerial shoots

as it grows. The resulting plant is comparatively slow in its spread and appears as a compact clump. This habit can be seen in the crane's bills (*Geranium* sp.), fringe cup (*Tellima grandiflora*), delphiniums and ice plants (for example *Sedum spectabile*). Groundcover plants with rootstocks need close planting and vigorous foliage to suppress weeds but their compactness and contained spread is an asset in many planting schemes where more rampant groundcover is not necessary.

BULBS AND CORMS Some herbaceous plants store food over their resting period in bulbs (swollen leaf bases) and others in corms (swollen stem base). These species may propagate themselves by producing small offsets (called bulblets and cormlets) from the parent organ. Common examples are the corms of montbretia (*Crocosmia* × *crocosmiiflora*) and crocus, and the bulbs of narcissi and tulips.

Habit

Trees and shrubs exhibit great variety of habit. We have examined this from an aesthetic point of view but a plant's habit also affects its ability to grow in combination with other plants. Canopy habit is the shape in which a plant grows and occupies space. It can be classified first according to life form; that is the tree habit, shrub habit and herbaceous habit. The canopies of these different life forms occupy different levels above the ground surface and this allows them to coexist in the same area by growing above or below each other. In addition, each life form includes plants with quite different size, shape and density. They may have a compact habit with a closely-knit surface or an open habit with widely spaced branches and large gaps between them. Their shape may be narrow and erect, arching, rounded or spreading.

The more open the habit, the more opportunity there is for close association with other species because it casts a lighter shade and because it allows more space within the bulk of its canopy for the branches of other species in the same layer. Trees and shrubs with open habit include birch (*Betula* sp.), ash (*Fraxinus* sp.), firethorn (*Pyracantha rogersiana*) and *Caryopteris* × *clandonensis*.

Compact, dense canopies produced by shrubs like koromiko (*Hebe* sp.), laurustinus (*Viburnum tinus*), *Brachyglottis compacta* and heather (*Calluna vulgaris*) are less able to share the space within their canopy with other plants and allow only very sparse growth below them. For this reason, low and medium height shrubs or herbaceous plants with dense canopies are very effective at forming groundcover of a single species

Longevity and Life Cycles

Different species have different life spans that range from a few months to thousands of years (see discussion in Chapter 2). Even within planted associations, the life spans of different shrub species might vary considerably and this clearly will affect the balance and composition of the planting over a period of years. The gaps left as the shorter lived species like *Parahebe*, *Pimelea* and *Lavandula* die or need to be removed have to be filled either by the spread of adjacent plants or with new planting.

In addition, the vigour, size and form of most plants vary significantly over the different phases of their life cycles. This means that competitiveness, rate of spread and habit will depend on the age of the plant as well as the species and environmental conditions.

Plants normally grow with their maximum vigour during the late establishment and semi-mature phases, but how soon this occurs varies with different species. Many herbaceous plants establish very rapidly, especially short-lived perennials and annuals. An early flush of growth from fast growing species can be of great value in a planting scheme, giving vigour, foliage bulk and the appearance of partial maturity in the early years. Groundcovers such as *Coprosma* x *kirkii*, *Geranium macrorrhizum*, *Symphytum grandiflorum* and *Lamium maculatum* can form a complete carpet within two growing seasons or less, while transplant trees and shrubs may take this length of time simply to establish their root system.

If a field layer that is quick to establish is planted under the canopies of trees and shrubs it will form an effective carpet during the early years. When the roots and crowns of the layers above reach their maximum vigour, they will compete strongly for light and moisture and if the field layer plants are not tolerant of this shade and dryness, they will begin to die back and then need to be replaced by better adapted species.

A similar cycle can be observed in taller shrubs planted among trees. If the shrubs are tolerant of both the open sunny conditions in the early stages, and of shadier, dryer conditions that prevail later, then replacement or regeneration will only be necessary as they become over-mature. This kind of adaptability is shown by many species of *Cotoneaster*, the taller coprosmas, *Pseudopanax* and *Berberis*, for example, and is one of the chief reasons for the popularity of these genera for use in public and commercial landscape.

It is a useful rule of thumb that the shorter the lifespan, the earlier is the stage of maximum vigour. This applies not only when comparing different life forms that have vastly different life expectancies (such as oaks and annuals) but also among trees and shrubs. Trees that exhibit the fastest growth in their early years tend to be relatively short-lived species, for example willows (*Salix* sp.), birches (*Betula* sp.), *Pittosporum* and *Hoheria*. Likewise the fastest growing shrubs are often the most short lived, for example lavender, broom (*Cytisus* sp.) and gorse (*Ulex europaeus*).

Although this is a management issue, it should also be considered at the design stage to make sure that plants will be compatible throughout the lifespan of a scheme. The need to replace or regenerate different parts of the association at different times is best understood and planned in advance. It is in this area, what might be called the developmental dynamics of planting, that the designer needs to have a good understanding of the growth and management of plant associations.

Plant Knowledge

There are enough examples of poor planting design to illustrate the problems that arise from lack of plant knowledge. In many cases plant combinations only approximate to the designer's intentions and only achieve this after laborious attentions by gardeners. Perhaps the commonest problem is that many of the species chosen are incompatible because of their habit or growth rate and requirements. This kind of unbalanced planting can be maintained by thinning, pruning and soil amelioration but will never look good, and will waste resources that could be put to better use. Management should be employed creatively and cost effectively to gain the maximum benefit from all parts of a planting scheme. It is bad design if maintenance time is wasted tending struggling plants or restricting the excessive vigour of those that are too aggressive for their neighbours.

If we fully understand the growth requirements, competitiveness, mode of spread, habit and life cycles of the plants with which we design we can be sure of creating effective, sustainable planting schemes. This is the essence of good horticulture. This degree of knowledge of a wide range of plants requires site study and observation and cannot be obtained from books or databases alone. The designer must work with plants and observe them growing under different conditions and in different associations. It is not possible to be a good planting designer without a sound horticultural understanding.

PART 2

Process

CHAPTER 9

A Method for Planting Design

All designers have a working method of some kind. They may have learned it in training, or it might have evolved over many years of practice. It may be unorthodox, or give unpredictable results; but as long as it helps them to solve design problems and make the most of their imagination, then it is a sound design method. Such a method can be particularly useful when the designer feels (as we all do at some time) blocked, frustrated or overawed by the apparent magnitude of their task.

We will experience many different demands during the process of design; from excitement at a glimpse of the site's potential, through frustration with inevitable difficulties and obstacles, to satisfaction at seeing our vision growing into reality. Throughout, we will be conscious of the need for a professional service to the client, without whom we would not have the opportunity to work on the project. So design in the environment is neither a simple artistic engagement, nor simply a technical task of problem solving. It is a combination of both creativity and technical skill and requires a breadth of knowledge and a depth of imagination if creativity is to flourish.

Design process is an intriguing aspect of theory – the 'how-to' of design. First, it is important to recognize that there are no absolute answers – the right system is the one that works for you. Secondly, good working method is not a straitjacket, imposed on creative thinking. On the contrary, it should help to free the imagination from the constant pressure of minor decisions.

This handbook is intended to help those undertaking planting design in a professional context, and so it will describe a design method based on the professional procedures and formal presentation or submission stages common in reasonably complex projects. We can distinguish between, on the one hand, this project methodology, which comprises the process of consultation and the professional relationship with the client, and the creative process, which is the 'how-to' of design creativity. The first is reasonably objective, the second very personal.

The logic of the method described here comes both from the creative demands of design and the need to respond to the client's requirements, and the same sequence and method can be used whether designing with all the elements of landscape or focusing on planting. The thought processes and the means of communicating ideas are very similar in both cases, but the medium is more restricted for planting design alone. This common process reflects the integrated nature of landscape, and how planting is a fundamental part of its design.

There are a number of distinct stages. In some projects, they need to be followed strictly in sequence and should result in drawings or written reports that are formally submitted to the client, to the planners and to the other professionals involved (such as engineers, landscape scientists, quantity surveyors and architects).

Although the design process is described in linear sequence, as we design we often find ourselves leaping forwards, exploring diversions and returning to earlier stages. So the process can be imagined not as a straight and narrow path but as a guiding orientation. The linear nature of the description here is partly due to the verbal mode of a book. It is interesting to compare the sequential thinking common in verbal argument and expression, with visual thinking and graphic expression, which makes it easier to conceive of numerous elements simultaneously and thus to comprehend the whole before the parts. Different parts of the process benefit from different approaches; for example, the analytical aspects of design need a sequential, convergent approach, using verbal and mathematical logic. The creative, synthesizing process needs a playful, exploratory approach, which is aided by graphic thinking and visual imagination.

An overview of the professional design process reveals four major phases:

1. **inception** – establishing the design brief and working relationships;
2. **understanding** – researching and analysing the cultural and natural aspects of the project;
3. **synthesis** – exploring and proposing creative ideas and solutions;
4. **realization** – refining and implementing the proposals.

Within each phase are a number of stages that are often represented by a drawing or written report, and within each stage it may helpful to identify several steps consisting of distinct procedures. The detail of the design method is likely to be of particular value to students and beginning designers. With practice, we begin to progress more easily through project stages and eventually achieve an almost instinctive grasp of what is needed. It is important to remember that different projects benefit from different design stages, and perhaps only a minority of them would need all those outlined below. When a stage is omitted, it is because we can safely leap from earlier to later points in the process. In making this leap we probably go through the same process, but it happens in our thinking and rough working, rather than being formalized in a separate drawing. Ultimately the process becomes fluid, flexible and adaptable to the needs of each site and client.

Inception

Initial Contact With the Client

Every design project begins with some form of contact between the client and the landscape architect. It will often be the client who initiates this, either with a letter or a phone call to enquire about the services that the designer can offer.

The best way to discuss a prospective commission is face to face, particularly with a new client, so a meeting is often arranged at which the client and designer and, if necessary, other professionals can discuss the scope and objectives of the project. This meeting may be on the site itself, or a separate site visit can be made, at which the designer will form his or her first impressions of the

opportunities and problems presented by the site and perhaps some preliminary ideas for design.

The main objective of the first meeting will be to clarify the nature of the project and to agree a fee scale for the consultancy. The designer's appointment and terms of reference should then be confirmed in writing. The Landscape Institute in Britain, the American Society of Landscape Architects, the New Zealand Institute of Landscape Architects and most professional organizations representing landscape architects in other countries have standard conditions of engagement, which it is normally wise for the designer and client to adopt. These conditions help avoid ambiguity about the responsibilities of the designer and client towards each other and to protect both parties. Once the appointment is agreed, the designer can safely proceed with the initial stages of work.

The client may be an individual if the site is private land such as a residential plot, but in the majority of landscape projects the client will be an organization such as a company, public authority or in some cases a community group. In the latter case the designer will normally report to one key person who will have authority to represent the client organization and make many of the decisions necessary to progress the scheme. For small projects the landscape designer may be the only consultant but for larger projects there is often a design team that includes the client, landscape architect and other consultants such as civil and structural engineers, building architect, quantity surveyor and ecologist. In addition to professional specialists, the local community or other users are likely to be involved in the design process through frequent consultation and attendance at design meetings. A project leader or manager is normally appointed to take responsibility for the organization and coordination of the work of the design team. The project leader may be one of the specialist consultants, often the architect or quantity surveyor, or on larger projects a specialist in project management may be employed.

A successful project needs a good client. Without clear instructions and the timely supply of the necessary information, the designer's job can become difficult and frustrating, but if the client has a strong vision of the quality and character of landscape that they want, this can be a great help, even an inspiration, for the designer.

Brief

The client's brief is a set of objectives and instructions given to the consultant. Its scope and detail can vary from a vague notion of 'landscaping' to a carefully compiled and highly specific set of requirements prepared by a client who has considerable experience of working with landscape architects and a real understanding of the potential of environmental design.

In most cases, there will be gaps in the brief that need to be filled by the designer with the agreement of the client. The completion of the brief can be an important part of the project process and the designer must work closely with the client to achieve a mutual understanding of the full requirements of the project and the potential of the site. To establish fully agreed and clearly stated objectives at this stage will lay solid foundations and help ensure the smooth running of the project.

A brief for planting design might contain requirements such as local identity, habitat conservation, visual improvements, corporate identity, and community involvement. Aims like these are conceptual rather than concrete and specific. They might be accompanied with requirements for facilities such as buildings, access, specific gardens and so on. How to interpret and implement the brief depends first on understanding and analysing the site and its context.

Understanding: Gathering and Organizing Information

Survey

Survey work is a major stage in the design process. It requires a rational, systematic approach, and for this reason it is helpful to divide the many and varied characteristics of the site into broad categories that include related aspects, such as the following:

Physical survey	geology
	topography
	climate
	microclimate
	hydrology and drainage
	existing structures and services
	pollution
Biological survey	soils
	vegetation
	fauna
	existing management of flora and fauna
Human survey	existing uses
	traditional uses
	access and circulation
	public perception of the site
	cultural significance of the site
	historic structures, events and relics
	particular groups and individuals with an interest in the site
Visual survey	views into, out of, and within the site
	landmarks and foci, both within and outside the site
	visual quality and character of the site and surroundings

A comprehensive methodology for landscape survey is beyond the scope of the present book but a thorough treatment can be found in Beer (1990) and Lynch and Hack (1985). We will confine ourselves to how to present survey information, and its role in the planting design process.

It is essential to record and collate survey data in an organized and accessible form, whether it is to be submitted to the client or is only for internal use. Both text and graphics are useful. Plans and diagrams are highly efficient for recording and communicating visual and spatial data such as the observation point and field of a view. To describe locations and visual information in words would be a cumbersome task, whereas sketches, photos and plans make light work of it. Biological and cultural aspects, however, often need extensive written and numerical data that can be brought together in a survey report or notes.

For presentation, survey data could be segregated on the basis of the four categories described above, one plan would include all the physical and climatic details, another would map the biological characteristics, another the social and cultural information, and so on. The survey would then be presented as series of 'layers' of abstracted information, each layer portraying a related aspect of the site. Drawings and diagrams would be supported by text as necessary. The number of layers in such an analysis can be increased and the amount of

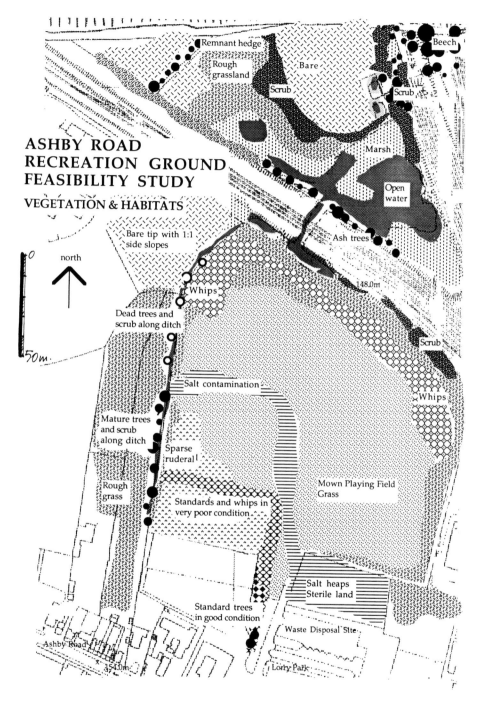

Figure 9.1 A survey plan showing broad categories of existing vegetation and habitats on a site for development as a public park. (Environmental Consultancy, University of Sheffield)

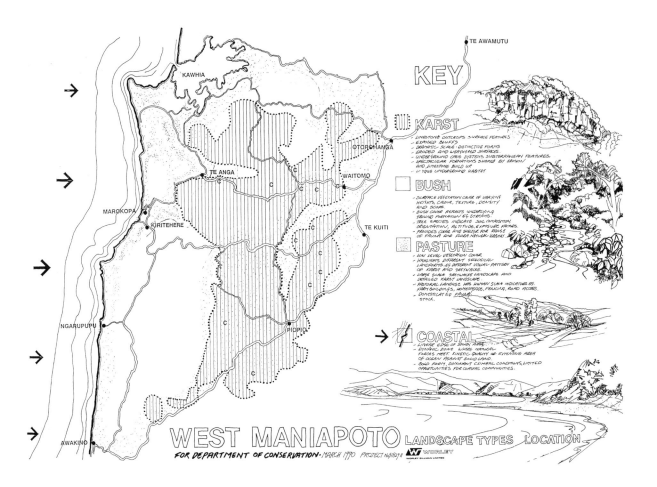

Figure 9.2 A landform-vegetation survey showing landscape character types.

information on each one reduced in order to emphasize quite particular qualities of the site. This is sometimes called layer analysis. There needs to be a balance, however, between how clearly an aspect is depicted and how much its relationship to other aspects is explored. There is a danger in excessive separation of site aspects or systems – that the exercise becomes one of reductive 'anatomical' analysis for its own sake.

If the total amount of data is not too great it could be summarized on a single plan, or on a series of transparent overlays superimposed on the physical survey. This method requires more graphic subtlety and skill, but has the advantage of helping us to see, at a glance, the sum of the environmental and social factors operating in any part of the site. Indeed, it is the interaction of these factors that determines the design choices to follow. The decision whether or not to plant in a particular location would be influenced by factors such as views, site history and existing ground flora – a species-rich grassland community, for example, would not survive under the increasing shade and different management in an establishing plantation.

Throughout the process of gathering and organizing survey information we exercise judgements about what it is essential to record, what can be ignored, how much detail is needed and how reliable it is. In effect, we are judging the likely implications of each site feature and factor for design. This kind of interpretation becomes easier as we gain more experience of design and helps us to avoid collecting too much information. So we need knowledge of what to look for, such as indicators of different ground conditions, or likely sources of pollution. However, much of the survey can be carried out by a less experienced designer with basic guidance.

Although some interpretation takes place during the gathering of data, there is a separate procedure of assessment and evaluation of the data and this forms the next stage in the process.

The Landscape Assessment

EVALUATING INFORMATION The survey data must be analysed and evaluated if we are to make sense of it and to use it in design. The purpose of the landscape assessment is to uncover the full potential of the site and to establish priorities for design. These priorities can become very important if we need to defend our proposals in the face of conflicting interests or budget cuts.

All landscape analysis requires selection. We must narrow down the field of interest so that we can concentrate on the essential problems. It is a reductive process in that we take apart the integrated whole of the site in order to understand it and change it. For example, a visual assessment should identify, mark on a plan and illustrate the key views, landmarks and perhaps zones of distinct visual character. This is essential if we are to argue for the conservation and utilization of the special qualities of the site. But the best analyses are those that manage to assess the value of the different aspects of the site without losing sight of the interrelationships between them. The effect of soil type on plant selection would be modified by local climate; visual quality may be ultimately connected to ecological diversity, and so on.

Some of the conclusions and recommendations that arise from the analysis will be based firmly on scientific evidence and will be difficult to refute. Others will be the result of judgement that is partly subjective. If these judgements are well informed by our knowledge and experience this should help them to carry sufficient weight with our client and colleagues. Many aspects of landscape design are inaccessible to science because they cannot be quantified. In particular, any attempt to evaluate the aesthetic qualities of a site will inevitably include a measure of cultural and personal subjectivity. The response of different people and different cultures to wildness, to enclosure and openness, even to particular plant species, varies. As professional designers we sometimes need to cultivate a degree of detachment in order to make informed judgements and to help us understand the true character and spirit of the place, but we should combine this professional distance with an awareness of our personal feelings about the place. These personal responses give valuable information and often help with design ideas.

OPPORTUNITIES AND PROBLEMS One of the best ways of coordinating the findings of analysis is to summarize the main opportunities and problems presented by the site and the brief. These might cross the boundaries of physical, biological, cultural and visual aspects and so help towards an integrated

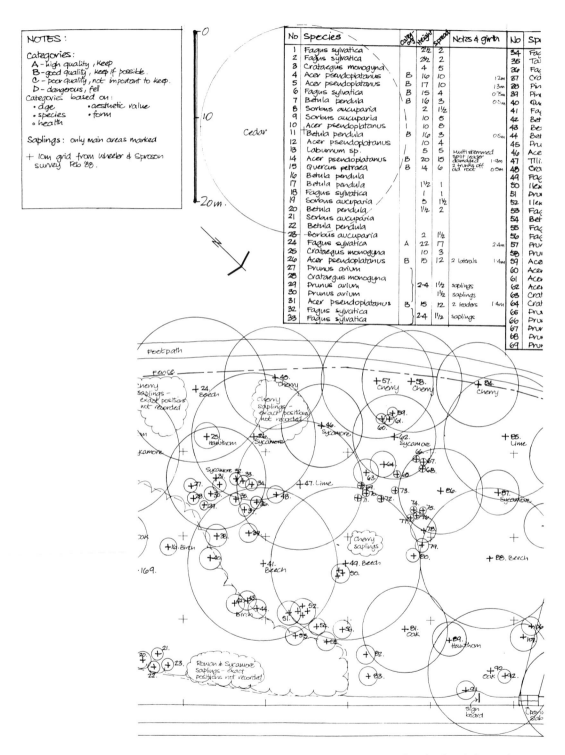

Figure 9.3 Part of a tree survey drawing showing bole position, canopy spread and other information on every individual tree except saplings. Each tree is graded A, B, or C according to its landscape value.

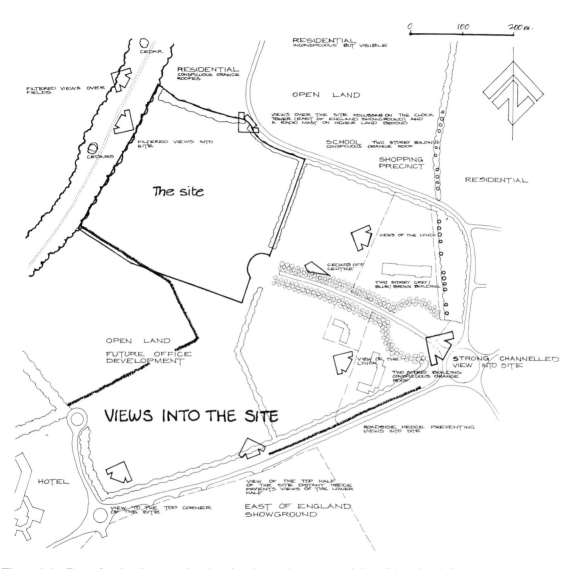

Figure 9.4 Part of a visual survey drawing showing major views and describing visual character.

assessment of the site. Also, a problem can often be redefined as an opportunity if it is perceived in an imaginative way. For instance, a nutrient-poor, dry soil, would be a problem for establishing intensive horticultural planting but is an opportunity to encourage a wide diversity of stress tolerant wild flowers in the absence of competitive coarse weed growth.

Much of the success of planting design depends on the skill with which different functions are integrated. Design that is mediocre is often caused by thinking in a separate way about solving each problem in turn ('separate thinking') rather than taking the chance to achieve different objectives at the same time. A screen of hedging cypress, for example, is a screen and little else, but a screen could also be an attractively diverse band of trees and shrubs that provide an important wildlife habitat and needs only minimal maintenance.

A statement of design objectives and planting functions is valuable information and should be fully utilized to communicate our intentions to the design team and to the users. It is also a checklist to which we can refer and make sure that no needs are overlooked and no opportunities wasted.

Synthesis – Generating and Organizing Ideas

Planting Policies

Whereas objectives are what we aim at, policies are the intended means of implementing those aims. For example, an objective might be the improvement of biodiversity, and in this case policies might include establishing typical indigenous plant communities in a range of different habitats. So with the drawing up of design policies we make our first proposals for the site. Policies are necessarily general in nature, statements of intent that need interpretation to translate them into actual design details. Policies should address the opportunities and problems of the site.

How exactly do we arrive at design policies? In some cases it is an obvious step from design functions. For example, if the site includes steep slopes that tend to erode and if hard engineering solutions would be too costly or out of keeping with the site character, a policy of bioengineering solutions to erosion problems would be appropriate. Other policy decisions might require more imaginative insights drawing on experience of a wide range of design solutions. Design policies are often accompanied by preliminary design ideas – what might be called an embryonic design concept.

The presentation of planting policies and initial design ideas can be an important stage of consultation in larger projects. It is the first opportunity that the client will have to consider the scope and nature, if not the details, of the design proposals and we can gauge their response before we commit ourselves to the development of those policies and ideas. Once policies are agreed with the client we have a sound foundation for the design development stages that follow.

Design Concept

A design concept can be many things to many people. It can be a central, generating idea that initiates the development of the design or the term can be used to describe an abstract level of proposals in the decision-making process. At root, a concept is an idea or group of ideas, which is understood as an integrated intellectual whole, rather than merely an aggregation of facts.

Whatever its origins, the design concept should develop the policies and should explore the spatial relationships between the various site uses and design functions. The spatial organization of the concept can be expressed as a 'bubble diagram' that shows the sequence, connections and hierarchy of spaces but not necessarily precise location or scale. It is, in effect, a topological map of functions for the site and a spatial interpretation of the brief. There may be many different solutions and bubble diagrams are a useful tool for investigating alternative spatial relationships, and for explaining these quickly and concisely to others.

A design concept provides an overview. It is a conceptual whole, connected by ideas and still abstract in nature. The abstraction is valuable at this stage because it allows us to handle large amounts of information and complex ideas simultaneously, and facilitates rapid consideration of different solutions, without the need to work laboriously through the details of layout and materials.

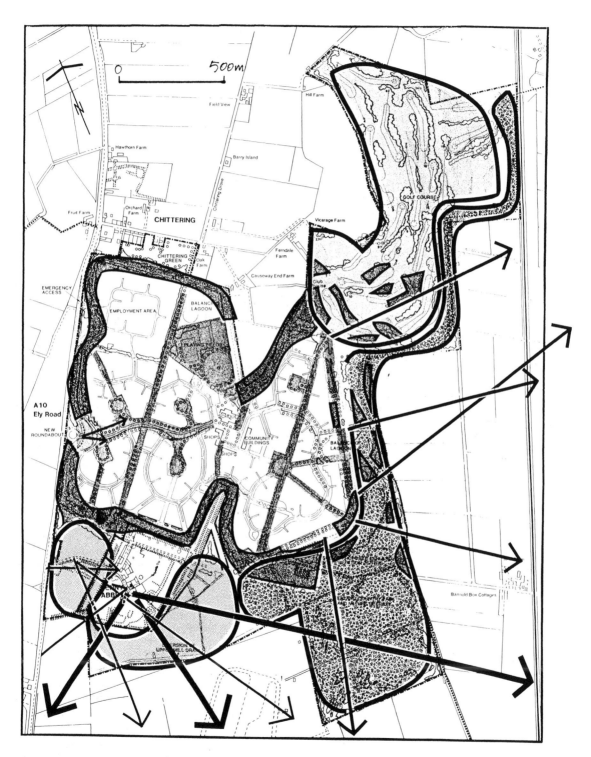

Figure 9.5 Key elements of the landscape design concept for a new settlement, drawn up for presentation. The drawing shows woodland structure, fenland country park and nature reserve, main open space structure, fields managed in accordance with English Heritage requirements, golf course and key views.

Schematic Planting Design

Once a concept has been explored, and we have found a good fit for the various functions, we can develop it to the next level, which is more precise about design elements, geometry of spaces, and zones of planting character on the site. To do this, we maintain the spatial organization while responding to the physical detail of the site. In practice, developing the spatial organization and the schematic layout often go hand in hand, because various abstract spatial relationships can be tested out in a schematic way on a base plan of the site area. The proposed design is then based on the fit of functions to site as well as function to function.

To produce a schematic planting layout we locate the different planting types (such as ornamental, naturalistic, habitat, shelter, screen and so on) and determine the positions of the major elements of planting structure (such as reforestation, hedges, copses and avenues). A realistic picture of the site is now beginning to emerge that will explain the distribution of planting character and define the location and size of the main spaces to be created. It is drawn to a scale convenient for the size of the site. For a large site, this might be a scale of 1:1000 or 1:500, for a smaller one, 1:500 or 1:200 scale. In order to avoid showing too much detail, it can be helpful to show schematic proposals at a smaller scale than the masterplan or sketch design to follow.

Masterplan

If the site is large (say greater than 1 hectare) and particularly if it includes a variety of land uses, buildings or distinct vegetation types, it will normally require a landscape masterplan. A masterplan represents an advance from schematic proposals but is still a strategic (rather than detailed) level of design. Scale depends on the size and complexity of the site but 1:500 or 1:1000 is common.

The main difference between schematic design and masterplan is that the latter commits us with more precision to an actual planting layout. The amount of detail and the refinement that we can show is limited by the scale of the drawing, but it is wise to avoid showing too much at this still early stage. Structure planting, avenues and specimen trees can be positioned but the layout of ornamental planting should only be shown in a notional way, even at 1:500 scale. These limitations are in fact a very useful restraint, encouraging us to work out the spatial structure of the landscape before elaborating the character and content of those spaces. It is common for samples of more detailed areas to be illustrated on the masterplan at a larger scale (say 1:100 or 1:50) in order to indicate the proposed character.

The masterplan is, as its name implies, an authoritative design document. It should always be discussed and agreed with the client and design team, and is often a key drawing submitted to the local planners for their approval. This formal procedure can be a useful discipline in the design process. It allows us to establish definitive patterns of use and planting at a comparatively early stage of design, and by doing this we gain agreement for the extent and location of at least the major planting areas.

Sketch Planting Proposals

Sketch proposals are drawn at a larger scale (often 1:500 for structure planting, 1:200 for general amenity planting and 1:100 or 1:50 for detailed ornamental planting) and they allow us to focus on the detailed composition and character of the spaces that were outlined at the previous stage. To work at this larger scale we may need to consider one part of the site at a time. If so, it is a good idea to choose self-contained sections of the site.

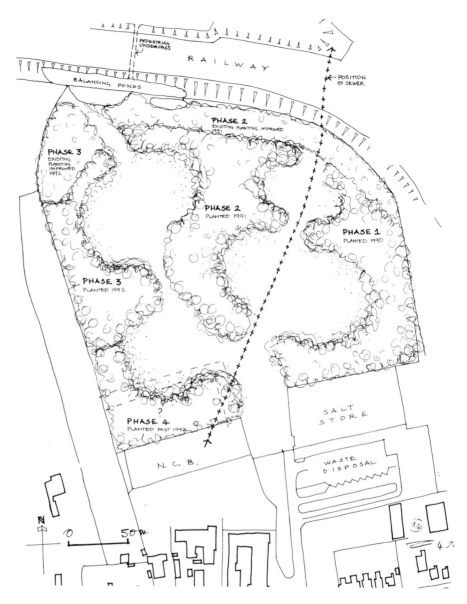

Figure 9.6 Schematic planting structure for a new woodland park on a landfill site. Likely phasing of planting areas is shown. The survey of this site is shown in Figure 9.1.

In sketch proposals we can be precise about the degree of enclosure, shape and proportion of spaces, the geometry and patterns within them and the location of focal elements. It is also a stage when we can start to envisage the aesthetic character and patterns of the planting. For example, an enclosure of given proportions could be laid out with rectilinear or curvilinear patterns of hard and soft surfaces; the planting within it could be minimal and modernist, dense and 'sub-tropical', loose and 'cottagey' or simple and formal.

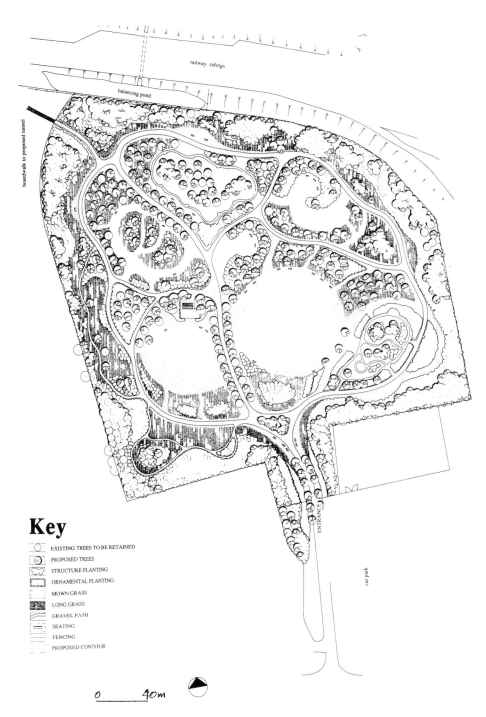

railway sidings

balancing pond

boardwalk to proposed tunnel

ENTRANCE

car park

Key

EXISTING TREES TO BE RETAINED
PROPOSED TREES
STRUCTURE PLANTING
ORNAMENTAL PLANTING
MOWN GRASS
LONG GRASS
GRAVEL PATH
SEATING
FENCING
PROPOSED CONTOUR

0 40m

Figure 9.7 Masterplan for a new woodland park on the landfill site. Note the
development from the schematic structure shown in Figure 9.6.

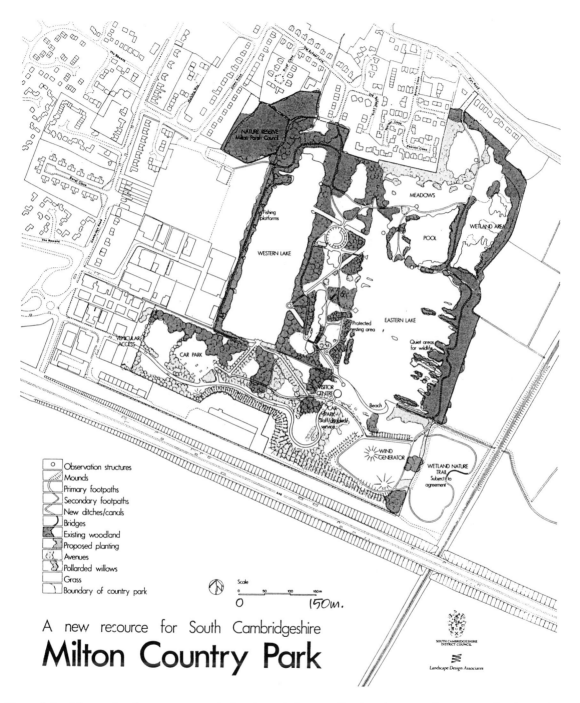

Figure 9.8 Masterplan for a country park showing existing woodland and proposed structure planting which will form a strong nature-like structure for recreation and conservation.

Figure 9.9 Masterplan for a regional park. This shows how different planting functions and types are fundamental to the landscape structure of the site (see colour section).

In order to define the three-dimensional structure of the space we decide on the height and habit of planting. Shrub planting should be defined as:

- 'tall shrubs', that is, those that will grow above eye level (over about 2 metres to give physical and visual enclosure); or
- 'medium shrubs' that will grow above about knee level (about 0.5 to 2 metres); or
- 'low planting', mostly below knee level (up to about 0.5 metres).

This distinction is useful because medium-shrub planting controls movement and separates areas more firmly than low planting, which merely carpets or edges the floor of a space. It can also be helpful to distinguish

- shrub thickets (providing dense solid enclosure) from
- open shrub planting (that allows some visual penetration); and
- herbaceous plants where these form a large proportion of the planting (this will affect the seasonal character of the vegetation and management required).

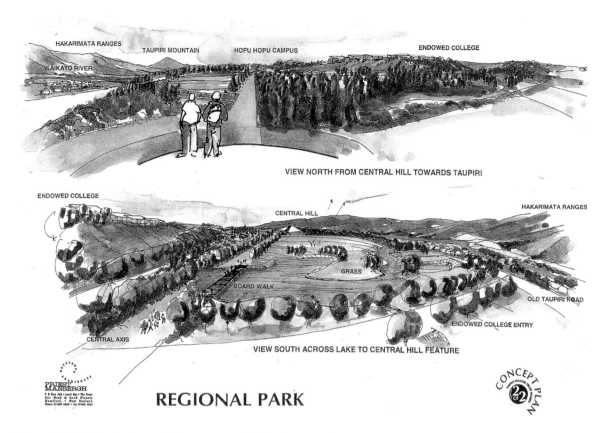

HAKARIMATA RANGES

TAUPIRI MOUNTAIN HOPU HOPU CAMPUS

ENDOWED COLLEGE

WAIKATO RIVER

VIEW NORTH FROM CENTRAL HILL TOWARDS TAUPIRI

ENDOWED COLLEGE

CENTRAL HILL

HAKARIMATA RANGES

GRASS

BOARD WALK

OLD TAUPIRI ROAD

ENDOWED COLLEGE ENTRY

CENTRAL AXIS

VIEW SOUTH ACROSS LAKE TO CENTRAL HILL FEATURE

PRIEST MANSERGH

REGIONAL PARK

CONCEPT PLAN

Figure 9.10 Sketch views of the structure planting in part of the regional park shown in the previous figure (see colour section).

Tree heights and forms should be shown. Useful categories are

- 'tall trees' (approximately 20 metres or more when mature) that require plenty of room if they are to develop naturally and will become major structural elements in any landscape;
- 'medium trees' (approximately 10–20 metres mature height) that are more easily accommodated in the urban landscape but are nonetheless of comparable scale to many buildings and other structures; and
- 'small trees' (approximately 5–10 metres) that can play an important decorative and structural role within smaller spaces such as gardens and courtyards but are generally subordinate to the built structures of the urban environment.

It is interesting to compare those heights, which are selected by reference to the human and urban environment, with the ranges common in natural plant communities. 'Tall trees' corresponds roughly to canopy and emergent forest trees, 'medium trees' to sub-canopy forest trees and 'small trees' to the shrub/small tree layer. 'Tall shrubs' also corresponds to the forest shrub layer, or to some secondary shrubland such as *maquis* in Mediterranean Europe, or fully developed tall sub-alpine scrub; 'medium shrubs' are commonest in the upper reaches of the sub-alpine zone, 'sage brush' or heath; 'small shrubs' and 'dwarf

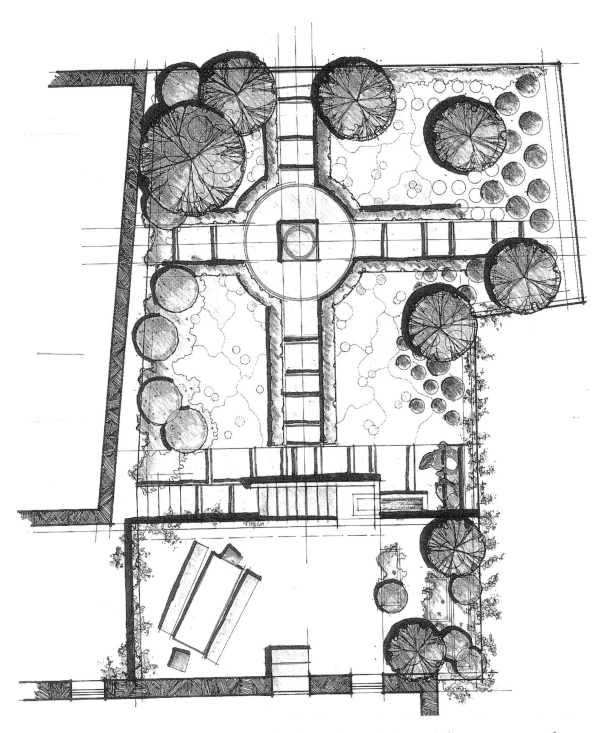

Figure 9.11 Sketch design for a residential courtyard. Note the use of colour to indicate arrangement of groundcover species (see colour section).

ornamental hedging　　functions frontage　　Woodland stand　　car parking bay division　　paths away from parking

Figure 9.12　Sketch illustrations of planting proposals for an hotel development showing the structural role of planting.

shrubs' in alpine, exposed heaths, moors and coastal vegetation. So when we are searching for, say, a small shrub for a planting scheme it is likely to come from, for instance, sub-alpine or dry-land scrub.

A summary of the main height categories is shown below. In most projects we will use just some of these categories as appropriate to the project and the scale we are working at, or we might refine some categories further if they are a particular focus of the design.

- tall trees (above 20 metres);
- medium trees (10–20 metres);
- small trees (5–10 metres);
- tall shrubs (2–5 metres);
- medium shrubs and the taller herbaceous plants (0.5–2.0 metres);
- low shrubs and herbaceous plants, including groundcover (up to 0.5 metres);
- mown grasses and other turf plants.

It is usually best not to define the precise heights of proposed trees in metres on a drawing because it is hard to predict this with much accuracy and because different plants in the scheme will reach maturity at different times. It is helpful, though, to draw the sketch plan and other illustrations in which the planting appears as it would look about ten years after going in the ground. This is a realistic timespan, because it is often within the client's planning period.

Massed plantations are distinguished from individual or grouped specimens and avenues. This is important for a number of reasons. First, the mode of planting is related to function, for example, mass planting will be most effective where screen and shelter are needed, small groups or individual specimens where the visual function is more important. Second, it affects the growth habit and appearance of the individual trees and of the whole plant association. Mass shrub thicket, for example, produces rapid growth but results in drawn plants with less foliage at lower levels of their canopy and in the interior of the association. Lastly, the cost of establishing a tree or shrub will be much greater if it is planted as a specimen rather than as part of a plantation, because of the cost of the nursery stock and the amount of aftercare needed.

The management of trees will also affect their role in spatial composition and so it should be clear whether they are to be pruned to produce a clean bole with raised crown, or if they are to be pleached or trained, pollarded or coppiced, or allowed to spread naturally.

It also helps to articulate the design if accent plantings or focal groups of trees, shrubs or herbaceous plants and areas of bulbs are located and larger areas of the

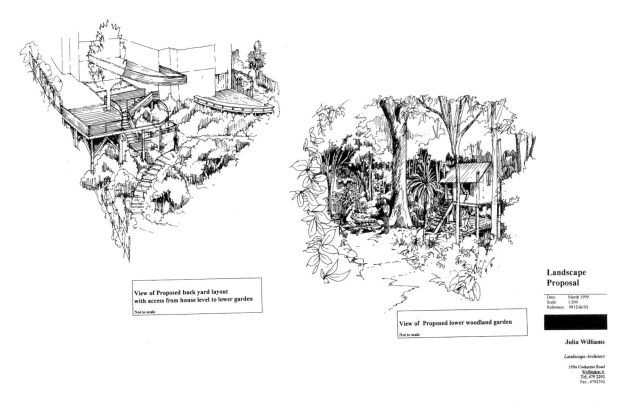

**Landscape
Proposal**

Date: March 1999
Scale: 1:200
Reference: 9812/sk/02

Julia Williams

Landscape Architect

199a Cockayne Road
Wellington 4,
Tel; 479 2292
Fax ; 4792592

View of Proposed back yard layout
with access from house level to lower garden

Not to scale

View of Proposed lower woodland garden

Not to scale

Figure 9.13 Sketch illustrations for a private garden on a steep slope. These views give an effective impression of the character and scale of the planting.

most ornamental planting are distinguished from others of similar height range. Labelling might include:

- specimen tree;
- pleached avenue;
- coppiced tree and shrubs;
- specimen shrub;
- focal plant group;
- ornamental shrub and herbaceous planting;
- spring bulb drifts.

Much of this information can be communicated graphically on plan and elevations, but notes will always be helpful. We use rapid freehand graphics in pencil or sketching pen and try as many alternatives as possible. Three-dimensional sketches, elevations, sections and plans will all help us to visualize different kinds of enclosure planting, different layout patterns, and different planting styles.

Note that the essential qualities of planting structure and character can be decided without choosing particular species and that sketch planting drawings are often presented without naming any species, but plans can be generously illustrated with vivid sketches of important views and typical character.

Although not essential, we might have some of the key plants and associations in mind from an early stage. At the sketch design stage it can be helpful to name

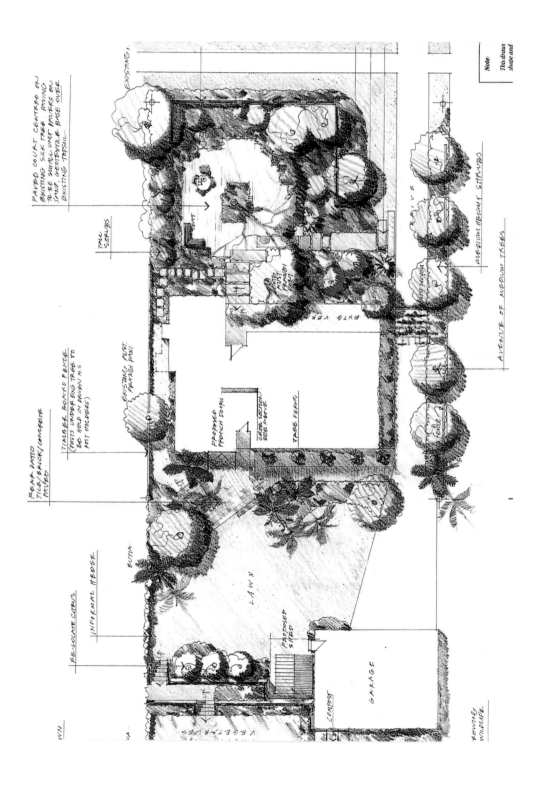

Figure 9.14 Sketch proposals for a private garden. Shadows are used to help explain the heights of planting and spatial form. The canopy of the large tree is drawn transparent to show the courtyard below (see colour section).

some of these, particularly those that are to have a major structural role, such as avenue trees, focal specimens or the dominant trees of a forest or woodland. This will give a more detailed impression of the proposals and help inform the client about the kind of plants suited to the site. It is best to limit the number of species defined at this stage, however, to retain flexibility, and to avoid getting bogged down in too much detail and 'not seeing the wood for the trees'. Furthermore, choosing the right species is time-consuming and most of it is best left until the layout, structure and general character of the planting has been agreed.

Detailed Planting Design

We can now give full consideration to the choice and layout of species and cultivars, and put together the details of plant communities and of characteristics like colour, texture, form, and fragrance. To do this imaginatively and thoroughly is an intensive task and it helps to deal with it in a number of steps.

CHOICE OF SCALE Detailed planting design needs to be done at a scale which is large enough to plan detailed composition with ease. For framework, woodland and out-field planting this is normally 1:500 or 1:250, for general amenity planting 1:250 or 1:200, and for detailed ornamental planting, 1:100 or 1:50. This may be the same scale as the sketch proposals and it is easiest if it is the same scale as final working drawings will be. The right choice of scale will allow us to plan the positioning of plants at a level of detail appropriate to the type of planting.

SPATIAL/HEIGHT STRUCTURE If the spatial composition of the planting is the primary focus of the design, the next step is to develop more detail of spatial form and enclosure over and above what was in the sketch design. We can work out the geometry, proportions and shapes of grass and paved areas and of planting and, within these, the make-up of planting and other structural elements. It is helpful to do this both on plan and in elevation and section. Axonometrics and other three-dimensional projections can be useful to give a good sense of the scale and proportions of the proposals.

PLANTING CHARACTER AND THEMES We can now develop our ideas about the character and themes of the planting in various parts of the site. This will be closely linked to the planting concept and earlier design ideas can now be explored in more detail. If, for example, the planting concept is historical, now would be the appropriate time to carry out detailed research on the species and varieties that were planted at a particular period, and to investigate present-day sources of supply. We can also develop the mood of the planting: colourful and dramatic, subdued and restful, or mysterious and exotic, and so on, and clarify whether the plants need to be robust and resilient or could be more delicate and horticulturally demanding. Specific planting themes might be developed based on aesthetic characteristics like colour or scent, or on seasonal features, such as autumn foliage or winter colour, or to fulfil a function like shade or habitat creation.

PLANT PALETTE With knowledge of the growing conditions and with a planting character or theme, we have narrowed down the field of possible plant material to manageable proportions. This is a good stage to scan nursery catalogues, reference books and databases and draw up a list or palette of plants for use in detailed design. The essential criteria for choosing species can be summarized as follows:

Habit and life-form
- annual/perennial
- woody/herbaceous
- deciduous/evergreen

Growing conditions
- likely temperatures
- rainfall, ground water and irrigation
- slope and aspect
- wind exposure
- shelter (provided, for example, by structures, land form and other plants)
- light and shade (also provided e.g. by structures, land form and other plants)
- soil type (e.g. loam, clay, sand, chalk, limestone, peat)
- soil nutrient level, drainage and depth
- soil reaction (acidity or alkalinity)

Planting functions
- shelter
- screening
- bioengineering
- revegetation
- wildlife habitat
- ornament

Character
- indigenous
- naturalistic
- artificial
- formal
- informal
- colours of flowers, foliage and fruits
- aromatic foliage and scent
- ornamental bark
- seasonal display

Examples of plants for different conditions, functions and aesthetic qualities can be found in many plant databases, such as *Helios* (2002) and *Trees and Shrubs* (2001), and reference books, including Palmer's *Manual of Trees, Shrubs and Climbers* (1994) for warm temperate climates, *The Hillier Manual of Trees and Shrubs* (1991) for cool temperate areas, and Laurie Metcalf's *The Cultivation of New Zealand Trees and Shrubs* (1991).

A list of species and cultivars, drawn up before detailing the planting, speeds up the design process by avoiding the need for detailed reference each time a new plant is selected. It also helps to build a picture of the character and design possibilities of the materials before starting to assemble them. A convenient way of laying out a plant palette is by height, site zone and planting function. We can then refer to the appropriate list when looking for, say, a small tree or a groundcover plant for particular conditions and purpose.

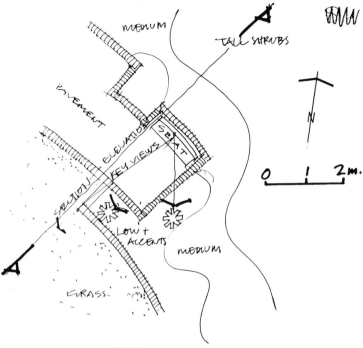

1. Height categories and locations of
 key accents in plan.

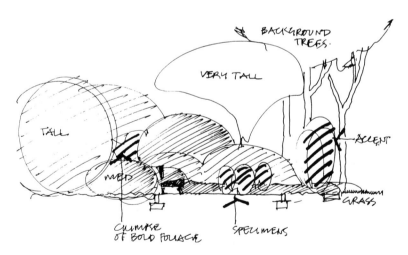

2. Abstract height, form and texture
 study in elevation.

Figure 9.15 An example of planting composition studies.

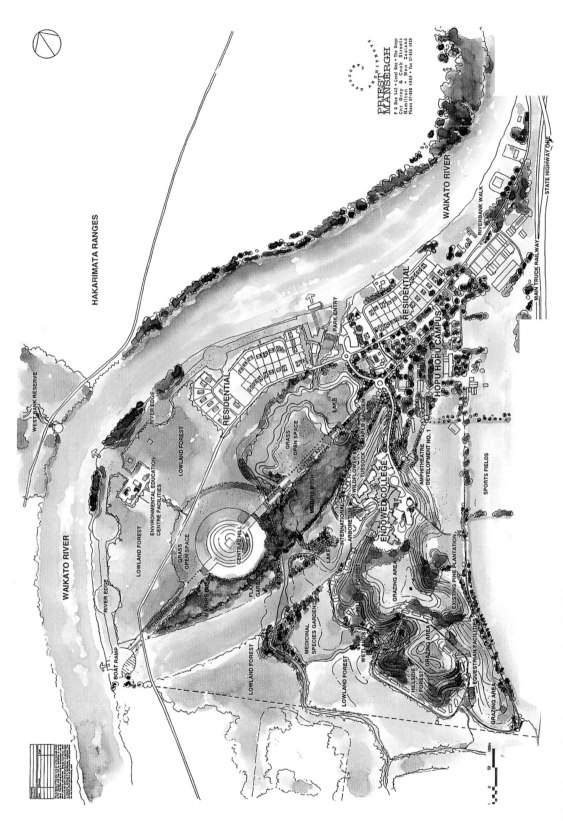

9.9 Masterplan for a regional park. This shows how different planting functions and types are fundamental to the landscape structure of the site.

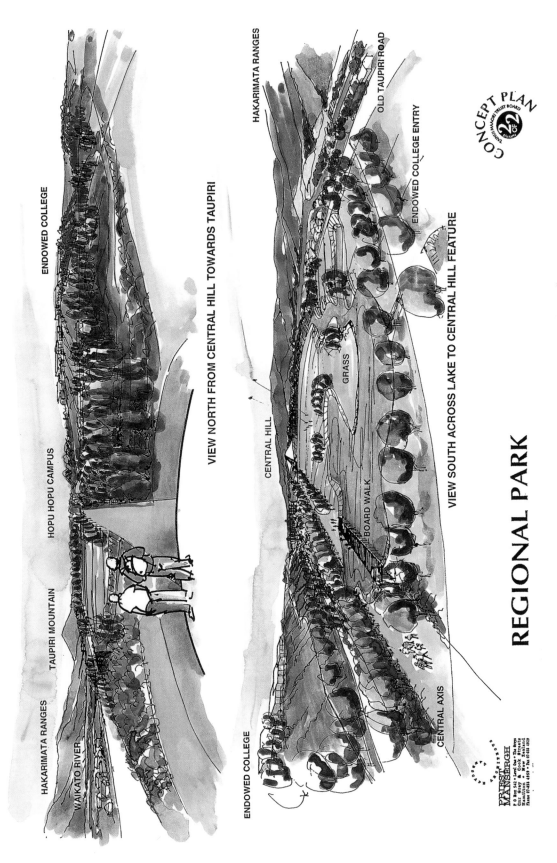

ENDOWED COLLEGE

HOPU HOPU CAMPUS

TAUPIRI MOUNTAIN

HAKARIMATA RANGES

WAIKATO RIVER

VIEW NORTH FROM CENTRAL HILL TOWARDS TAUPIRI

HAKARIMATA RANGES

OLD TAUPIRI ROAD

ENDOWED COLLEGE ENTRY

CENTRAL HILL

GRASS

BOARD WALK

ENDOWED COLLEGE

CENTRAL AXIS

VIEW SOUTH ACROSS LAKE TO CENTRAL HILL FEATURE

REGIONAL PARK

9.10 Sketch views of the structure planting in part of the regional park shown in the previous figure.

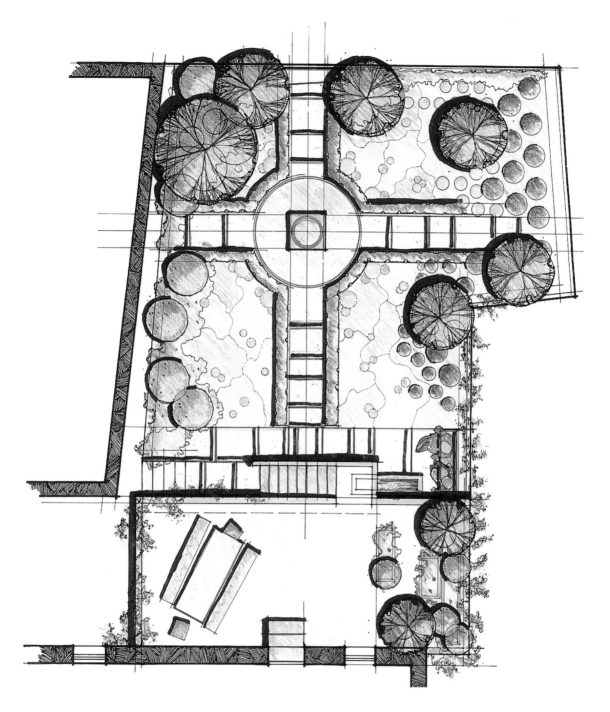

9.11 Sketch design for a residential courtyard. Note the use of colour to indicate the arrangement of groundcover species.

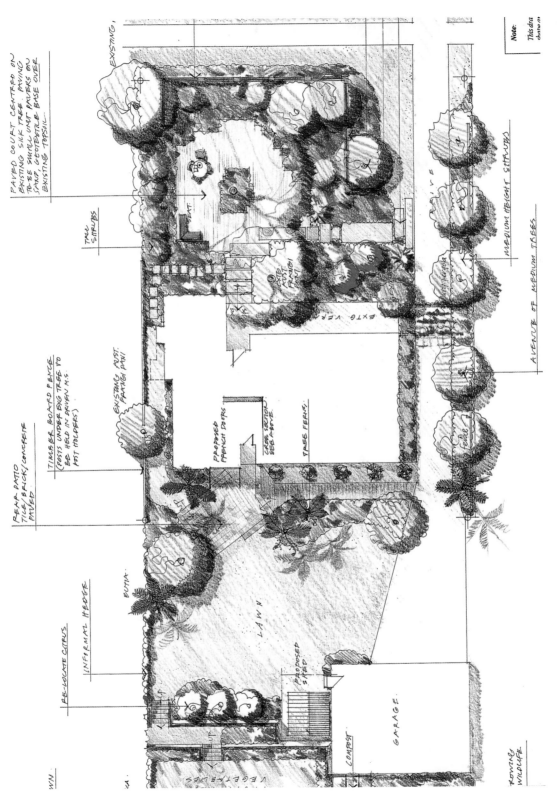

9.14 Sketch proposals for a private garden. Shadows are used to help explain the heights of planting and spatial form. The canopy of the large tree is drawn transparent to show the courtyard below.

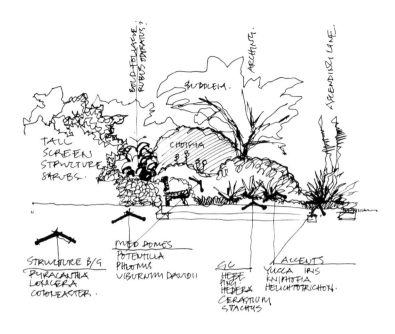

3. Representative composition study
 in elevation with possible species
 annotated.

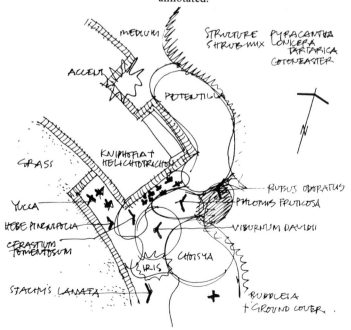

4. Species areas shown on plan.

COMBINING PLANTS The design of successful planting requires an intimate knowledge of the form and growth habit of the species and, if the ornamental function of the planting is a high priority, we must also be familiar with their aesthetic characteristics. It is not easy to imagine the possible combinations and permutations of all these. A way to develop the visual and spatial aspects of plant associations is with composition studies.

COMPOSITION STUDIES These are rapid freehand line drawings, elevations, sections or eye-level perspectives, and drawn roughly to scale. They help us to visualize the intended composition from the common and important viewpoints. They also help us to imagine alternative plant arrangements and avoid mistakes in scale, edge treatments and the positioning of plants in relation to building façades. They enable us to design as we draw and they can later be refined to provide presentation visuals that accompany the plan.

Composition studies are developed in stages. First we select an integral portion of the planting from a rough layout of height structure and transpose the plant height categories into elevation at an approximate scale of 1:100 or 1:50 or, for very detailed groupings, 1:20. The heights can be drawn diagrammatically to begin with and then refined and developed to show the outlines of plant forms and masses.

For ornamental planting the next step is to consider texture and colour. This is often done in that order, but if colour is the dominant element in the composition, it can be studied before texture. Texture can be drawn diagrammatically using hatching of varying density and tone; or a more realistic rendering of foliage and leaf qualities may be used to give an impression of the qualities of line and leaf and stem detail. In either case, texture rendering can be overlaid on the outlines of form.

Colour can be worked on a separate sketch or added to the form and texture study. It can be drawn in media such as coloured pencil or pastels, or annotated on the drawing. For many people colour is the most difficult aesthetic characteristic to plan in advance. The natural colours of flowers, fruits and foliage are so subtle and varied, and the visual effects of their juxtaposition can be so surprising, that the only sure way to use plant colours is from experience or directly on to the landscape itself. Arranging pot-grown specimens on site while they are in flower is the surest way. We cannot always do this, but we can keep a look-out for colour associations that work well and repeat or rearrange these in our own designs.

Elevations and perspective sketches inevitably hide some of the planting. If the planting area is broad or its internal composition is particularly important, we should sketch cross sectional elevations through it at critical points. These will show layers and groups of planting that could not be appreciated in front elevation and is important for understanding the opportunities for different canopy layers in woodland and larger scale structure planting. Composition studies need not be drawn for every planting area, but they provide a valuable design tool for dealing with the most important and visible plant groupings.

CHOOSING SPECIES While sketching, suitable species from the select lists might come to mind and can be labelled on the drawing. However, for a designer without extensive plant knowledge it is better not to identify all species at the time of drawing. It is usually easier to choose plants from our palette once we are happy with the arrangement we have sketched. This sequence also allows us to refine the composition by thinking through the effects of alternative plants, and

we can go back and redraw sketches with different plants before finally choosing a particular species. It is a process of trying out until we find a good solution.

Not all plants can be identified and located on an elevation or section; plant selection can only be completed on a plan, and a scale plan is essential to communicate the detailed planting design to the landscaper who will implement it. Only in plan can the whole site be seen at once, so composition studies need to be transposed back into plan to form their part of the whole scheme.

Some designers like to work in plan from the beginning of detailed design, perhaps because it saves time. To achieve good results in this way requires good plant knowledge and an ability to visualize in three dimensions, so the use of elevations or perspectives is generally recommended.

SEASONAL TABLES Composition studies help us to design with form and space in three dimensions. We also need to design in the time dimension. The appearance of plants changes through the seasons and some species only look their best for short periods. For example, the leaves of some coloured foliage plants, such as golden sycamore (*Acer pseudoplatanus* 'Worleei') and golden honey locust (*Robinia pseudoacacia* 'Frisia') look spectacular as they emerge in spring but have faded to undistinguished green by midsummer. We can plan planting to achieve attractive, simultaneous features as well as a succession of interest. A way of doing this is with a seasonal table like the one below, showing periods of flower, fruit, leaf colour, spring foliage colour or winter stem colour:

Table 9.1 Period of interest (northern hemisphere)

```
Species                 Jan Feb Mar Apr May Jun Jul Aug Sep Oct Nov Dec

Cornus 'Elegantissima'  - -stems- - - - - -x- - - - - - foliage- - - - - - - -x-autumn colour-
Pyracantha 'Mojave'     - -berries-              -flower-      - - - - - - - -berries- - - -
Betula pendula          - - - -bark- - - - - - - - - - - - - - - - - -autumn colour -
Vinca minor                       - - -flower- - - - - - - - - - flower- - - -
Buddleja davidii                                     - - -flower- - - -
```

By looking down the columns of such a table we can see what is happening in any month of the year and check that there are no long periods with no interest.

A similar table could be drawn up to show only flower, if this is a key element of the composition and requires detailed planning:

Table 9.2　Period of flower (northern hemisphere)

Species	Jan	Feb	Mar	Apr	May	Jun	Jul	Aug	Sep	Oct	Nov	Dec
Mahonia × '*Charity*'	------	------									----	----
Crocus tomasinianus		---										
Scilla sibirica			---									
Muscari armeniacum			----									
Viburnum × *burkwoodi*				------								
Ajuga reptans				----								
Abutilon × *suntense*				------								
Clematis montana rubens				-----								
Syringa velutina				----								
Cistus 'Sunset'					------							
Thymus drucei					------							
Dianthus deltoides					-----							
Lavatera 'Barnsley'						---------						
Rosa 'Iceberg'						---------------						
Caryopteris × *clandonensis*								-----				
Nerine bowdenii									----			

The flower colour of each species could be noted on the line or shown with coloured pencil or pastel.

PRESENTATION OF DETAILED PLANTING PROPOSALS A detailed planting design proposal, including plan and sketch illustrations, can be presented to the client, user groups and, if necessary, the planners. This will explain the finer points of the design and it can be an important consultation stage if the client or the users are interested in the horticultural detail. It can be drawn in a semi-realistic style to give a vivid impression of the appearance of the planting. The more distinctive plant species such as cabbage trees, palms, tree ferns, hostas and such like should be recognizable in illustrations. Detailed planting proposals can include the names of some species although the client and users will often not have sufficient plant knowledge to recognize many of them and so must trust the designer's judgement. The local authority planners responsible for the project, however, may require detail of species, stock sizes and spacing so that they can approve the proposals.

If the client and users are less interested in the horticultural detail, which is often the case with industry and other business organizations, the designer can go straight from sketch design to the working drawings. The client will rely on the designer to make sure that the agreed objectives and design idiom are realized and will leave the detail of plant association to the designer.

Draft working drawings of selected parts of the site can, however, be included with the sketch design proposals if required by the planners or client. These would illustrate the range of species, density of planting and style of design, but it should be made clear that they are illustrative samples and can be modified before the final planting plans.

Working Drawings

To implement the planting design we need working drawings (often called planting plans) that include all essential information for the physical setting out and the planting on site. A planting plan therefore needs to show:

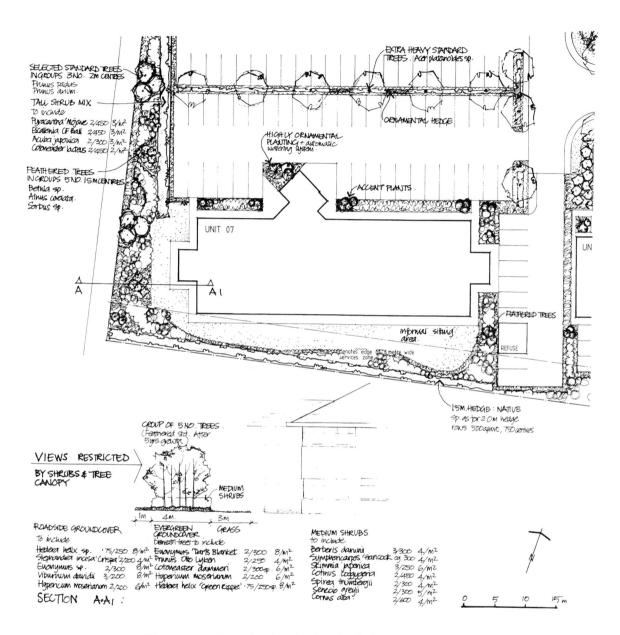

Figure 9.16 Part of a plan showing detailed planting proposals for a business park. Species, stock sizes and planting densities are given but not numbers and locations.

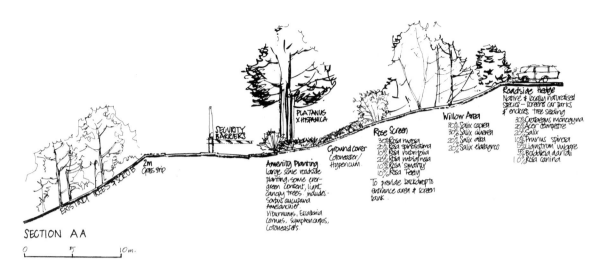

Figure 9.17 Part of detailed planting proposals for an industrial site illustrated in cross section.

1. outline layout of buildings and hard and soft landscape, sufficient to locate planting areas;
2. critical dimensions for the setting out of planting beds themselves;
3. dimensions for locating trees where they are close to buildings or services;
4. full scientific names of all plants and their locations;
5. density or spacing, and quantities of each species;
6. size or age of nursery stock, if this varies for any single species, otherwise it can be confined to the plant schedule.

Additional information is usually presented as a written specification and plant schedule, which may be included on the drawing, if it is brief. However, it is often best to keep the information on a planting plan to graphic essentials, because of space and so that planting plans are easy to read, both in the studio and on site. A specification and schedule on the drawing is only really suitable for small and simple planting projects.

The function of a working drawing/planting plan is, at least in commercial and public projects, to instruct the landscaper, rather than give a visual impression of the established design. Being, in effect, a set of technical instructions, a planting plan should be clear and precise without superfluous information or flourishes (these should be reserved for the design presentation drawings). The best working drawings are often those on which the information is pared down to the bare minimum – sometimes called a 'naked drawing'. An alternative view is that planting plans can serve more than just the working drawing function and that their style can be modified accordingly. For example, on private residential projects there is often a need to combine the implementation drawing with an explanation of planting details to the client. In this case, it makes sense to use graphic technique that illustrates the size and character of the plants as well as their positions. This sort of pictorial planting plan needs to be at a large scale to be effective. A disadvantage is that it cannot show overlapping strata of vegetation because the spread of a plant is drawn. It is hard to show on plan, for example, a layer of groundcover below a drift of bulbs both of which are spreading under the canopy of a tall shrub and trees above, at the same time as specifying the positioning of all these kinds of plants. This leads to the tendency to design in one layer only.

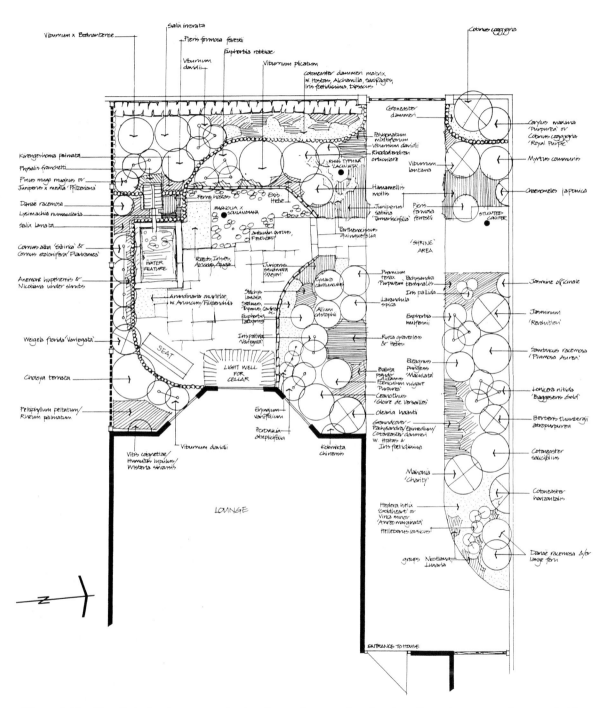

Figure 9.18 Detailed planting proposals plan for a private garden showing all species, areas to be occupied by low groundcover and approximate spread of medium and tall shrubs.

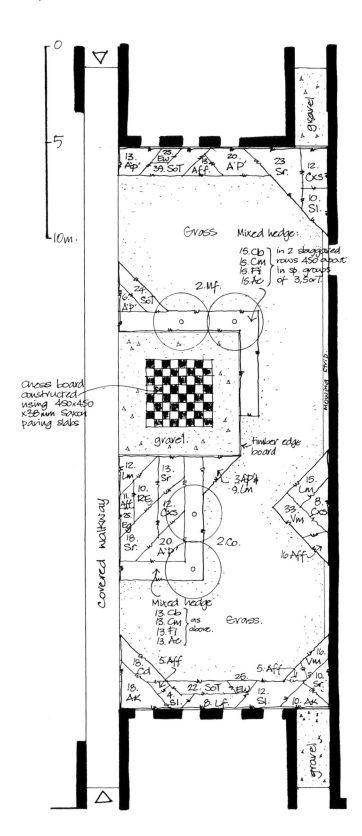

Figure 9.19 Construction drawing for ornamental planting in an office courtyard. Species are identified by key letters which would be explained in a schedule on the drawing. Note that the first letters of genus and species are used to aid quick identification.

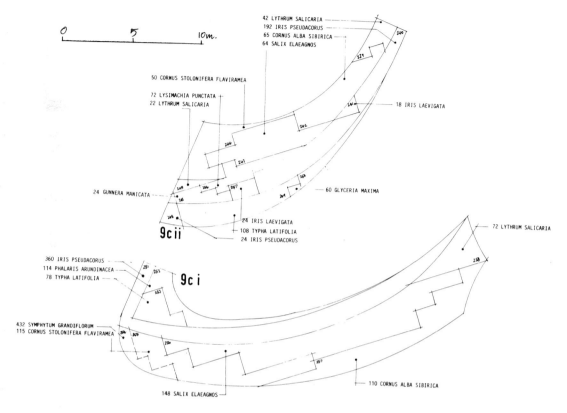

Figure 9.20 Part of construction drawing for ornamental planting in a garden festival site, including marginal aquatics. The beds shown are keyed into a location plan. Note the rectilinear shape of drifts which assists the calculation of plant numbers and setting out. The angular shapes will be less noticeable on the ground and will soon disappear as plants establish.

PLANTING PLAN GRAPHICS The best method of describing planting on a working drawing will depend on the type and scale of the planting. There are three basic techniques.

1. **Individual locations**
 Locate individual plants with a dot, cross or other symbol.
2. **Drifts**
 Delineate an area to be filled with a given number of plants of the same species, at given spacing (centres abbreviated to c/s, ctrs. or c/c) or density (per square metre abbreviated to /m² or .m⁻²).
3. **Mixes**
 Delineate an area to be filled with a mix of given numbers of plants of different species at given spacing. Describe the method of distribution of the different species.

It is unnecessary and cumbersome to show the positions of all the individuals within a drift or mix, even on the largest scale plan; the way that plants are to be arranged can be described in words or by graphic example. Distribution around

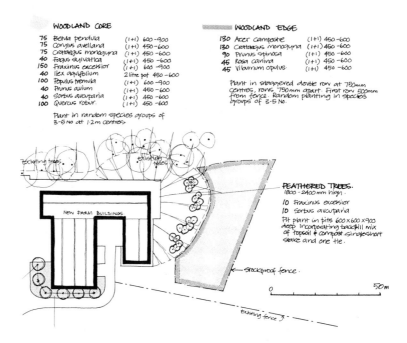

Figure 9.21 Construction drawing for outfield planting using species mixes. The schedules indicate numbers, age and stock sizes of each species in each mix.

the edges of the planting areas is important for the look of the scheme and often needs explanation. It can de described in words or shown on the plan with dimensions if necessary. It is by far the best practice to label all species fully and directly on the plan, rather than use codes and keys that need cross-referencing and are difficult to read, especially on site. The use of keys (legends) causes most contractors to fully label plant areas on copies of the plan before setting out, in order to reduce the risk of errors, and to make their job easier. It is far better if the designer does the labelling.

The three methods outlined above give all the flexibility we need to accurately describe most arrangements of plants. There are ways of introducing more sophistication into large-scale planting mixes and we will explore these in Part 3 when we look at revegetation, woodland and outfield planting.

ORNAMENTAL PLANTING For ornamental planting drawings it is common to show mainly individual locations and drifts with occasional use of mixes when these are too extensive or complex to be described by a combination of groups or drifts overlaid with spot locations. The most detailed ornamental planting such as found in gardens and courtyards may require a plan scale of 1:50; other ornamental plantings can be adequately shown at 1:100.

OUTFIELD PLANTING Outfield planting, by which we mean forest revegetation, woodlands, shelter hedges, copses and screen belts is of a larger scale and normally detailed on plans at 1:250, 1:500 or occasionally 1:1000 scale. These scales are adequate because the exact location of most of the individual trees or shrubs, or even of groups, is not critical for the composition of the association. For economy of time and printing, much use is made of mixes for outfield planting. These can be described in notes on the plan, or by drawing

a sample planting unit or units that are then repeated over large areas. This repetition of a standard pattern is sometimes called a planting matrix. Matrix units can be drawn for, say, dry, wet and poorly drained areas, or for woodland edge and woodland core and so on. In this way planting idioms are devised and then distributed over the site according to conditions and function.

In addition to the mixes or planting matrix, we can provide a little more sophistication and control by also showing single trees or strategic groups within or adjacent to the mix or units. The design and specification of planting mixes and matrix units will be described in detail in Chapter 10 on framework planting.

URBAN AMENITY PLANTING It is helpful to distinguish a type of planting that is intermediate in scale and character between the more highly ornamental planting and outfield structure planting. This is found in streets, squares, parks and institution grounds, commonly with a high proportion of exotic species and is often called urban amenity planting. It can usually be adequately detailed on plans at 1:250 or 1:200 scale and using graphic techniques similar to ornamental planting but often with more reliance on shrub mixes. If the planting covers larger areas, these mixes are an economical and appropriate way of introducing variety in extensive planting where there is not the need for constant control of detailed composition.

Specifications

In most projects, planting plans are supported by written specifications that define the quality of plants and other horticultural materials and the operations of ground preparation and planting. These specifications form part of a planting contract with a private landscape contractor or can constitute instructions to a direct labour force. The horticultural and legal detail required for writing specifications and contracts is beyond the scope of this book. Professional associations or institutes can usually give references for landscape contracts and specifications written for their country.

Realization

Turning proposals into reality requires the services of a specialist landscape contracting firm or other landscape unit such as the direct labour organization of a public body or the in-house landscape team of a large private company. If the work is to be implemented by contract the landscape architect normally has full responsibility for supervising the planting operations and is in a good position to make sure the design is properly interpreted on the ground. If the planting is carried out by a direct labour organization, the landscape architect's relationship with the person on the ground is less formally defined, but the designer will still have some control over the implementation.

Because planting is a craft skill, designers should be familiar with techniques of establishing and tending plants. Then they will understand the needs of the landscaper, whether external contractor or in-house, and be able to solve practical problems that come to light during the work. This practical knowledge also gives designers the opportunity to work closely with the landscaper and, if the conditions allow, to refine and develop aspects of the design during implementation.

Planting

The planting operations usually take place over a number of months during the planting season. Subsequent phases can be implemented during following seasons if the project is large or if parts of the site are not available at the early stages.

Figure 9.22 An example of a repeating unit for woodland planting. The setting out of units would be shown on a separate plan.

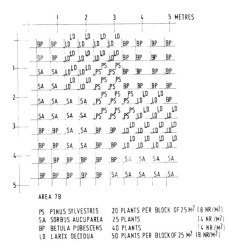

AREA 7B

PS PINUS SYLVESTRIS 20 PLANTS PER BLOCK OF 25 M² (8 NR/M²)
SA SORBUS AUCUPARIA 25 PLANTS (4 NR/M²)
BP BETULA PUBESCENS 40 PLANTS (4 NR/M²)
LD LARIX DECIDUA 50 PLANTS PER BLOCK OF 25 M² (8 NR/M²)

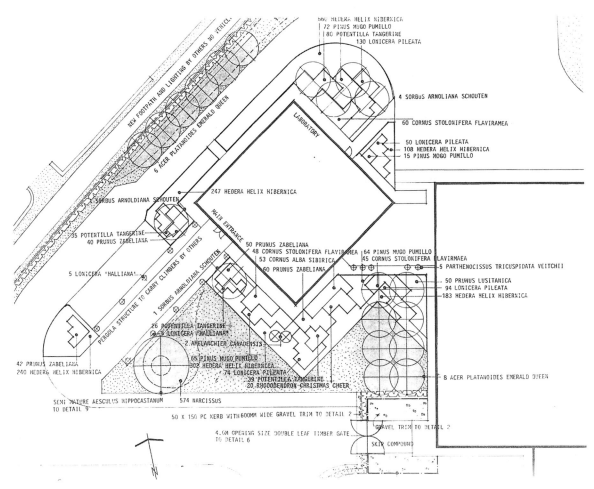

Figure 9.23 A construction/working drawing for urban amenity planting to a commercial development. Note the full plant names and quantities annotated on the plan.

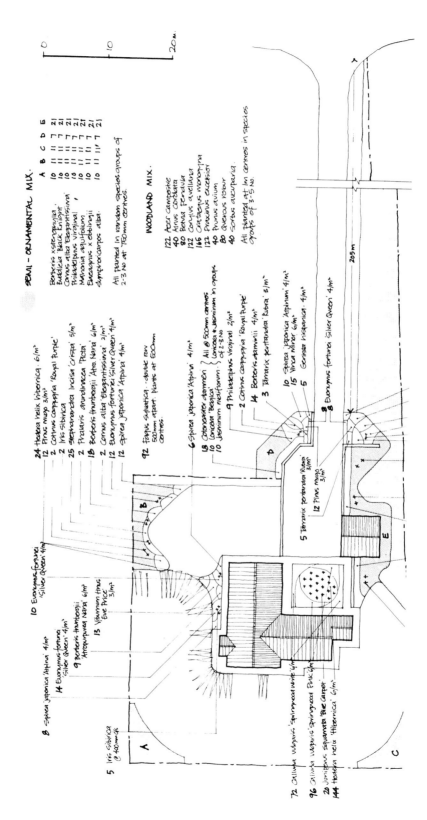

Figure 9.24 Part of drawing showing ornamental planting and woodland edge planting linked by a 'semi-ornamental' shrub structure planting mix. The proposals are for a private garden.

During the implementation frequent decisions are made by the designer to interpret details of the design and to solve unforeseen problems that commonly arise during operations. The implementation phase can also be a chance to refine and, in some cases, to modify the design. There are good reasons of economy and simplicity for adhering strictly to the working drawings, but in most cases designers can, if they wish, instruct variations to modify the arrangement of plants on the ground. In fact, it is accepted practice to omit the positioning of some plants from the working drawings and to specify that they will be set out on site by the landscape architect. This kind of flexibility is most needed when there are aspects of the site or construction layout that are unknown at the design stage. For example, the exact position of an underground service run may need to be determined on site during the planting operations and only then can trees be located at a suitable distance. Refinement can also be made for purely aesthetic reasons. We may want to set out an important group of specimen trees or shrubs ourselves, if their exact positions are critical for the composition. Avenues and other formal planting are good examples of groupings whose positioning must be at least carefully checked on site, if not set out by the designer in person.

Establishment

The implementation of any planting scheme normally includes an establishment or 'aftercare' phase following the actual planting. This lasts for a period between one and three years, during which the contractor will make sure that the scheme does not succumb to weeds, bad weather or pests during this vulnerable phase of its life cycle. In a landscape contract the establishment phase is made up of two parts: the contractor's liability for plant failures (usually called the 'Defects Liability Period') and paid aftercare work (usually called 'Aftercare Works' or 'Maintenance Works').

During the Defects Liability Period (DLP) any plants or other materials and any problems arising from poor workmanship are put right by the contractor at no extra cost. This includes replacing plant losses ('beating up') after each growing season. In effect, the contractor guarantees a full complement of healthy plants at the end of the DLP, subject to specified exclusions such as vandalism. The Aftercare Works are made up of routine maintenance such as weed control, watering, pruning, hedge clipping, grass cutting and litter collection. All these are essential for successful establishment and without them, it would be unreasonable to expect the contractor to guarantee the planting.

The main objective of the establishment phase is to achieve a closed canopy or groundcover of vigorous, healthy plants. The aftercare period is also an excellent time for the designer to take stock of the scheme's success. Any need for additional planting to strengthen should then become apparent. What is needed may be no more than half a dozen transplants on a corner or another drift of bulbs beneath a grove of trees but it can make a significant difference to the impact of the scheme.

On some sites there can be uncertainty about which species will establish most successfully. If this is so, it is only sensible to wait for one or two seasons to see which are the best adapted and then to use them to thicken up the plantations or beds. To give the flexibility to modify and add to the planting during the contract we can set aside a sum of money to cover additional planting and to make it clear to the client and the landscaper that this is a necessary and anticipated part of the project.

Management

The full effect of mature planting envisaged by the designer will only be achieved once the scheme has passed into the landscape management phase, and so success depends on the landscape manager's interpretation of the designer's intentions. The management phase of a planting scheme can be regarded as starting at the end of the establishment period and continuing for as long as vegetation exists on the site. It includes maintenance, that is, the regular, repetitious tasks to keep the site clean and free from weeds and pests, and the seasonal work of grass cutting, pruning and replacing occasional losses.

Management is also an important design tool. Indeed, many of the qualities of richly planted landscapes owe as much, if not more, to creative management as to the original design. By pruning, thinning, replanting and allowing selected plants, even self sown 'weeds', to naturalize and spread, management shapes and controls the development of the plant association. Pruning can encourage the most attractive aspects of plant habit, or restrict some plants in favour of others; thinning can remove some plants altogether to make way for others, or change the structure and spatial characteristics of woodland by opening up glades or reducing its density. Many plants that are essential to the long-term success and character of a landscape, are best introduced once an initial nurse crop has been established. These second stage species include many long-term forest trees, such as the podocarps and slower growing broad-leaved trees of New Zealand forest. The shade- and moisture-loving plants of the forest floor are also best introduced at later stages. Examples of these include many vernal herbs of the deciduous forest and ferns of the evergreen rainforest.

With the exceptions of the long-lived trees, all planting needs some kind of regeneration within the foreseeable period of landscape management. This can be allowed to happen spontaneously by providing the right conditions or we can control the process by hard pruning, coppicing, pollarding or replanting chosen species. Herbaceous plants and shorter-lived shrubs need dividing or replanting at relatively short intervals of five to ten years. Longer-lived shrubs and trees do not necessarily need attention in the short term, but it pays to develop a varied age structure at an early stage in the life of the planting scheme in order to prevent wholesale senescence at a later date. Finally, some of the most delightful effects can come from the unexpected, spontaneous spread of both planted and 'weed' species, and it is sensitive management that allows and encourages the right balance of control and spontaneity.

There is scope within landscape management for creative intervention and periodic redesign. A designer's sensitivity, if not a full design training, is an asset for a landscape manager. Indeed, it may be essential if the designer's full intentions are to be realized. If this is not possible, there are ways we can, as designers, be involved in management. The greatest control is achieved if we draw up a management contract that specifies the operations to be carried out as well as the design objectives. These operations are then supervised by the designer on site.

Management contracts are normally term contracts, renewable after a period of between three and five years. This timescale will allow us to see at least the shrub and herbaceous planting achieve maturity before the end of the second management contract. By this stage, the tree planting will also be well on its way towards an effective role in the planting composition even though it may not reach full maturity until fifty to one hundred years after planting. After one or two terms of a management contract, we can demonstrate to the client and landscape staff what we are trying to achieve and, if necessary, hand over responsibility with confidence that the design intentions are understood.

If we do not have the opportunity to supervise a management contract we may be able to draw up a management plan that includes a specification and an outline work programme for use by the landscape manager. This should include a full explanation of the intended form and character of the planting as well as the main operations required. It helps if we can arrange regular meetings with the landscape manager to oversee the general direction of the management work and help to make key decisions. If continuing involvement is not possible, we can safeguard the investment of time and money that was made in a planting scheme by making sure the landscape manager and staff are thoroughly briefed when the site is handed over to the client at the end of the establishment period. This briefing could take the form of an illustrated management report and a discussion at which management staff can quiz the designer. Visits to mature sites of a similar character can be very helpful.

Learning Through the Design Process

We have now followed the design process through inception, analysis, synthesis and realization. The realization of our vision can be the most satisfying part of the work; it is also the most edifying. To see our design on the ground and growing towards maturity provides an invaluable opportunity to learn from our successes and our mistakes. To assess the finished product is the best way to find out if we have solved the problems and achieved our design objectives.

So design does not end with realization. We should feed the lessons from each completed scheme into the process of the next project. In this sense, design is a cycle. Observation and evaluation of a completed design can inspire and generate ideas for the next. This creative cycle operates not only from one design project to the next but also within the stages of the design process. It is a means to generate ideas and select from alternative options. Both analysis and synthesis play a part in this cycle. Laseau (2000) regards reductive and expansive types of thinking as overlapping through the design process: 'While the ... design process involves decision making aimed at the reduction of alternatives in search of a final solution, it also involves elaboration aimed at expanding the range of possibilities.' Decision making requires a focused, single-mindedness whereas elaboration grows from the attitude of exploring for its own sake, for the fun of it. Perhaps it is the ability to integrate these complementary frames of mind that is the key to creativity. If we can allow them to coexist, to support and cross-fertilize each other, then problem solving will become an adventure and inventive exploration lead to creative answers to design problems.

Practice

CHAPTER 10

Structure Planting

Introduction

The third and final part of this book will look at the practice of detailed planting design and answer questions such as: What range of plants is right for this kind of planting? and, How can we put them together in an effective and imaginative way? This will give us a basic repertoire of design techniques from which we can select and adapt what we need for the design of different projects and sites. It is beyond the scope of this book to deal with landscape techniques like ground preparation and weed control and for this, the reader is referred to the many good publications dealing with horticultural and arboricultural techniques.

Framework planting and ornamental planting deserve separate chapters because the species most commonly used for each type, and the roles that they play, are often quite distinct. Despite this distinction, there are important areas of overlap between structural and decorative functions of plants and we need to consider visual composition when detailing framework planting and to take account of the space forming qualities of ornamental planting.

Forest and Woodland

In *The Poetics of Gardens* (1988), Moore *et al.* suggest that 'planting a new tree is one of the noblest acts of optimism'. As designers in the landscape, we have the chance to establish trees by the thousand in new forests and woodlands. From a long-term, environmental perspective this might be the most valuable part of our work, especially in deforested landscapes such as in much of Europe and New Zealand. New forest and woodland can range in scale from a small copse or grove of a few hundred square metres to continuous forest of hundreds of hectares, and it can be created in rural areas, on the city fringes or, increasingly, within revitalized urban areas. The 'urban forest' and urban woodlands are of particular importance and social value because they are close to and can form part of the everyday lives of large numbers of people.

A note on terminology is appropriate at this point. 'Forest' and 'woodland' both have strict, scientific definitions in addition to technical meanings in the forestry industry and broad colloquial use. In ecology, 'forest' refers to a plant community dominated by tree species and which forms a mostly continuous canopy at five metres or more in height. 'Woodland' refers to a dispersed community of trees with other plants forming a characteristic component at a lower level (such as, 'coppice and standard woodland', 'savannah woodland' or

'wood-pasture'). In commercial forestry the term 'forest' refers to a plantation or a naturally occurring forest used for production purposes. In lay use, 'forest' is usually applied to tree-dominated communities of large extent (for example, the 'primeval forest' of Europe or the forests of Russia), whereas a 'woodland' refers to smaller, but not necessarily more open, tree-covered areas, which are often managed or used by people in some way. In this book we will use the terms in their ecological sense, but will also allow for the common use of the term woodland in Britain where it refers to smaller areas of trees, in both rural and urban locations. In other countries, other terms are used. In New Zealand for example, 'bush' has come to refer to any dense growth of native trees and large shrubs, whether primary forest or secondary growth, and 'forest' is commonly used in the commercial forestry sense.

Where is new tree planting taking place on a significant scale? Where is the future tree structure of the landscape being established? In England, the new 'National Forest' in the Midlands, other regional forests, and woodland planting associated with development – particularly roads and industry, have already started to make a real difference. This planting is beginning to create a substantial framework of tree covered land within which the changing economic activity of the country takes place. We might call these areas 'treeland', to distinguish them from woodland and forestry plantations and to acknowledge the differences in origin and function.

New amenity forest and woodland planting are usually on a smaller scale than commercial forestry, but none the less make a major contribution to the visual and ecological qualities of the landscape. In the rural and urban fringe, such planting is often associated with new development of some kind. This includes recreational projects like country parks and visitor facilities for national parks; these may give the chance to establish substantial areas of new woodland or forest or the regeneration and revegetation of existing, degraded forest communities. Industrial development in rural areas is another opportunity for woodland or treeland planting, and a big contribution to tomorrow's forest is provided by the plantations established on reclaimed industrial land such as industrial spoil and old quarry and extraction workings. In some cases, the land purchase that is needed for new roads can leave enough area, not only for highway verge planting, but also for adjacent blocks of reafforestation and treeland. A further opportunity is provided by recent changes in agricultural policy in Britain that encourage lowland forestry and woodland planting on less productive farmland.

In urban areas the chances to establish new woodlands seem, at first sight, more restricted for two main reasons. First, high land values create pressure for land use with a substantial financial return. Second, public perception of the 'urban forest' (including urban woodland, and the 'urban bush') has focused on the negative side, seeing it more as cover for attackers, drunks, drug takers and rubbish tippers than as a habitat for wildlife and a place for relaxation and recreation. However, these perceptions are changing with the growth of the urban environmental movement and environmental consciousness in general, and with successful examples of multiple use urban woodlands. Urban tree planting of all scales and styles is now understood as an essential strand of the 'urban forest' – a fabric of trees and small woodlands that are interwoven with buildings, roads and open areas.

In rural areas of European countries, landscape architects play a valuable role in the design of timber plantations including advice on plantation location and shapes, conserving existing vegetation, and establishing indigenous fringes and frames to contain the crop species.

Plate 138 Ash (*Fraxinus excelsior*) and sycamore (*Acer pseudoplatanus*) woodland has colonized and established itself in an abandoned chalk quarry near the river Humber, UK. Note the rich shrub and herb growth beneath the trees.

Designing Forest and Woodland

When designing forest and woodland, there are a number of basic questions that should determine the design approach, including which species to use and how to arrange them.

What Functions will the Forest or Woodland Perform?

The most common and important functions include habitat creation, visual amenity, recreation and microclimate improvements. These functions are the main factors that decide what spatial structure and which species will be appropriate.

What Canopy Structure is Ultimately Required?

We saw in Part 1 that the distribution and density of canopy layers (strata) give the forest its spatial qualities, and that these qualities in turn influence the perception and use of the forest. Although the mature forest structure only develops fully over many years, we need at the outset to choose the right balance of species and arrange them so as to create the desired canopy structure. Continuing management of this initial forest community, including second stage planting, is an important part of developing the forest structure.

What are the Soil and Climatic Conditions?

The growth conditions of the site are a further guide to species selection. Species chosen need to be well suited to all aspects of the site's environment so that we can establish a vigorous woodland with an economic level of establishment and management work.

What Forest Species Already Grow Successfully Nearby?

If site conditions are similar to those on nearby land and if we want to reflect and maintain the existing landscape character of the area, we can rely mainly on locally proven species. We can broaden this palette in places, but remember that new woodland plantations and forest revegetation sites are not the best place for collections of unusual trees and shrubs.

We may be trying to establish planting on a site with unusual soil conditions, such as derelict land, or there may be no existing woodland in the vicinity – perhaps because the site lies in an urban area or because the tree cover of the surrounding countryside has long been removed. In this case, we can study the vegetation or planting of comparable sites elsewhere and look for recommendations in the technical literature on our particular landscape problems. It is usually possible to find some examples of spontaneous colonization somewhere in the district – roadsides, neglected land, even gardens can provide examples, however small, of how nature would revegetate if given the chance.

How Will the Forest or Woodland be Perpetuated?

The level of future management is a further consideration. If it seems likely, for example, that little or no thinning and restocking will be carried out, then we should anticipate this at the design stage by creating a plantation that will have a better chance of surviving and regenerating itself without management. This may mean sacrificing diversity and spending more time and money on the initial site preparation, planting and mulching. On the other hand, an assured management programme carried out by skilled landscape staff would allow rapid establishment and a diverse and sustainable woodland or forest in the long term.

Once these questions have been answered, we can decide on and plan an establishment strategy and draw up a plant palette for the planting. There are strong arguments for confining this mostly to native and long naturalized species. Forest and woodland are among the largest elements in the landscape and so have a powerful effect on the character and qualities of both the rural and the urban scene. Large tracts of exotic species often appear foreign to the surrounding landscape and at odds with the essential spirit of the place, especially in rural settings. A further reason is the pressing need to protect and extend the habitats available for wild plants and animals. By establishing native forest and woodland, which are among the richest indigenous ecosystems, we can help improve both the extent and the diversity of wildlife.

Although native trees and shrubs are generally the most valuable for creating wildlife and reflect the indigenous character of our landscapes most strongly, many exotics are none the less familiar in the rural landscapes of many countries, even in the wilder parts. Although they rarely support as many species of insect and other fauna as native trees and shrubs, many introduced species do provide food and shelter for wildlife and so can be useful for conservation alongside true natives. In particularly difficult soils and climatic conditions, some exotics may be easier to establish than natives and, where there is an economic incentive, this often leads to their widespread planting. For example, *Acer pseudoplatanus* and *Larix decidua* are frequently planted and provide valuable shelter in exposed, upland landscapes of England; and *Cupressus macrocarpa* and *Pinus radiata* are used to create tall shelter hedges across the windswept Canterbury Plains of New Zealand where native trees are slow to establish.

Some exotics are well enough suited to their new conditions to be able to naturalize and spread. Examples of trees that have naturalized in parts of England include Spanish chestnut (*Castanea sativa*) Turkey oak (*Quercus cerris*) and Norway maple (*Acer platanoides*). Some exotic species, such as sycamore (*Acer pseudoplatanus*) and *Rhododendron ponticum*, have colonized with such vigour that they have spread at the expense of native plants and wildlife habitats. In New Zealand, the unique indigenous and largely endemic flora is unusually vulnerable to displacement by exotic species, and many introduced species, such as *Pinus radiata*, gorse, broom, *Albizia lophantha* and some *Acacia* species, are regarded as serious pest plants in certain areas. Great care should be taken not to contribute to the even wider spread of pest species.

In the past, techniques of establishing woodland and forest were based on methods adapted from commercial forestry and combined, in some cases, with a more horticultural approach of the kind employed by the larger private estates. These techniques included using short-term, nurse trees planted at the same time as slower growing species; the use of seedling transplants widely spaced in regular rows; and a restricted range of species. More recently, techniques of design and establishment based on ecological principles and objectives, inspired by the pioneering ecological parks and plantings in The Netherlands, have been adopted. Ecological, or naturalistic planting as it is often called, has since been developed and refined with considerable success and the design of forests, woodland, scrub and shrubland has, as a result, become much more sophisticated.

There are occasions when a simple monoculture, such as a group of totara, a grove of Scots pine or a beech 'hanger' on the crest of a hill, is a good design solution. At other times, we want the kind of diversity of appearance, structure and wildlife habitats that ecological planting can produce. The level of diversity in a forest community is often characteristic and typical of the natural forest of an area. We see this if we compare the complexity of the lush, 'subtropical', lowland rainforests of northern New Zealand with the simple structure and composition of the beech forests of the eastern South Island, or with the pure stands of kahikatea (*Dacrycarpus dacrydioides*) that once towered over the lowland swamps. So, the amount of diversity we are aiming for should reflect both means of establishment and the best aspects of local character.

Another important element of our strategy is the staging of the planting. In some cases all the planting is best done in one go and the plantation then managed over a period of years to allow the slower growing and less competitive species to establish. If there is going to be an opportunity for a second stage of planting, this may be the best time to introduce species that need more sheltered, shaded and protected conditions. The second stage planting often takes place once the pioneer or nurse trees and shrubs have created a protected partly shaded growing environment in glades and below their canopy. The time between stages one and two can be as little as three years under favourable conditions and intensive management, and as much as twenty years where growth is slow and difficult.

Planting Mixes

The basic unit of forest and woodland design is the planting mix. This is the mixture of trees and shrubs that are planted in a particular area. These species will occupy different niches in the plantation as it matures and only some of them are likely to remain part of the plant community when it reaches maturity.

Most new forests and woodlands benefit from more than one planting mix. In fact, a plantation can consist of a mosaic of different mixes reflecting different

conditions and functions in the forest. The constituents of each mix will be carefully selected to suit the ground and microclimate in different areas and to provide the desired canopy structure for different parts of the forest. From a design point of view it is useful to categorize mixes, first by canopy structure and then according to environmental conditions. What follows is a sample of planting mixes covering the main types of framework planting. As in Chapter 8, we will illustrate principles with contrasting examples from Europe and New Zealand.

High Forest/High Canopy Woodland

Approaches

High forest and high canopy woodland are communities in which the dominant trees are tall forest species, usually of at least 15 but commonly 20 or more metres height, and which represent a mature phase of forest development rather than early colonizing and pioneer communities. A high canopy mix that will ultimately provide the inner core of mature woodland or forest is often called a core mix. This can contain, at time of planting, the species that will eventually form one, two or more canopy layers.

Approaches to establishing high forest communities on open land differ according to the ecology of the species concerned. In some kinds of temperate forest, such as New Zealand montane southern beech forest and the European oak woods it is possible to plant at least some of the trees that will eventually form the dominant canopy at the outset. They can be combined with a selection of co-dominants, sub-dominants and shrubs and, with appropriate management, will develop over, say, fifty years into a forest community. In other regions and

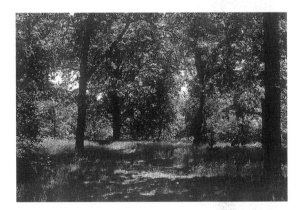

Plate 139 In this high canopy oak woodland (*Quercus robur*) a cross-section of three-layered woodland structure has been revealed by felling in preparation for road construction. An understorey of shrubs including elder (*Sambucus nigra*) and hazel (*Corylus avellana*) is well developed and clearly distinguishable below the oak canopy. Beneath the shrubs a field layer of bramble (*Rubus fruticosus*), honeysuckle (*Lonicera periclymenum*) and shade-tolerant herb species can be found although its density is limited by the shade cast by the two strata above it (Nottinghamshire, UK).

Plate 140 This high canopy oak (*Quercus robur*) wood, which is located in a country park, demonstrates a two-layer structure. The understorey is largely absent but a field layer of grasses and other herbs is well developed. The spatial qualities are quite different to those in a three-layer wood and the openness beneath the tree canopy is well suited to informal recreation use by comparatively large numbers of people (Nottinghamshire, UK).

with other forest types, such as the podocarp-broadleaved forests of New Zealand, successional factors are more important for successful establishment and many of the ultimate forest dominants are best introduced once favourable growing conditions have been created by pioneer or nurse communities.

Even in the case of deciduous oak or European beech woodland, there are arguments for excluding the future dominant trees from the initial planting, especially the slower growing species such as pedunculate and sessile oak, beech and hornbeam. Landscape architect and conservationist Chris Baines (1985), for example, suggested that

> We should allow for much more natural colonization. Instead of attempting to produce native woodland in one stage I am convinced results would be far better if initially we established dense scrub, and so created a sheltered woodland environment at ground level. There is hardly a site in Britain that would not naturally acquire climax species, such as oak.

This approach is ecological in that it follows more closely the sequence of spontaneous regeneration and succession. It is also true that the majority of dominant high canopy trees and shade tolerant understorey species establish more successfully after a pioneer community has first colonized the ground. This is particularly noticeable on inhospitable sites where the shelter, shade and improved soil that pioneers can provide are especially valuable.

To establish high forest communities using a successional approach we would start by establishing a scrub or low forest community and then introduce the final dominant forest species as second stage planting or seeding, once the pioneer planting had created the right conditions. We will discuss this further

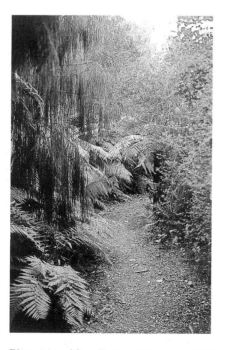

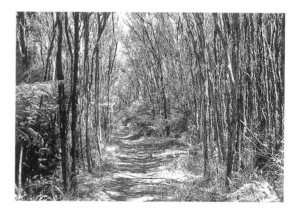

Plate 142 Natural colonization of forest tree and shrub species in sheltered semi-shade under an old manuka stand. The manuka is even aged and colonized following the destruction of the original forest by fire (Orongorongo range, near Wellington, New Zealand).

Plate 141 New Zealand forest establishing vigorously from planted stock including the more light tolerant podocarps such as rimu (*Dacrydium cupressinum* – seen here with the pendulous foliage) and totara (*Podocarpus totara*). Pioneer tree and shrub species tree ferns and ground ferns were also included in the original planting. (University of Canterbury, Christchurch, New Zealand.)

under the sections on design of low forest and scrub mixes (pp. 222–9). One issue with this approach, however, is the time lapse before high canopy trees start to colonize. Even if pioneer trees and scrub are planted and managed to encourage quick establishment, it is generally some time between 10 and 50 years before conditions are right for colonization by the species that will succeed them. Yet as Chris Baines points out, this delay 'hardly matters if we are realistic about the time scale of oak woodland' and the pioneer community will have its own value and character in the mean time. His comments are also very relevant to other forest types. For example, the dense manuka (*Leptospermum scoparium*) scrub that develops on burnt areas in New Zealand, begins to degenerate after 15 to 20 years, and at this stage larger and longer lived forest species establish.

Notwithstanding the ecological arguments, it is feasible to establish many forest trees including oak, beech, ash and lime, at the outset, given adequate soil and microclimatic conditions. European oak and ash, in fact, are not only high forest dominants but can also act as natural pioneers in low fertility grasslands, where their large seeds provide the food store to grow above competing herbs. In New Zealand, the southern beeches or tawhai (*Nothofagus* sp.) colonize open areas such as slips, road cuttings and riverbanks. So there is an ecological precedent as well as a practical reason for including forest trees such as these in the initial planting and accompanying them with some plants from the other forest layers.

Layer Components

In much of Britain and parts of north-west Europe, high canopy woodland would be dominated by trees such as:

- pedunculate and sessile oaks (*Quercus robur* and *Q. petraea*),
- European ash (*Fraxinus excelsior*),
- European beech (*Fagus sylvatica*),
- Scots pine (*Pinus sylvestris*),
- sycamore (*Acer platanoides*),
- hornbeam (*Carpinus betulus*),
- large and small leaved limes (*Tilia platyphyllos* and *T. cordata*).

Any of these species can be used as key components of a planting mix. The choice will depend on the local ecology and site conditions.

Smaller trees, which do not attain the full height of the forest dominants and are often referred to as sub-dominants, include:

- rowan (*Sorbus aucuparia*),
- field maple (*Acer campestre*),
- gean (*Prunus avium*),
- wild service tree (*Sorbus torminalis*).

Within the woodland interior, these grow most vigorously in canopy gaps. The more shade tolerant such as rowan, field maple and wild service tree grow well below the canopy of the dominant trees where shade is not too dense.

The 'shrub layer' will consist of shade tolerant shrubs and small trees of shrubby habit. In Britain, according to area, these would include:

- hazel (*Corylus avellana*),
- holly (*Ilex aquifolium*),
- box (*Buxus sempervirens*),
- wild privet (*Ligustrum vulgare*),
- elder (*Sambucus nigra*),
- midland thorn (*Crataegus oxycantha*),
- common hawthorn (*C. monogyna*).

In special locations more unusual shrubs like butcher's broom (*Ruscus aculeatus*) and laurel daphne (*Daphne laureola*) might be appropriate if suitable stock can be found. In established woodland the shrub layer often includes large numbers of tree saplings, especially of the more shade tolerant species such as European beech and sycamore. Having germinated and established as far as the sapling stage, they cannot progress further (or only very slowly) and so they wait for a gap to appear in the canopy so they can continue their growth under better light conditions.

The third stratum that is useful for the designer to consider is the herb or field layer. In established forest and woodland this normally includes a high proportion of herbaceous species but shade tolerant, low and scrambling shrubs also form a significant part. Some of these field-layer shrubs could be included in planting, provided they are given particular attention in aftercare and management (this will be discussed later). These include:

- bramble (*Rubus fruticosus*),
- ivy (*Hedera helix*),
- honeysuckle (*Lonicera periclymenum*).

Herbaceous field-layer species cannot be successfully established until the woodland structure is well developed and the right conditions of shade and shelter exist at ground level.

Nurse Crops

An established method of assisting the establishment of slower growing and more demanding species is the use of a 'nurse crop' consisting of fast growing trees (usually pioneer species). Nurse trees include:

- birches (*Betula pendula* and *B. pubescens*),
- alders (*Alnus glutinosa, A. incana* and *A. cordata*),
- larches (*Larix kaempferi, L. decidua* and *L. x eurolepis*),
- willows (*Salix* species),
- poplars (especially *P. tremula*).

These are normally planted with the intention that they will be removed after 7–20 years when they have done their task, to allow the long-term components of the mix to flourish. In commercial forestry the nurse crop may also be a source of early financial return. In landscape plantations they can provide rapid height and bulk, for example, where screening or shelter is a priority. Although fast-growing nurse and pioneer trees are planted mainly for their early impact, selected groups can be retained during thinning operations to add to the species and structural diversity of the mature woodland. A dense grove of birch or willow among stands of oak and ash can increase both the habitat and visual interest of the wood.

The close planting of nurse and long-term species can, however, create difficulties. The high canopy dominant trees are slower to establishment than the nurse species so they need to be arranged so that the quick growing trees and shrubs do not suppress their growth in the early years. At the common landscape tree spacing of 1–2 metre centres, a nurse crop will soon begin to shade and suppress slower growing trees and shrubs with their vigorous spread and dense foliage unless frequent attention is given to thinning and cutting back. (Although species like birch and aspen are pioneers and naturally give way to oak, beech and other climax species in many successions, this second wave of colonizers normally establishes below gaps once the pioneer canopy has thinned with age. In small glades and under the thin canopy of older trees, conditions near ground level are light enough for seedlings of many of the climax species but still too shady to allow widespread regeneration of the more light demanding pioneers.)

A second problem is that vigorous, established nurse trees are not always easy to eliminate. All the species mentioned above, except larch, regenerate freely from cut stumps and the resulting re-growth is bulky and rapid. Unless this 'coppice' is cut regularly it will continue to be highly competitive and will ultimately form large, multi-stemmed trees. The stumps of felled trees can be killed with herbicides but the large-scale use of these powerful chemicals is discouraged due to the danger to operators, other plants and wildlife. Mechanical stump removal by grubbing out or grinding is difficult in the confined space of the plantation. In addition, simply felling nurse trees that are likely, at that stage, to be the largest in the plantation, can be difficult without causing damage to other trees and shrubs.

To avoid these difficulties it is best to omit very vigorous nurse species from the woodland core altogether and rely on shrubs and trees of more moderate growth rate to give early visual effect and shelter.

- Ash (*Fraxinus excelsior*),
- gean (*Prunus avium*),
- rowan (*Sorbus aucuparia*),
- elder (*Sambucus nigra*), and
- hawthorn (*Crataegus monogyna*)

all make good growth in the early years provided that exposure is not too harsh, and will give protection for species such as oak, beech and lime.

Alternatively, the nurse species can be segregated from the long-term components of the mix to avoid excessive competition and allow easier management. This principle is employed in forestry where the nurse and main crops are planted in separate rows so that at the first thinning the nurse trees can be easily felled and removed to leave space for the spread of the main crop. The appearance and spatial qualities of such a regular planting grid would be quite out of character for many landscape plantations, so more sophisticated irregular distributions are often used. Nurse species can be grouped in variable blocks or bands to allow easier thinning and to maintain gaps between their massed canopies. These gaps become glades where the slower growing species can thrive in the comparatively light and sheltered microclimate.

Developing a Planting Mix

Let us now look at some examples of core mixes that include several canopy layers and a variety of species in each. We will use a high forest core mix to demonstrate a method of determining proportions, grouping and spacing of

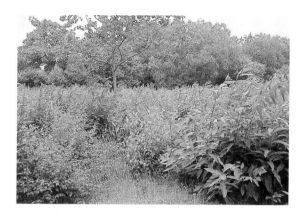

Plate 143 This Surrey (UK) woodland is being managed as coppice and standard. It can be seen from the age of the standard oak that it is still in its early years. The coppice layer consists mainly of Spanish chestnut (*Castanea sativa*) and rowan (*Sorbus aucuparia*). The birch (*Betula pendula*) in the foreground has also been cut back and is re-growing strongly.

species. It must be stressed that all the mixes suggested are intended to illustrate the method of design and should not be taken as standard mixes for use in actual projects. Every site is different and every plantation must be designed afresh with full knowledge of all the site's conditions.

To illustrate the design of a high canopy woodland mix, we will first assume a planting site in lowland southern Britain, reasonably sheltered and with a moist clay or loam soil. This is the kind of land that under natural conditions would eventually support mixed pedunculate oak woodland. It would be almost impossible, and certainly unnecessary, to install all the components of the mature vegetation at the outset, but by studying the local vegetation we can learn which species are best for initial planting in the local conditions, and their compatibility with one another. Many successful mixes are based on existing indigenous communities, but modified to allow for design objectives and the needs of plant availability and implementation.

Constituents of the Mix

The dominant canopy could consist of pedunculate oak (*Quercus robur*) mixed with smaller numbers of co-dominants such as hornbeam (*Carpinus betulus*) in the south and east of England. Sub-dominant trees associated with oak are field maple (*Acer campestre*) and gean (*Prunus avium*) and sometimes rowan (*Sorbus aucuparia*) or crab apple (*Malus sylvestris*). Some of these could be included.

Shrub-layer planting might consist of hazel (*Corylus avellana*), holly (*Ilex aquifolium*), and hawthorn (*Crataegus monogyna*) or midland thorn (*Crataegus oxycantha*), all of which are common in the interior of oak woods. Midland thorn, however, is difficult to obtain in its typical form in the nursery trade but elder could be substituted if it is necessary to maintain a high level of diversity in this layer.

The field layer of an established oak woodland would be likely to include bramble (*Rubus fruticosus*), honeysuckle (*Lonicera periclymenum*) and ivy (*Hedera helix*) in addition to numerous herbaceous species. Because of chemical weed control techniques often used in young plantations and because of their rampant, scrambling habits, it is not always easy to successfully establish field-layer shrubs at the outset. However, if more labour intensive management can be provided during the establishment phase this would allow the extra care necessary to avoid herbicide damage, and regular cutting back will ensure that bramble and honeysuckle do not smother adjacent trees and shrubs before they are strong enough to outgrow the scramblers. Also, bramble is rarely available from

nurseries and so it is best transplanted in small quantities as stolons from a local source. Ivy is difficult to establish in very young plantations because of its low spreading evergreen foliage. This makes it particularly susceptible to herbicide damage and it needs a rather different approach to weed control than is suitable for mass planting of young trees; it is probably best introduced at a later stage.

Herbaceous species (such as primrose, bluebell, wood anemone, wild garlic and parson in the pulpit) cannot establish until the plantation has reached early maturity and conditions are sheltered and shady with some bare ground. At this stage they can be introduced by seeding or by planting pot-grown material if they do not colonize spontaneously from local sources. The herbs that would succeed in the conditions of the establishment period of the plantation will be highly competitive species such as coarse grasses, docks and nettles and would constitute serious competition for the woody transplants.

Our high forest core mix might thus comprise the following, but please note that all mixes illustrated in this book are necessarily hypothetical and intended to be illustrative only. They should never be copied on an actual site. The detailed ecology of each site must always be thoroughly understood before finalizing any planting of indigenous species:

Dominant trees:	*Quercus robur* (pedunculate oak)
	Carpinus betulus (hornbeam)
Sub-dominant trees:	*Acer campestre* (field maple)
	Prunus avium (gean)
Shrub layer:	*Corylus avellana* (hazel)
	Ilex aquifolium (holly)
	Crataegus monogyna (hawthorn)
	Sambucus nigra (elder)
Field layer:	*Rubus fruticosus* (bramble)
(subject to management)	*Lonicera periclymenum* (honeysuckle)

In this mix *Prunus avium, Sambucus nigra* and, to a lesser extent *Acer campestre*, are the fastest growing species and can act as a nurse in the early years. Because of its early vigour *Sambucus* can inhibit the establishment of trees such as *Quercus* and *Carpinus* and so regular coppicing will probably be needed to make sure the slower growing species have enough space to develop.

If a simpler canopy structure is wanted, the understorey can be omitted and the remaining strata simplified by reducing the number of species present. A plantation of just two species could eventually form a woodland of simple but none the less memorable character. Beech and birch, for example, are species that often form attractive woodland monocultures. However, if we are going to rely on just one or two species we need to be very confident of their ability to succeed on the site. It is often wiser to include a range of species as an insurance against poor establishment by some of the mix.

An example of the woodland core mix without the understorey might be (site conditions as before):

Dominant trees:	*Quercus robur*
	Fraxinus excelsior (ash)
Sub-dominant trees:	*Prunus avium*
	Acer campestre

Field layer: *Rubus fruticosus*
(subject to management) *Lonicera periclymenum*

This mix gives four tree species and so a reasonable level of confidence of success and would eventually form a mixed tree canopy above the ground layer. Honeysuckle, bramble and other self-sown species would scramble on the ground and honeysuckle would clamber up the well lit trunks. This 'woodland room' structure would be ideal if views through the woodland are wanted or if easy access beneath the canopy is needed.

A different structure again would consist of clear distinction between high tree canopy and dense shrub layer. This would be created by omitting the sub-dominant trees that bridge the gap between the dominant trees and the shrubs. In addition the shrub layer could be regularly coppiced (that is cut hard back to near ground level, in order to produce multi-stem regrowth) to give dense, bushy growth and prevent the shrubs from being drawn into tall spindly specimens. Almost all deciduous shrubs can be safely cut down to near ground level but species that respond particularly well to coppicing include *Corylus*, *Sambucus*, dogwood (*Cornus sanguinea*) and guelder rose (*Viburnum opulus*). Not only shrubs but trees such as *Fraxinus*, *Carpinus* and Spanish chestnut (*Castanea sativa*) also respond well to cutting back and so might be included to form part of the coppiced layer. Traditional British coppice and standard woodland was managed primarily for the production of 'underwood' from cutting the coppice (for example, hazel and Spanish chestnut) and from the less occasional felling of mature standards (often oak). If the high canopy is not too dense this woodland structure is very beneficial for wildlife due to the diversity of light and shade in clearings and thickets that is produced by the rotational cutting of sections of the shrub layer.

A high canopy/shrub layer mix for the same site as our pedunculate oak woodland, suitable for coppicing (but not aimed) at economic return would be:

Dominant trees: *Quercus robur*
 Fraxinus excelsior

Coppice shrub layer: *Corylus avellana*
 Sambucus nigra
 Cornus sanguinea
 Prunus spinosa

Blackthorn (*Prunus spinosa*), although intolerant of dense shade, can be included if the tree canopy is to be open enough to allow high light levels in some areas. It is a valuable component of dense understorey because it forms spreading thickets and provides good nesting cover.

If coppice trees are to be included in the understorey the mix could be modified as follows:

Dominant trees: *Quercus robur*
 Fraxinus excelsior

Coppice layer: *Crataegus monogyna*
 Corylus avellana
 Carpinus betulus
 Fraxinus excelsior

The four mixes above show how species selection will create a variety of different

woodland structures. Note that the number of species in each mix varies from six to ten – this may seem a small number for a whole woodland, but the plantation will usually consists of several mixes, so the total number of species planted could be two or three times that in the core mix alone. Also, other trees and shrubs will colonize as the plantation establishes and add to the richness of the woodland community.

Woodland management is vital for the structural development of forest and woodland. At the time of planting our main task as designers is to provide a range of species that can be easily managed to produce the desired forest or woodland association and structure. Not just the choice of species but also their relative proportions in the mix and arrangement on the ground influence the management requirements and the ultimate spatial structure of the wood.

Mix Proportions

Because of their eventual size high forest trees can form a dominant canopy from a relatively small number of plants. In traditional coppice and standard woodland, for example, the number of mature standards could be as low as 12 per acre, that is 30 per hectare (Tansley, 1939). This produced a very open canopy that ensured that the underwood would flourish. A denser canopy of, say, 45 trees per hectare would produce a more enclosed woodland or forest character. To create this final tree spacing we could include the dominant species at 10 per cent of the planting mix, space plants at 1.5 metre centres and assume that approximately one in ten of the transplants will grow to maturity. One way of doing this would be to plant groups of ten oak and ten hornbeam at intervals across the plantation core and aim to manage these so that at least one tree of each group grows to maturity. This would give mature dominants at approximately 15 metres spacing.

Of course, we are not necessarily aiming for regular spacing nor for a precise spacing of mature trees. In fact, we may well want to encourage a lot of variation in distribution, so these figures are intended only as an explanation of initial proportions and spacing. They show that 10% can be an adequate starting proportion for the largest tree species. If we want to favour oak as the commonest tree and include hornbeam as its associate, we could give them mix proportions of 7.5 per cent and 2.5 per cent, respectively.

Holly, because it is slow growing and comparatively expensive, is often kept to a small proportion, about 5 per cent. The ground layer brambles and honeysuckle should also be small in numbers due to their propensity to compete vigorously with the trees and shrubs in the early stages. A total for these two of 5 per cent would be enough to introduce them into the plantation so that, if conditions are favourable later, they will spread to occupy their natural niche.

This leaves 80 per cent of the mix to distribute between the remaining shrubs and smaller trees that, being quicker to establish, will make up the bulk of the woodland in its early stages. Twenty per cent for the smaller overstorey trees would be enough to introduce diversity into this layer when it begins to differentiate from the shrubs. The understorey shrubs are then left with 20 per cent of the mix each. On this basis, the proportions would be as follows:

Table 10.1 High canopy woodland mix

Dominant trees:	*Quercus robur*	7.5%
	Carpinus betulus	2.5%
Sub-dominant trees:	*Acer campestre*	10%
	Prunus avium	10%
Shrub layer:	*Corylus avellana*	20%
	Crataegus monogyna	20%
	Ilex aquifolium	5%
	Sambucus nigra	20%
Field layer:	*Lonicera periclymenum*	2.5%
	Rubus fruticosus	2.5%
		100%

Spacing and Setting Out

A glance into a woodland glade with regenerating oak or at drifts of birch or sallow colonizing open ground will quickly show the prodigious abundance of seed and seedlings that nature provides. It is common to see multi-stemmed saplings coming from several seeds germinating in one location and single seedlings only a few centimetres apart. This apparent extravagance is not only an insurance against losses but it also helps give the seedlings an advantage over competing herb species and the mutual competition increases their growth rate. Even comparatively light foliaged trees such as birch will, in close-knit young clumps, soon cast enough shade to suppress grasses and 'weeds'. The mutual competition also results in self-thinning, and the selection of the most vigorous young trees.

When establishing forest and woodland the closest we can come to imitating spontaneous regeneration is by direct seeding of trees and shrubs. If we use the more traditional method of planting nursery grown transplants the principles of 'over provision' and beneficial competition still apply. With sufficiently close initial spacing, the young trees and shrubs will quickly reach the size at which they form a near continuous canopy that suppresses weed competition and accelerates their own growth rate. In practice, the choice of spacing is determined by the need to find the right balance between costs at planting and the cost of establishment and management work later. Dense initial planting will quickly give a closed canopy that reduces the need for weed control and beating up but will need earlier thinning to avoid drawn and whippy plants. Wider spacing of trees and shrubs at planting will postpone the need for thinning but will also extend the vulnerable period during which intensive maintenance is needed and before an equivalent visual impact is achieved.

Practice suggests that a spacing of 1–2 metres gives reasonably quick establishment without incurring excessive management costs. In cool temperate Europe, under good growing conditions, a planting spacing of 1 metre will give a more or less closed canopy after two or three growing seasons and 2 metre spacing would probably extend this to five seasons. These establishment periods are much influenced by soils, microclimate and variations in weather conditions, especially rainfall in the growing seasons. Under average conditions with no particular impediments to growth, plant spacing of 1.5 metres is a good compromise. Perhaps surprisingly, this applies to a variety of climates and not just north-west Europe; in other regions the growth rates may be different, but

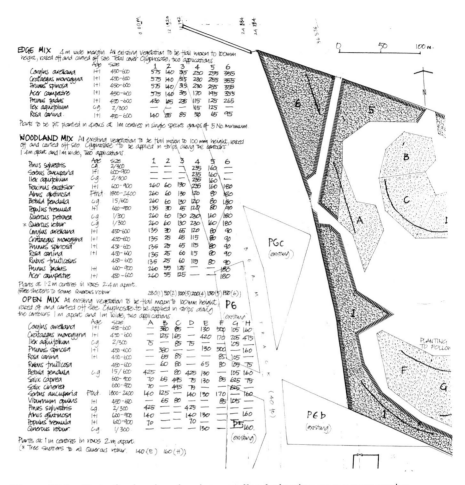

Figure 10.1 Part of a drawing showing woodland planting on a power station pulverised fuel ash reclamation site. Note the use of tables to show plant numbers in each plantation area in an economical way. Species are to be randomly mixed within each mix area.

the relative growth rates of weeds and stock remain comparable and so similar spacing allows effective establishment.

If rapid impact is needed or if the environment is particularly harsh, spacing might be reduced to 1 metre or, in extremes, to 0.75 metres. If the implementation budget is low and there is no urgency for a visual effect, 2 metres apart could be adequate.

A simple approach to setting out would be to intimately mix together all the transplants (in their given proportions) and then to plant this mix at constant spacing across the plantation area. This would give, in theory, a plantation in which each species is evenly spread throughout and intimately mixed with the others. For this approach the schedule to go on the planting plan would be as in Table 10.2. The percentage column in the previous table has simply been translated into the total number of plants of each species, and we assume an area of 1 hectare (10,000 square metres) and spacing of 1.5 metres (this is often referred to as centres abbreviated to c/s, ctrs. or c/c which is equivalent to 0.45 plants per square metre).

Table 10.2 Planting mix showing proportions

Species	Proportion	Total quantity
Quercus robur	7.5%	340
Carpinus betulus	2.5%	115
Acer campestre	10%	450
Prunus avium	10%	450
Corylus avellana	20%	900
Crataegus monogyna	20%	900
Ilex aquifolium	5%	225
Sambucus nigra	20%	900
Lonicera periclymenum	2.5%	115
Rubus fruticosus	2.5%	115
		4510

Note: quantities are rounded up to the nearest 5.
All plants shall be evenly mixed and planted at 1.5 metres c/s throughout the mix area.

This method of random distribution has resulted in a number of problems. Chief among these is the ability of the most vigorous species to dominate the entire area from an early stage because they are evenly mixed in with the slower growing trees and shrubs. When this happens, constant attention is needed by thinning or coppicing to avoid the suppression and loss of the slower, long-term trees. Also, 'even distribution' does not allow us to vary the spacing of plants in order to take account of the different growth rates and habits. The management responsibilities for this kind of planting are onerous and so are often not properly attended to and the result is a laissez-faire woodland in which the most aggressive species exclude the others. Although this is perhaps more 'ecological', it wastes some of the effort put into the design and planting, and it would have been better to restrict the mix to vigorous pioneer species at the initial planting and take a successional approach to woodland establishment.

To overcome the problem of differential growth rates, one approach is to group each species in drifts or clumps of between 5 and 50 plants. This kind of grouping also has advantages in the appearance of the young plantation. Dense stands of the same species appear 'natural', being common in spontaneous colonization, and these bold masses also have a strong visual impact. This group arrangement allows us to specify different spacing for different species and even to vary the spacing used for any particular species. Slower growing, less competitive trees are placed in medium-sized groups of between 10 and 20 where they will occupy an area free from immediate competition. The area would be between 10 and 50 square metres in size, which is large enough to give good light conditions for most of the group, but small enough to benefit from the shelter of surrounding, taller plants. At least one of each group can then be expected to grow to maturity.

The faster growing trees and shrubs, or those chosen specifically as a short-term nurse, can be treated in a number of ways. If they have reasonably compatible growth rates (e.g. larch and birch) they can be evenly mixed, or they can be segregated in drifts for visual reasons. Thus, groups of fast growers could form extensive bands weaving through the plantation and protecting pockets of the less competitive species, either in single species drifts of between 30 and 50 or in larger mixed groups. Alternatively, the fast-growing trees can be spread in

smaller pockets of 10 to 20, through a mass of competitive but lower-growing shade tolerant shrub species.

Species included in very small proportions are usually best planted in occasional small groups. For example, holly or hornbeam might be grouped in fives or tens but because of their slow growth care should be taken to locate the groups among other slower growing species such as oak so they are not smothered by trees like poplar or willow. (Holly, however, is tolerant of comparatively low light levels and so would suffer less than most species from shade suppression.)

With spacing remaining uniform, group sizes can be included in the mix schedule and arrangement specified as in Table 10.3.

Table 10.3 Planting mix showing group sizes

Species	Group size	Total quantity
Quercus robur	10	340
Carpinus betulus	10	120
Acer campestre	15	445
Prunus avium	15	445
Corylus avellana	20	900
Crataegus monogyna	30	900
Ilex aquifolium	5	225
Sambucus nigra	30	900
Lonicera periclymenum	3	111
Rubus fruticosus	3	111

Note: number totals are adjusted to be divisible by the group size.
All plants shall be planted at 1.5 metres c/s in single species groups of the size shown. Groups shall be evenly distributed across the mix area, except where otherwise shown on the drawing.

Further sophistication and a more nature-like appearance can be achieved by varying the spacing. For example, whereas most of the hazel can be safely planted in groups of between 10 and 30, at 1.5 metres spacing, some could be notch planted into thickets of 10 or 15 at 300 mm spacing, or pit planted all in one large hole. This would simulate multiple shoots from coppice stumps, (and perhaps confuse the landscape archaeologists of the future!). Birch is often found in multi-stemmed form and this can be produced in planting by placing three or five transplants in one large pit. Ash can be treated in a similar way, as can many other trees and shrubs. For some species, variety can be introduced by giving a range of acceptable spacing, say between 0.5 and 2.0 metres, rather than defining a constant spacing.

There is scope for experimentation of this kind provided that instructions given to the landscape contractor are clear and practical, but it is good practice for new and experimental techniques are at least demonstrated on site by the designer if not carried out by him or her in person. Many of these imaginative touches have been tried out with some success in ecological and nature-like planting projects (Tregay, 1983) some transplants have even been planted at odd angles rather than upright in order to produce mature specimens of more varied form.

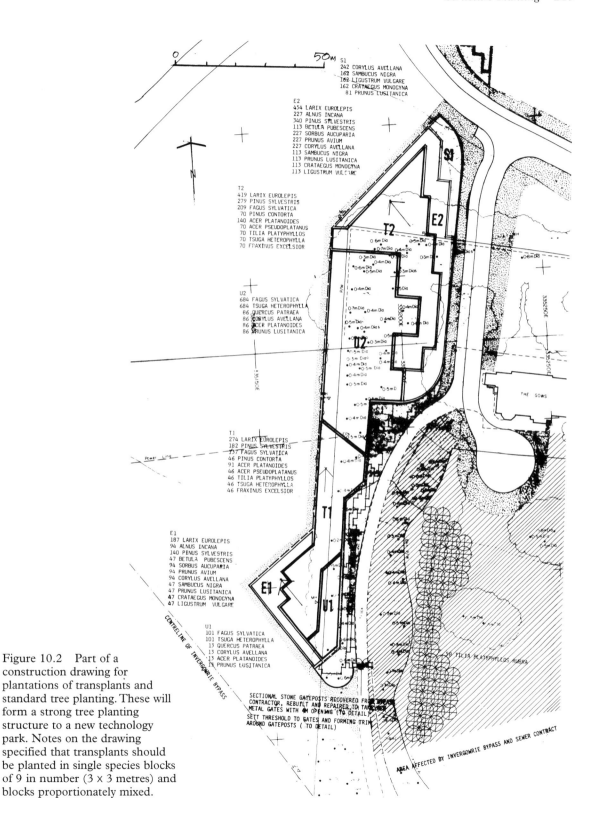

Figure 10.2 Part of a construction drawing for plantations of transplants and standard tree planting. These will form a strong tree planting structure to a new technology park. Notes on the drawing specified that transplants should be planted in single species blocks of 9 in number (3 × 3 metres) and blocks proportionally mixed.

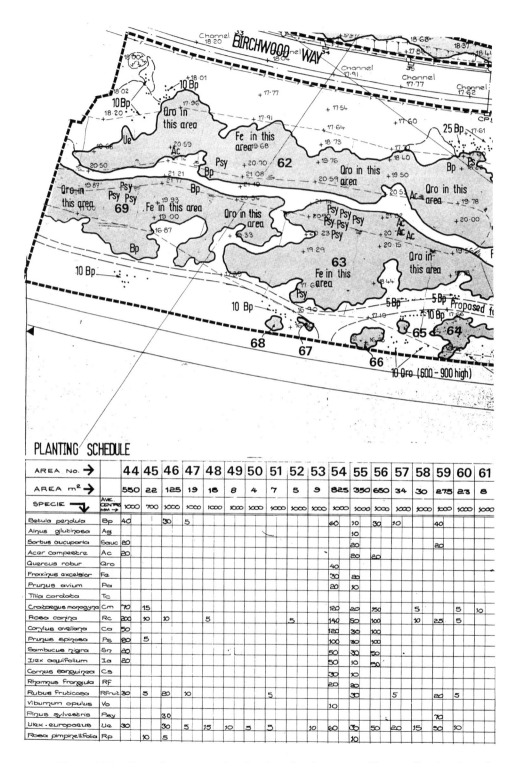

Figure 10.3 Part of a construction drawing showing nature-like woodland and scrub planting. Note the complex edge to planting areas and the concentration of certain species in selected areas.

Table 10.4 Spacing for each species

Species	Group size (number of plants)	Spacing within group (metres c/s)	Note
Quercus robur	10	1.5 m	
Carpinus betulus	10	1.5 m	
Carpinus betulus	50	2.0 m	(1 group = 5 clumps of 10 @ 300 mm c/s, clumps 2 m apart)
Acer campestre	15	1.5 m	
Prunus avium	15	1.5 m	
Corylus avellana	20	1.5 m	
Corylus avellana	50	2.0 m	(1 group = 5 clumps of 10 @ 300 mm c/s, clumps 2 m apart)
Crataegus monogyna	30	1.0–1.5 m	
Ilex aquifolium	5	1.0 m	
Sambucus nigra	30	2.0 m	
Lonicera periclymenum	3	1.5 m	
Rubus fruticosus	3	1.5 m	

All that then remains to fully specify the composition and setting out of this more complex mix is to calculate the total quantities of each species required. When we are using different spacing it is easiest to apportion species by the area rather than by number. If oak is to occupy 7.5 per cent of the planting area assigned to a particular mix, we calculate the total number of square metres to be planted with oak (= 7.5 per cent of the total area) and then multiply this by the planting density to find the total quantity of oak. For example, if the mix occupies 1 hectare (10,000 m²):

Species	Area	Group size	Spacing	Density	Total area	Total plants
Quercus robur	7.5%	10	1.5 m	0.45 per m²	750 m²	340

The same calculation is performed for each component of the mix. The schedule of species shown on the planting plan (Table 10.5) need not include columns for percentage, density or total area.

Table 10.5 Woodland core mix (total area 10,000 m²)

Species	Group size (no. of plants)	Spacing within group (c/s)	Total no. of plants	Note
Quercus robur	10	1.5m	340	
Carpinus betulus	10	1.5m	90	
Carpinus betulus	5 × 10	2.0m	100	(1 group = 5 clumps of 10 @ 300 mm c/s)
Acer campestre	15	1.5m	450	
Prunus avium	15	1.5m	450	
Corylus avellana	20	1.5m	860	
Corylus avellana	5 × 10	2.0m	250	(1 group = 5 clumps of 10 @ 300 mm c/s)
Crataegus monogyna	30	1.0–1.5m	1280	(average density 1 per m²)
Ilex aquifolium	5	1.0m	250	
Sambucus nigra	30	2.0m	500	
Lonicera periclymenum	3	1.5m	111	
Rubus fruticosus	3	1.5m	111	

Once again, the totals have been rounded up so that they are divisible by the group size to avoid sub-division of groups.

The more complex aspects of setting out such as coppice imitation and continuously variable spacing are best illustrated with sample drawings because the landscaper is less likely to be familiar with this approach. Otherwise a schedule such as that above need only be identified with the mix area on the plan that it applies to, either by code (a letter, number, colour or tone) or arrow.

Subsidiary Mixes

Any notable differences in soil or microclimate could be exploited by planting a range of trees and shrubs that are specifically adapted to those conditions. In established woodland such specific communities arise naturally and are sometimes called 'societies' to distinguish them from the main 'associations' or communities. For example, alder societies are found on wet ground in oak woods. Alder is the dominant tree and may be associated with other moisture loving species, and the shrub and field layers are also different from those in the adjacent oak woodland. Subsidiary planting mixes might be drawn up for wet hollows, exposed ridges or for steep slopes with thin, dry soil.

Table 10.6 An example of a wet woodland mix

Tree layer:	*Alnus glutinosa*	30%
	Betulus pubescens	20%
	Salix alba	10%
Shrub layer:	*Frangula alnus*	10%
	Salix cinerea	10%
	Viburnum opulus	20%

Another way to respond to differences in site conditions is to identify the most successful species in different parts of the site, say five years after planting, and to promote these with management. Indeed, the more subtle variations in soil and drainage can sometimes only be identified in this way.

Low Forest/Low Woodland

Low canopy woodland or low forest refers to plant communities dominated by trees of between about 7 and 15 metres height. It may either be a stage in development towards a full height forest or woodland, or it may be a more or less stable community resulting from environmental pressures that prevent the establishment of the tall forest species. From a design point of view it can be seen as an end in itself or as means to ultimately creating a high forest association like the New Zealand podocarp-broadleaved forest.

Fast growing 'pioneer' low forest trees include kanuka (*Kunzea ericoides*), kohuhu (*Pittosporum tenuifolium*), tarata (*Pittosporum eugenioides*), tutu (*Coriaria arborea (note this is very poisonous)*) and makomako (*Aristotelia serrata*). Birch, sallow and rowan can play a similar role in European deciduous forest development. These trees could be combined with a selection of light-demanding shrubs that would, in the longer term, survive in open areas (such as manuka, *Leptospermum scoparius*), and moderately shade-tolerant species (such as karamu, *Coprosma lucida*) that would form an understorey below the trees. We will compare two mixes, one in New Zealand and one in Britain, illustrating the similarities in principle and the differences in ecology.

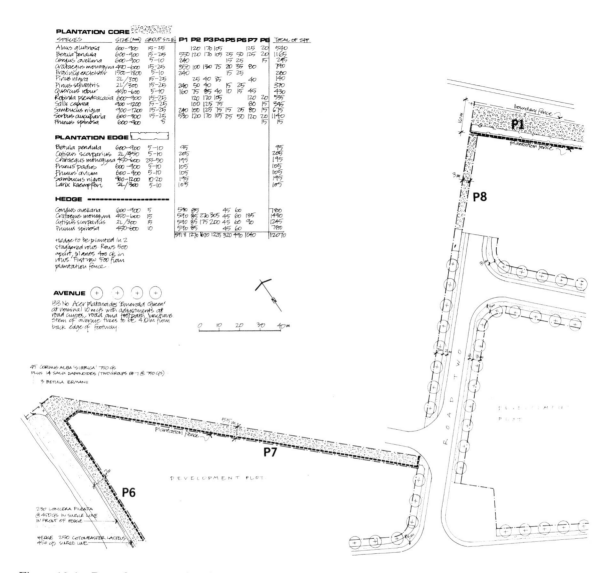

Figure 10.4 Part of a construction drawing for woodland belt structure planting to a business park. The table shows number of each species in each mix area, size of groups of each species and nursery stock size. Woodland core, woodland edge and perimeter hedge mixes are all represented. The setting out of mixes areas and plant spacing is shown in the cross-section in Figure 10.5.

First, imagine a grassland site in hill country in one of the moister regions of North Island New Zealand. Remnants of old indigenous forest will probably be found in reserves and perhaps in some steep gullies and inaccessible land, but this will not necessarily help a great deal with choosing species for revegetation because the trees that survive in these isolated bush remnants originally established under very different environmental conditions. We will find better guidance in areas where bush is recolonizing secondary sites (such as retired grazing land, steep road cuttings, and so on). Where the ground is reasonably moist but well drained, species are likely to include, for example, mahoe

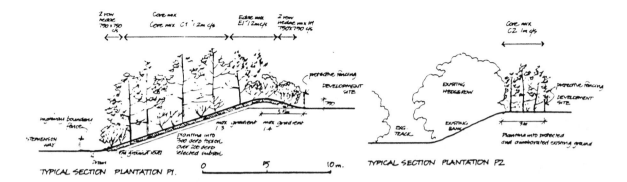

Figure 10.5 The use of cross-sections to show the relationship of different mixes and plant spacings in woodland belts around a business park.

(*Melicytus ramiflorus*), rangiora (*Brachyglottis repanda*), kohuhu, ti kouka (*Cordyline australis*), tarata, houhere (*Hoheria sexstylosa*), whauwhaupaku (*Pseudopanax arboreus*) and tutu. On drier ground we would be likely to find kanuka and shrubby species like manuka (*Leptospermum scoparium*), tauhinu (*Cassinia leptophylla*) and small leaved coprosmas or it may be dominated by the adventive colonizers, gorse (*Ulex europaeus*) and broom (*Cytisus scoparius*).

If the regenerating bush is at an early stage it would be too dense to include a distinct shrub layer, but a mature secondary bush community will be a little more open and some shrubs can grow below the tree canopy, including karamu (*Coprosma lucida* and *Coprosma robusta*), kanono (*Coprosma grandifolia*), rangiora (*Brachyglottis repanda*) and hangehange (*Geniostoma ligustrifolium*) and some of the small-leaved coprosmas. We can select from these species to design a mix that will grow first as a vigorous pioneer thicket, then become a low forest 'bush' community and eventually provide the conditions for colonization by high forest trees such as rewarewa (*Knightia excelsa*), tawa (*Beilschmiedia tawa*), hinau (*Elaeocarpus dentatus*) and the podocarps. An example of such a mix would be as follows, but please note that all mixes illustrated in this book are necessarily hypothetical and they are intended to be illustrative only. They should never be copied on an actual site. The detailed ecology of each site must always be thoroughly understood before finalizing any planting of indigenous species.

Table 10.7 An example of a New Zealand low forest mix

Tree layer:	*Pittosporum tenuifolium*	15%
	Hoheria sexstylosa	15%
	Melicytus ramiflorus	10%
	Pseudopanax arboreus	10%
	Cordyline australis	5%
Shrub layer:	*Coprosma lucida*	10%
	Brachyglottis repanda	10%
	Coprosma robusta	10%
	Coriaria arborea (note this is very poisonous)	5%

Plate 144 Self-sown birch (*Betula pendula*) and goat willow (*Salix caprea*) have colonized open land to form this pioneer low woodland at Stocksbridge, Yorkshire, UK. Note the high canopy woodland developing in the background.

Plate 145 A mosaic of open space and young woodland of birch (*Betula pendula*) and oak (*Quercus petraea*) in a Sheffield park, UK.

Plate 146 This fenced framework plantation for a science park in Warrington, UK, contains a woodland scrub mix of transplants and groups of staked ash 'whips' (*Fraxinus excelsior*). Note that the plantation incorporates and protects a remnant of an old hedgerow.

It is interesting to compare this situation with the European example of birchwoods. These occur on free draining, acidic soil in the moister areas of north or west Britain, where they form indigenous low-canopy woodlands that have developed in areas affected by past management or disturbance. The original forest would probably have been sessile oak–birch woodland, but the oak has been lost, perhaps by felling, and the low woodland is now dominated by the downy and silver birches (*Betula pubescens* and *B. pendula*) associated with rowan (*Sorbus aucuparia*), willows (*Salix* sp.) in wet places and, locally, bird cherry (*Prunus padus*). The shrub layer includes hazel (*Corylus avellana*) and, occasionally in wetter areas, guelder rose (*Viburnum opulus*). Gorse (*Ulex europaeus*) and broom (*Cytisus scoparius*) are present in light glades and open edges. In areas where this kind of woodland is typical we could create something similar to that in Table 10.8.

Table 10.8　Birchwood mix

Tree layer:	*Betula pendula*	15%
	Betula pubescens	15%
	Sorbus aucuparia	10%
	Prunus padus	5%
	Salix caprea	5%
Shrub layer:	*Corylus avellana*	20%
	Viburnum opulus	20%
Glade shrubs:	*Ulex europaeus*	5%
	Cytisus scoparius	5%

If wind exposure is severe we can increase the proportion of the wind hardiest plants – birch, rowan, gorse and broom. Under sheltered conditions, the most vigorous species in the early years would be willows and so this should be either kept to a low percentage (as shown above) or, if required in bulk numbers for quick effect or a nurse crop, it would be segregated in large drifts or groups. Note that, overall, 50 per cent of the mix consists of tree species. This will ensure that the planting develops a strong woodland character with a more or less closed canopy but including some more open stands and occasional glades.

If we want to encourage the development of the birchwood to oak–birch woodland we could select and release any oak seedlings that arise spontaneously, or we could introduce oak seed or plants, once the conditions at ground level are suitable. If we do introduce oak in this way, their source should be local because they will then be well adapted to the local conditions and will not introduce new genetic material to the local gene pool.

Shrub Thicket

In the early years of descriptive ecology Salisbury (1918) identified a lowland deciduous shrub community which he called 'thicket scrub'. It is a good example

Plate 147　Scattered planting of low thicket scrub transplants protected by tree shelters in an exposed coastal location in Cumbria, UK. Species include burnet rose (*Rosa pimpinellifolia*), gorse (*Ulex europaeus*), goat willow (*Salix caprea*) and sea buckthorn (*Hippophae rhamnoides*).

Plate 148　Low scrub, including gorse (*Ulex* sp.) and dwarf willow (*Salix* sp.), is now well established in a south-facing slope at the wildlife garden site, planted for the 1984 Liverpool International Garden Festival.

Plate 149 High canopy woodland in an urban park in Sheffield, UK, with an open edge that allows free access between the open space, the path which follows the edge and the interior of the wood.

of a structural type of close-knit shrub growth with little development of lower vegetation layers. We will call this structural type 'shrub thicket' because it is a combination of terms in common use that most people would recognize as describing Salisbury's 'thicket scrub' and other similar communities. He regarded it as a sub-seral or, rarely, climax (stable) community characterized by dense stands of shrub species, and almost devoid of trees. Because in Europe these are often the result of grazing, they are dominated by thorny species such as hawthorns (*Crataegus monogyna* and *C. oxycantha*), gorse (*Ulex europaeus*), blackthorn (*Prunus spinosa*), wild roses (*Rosa* sp.) and brambles (*Rubus fruticosus*). These give protection to smaller numbers of unarmed shrubs including hazel (*Corylus avellana*) and dogwood (*Cornus sanguinea*). Bramble, field rose (*Rosa arvensis*) and old man's beard (*Clematis vitalba*) would scramble among and into the taller growing shrubs.

Dense plant communities dominated by shrubs are more diverse in a country like New Zealand because of the greater range of altitude and natural shrub habitats. Coastal scrub, sub-alpine scrub, dense shrub colonization of open sites and what ecologist Peter Wardle (1991) calls 'grey scrub' are all comparable in structure to lowland deciduous shrub thicket and so can be included in this structural category. Grey scrub consists of thickets of very stiff and twiggy, small-leaved evergreen shrubs that give a greyish appearance due to the lack of green leafage. The toughness of its outer stems makes it resistant to both frost damage and browsing even though it contains few if any prickly shrubs.

In stock-fenced planting areas with a suitable climate, a shrub thicket will eventually progress to forest or woodland. In its most vigorous stage, however, the dense canopy close to ground level will prevent the establishment of tree seedlings or a field layer. This single layer structure may persist if shrubs are planted at high densities, using species that regenerate vigorously and continuously, such as bramble and, in Britain, *Rhododendron ponticum*. A thicket of species such as manuka (*Leptospermum scoparium*), kanuka (*Kunzea ericoides*) or gorse (*Ulex europaeus*) that do not regenerate in their own shade would, sooner or later, allow a field layer of tree seedlings to develop and promote faster succession to woodland or forest.

A possible deciduous shrub thicket mix for a well-drained, calcareous soil in lowland Britain is given in Table 10.9. If these were spaced at 1 metre or 1.5 metres apart, they would rapidly form a close-knit low canopy providing visual screening and good cover for nesting birds and other wildlife. If the spacing were to be varied in different parts of the plantation, say from 1 metre to 3 metres apart, more diversity in ground conditions would develop and this would be attractive to a wider range of fauna and flora. Alternatively, some areas could

Table 10.9 An example of a shrub thicket mix (calcareous soil, UK)

Tall shrubs:	*Crataegus monogyna*	20%
	Prunus spinosa	20%
	Rosa canina	10%
	Cornus sanguinea	10%
	Ligustrum vulgare	10%
	Corylus avellana	10%
	Rhamnus catharticus	10%
Low–medium shrubs:	*Rubus fruticosus*	5%
	Rosa arvensis	5%

simply be left unplanted to become glades where tree species would be likely to colonize at a later stage.

A dense, thicket-like scrub in lowland areas of New Zealand would need to either imitate natural shrub communities like those found in exposed coastal or mountain sites or to reflect early succession stages found in the more difficult lowland sites. Note that it is important when planting indigenous species in a natural habitat to make sure that they are propagated from local sources. This will avoid genetic mixing and the consequent reduction in the genetic diversity of species. A successional scrub thicket mix for a well drained lowland site of low to moderate fertility is given in Table 10.10, and for sites of very low fertility in Table 10.11.

Table 10.10 Shrub thicket mix (lowland, NZ)

Tall shrubs:	*Coprosma robusta*	20%
	Coprosma lucida	20%
	Hebe stricta	20%
	Leptospermum scoparium	20%
	Brachyglottis repanda	15%
	Coriaria arborea (note this is very poisonous)	5%

Table 10.11 Shrub thicket mix (poor soil, NZ)

Shrubs:	*Coriaria arborea* (note this is very poisonous)	20%
	Hebe stricta	20%
	Leptospermum scoparium	20%
	Cassinia leptophylla	20%

Suitable spacing would be similar to the British example, that is, for small planting stock, between 1 and 1.5 metres apart in order to give fast establishment of a shrub canopy. This would grow to give a mature canopy of 3–6 metres height. Again, tree species would come into the scrub as it reached late maturity and began to open up. Many of these would be the fast growing, small and medium sized trees that form low pioneer forest, but some tall forest species may also arrive at this stage. The process of succession could be helped by timely planting of tree species, perhaps combined with thinning and crown raising of the maturing shrubs. If a permanent shrub thicket structure is wanted the shrubs such as *Hebe*, *Coriaria* and *Coprosma* can be regenerated by coppicing.

Woodland Scrub

Woodland scrub represents what is often a transition state between scrub, dominated by shrub species, and forest or woodland. It would contain a similar range of pioneers and small trees to that found in low woodland or forest, and it may also include young trees of the high forest dominants. The trees would form a scattered, open canopy, allowing a thicket of light-demanding shrubs and sapling trees to thrive below.

This kind of canopy structure could be created from the low canopy woodland mix by thinning and coppicing to maintain large shrub-filled glades below a dispersed canopy. However, if woodland scrub is our objective at the design stage, we can anticipate this by including a higher proportion of light-demanding shrubs and those that flower and fruit better in the sun. These would be accommodated by reducing the proportion of trees compared to that in a woodland mix. The low-canopy deciduous woodland mix for a mildly acidic soil (see pp. 225–6) could, thus, be modified to a woodland scrub mix (Table 10.12).

Table 10.12 Woodland scrub mix

Emergent trees:	*Betula pendula*	5%
	Sorbus aucuparia	5%
Shrub layer:	*Crataegus monogyna*	20%
	Viburnum opulus	20%
	Corylus avellana	20%
	Ulex europaeus	15%
	Cytisus scoparius	15%

High Scrub

In the case of both woodland scrub and shrub thicket we can modify the eventual structure to include space below the canopy by excluding the lower growing, spreading species and plant mostly tall shrubs that, are drawn up by mutual competition to tree-like form. Thorn (*Crataegus*), elder (*Sambucus nigra*), hazel (*Corylus avellana*) and goat willow (*Salix caprea*) will all grow to 6 or 8 metres or more under good conditions and, when planted en masse, will develop a raised tree-like canopy. A classic New Zealand example of high scrub is a mature manuka (*Leptospermum scoparium*) that often reaches between 5 and 7 metres in height. These also create a structure like a miniature woodland – open below with a raised canopy above of fairly even height.

Edges

The edges of plantations are of great importance for a number of reasons. From outside they are the most visible part, and at close quarters they play a key role in the structural character of the planting as a whole. Edges may be open, allowing views into the core of the forest or woodland and giving free access from adjacent land, or they can be closed with dense shrub growth to form a barrier to both access and vision, giving more shade and shelter within the core of the woodland or forest.

The edges of both tree and shrub communities offer different environmental conditions from the interior. They have higher light levels, with only periodic shade and greater wind exposure. Wind reduces both temperature and humidity. If a more or less closed edge is wanted, we can design a specific mix to take advantage of the higher light levels and provide maximum shelter.

The ecological role of forest edges varies according to the forest type and local ecology. For example, in European temperate deciduous woodland, the edge is often the most ecologically diverse part of the community and provides the greatest range of habitats for both plants and animals per unit area of the entire forest. For this reason, European plantations are often designed to maximize the edge and increase its diversity by designing small, narrow areas of planting with intricate shapes and multiple aspects. This is the reverse of the situation in countries such as New Zealand and many in subtropical climates where the indigenous vegetation is easily displaced by an invasive exotic flora. Here, the edge is the part of the native forest remnants that is most vulnerable to colonization by light-demanding adventive species, and for this reason efforts are made to minimize the extent of the edge and to increase the proportion of forest interior. This is done by filling in undulations in the perimeter of forest remnants and existing plantations and by enlarging their total size to achieve a more favourable ratio of interior to edge. In the case of revegetation, one large continuous area would be preferred to many small areas for the same reasons.

The edges of established deciduous temperate woodland are characterized by dense shrub growth and small, light-demanding tree species. The shrubs may include shade bearing species but growing with greater vigour to a denser canopy, and flowering and fruiting with greater profusion than in the shade. *Crataegus, Sambucus, Lonicera periclymenum* and *Rubus fruticosus* are all shrubs that, though they are common in the forest interior, flower and fruit more profusely at the woodland edge.

This marginal vegetation often shows a height gradient from small trees and tall shrubs, that are tucked under the outer line of the high canopy, down to sapling trees, low shrubs and herbs that border the grassland, path or other surface that bounds the woodland. The edge of tall scrub can show a similar but more restricted gradient. This gradient or 'ecotone' represents a transition between the communities of the woodland core or tall scrub and the adjacent land. In proportion to the area that it occupies, it offers relatively high visual and habitat diversity.

In plantations we can imitate this kind of marginal ecotone by designing a low edge mix for the outer perimeter and a tall edge mix to be planted between this and a woodland core mix. In order for it to establish successfully and to really contribute to the ecotone the optimum width for an edge mix is about 5 metres and a minimum width of 2 metres is essential. The width of the edge mix planting areas need not, of course, remain constant and greater visual interest and habitat diversity is achieved if there is enough space for them to vary considerably in width, broadening out in places into patches of scrub on the woodland margins and disappearing altogether in others.

We can achieve a closer match to microclimatic conditions as well as introduce further diversity if we vary the constituents of the mixes according to aspect. In the northern hemisphere, south-facing edges will be warm and sheltered and they will receive prolonged direct sunlight and allow filtered sunlight further into the woodland core. This can be reflected in a wide edge and a high proportion of light-demanding and attractive flowering species such as wayfaring tree (*Viburnum lantana*) and roses (*Rosa* sp.). North-facing edges, although considerably less shaded than the plantation interior, will receive only short periods of direct sunlight and will bear the brunt of cold winter winds. Thus hardier, more shade tolerant species will be suitable here, such as elder (*Sambucus nigra*) and blackthorn (*Prunus spinosa*). In Britain, west-facing edges suffer the strongest and most prolonged winds and east edges are prone to cold, dry easterly winds that can be damaging in spring. Species should be chosen

Plate 150 Gorse (*Ulex europaeus*) and wild roses (*Rosa arvensis* and *Rosa canina*) form a low edge to roadside woodland planting in Milton Keynes, UK.

Plate 151 A clipped *Cotoneaster lacteus* hedge forms a neat dense edge to mixed woodland structure planting at the entrance to a business park near Leicester, UK.

Plate 152 Outlying groups of self-sown birch (*Betula pendula*) add to the spatial intricacy and microclimatic diversity on the edge of this wood, Stocksbridge, UK.

accordingly, avoiding evergreens on east edges due to their vulnerability to physiological drought, and including the most wind firm species on west edges.

Shrubs and trees with a requirement for high light levels will, in the long term, be restricted to edges and glades. These include roses, wayfaring tree, dogwood (*Cornus sanguinea*), blackthorn, gorse (*Ulex europaeus*), broom (*Cytisus scoparius*), crab apple (*Malus sylvestris*), birches (*Betula* sp.) and wild cherries (*Prunus* sp.). Many of these are also common in scrub associations; indeed, woodland edges can be regarded as narrow bands of scrub restricted by the shade of the interior on one side and by a different land use or management on the other.

Edges are equally important to the forest plantings and bush remnants of New Zealand but for different reasons, as already explained. In this case the edge will have a protective barrier function. It is designed to create a rapid transition from the open conditions of light and exposure on the outside to the deep shade and shelter of the forest interior. To achieve this, species chosen should be vigorous enough to establish in the presence of exotic weeds and to persist with a dense continuous canopy that will create a heavily shaded barrier zone between the open habitat and the interior. Suitable plants depend on the area and soils but might include some of the following: kohuhu (*Pittosporum tenuifolium*), tarata or lemonwood (*Pittosporum eugenioides*) koromiko (*Hebe stricta* and *Hebe salicifolia*), mahoe (*Melicytus ramiflorus*), harakeke (*Phormium tenax*), lacebark (*Hoheria*

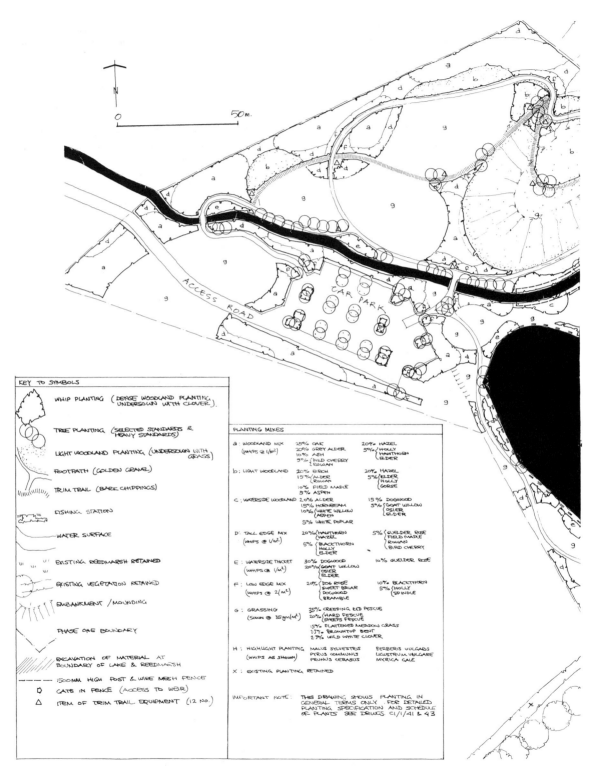

Figure 10.6 Part of a detailed planting proposal for a country park. Various woodland, edge and scrub mixes are proposed to suit environmental conditions and achieve structural and habitat diversity.

sexstylosa), whauwhaupaku or five finger (*Pseudopanax arboreus*), karamu (*Coprosma lucida, Coprosma robusta*), ngaio (*Myoporum laetum*), rangiora (*Brachyglottis repanda*) and heketara (*Olearia rani*). To these dense canopy forming species can be added a proportion of others, for diversity, including kowhai (*Sophora tetraptera*) and ti kouka or cabbage tree (*Cordyline australis*).

As well as performing the function of a weed barrier, edge planting in New Zealand should take advantage of the particular aspect of the margins. Heketara (*Olearis rani*), ti kouka and lacebark, for example, thrive and flower in the full sun of a north-facing edge whilst rangiora (*Brachyglottis repanda*) and whauwhaupaku prefer sheltered and shaded, southerly aspects which do not dry out quickly. The margins of established forest form a plant community that is often distinguished by an abundance of fruiting shrubs and lianes – especially karamu with its large red berries, ngaio, mahoe, ti kouka, poroporo (*Solanum* sp.) and lianes and climbers such as passion vine (*Passiflora tetrandra*) and bush lawyers (*Rubus* species) (Gabites and Lucas, 1998). The margins of New Zealand forest are attractive to a wide range of feeding birds, thanks to the heavy fruit crop, the nectar flowers such as kowhai (*Sophora tetraptera*) and harakeke that attract tui and bellbird, and the abundant insects consumed by birds like the fantail or piwakawaka.

Tall Edge

A tall edge refers to one that includes both shrub and tree species. For a tall edge structure, suitable species include many that would be selected for high scrub and woodland scrub. A tall edge mix to surround the deciduous oak woodland described earlier could include tree layer sub-dominants and shrub-layer species that would benefit from the more open conditions. It should also include specifically light-demanding trees and shrubs in order to provide greater species diversity. If the trees are of small or medium stature and kept to a small proportion this will avoid heavy shading of shrubs. Shrub species can be chosen from among the taller species that are capable of reaching 3 metres or more in height.

Table 10.13 An example of a tall edge mix

Medium/small trees:	*Acer campestre*	5%
	Prunus avium	5%
	Malus sylvestris	5%
Tall shrubs:	*Crataegus monogyna*	25%
	Ligustrum vulgare	20%
	Rosa canina	20%
	Viburnum opulus	15%
	Salix caprea	5%

Note that *Salix caprea* is restricted to 5 per cent due to its vigour and rapid canopy spread.

Table 10.14 A New Zealand equivalent for an edge with a shaded aspect

Medium/small trees:	*Pittosporum eugenioides*	10%
	Pseudopanax arboreus	10%
	Myoporum laetum	5%
	Cordyline australis	5%

continued

Tall shrubs:	*Hebe stricta*	20%
	Phormium tenax	20%
	Coprosma lucida	15%
	Coprosma robusta	15%

Low Edge

A low edge is one dominated by shrub species growing to between 2 and 4 metres high. Many low and medium height shrubs are characteristic of the more difficult soil or climatic conditions. *Ulex europaeus, Calluna vulgaris, Erica carnea* and *Cytisus scoparius*, for example, on exposed acidic sites, and *Erica tetralix* and *Myrica gale* on permanently damp soils. These would be suitable for a low edge mix around British woodland in comparable conditions. In time, tall herb species could colonize the plantation edge and supplement the low shrubs, but in the early stages weedy herb species would be very competitive and need to be controlled.

A possible low edge mix for neutral or calcareous soil in lowland Britain would be:

Cornus sanguinea	30%
Prunus spinosa	30%
Rosa arvensis	30%
Rubus fruticosus	10%

Rubus fruticosus is included in only small proportion because of its tendency to scramble over and smother small shrubs and because it is difficult to obtain in large quantities in the nursery trade and may have to be transplanted as stolons from local sources.

A shrub mix for a lowland coastal New Zealand location, would be:

Coprosma robusta	25%
Olearia paniculata	20%
Phormium cookianum	20%
Olearia solandri	15%
Coprosma propinqua	15%
Solanum laciniatum	5%

Plant spacing for low edge mixes should normally be closer than for core mixes and tall edge mixes because of the lesser spread of many of the species. If the core and tall edge spacing is 1.5 metres then 1.0 metres would be suitable for many low edge species or if a more rapid establishment is desired, 0.75 metres centres could be used. We should also remember that the ultimate height of a planting mix will depend to a large extent on environmental conditions. A low edge in an exposed coastal or mountain site might grow to half the height or less than the same mix in a sheltered, nutrient-rich site.

Outlying Groups

If established forest, woodland or scrub is surrounded by cultivated or otherwise intensively managed land, it will have a sharply delineated edge. Where the adjacent land is unmanaged, on the other hand, forest or scrub will, sooner or later, colonize and spread. Various stages of this colonization can be observed on abandoned pasture, around unmanaged scrub, along roadside and railway verges

and other 'disused' land. The sight of this spontaneous process underway can be satisfying – evidence of nature at work in the landscape.

If space allows, we can encourage or imitate this kind of marginal colonization around the edges of plantations and revegetation. It would happen naturally under the right management conditions, but only after the planted trees and shrubs had reached the stage of setting viable seed, or if there are other parent trees locally. For an earlier effect we can plant small groups of various shapes and sizes and occasional individual trees or shrubs in grassland adjacent to the plantation. Suitable species would include those already present in the woodland edge mixes and light-demanding scrub and pioneer trees. These outlying groups are thus rather like pieces of the edge or scrub mix broken off and scattered beyond the main body of the planting.

Where the ecology is favourable, the intricacy and variety of the plantation margins will be enhanced if the edge is irregular in outline, creating bays and spurs that interlock with surrounding open land. Not only does this fragmented edge give the appearance of natural colonization, but its greater length and the numerous small-scale variations in light and shade, shelter and openness, further diversify the habitats for invertebrates and birds.

Clumps and Copses

Clumps and copses are compact, contained patches of woodland or forest; but the words do have slightly different connotations. Copse derives from coppice and so suggests a small wood that, if not actually managed as coppice by regular cutting, does at least include a shrub understorey. Tree clumps, on the other hand, probably make us think of small grazed stands of trees in parkland with only a sparse understorey, if any.

Clumps and copses, although isolated elements and lacking much of the ecology of larger woodland or forest proper, are of sufficient scale to contribute structure to the largest outdoor spaces. They do not provide continuous enclosure but a number of them will create a fluid space that opens and closes as we move around and between them. A single clump or copse can be a focus or landmark in parkland or within the wider landscape. Their structural role is similar to that of single trees but on a larger scale and they were a well used element in the landscape gardening of larger private European estates in the eighteenth and nineteenth centuries.

The canopy structure of a tree clump can best be achieved by a woodland design approach with a simple mix that includes only trees. Single species clumps are often visually successful because of their boldness and uniform appearance. We could use a single species at time of planting or, if the chosen tree needs shelter to establish well, we could add nurse species to the mix and remove them once the long-term trees are established.

A copse, on the other hand, would need a more varied mix including shrub as well as tree species and could be further diversified with edge mixes. To fully develop both edge and interior structure the copse needs to be at least 15 metres but preferably 20 metres across. If less than 15 metres, a simpler structure is best, such as a single edge mix that follows only part of the perimeter, or a single woodland mix could be used that includes shrub species and small trees that will grow in both the shade in the interior of the copse and the open conditions at its margins.

Woodland and Forest Belts

Belts are narrow strips of woodland or forest too wide to be called a hedgerow but too narrow to allow the full development of both edge and interior. They can be established in linear plantations between 3 metres and 15 metres wide and are often used in large-scale landscape projects because they can provide a planting framework that defines and encloses zones for different land use or character. They are economic in use of ground area and can absorb irregularities in the shape of site boundaries leaving more efficiently shaped development compartments. Belts also provide improved microclimate within landscape compartments, but to provide optimum shelter, the belts needs to be at least 10 metres wide. For a full treatment of shelterbelt planting refer to Caborn (1975) and Ministry of Agriculture, Fisheries and Food (1968).

Although woodland belts are an important element in the large-scale framework of the landscape they bring certain management problems that should be understood by the designer. If they are less than about 25 metres wide, large-scale clearance can sometimes be required for regeneration. The most vulnerable woodland belts are those that consist of dense stands of fast and evenly growing, short-lived trees of the kind often planted for quick screens. These may be very successful in their early years, giving rapid impact and so pleasing both client and planning authority, but we will later have to make the decision whether to clear, fell or regenerate in compartments. Neither of these alternatives are ideal so management of woodland belts is often neglected resulting in gradual decline.

If we want to help the long-term perpetuation of a woodland belt we can design it to have a varied and open canopy structure that includes glades and areas of scrub that can be planted with forest trees in the future without the need to remove major sections of an established, uniform stand. With this approach the overall structure of the belt would be maintained even though individual trees and groups of trees come and go.

The design of woodland belts can be approached in the same way as larger plantations. On many sites we will wish to achieve the best screening and sheltering that is possible and if a width of 25–30 metres is available we can achieve both a dense screen and optimum shelter and allow for future regeneration. However, 5–10 metres is more common, so we might need to accept that the woodland belt will be a temporary feature and make the best use of the width available. Maximum bulk and density can be achieved with a high or low woodland mix including a dense shrub understorey and an edge mix along at least one margin, preferably the side that faces the prevailing wind.

Impenetrability will not necessarily be the objective, however. For more

Plate 153 This belt of woodland is no more than four metres wide but, ten years after planting, provides an excellent screen to extensive car parks. In the future selected coppicing of shrubs and thinning of trees will be necessary in order to maintain the visual density of the belt throughout its height (Warrington, UK).

openness and visibility in the mature plantation, we could plant just a high canopy tree mix and the end result would be tall trees with more or less open space below. Many woodland belts of this structure can be seen in first generation postwar British new towns. They were often planted en masse with 'standard' trees in mown grass but later experience indicated that the same results can be achieved more quickly and cheaply if we adopt a woodland planting or revegetation approach, starting with small planting stock at close centres.

For a woodland belt plantation to include an interior and an edge along both margins we would need a minimum of two mixes, a core mix and an edge mix. If the plantation were wide enough, say 15 or 20 metres, we could introduce more variety with low and tall edge mixes on different sides or, if the belt ran roughly east–west, the sun-facing margin would support a more light-demanding edge mix than the shaded margin. This would give us a maximum of five primary mixes. If ground conditions vary significantly within the plantation we may need to reflect this in subsidiary mixes. A final level of subtlety could be introduced by inserting clumps or even single specimens into the mixes near or just beyond the edge of the plantation in key positions such as entrances. These would stand out from the backcloth of foliage and act as foci or accents.

Subtle variations like these can help give maximum habitat potential and introduce visual richness, but simple effects can be very successful and memorable. Generous belts of just one or two, well-chosen species, can give the landscape a strong character and become landmarks in their own right. The shelter belts of Scots pine in Breckland, Norfolk and beech and sycamore shelter belts in the British uplands have this quality.

Hedges and Hedgerows

A hedge is most easily defined by its function. Hedges originated in agriculture as stock barriers and, even in park and garden roles, the barrier function remains essential, so a succinct definition would be a line of woody plants managed to form a barrier. A distinction between hedge and hedgerow is helpful. We will use 'hedge' to describe a linear planting that is either regularly trimmed to keep it compact and impenetrable, or consists of naturally compact shrubs that need no more than occasional clipping to maintain a continuous barrier. Although clipped hedges often include tree species, these tend to be those that are well adapted to close trimming and become an integral part of the hedge tapestry. A 'hedge' by our definition would not include trees growing in their natural tree form habit. A 'hedge' is thus a compact living wall akin to a simple free-standing masonry wall.

We will use 'hedgerow' to describe both hedges that have become overgrown and include shrub and tree species at various stages of development, and hedges in which trees have been deliberately planted or selected during management to grow to maturity above the clipped hedge. A 'hedgerow' thus contains either trees or tall shrubs in their natural habit and is rather looser and more varied in form than a hedge. If it has developed from an unmanaged hedge, it may have lost its original barrier function.

Hedges and hedgerows are familiar and characteristic features of large parts of the agricultural landscape in lowland Britain and, to a lesser extent, of other countries. In Britain where they support a wide variety of native species and habitat, hedges are a good example of the balanced coexistence of human activity and nature conservation. When originally planted they were probably never intended to be anything other than the most economic means of sub-dividing

land and facilitating profitable farming, but they have since become havens for wildlife and their removal is now opposed by conservation interests. Hedged fields in livestock farming areas are of a moderate, human scale and the hedges give a sense of enclosure and protection that is uncommon in intensive landscapes of the agricultural industry. From a more distant viewpoint they can be seen to weave the fields, woods, tracks, roads and other elements of the rural scene into a single green tapestry. Rural hedges and hedgerows give an effective and attractive landscape structure that helps to integrate the economic, wildlife and visual functions of the countryside.

In New Zealand hedges are some of the most unfortunate introductions of exotic species. Gorse and barberry are two serious agricultural weeds and 'plant pests' that were originally imported and planted by European settlers to form paddock hedges. It was not realized at the time that they would adapt to their new home to the extent that they would spread to cover hundreds of thousands of hectares of marginal farmland, river margins and disturbed areas. There is no ecological reason why some native New Zealand plants should not form good agricultural hedges, but the reason they have not been widely adopted is because they are slow growing, expensive to establish, do not have thorns to dissuade stock and cannot be moved. The standard solution is the electric 'hot' fence, and native tree and shrub hedges are only likely to find a role in the agricultural landscape where there is a desire for visual and ecological amenity as well as boundary definition.

Hedges

Hedges are long-established elements of park and garden design. They can provide many functions including enclosure, spatial definition, sculptural form, decorative pattern and a backdrop to displays and sculpture. The first function of a traditional hedge, whether in the rural or urban landscape, is to make a dense barrier in a narrow strip of ground. To establish an impenetrable canopy of foliage, we need species with a habit of dense growth that is promoted by regular trimming.

RURAL HEDGES Rural hedging is usually on a larger scale than urban or garden hedges and, because of the quantity involved, the species for rural hedging need to be cheap and easy to produce. Their growth habit is also important – dense, compact foliage down to near ground level is essential. The best hedging plants respond well to regular trimming or laying, producing a good proportion of compact side shoot growth rather than all vigorous extension shoots. In addition, it is important that the species chosen fit well with the character of the local vegetation, as in most cases they will need to fit with the existing hedges, woodland or scrub.

With age, rural hedges gain a wide diversity of woody and herbaceous species. The majority of these colonize from local sources so that the hedge comes to reflect the flora of the surrounding landscape. From an ecological viewpoint, hedges could be regarded as narrow strips of scrub where the succession to woodland is prevented by management, and hedgerows could be thought of as strips of woodland scrub or woodland edge. Indeed, they have a similar richness of species to that found in woodland margin communities. Rural hedges may have originated in several different ways – as woodland relics that have survived clearance; from spontaneous scrub colonization of unmanaged field boundaries; from hedge planting of mixed species, or from hedge planting of a single species (Pollard *et al.*, 1975). Many parts of Britain are characterized by particular hedge

species, for example, hazel (*Corylus avellana*) in Monmouthshire, elm (mainly *Ulmus procera*) in Somerset and north Buckinghamshire, and karo (*Pittosporum crassifolium*) enclosing the bulb fields of the Scilly Isles. Yet some of the typical plants in old established hedges may not be the best in terms of growth habit, so when planting new hedges, we need to decide whether the first priority is the local character or the effectiveness of the hedge as a barrier.

SPECIES FOR RURAL HEDGING In Britain, the most commonly planted hedging species has been hawthorn or quickthorn (*Crataegus monogyna*). This is because it is ideally suited to large-scale work, being economical to propagate and quick to establish in a wide range of soils and climates. It forms an impenetrable, thorny barrier. Other species planted to form rural hedges include hazel (*Corylus avellana*), especially in Wales, holly (*Ilex aquifolium*) in Staffordshire, blackthorn (*Prunus spinosa*) and elm (*Ulmus* sp.) in various parts of Britain, beech (*Fagus sylvatica*) on the margins of Exmoor and fuchsia (*Fuchsia magellanica*) in the west of Ireland. All these have been used in single species hedges because their growth habit is so well adapted to hedge management.

Many other shrubs and trees have been planted in mixed hedges in the past because of their availability as young seedlings in local woods and scrub and, more recently, by conservationists and landscape designers wishing to achieve diversity in new hedges and hedgerows. These secondary species include field maple (*Acer campestre*) – an excellent hedging plant and much used in France; hornbeam (*Carpinus betulus*) – like beech, rather slow and more common in parks and gardens; wild privet (*Ligustrum vulgare*); cherry plum (*Prunus cerasifera*) – not a British native but it fits the rural landscape; dogwood (*Cornus sanguinea*), guelder rose (*Viburnum opulus*), wayfaring tree (*Viburnum lantana*), and oak (*Quercus robur* and *Q. petraea*). The oaks, although they may become rather open at the base, respond well to regular trimming by retaining their brown leaves in winter like beech and hornbeam. Any of these could be used in the rural landscape provided that attention is paid to local character and typical vegetation.

There are a number of species, however, sometimes planted for hedges in rural areas, some of them recent introductions, that are difficult to harmonize with the

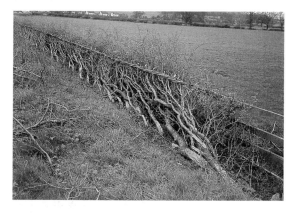

Plate 154 Traditional laying of a recently established rural hedge in Cheshire, UK. Note the fence put up to contain stock while the hedge is developing into a stock-proof barrier.

Plate 155 Tall willow hedges shelter kiwi fruit orchard in Bay of Plenty, New Zealand. *Salix matsudana* is commonly used for this purpose.

British landscape and poor for wildlife. The most common is leyland cypress (x *Cupressocyparis leylandii*) which is a popular hedging plant because of its rapid growth rate – an annual height increment of 1 metre is common. It is used in gardens, parks, estates, industrial screenings, and windbreaks by fruit growers and market gardeners. Its form and foliage colours are unlike any other native or naturalized trees in our countryside and so it is often conspicuous and intrusive in rural settings. This effect is exacerbated when hedges or individual trees of leyland cypress are allowed to grow to full size. (Once above about 4 metres, hedges are difficult and expensive to trim on top.)

There are also some British native species that should be avoided if an even, dense hedge is wanted. Elder (*Sambucus nigra*), the larger willows (*Salix caprea, S. cinerea* and other species) and poplars (*Populus alba, P. tremula* and other species) all grow so rapidly that they dominate and suppress other species and will result in a hedge of very uneven height within a month or two of trimming. In addition, they have a leggy habit and leave large gaps near the ground, even when regularly cut. These vigorous species could, however, be included in hedgerows where a more variable and open character is desired.

There is a good range of reliable hedging plants to choose from without using exotic species and the more vigorous natives. A selection should, of course, take into account the local conditions of soil and exposure. Some plants are highly adaptable – hawthorn and blackthorn for example – while others are best suited to specific conditions, such as wayfaring tree on calcareous soils and guelder rose in moist ground. Another important factor for large-scale hedging is cost. Close spacing is necessary for a quick dense barrier, and so large quantities of plants are needed. Prices vary greatly; the cheapest species is usually hawthorn while holly can be ten times as expensive due to the propagation techniques used, its slower growth and the need for container-grown or rootballed stock.

HEDGE MIXES Let us assume that we need a quick growing hedge for a site with an average loam or clay loam soil in a reasonably sheltered midland site. If we want to keep the costs down, the chief constituent of the mix might be hawthorn. Other species could be drawn from the characteristic local hedge and scrub flora. A total of five or six species would be enough to provide an attractive diversity, but there is no rule about this and factors such as local character, wildlife habitat, and stock availability will affect the range to be used.

A possible hedge mix for a neutral to calcareous soil would be:

Crataegus monogyna	50%
Prunus spinosa	15%
Corylus avellana	15%
Acer campestre	15%
Cornus sanguinea	5%

If winter foliage is important and the rate of establishment less so, a suitable mix would be:

Ilex aquifolium	30%
Fagus sylvatica	30%
Crataegus monogyna	10%
Acer campestre	15%
Prunus spinosa	15%

The evergreen foliage of holly (*Ilex aquifolium*) and the retention of leaves through the winter on beech (*Fagus sylvatica*) would make this a colourful and varied hedge throughout the year. These species are slower growing than the remainder of the mix and so given higher proportion of the planting mix. The more vigorous shrubs, although smaller in numbers at planting, will ultimately form a comparatively large proportion of the established hedge.

In New Zealand, red matipo (*Myrsine australis*) and forms and hybrids of *Coprosma repens* such as 'Karo Red' and 'Yvonne' are some of many that make fine winter foliage hedges.

SETTING OUT AND SPACING In order to create dense even growth from near ground level upwards, hedges are traditionally planted as small stock at close spacing. For example, it is common to use two-year-old hawthorn transplants (these can be any height between 30 cm and 60 cm). Occasionally, seedlings between 20 cm and 40 cm tall are transplanted to their final positions after just one season's growth in the nursery. Spacing can be varied according to the budget available but 30 cm is common for the smaller transplants. Sometimes, three-year-old transplants of between 60 cm and 90 cm tall are used. These, and the larger two-year-old plants, can be set 45 cm apart.

It is unusual to use larger plants, especially for long hedges in rural locations, but occasionally there is a need for a strong visual impact immediately after planting. This could be achieved by using advanced stock, 0.9–1.2 metres tall at 45 cm or 50 cm apart. It is often more difficult to get dense branching near ground level with larger stock because the plants will probably have been drawn up in the nursery rows. If these plants are cut back to one third of their height, this will promote rapid, bushy growth and produce better hedging plants. From a cultural point of view this hard pruning is preferable to the short-term gain in height achieved by not pruning.

To achieve a dense barrier as soon as possible a good approach is to plant two staggered rows 30 cm or 45 cm apart. With this method, the distance between plants is effectively reduced to half (approximately 15 cm to 23 cm) by the extra row and the width of the hedge will reduce gaps at the base. Three rows can be justified if a wide hedge is wanted, and should be staggered for maximum overlap. Single row hedges are sometimes planted in rural locations but are more common in gardens and urban sites where space is limited. They are most successful if the densest growing species are used, such as yew (*Taxus baccata*), totara (*Podocarpus totara*), beech, hornbeam, and korokio (*Corokia* x *virgata* cultivars).

For hedges of only one species, the setting out can be described on the planting plan in words, although a small sample detail of the dimensions within and between rows and to adjacent plants or edges is helpful. For mixed hedges, not only dimensions but also the relative positioning of different species should be drawn. This can be done economically by designing a planting unit, perhaps 5–15 metres long, that is to be repeated along the entire length of the hedge. This technique is similar to the repeating unit matrix that can be used to detail large-scale plantation mixes.

Hedgerows

In hedgerows the barrier function is often less important, and trees or large shrubs can be allowed to grow to maturity above the smaller species. The lower layer can be trimmed to maintain its compactness or allowed to develop its natural form.

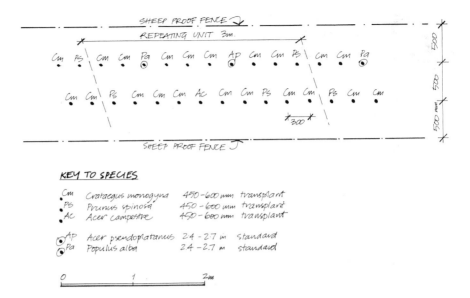

Figure 10.7 Part of a drawing showing a repeating unit for hedgerow planting on a reclamation site. Note close spacing for quick establishment of a stock-proof barrier and standard trees confined to one row for ease of hedge maintenance.

If the hedgerow is to include fully grown trees, these should be positioned at the desired intervals. If the hedge is to be trimmed in the early years, they are best planted as staked, feathered or standard trees rather than as transplants, to distinguish them from the plants that are to be trimmed.

A hedgerow is rather like a narrow strip of tall woodland edge or woodland scrub and we can approach the choice and arrangement of species in a similar way. The main differences will be the scale of grouping of different species and the advantages of planting in parallel rows rather than randomly. Species groups should be smaller in hedgerows than in woodland or scrub because of the narrower width. Group sizes from 5 to 15 would give a good balance of diversity and there is less risk of vigorous species completely suppressing their neighbours because the slower growing canopies can spread laterally into the space beside the hedgerow. Hedgerows are best planted in parallel rows because their alignment is likely to be important and because aftercare and establishment work in a narrow strip is made easier by regular spacing.

We need not confine hedges and hedgerows of traditional rural character to rural locations. They can be ideal barriers and boundaries in housing developments, in the grounds of industry and other institutions, in the larger town parks and in urban wildlife parks. Indeed, a design precedent for this has been set by the conservation of existing hedges and hedgerows and their retention within new developments. However, hedges in gardens, town parks and urban areas have traditionally had a more formal or exotic character and the next section will discuss the design of traditional urban and garden hedges.

Urban and Garden Hedges

Hedges, both formally clipped and free growing, are among the most important structural elements in the layout of gardens and urban landscape. For example, the expertly tended, traditional formal hedges in the early twentieth century

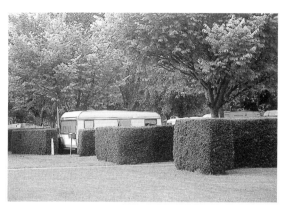

Plate 156 This broad, medium-height hedge of box (*Buxus sempervirens*) provides low-level enclosure for bays of colourful bedding. A weaving hedge such as this is an excellent means of structuring a linear planting area and creating well-proportioned compartments for planting display.

Plate 157 Boundary definition and containment are important functions of hedges. New Zealand totara (*Podocarpus totara*) is a good formal hedging plant for urban locations (Hamilton, New Zealand).

gardens at Hidcote Manor in Gloucestershire and Newby Hall in North Yorkshire are crucial to the spatial composition and experience of these gardens. Formal, clipped hedges are less common in the urban landscape because of the regular trimming that they demand. However, despite the cost of maintenance, clipped hedges have undergone a revival, with their sculptural qualities being utilized in contemporary as well as period design. The Thames Barrier Park in London is a good example of a contemporary, sculptural interpretation of the traditional role of clipped yew hedging as a backdrop to herbaceous planting. Hedges have also found a place in prestige landscape schemes such as business parks and corporate headquarters. Here they form distinctive and efficient enclosure for car parks, lunch areas and small-scale planting, and are also employed in the traditional role of boundary definition. In addition to these structural roles, the colour and texture, and the crisp line of a well-maintained hedge can be a complement to flowers, foliage and other landscape materials such as stone, timber and metal.

If a less intensively maintained, or a more informal green barrier is required there are many shrubs such as the smaller *Hebe* species, *Corokia* cultivars, *Escallonia* cultivars and *Rosa rugosa* that will form a compact, dense hedge needing only an occasional light trim to avoid it getting leggy at the base. Such informal, low maintenance hedges have become common due to the need to keep labour costs as low as possible, but they also have many aesthetic qualities that justify their use. They make a more casual outline than clipped yew or box and, because pruning is minimal, many species also flower and fruit.

SPECIES FOR FORMAL HEDGING In Britain and other cool temperate climates the classic clipped hedging plants are yew (*Taxus baccata*), box (*Buxus sempervirens*) and beech (*Fagus sylvatica*). All look good throughout the year, as yew and box are evergreen and beech retains golden brown winter foliage when clipped. All respond to regular trimming by producing dense twiggy growth down to near ground level. This compact habit, however, is due to their naturally slow growth rate and so it is no good being impatient for such a fine hedge. Yew and box will take about ten years to form a full hedge 2 metres high, and beech takes seven or eight years to achieve the same.

Cypress (*Cupressus sempervirens* and *C. macrocarpa*) and myrtle (*Myrtus communis*) are the classic hedge plant in Mediterranean countries, and feature in such great hedged gardens as the Generalife in Granada. A number of New Zealand plants make excellent clipped hedges. Totara (*Podocarpus totara*) is a good match for yew, its only disadvantage being that it does not regenerate from hard pruning into old wood. Korokio (*Corokia* × *virgata* compact cultivars, like 'Mangatangi' and 'Cheesmanii') and kohuhu (*Pittosporum tenuifolium*) especially cultivars like 'Mountain Green'. In a mild, seaside location few can match karo (*Pittosporum crassifolium*) and taupata or mirror plant (*Coprosma repens* and its cultivars).

When formal hedges are required in an urban or garden environment, it is often appropriate to make use of a wide range of exotics. This provides a good choice, in particular of evergreen and fast growing species and, with care, they can make hedges of comparable quality to yew, box and beech. These include the following: hornbeam (*Carpinus betulus*), which is very similar to beech in foliage but faster growing in good soils; western red cedar (*Thuja plicata*) and white cedar (*Thuja occidentalis*), both of which have emerald green foliage; holly (*Ilex aquifolium*) with its shiny dark blue green leaves has a depth of tone similar to yew; holm oak (*Quercus ilex*) is a similar colour to holly but with a matt surface; akiraho (*Olearia paniculata*); pohutukawa (*Metrosideros excelsa*) tends to retain its juvenile foliage when clipped as a hedge; myrobalan plum (*Prunus cerasifera*); cherry laurel (*Prunus laurocerasus*), with large shiny bright green leaves gives a bold texture; and field maple (*Acer campestre*), which is a common hedging plant in continental Europe. Most of these species are faster growing than yew and box and so can provide an alternative where quick impact is needed.

Two shrubs extensively used as clipped hedges are garden privet (*Ligustrum ovalifolium*) and *Lonicera nitida*. They are popular because of their very rapid growth and low cost, and they make good solid hedges. However, they need clipping at least three times each season to keep them even reasonably shapely and compact. This may be too heavy a maintenance liability to impose on most clients.

Choice of species will depend on many criteria. Growth requirements are paramount, but growth rate, cost and aesthetic qualities will also be important. With the exception of cherry laurel, all the species quoted possess fine or medium textured foliage. (This is no coincidence – small leaves and twigs allow trimming without unsightly foliage damage, and compact growth with fine twigs and leaves is a characteristic of many slow growing, compact plants.) If the hedge is to form a backdrop or we want it to be visually recessive for other reasons, then fine texture is an advantage. Dark colour and matt surface provide an excellent background to many features such as sculpture, statuary, fountains, flower colour and foliage.

Some shrubs will flower and fruit even when regularly trimmed, provided clipping is done at the right time of year. For example, bottlebrush (*Callistemon citrinus*) and myrtle respond well to clipping and also flower, Darwin's barberry

(*Berberis darwinii*) produces rich orange flowers in spring on the previous year's shoots. It can, thus, be clipped after flowering and again, lightly, in autumn and will produce a display the following spring. Firethorns (*Pyracantha* species), especially the compact cultivars, and *Cotoneaster lacteus* can be treated in a similar fashion and have the added attraction of berries in late summer that last well through the winter.

There are many additional species that, although not often seen as such, make attractive and effective hedges. Rosemary (*Rosmarinus officinalis*) can be clipped to form a low aromatic hedge. *Berberis thunbergii* and small cultivars of rohutu and its hybrids (*Lophomyrtus obcordatus* and *L.* x *ralphii*) are also good for dwarf hedging. *Viburnum rhytidophyllum* makes an imposing, if sombre, background and many species of barberry including *Berberis thunbergii* and *B. sargentiana* are effective barriers. Indeed, it is worth trying any shrub that has a compact growth habit and we may discover an unusual and attractive hedging plant.

MIXED HEDGES The mingling of foliage textures and colours in hedges of mixed species can be effective in formal, urban or garden planting, just as in rural locations. The variations of green and copper beech, of beech and holly in winter can be very attractive. A memorable combination seen by the author was a 1-metre tall clipped hedge of *Senecio* 'Sunshine' and *Berberis thunbergii* 'Atropurpurea', planted to edge a car park. The contrast of grey and plum foliage colours was emphasized by the harmony of texture and the consistency of shape and outline.

For establishment and ease of maintenance of mixed hedges it is important to choose plants with well-matched growth rates. If one is more vigorous it can still be included provided that its proportion in the mix is reduced accordingly. For example, 15 per cent of firethorn in a beech hedge would add winter foliage variety and the attraction of autumn fruits without dominating the slower growing beech.

SPECIES FOR INFORMAL HEDGING The criterion for successful informal hedging shrubs is a natural compactness of habit and a canopy well furnished to the ground. Their form may vary from rounded dome-shaped shrubs like *Viburnum tinus*, *Hebe* and *Olearia* species, *Griselinia littoralis* and *Escallonia* cultivars, to more upright growers such as *Fuchsia magellanica*, *Berberis gagnepainii* and the smaller, clump-forming bamboos like *Arundinaria murieliae*. All these species make a dense barrier to their mature height if planted sufficiently close. Although, botanically, New Zealand flax or harakeke (*Phormium tenax*) is a large herb, it makes a very effective hedge in its native land, growing up to two or three metres high and flowering on tall stems held above the foliage.

One of the great advantages of informal hedges is that flower and fruit are not inhibited by trimming. Many roses, for example, make effective and showy informal hedges, especially *Rosa rugosa* cultivars, hybrid musk roses and a number of species roses and hybrids such as *R. rubiginosa*, *R.* 'Canary Bird' and *R. pimpinellifolia*. For lower-growing, informal hedges species include lavender (*Lavandula spica*, *L. stoechas*, *L. dentata* and cultivars), *Berberis thunbergii* 'Atropurpurea Nana', *Potentilla* species, the smaller shrubby veronicas (*Hebe* sp.) and rosemary (*Rosmarinus officinalis*). Many species can be planted as an informal hedge. The most important thing to avoid is, in the case of taller shrubs, a leggy or open habit and, for low hedges, sprawling or excessively spreading growth.

SETTING OUT AND SPACING For both formal and informal hedges the principles of setting out and spacing are similar to those that apply to rural hedges containing mainly native species. Under most conditions it is best to plant

small stock as close together as possible. If the plants are available as field-grown transplants the smallest size available should be specified and planted at 35–45 cm spacing for tall and medium hedges or 25–35 cm for low hedges, in two staggered rows 30–40 cm apart. If a narrow hedge is required, a single row is usually sufficient but the spacing in the row should then be towards the low end of the ranges quoted. For example, bare-root *Rosa rugosa*, 45–60 cm tall could be cut back to 20 cm and planted in a single row at 30 cm spacing.

Many species used in urban and garden hedges are only available as container-grown stock and may be difficult to obtain as small 'liners' or 'root trainer' stock. They will also be more costly than bare-root, field-grown transplants. Larger, container-grown plants should, therefore, be used sparingly. For example *Pyracantha* cultivar, 45–60 cm tall, in 2-litre containers, could be confidently planted 50 cm apart in a single row.

Most hedging plants need pruning after planting to promote bushy side branching. They should be cut back to about one third of their original height. There are exceptions to this rule: the leading shoot of yew should not be pruned until it has reached its final height because it is naturally bushy at a young age and removing would only slow down the vertical growth. The leaders of beech, hornbeam and holly can also be safely left for a number of years after planting unless the hedge is composed of particularly straggly specimens.

The location and alignment of urban and garden hedges is often critical – small errors or deviations can have a disproportionate effect on the appearance of formal hedges. Because of this, care must be taken in the detailing of hedges on planting plans. Dimensions should be shown on the drawings to fix the position of hedge lines relative to 'anchor points' and the spacing of plants in the rows specified. For a hedge, unlike a plantation mix or groundcover, the positions of individual plants or at least the line of plants rows should be shown on the drawing.

TREES IN HEDGES Spreading tree canopies above a green wall of hedge foliage are very attractive. This 'colonnade' form can be seen in formal parks and gardens, but it can be difficult to establish and maintain. In the first place, cutting of the hedge is more difficult because of the need to work around the stems of trees. Hand work is essential to achieve a tidy finish and avoid the risk of damage to the trees. Also, once the tree canopy begins to thicken and spread, the shade it casts suppresses the foliage immediately below it and tends to produce uneven and open growth that may not be acceptable in a formal hedge. Shade can be reduced by raising the crowns of the trees to allow more light under their canopies, but it is better practice to set the trees back rather than plant within the hedge line. Two metres distance is enough to reduce root and canopy competition with the hedge plants for many years, and shade cast by the trees will be more evenly distributed along the face of the hedge. Setting trees back also allows easy access to all faces of the hedge for maintenance.

Perimeter Hedging

If we want a very quick screening of the plantation edge and an ordered, managed appearance, a perimeter hedge may be the answer. This would consist of two or three rows of closely spaced transplants that could be trimmed once or twice per year. The comparatively narrow width of a hedge is an advantage if space is too limited for the development of a broad, free-growing edge structure.

Plate 158 An urban hedgerow of Norway maple (*Acer platanoides*) planted in a hedge of *Cotoneaster lacteus*. The restricted width available for planting made this a suitable means of integrating the decked car park within the planting structure of the office development site.

Plate 159 Hedge clipping is easier if trees are planted next to rather than within a hedge (Warrington, UK).

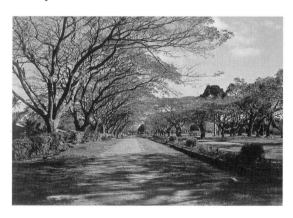

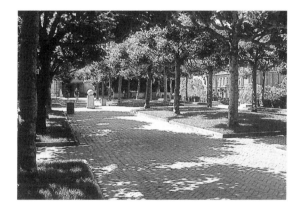

Plate 160 A magnificent single line avenue of the tropical rain tree (*Albizia saman*) line the approach to Toloa College, Tonga.

Plate 161 Plane trees planted at 6-metre spacing in rows and 7 metres between rows form a strongly defined avenue at University of California, Berkeley, USA.

The hedge could have the rougher character of a rural hedge or hedgerow, or be more formal as in parkland or urban landscape. The choice will depend on the setting and function of the plantation. The design of plantation hedges is very similar to that of 'free standing' hedges and the reader is referred to the section on hedges and hedgerows.

Avenues

For our purposes 'avenue' will mean any linear, geometrical planting of trees in which each tree is identifiable as an individual. It will include single lines and two or more parallel rows of trees, which may be straight or curved and might follow a single direction, defining a linear space, or form squares or circles to enclose a static space. The visual qualities and detailed design of avenues is quite distinct from mass structure planting but they can be equally dominant elements in the

structure of the landscape, defining spaces and boundaries just as effectively, but in a more geometric manner.

Avenues are traditionally associated with fine buildings, monuments and important or ceremonial routes. The vista created by a straight, two-row avenue is often focused on a building façade or monument for which it creates an impressive approach. Avenues are also planted to give character, identity and distinction to vehicle or pedestrian routes.

Because of their linear nature avenues are an effective and economical means of defining territorial and spatial boundaries and of articulating circulation. Their scale and proportion can vary from an intimate path under small flowering cherries to a grand parade flanked by stately lime or plane trees. The degree of enclosure can also be controlled. Avenues of mature trees do not give full separation at lower levels, rather they create raised structures such as a green 'arcade' with foliage 'roof', a 'colonnade' with 'windows' between the trunks, or an implied boundary along a line defined by widely spaced specimens.

The detailed design of avenues is a question of choosing the right species and spacing according to function and appearance.

Avenue Species

A formal avenue needs to be consistent in canopy habit and foliage. Such uniformity demands a single species of tree that must be reliable and consistent in its growth. It should not show undue response to variations in soil and microclimate on the site; it should not be over-susceptible to diseases and disorders; and it should not need frequent arboricultural work to maintain a safe and well-shaped crown. It is a further advantage if the species is available as a cultivar, which, because it has been propagated vegetatively, will be genetically consistent. Trees propagated by seed often show too much variation to make a good formal avenue.

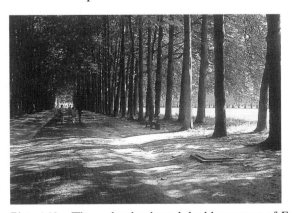

Plate 162 An unusual avenue tree is ti kouka or New Zealand cabbage tree (*Cordyline australis*) seen here in Hawkes Bay, New Zealand. It lacks the regularity of traditional avenue species but more than compensates with character.

Plate 163 These closely planted double avenues of *Fagus sylvatica* are part of the great Renaissance park at Het Loo in the Netherlands. The impression is of great green arcades lifted high on sturdy pillars of the beech trunks.

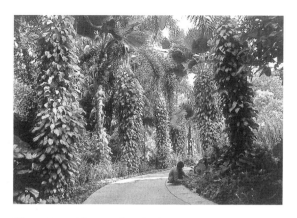

Plate 164 Small trees such as *Robinia pseudoacacia* 'Bessoniana' form intimate, human scale avenues and are particularly successful when set within larger enclosures such as urban squares or streets (Vision Park, Cambridge, UK).

Plate 165 The trunks of this small palm avenue are delightfully clothed with climbers to give low level detail to the curving space (Singapore Botanical Gardens).

Trees traditionally planted to make tall avenues in northern Europe include limes (*Tilia* species), London plane (*Platanus* × *acerifolius*), Norway maple (*Acer platanoides*), elms (especially *Ulmus glabra*), horse chestnut (*Aesculus hippocastanum*), Spanish chestnut (*Castanea sativa*), beech (*Fagus sylvatica*) and the more regular growing species of poplar (such as *Populus robusta*). For urban areas, avenue trees should not attract pests, especially aphids, which drop sticky 'honeydew' on vehicles and furniture below. *Acer platanoides*, *Tilia euchlora*, *T. petiolaris* and *Platanus* × *hispanica* are the most suitable in this regard. Two large trees that have been recently tried in urban planting and should make good tall avenue trees are Turkish hazel (*Corylus colurna*) with its regular conical form, and raoul (*Nothofagus procera*), which is fast growing. Other species that produce good tall avenues in suitable conditions include pin oak (*Quercus palustris*), with its spectacular autumn colour; Turkey oak (*Quercus cerris*) which tolerates air pollution well; and sycamore (*Acer pseudoplatanus*) that grows into an elegant specimen when given room to spread. In parkland, estates and rural areas it would be worth trying larch (*Larix* sp.), hornbeam (*Carpinus betulus*), Hungarian oak (*Q. frainetto*), chestnut leaved oak (*Q. castaneifolia*) and sessile oak (*Q. petraea*). The last three species are faster growing oaks than the pendunculate oak and form a straighter bole and more regular crown. Evergreens include black pine (*Pinus nigra nigra*), which makes a stately mature tree, wellingtonia (*Sequoiadendron giganteum*), which forms dramatic avenues in historic parks such as at Stowe, Buckinghamshire, and, especially in Mediterranean areas, Italian cypress (*Cupressus sempervirens*). In warm temperate and subtropical climates, two New Zealand species have proved to be good avenue trees. These are puriri (*Vitex lucens*), which flowers almost all year; and, where there is enough space to benefit from its natural spreading habit, the pohutukawa (*Metrosideros excelsa*). Other avenue trees for warmer areas include some of the figs, such as *Ficus microcarpa*, which is a commonly planted street tree; jacaranda (*Jacaranda mimosifolia*) with its spectacular blue flowers; and some of the flowering eucalypts, like *Eucalyptus ficifolia*, which does not drop exfoliating bark and has stunning crimson orange flowers. Many palms are used for avenue planting where the climate is suitable. Canary Island Palm (*Phoenix canariensis*) makes a classic avenue in warm temperate and Mediterranean climates; and equally good

though more spectacular is the skyduster (*Washingtonia robusta*).

For an avenue of medium height (about 10–18 metres at maturity) the following species provide a range of reliable trees with consistent habit: many *Sorbus* (especially *S. aria*, *S. intermedia*, *S.* x *thuringiaca*, *S. aucuparia* and *S.* 'Sheerwater Seedling'), some of the flowering crab apples (especially *Malus tschonoskii* with its compact columnar form), double flowered gean (*Prunus avium* 'Plena'), mop-head false acacia (*Robinia pseudoacacia* 'Bessoniana'), the compact hornbeam (*Carpinus betulus* 'Fastigiata'), spineless honey locust (*Gleditsia triacanthos* 'Inermis'), manna ash (*Fraxinus ornus*), which is more compact than many other ashes; Italian alder (*Alnus cordata*), which has glossy foliage and a neat conical crown; and the male form of maidenhair tree (*Ginkgo biloba*), which is a common street tree in Japan and the USA where its naturally fastigiate habit is a great advantage. In warmer temperate climates reliable species include Chinese elm (*Ulmus parvifolia*), Indian bead tree (*Melia azederach*), *Pittosporum eugenioides*, *P. tobira* and *P. undulatum*, olive (*Olea europaea*), orange trees (*Citrus* species, especially the Seville orange *C. aurantium*) and Brazilian pepper tree (*Schinus terebinthifolius*).

If regularity of form is unimportant, the choice of avenue trees broadens to include virtually any species suited to the local conditions. If pedestrian or vehicular circulation is required beneath the avenue we should choose trees that can be pruned to give a raised crown above head height and are not prone to dropping branches, or wind damage. In these circumstances trees such as *Robinia pseudoacacia*, which leaves a litter of spiny twigs, would not be a good choice.

Small avenues (less than 10 metres high) can be effective and attractive structural elements in the human scale landscape of courtyards and gardens. Good trees for this purpose include the following: flowering cherries and plums (especially *Prunus* 'Accolade', *P.* 'Kursar', *P. padus* 'Watereri', *P. sargentii*, *P.* 'Shirotae', *P.* 'Tai Haku' and *P. cerasifera*), some of the flowering crab apples (such as *Malus floribunda* and *M. hupehensis*), the tree cotoneasters (*Cotoneaster* x *watereri* and *C.* 'Cornubia'), willow-leaved pear (*Pyrus salicifolia* 'Pendula'), the ornamental thorns (especially *Crataegus* x *lavallei*, *C. crus-galli* and *C. prunifolia*) and the smaller cultivars and species of *Sorbus* (such as *S.* 'Joseph Rock', *S.* 'Embley', *S. hupehensis*, *S. cashmiriana* and *S. vilmorinii*). Unusual and distinctive avenues can be created with species of striking habit such as ti kouka (*Cordyline australis*), chusan palm (*Trachycarpus fortunei*) and giant bird of paradise (*Strelitzia nicolai*).

Setting Out and Spacing

The regularity of geometry and spatial form that can be created with avenue plantings lends itself to architectural metaphor. For example, a single line of closely spaced trees with clear boles and linked canopies becomes a green 'colonnade'. Two lines with canopies meeting overhead forms an 'arcade' and, if in the shape of a square become an enclosing 'cloister'. The trunks and angled branches of closely spaced large trees create a room- or canopy-like structure. Widely separated trees take on the processional character of rows of columns.

We can see that the layout of avenue trees affects the spatial qualities to be achieved. The spatial arrangement of the avenue will also influence choice of species and techniques of establishment needed to achieve the design objectives.

For avenues of large trees with canopies that are close together, but not continuous, a planting distance of 20–25 metres apart is ideal. This will allow the largest trees like lime and plane to develop into broad, spreading specimens;

however, for the full effect we may have to wait anything up to one hundred years. To achieve quicker visual impact, on a timescale that is acceptable for most landscape projects we could plant two (or three) times the number and remove alternate trees (or two out of every three) when the canopies begin to overlap. The initial spacing would then be between 6 and 12 metres. This would give a good sense of continuity and spatial definition about 15 years after planting. Unfortunately, when the time for this rather drastic thinning arrives, it can be difficult to find the courage to fell what may be fine young trees and even more difficult to persuade the public or client that it is necessary. A way of clarifying management intentions from the beginning is to choose a fast growing, short-lived species for the temporary tree. A poplar or Italian alder (*Alnus cordata*) might be planted between the long-term species, and felled with less contention after ten to twenty years.

The distance between rows should be of the same order or greater than the spacing of the trees within the row. If the lateral spacing of an avenue is less than its longitudinal spacing it will give the impression of passing through a series of arches, and will tend to reduce the strength of enclosure. At this large scale, double avenues (with two rows on either side of the axis) or even triple avenues can give an impressive grandeur.

A linked avenue, where the tree canopies meet to form parallel 'colonnades' or an 'arcade' roofed with foliage, needs tree spacing significantly less than the mature spread of the trees. Large trees such as lime and plane would need to be no more than 15 metres apart at maturity. Ten metres apart would achieve the effect more rapidly. With increasingly close spacing, more enclosure is created and the avenue becomes less a series of individuals and more a continuous, sculpted form. At very close spacing, say 4–5 metres, more vigorous trees will shade and suppress the weaker trees. Different growth rates can be moderated by pruning but, as the trees become larger this becomes more difficult and expensive. If we are prepared to accept less uniformity, there is no reason why we should not plant as close as 2 or 3 metres in the rows. This could create an unusual and dramatic effect.

The smaller the canopy spread the closer we need to plant to achieve the same degree of continuity. Medium-sized avenue trees such as *Sorbus aria* or *Robinia pseudoacacia* 'Bessoniana' would never give linked canopies at spacing much greater than 9 metres, and 5–6 metres apart is recommended. For quick establishment, we could reduce this to about 4 metres. Trees with a narrow crown such as *Malus tschonoskii* or *Ginkgo biloba* should be placed correspondingly closer and, although an ascending habit will not be suited to the arcade or colonnade form of linked avenue, spacing of 5–7 metres will achieve a strong, integrated appearance. The smallest trees such as *Sorbus vilmorinii* and *Pyrus salicifolia* 'Pendula' are best planted no more than 5 metres apart.

For regular planting of two or more rows we can use a rectilinear grid or a staggered grid. The former, in which trees either side of the axis are opposite one another, gives a more formal appearance. Staggered planting gives a lighter visual rhythm, but viewed from the side, the density will appear greater.

In practice, the location of trees will be affected by numerous site constraints such as road junctions, side paths, the windows and entrances of buildings and underground and overhead services. It is rare to achieve identical spacing throughout the length of an avenue. Fortunately, this is not of great consequence except in the most formal and grandest of designs. On most sites, occasional breaks in the avenue and irregularities in spacing are acceptable, if the reason for them can be seen and understood. So it is more important to try to overcome restrictions imposed by invisible constraints such as underground services, and

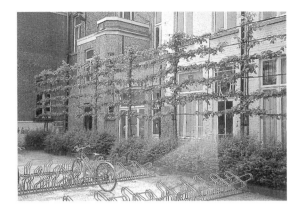

Plate 166 Pleached limes (*Tilia* sp.) separate the building from the bicycle park (Leuven, Belgium).

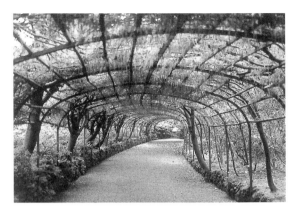

Plate 167 A laburnum tunnel, such as this famous one at Bodnant in North Wales, can impress not only with its spectacular flower display in May but also with its dynamic spatial qualities.

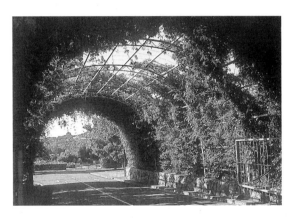

Plate 168 A large-scale climber tunnel creates a dramatic vehicle entrance to Auckland Regional Botanical Gardens, New Zealand.

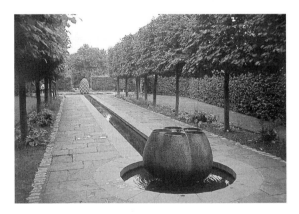

Plate 169 Pleached lime (*Tilia*) create a geometric setting for sculpture in a Bristol park, UK.

this is best done by anticipating these problems and dealing with them at the site planning stage.

Trained Trees and Vines

Pleached lime and laburnum tunnels are traditional examples of the use of trained tree form to achieve a green architecture with strong enclosure and control over form. In terms of function, this kind of trained form is similar to close planted avenues, but the management commitment is greater and much of it needs hand work. Despite this, these traditions have come back into fashion and designers are exploring their broader possibilities and fresh interpretation in public spaces. An advantage of trained tree forms is that, because clipping or training is established as part of continuing management, they can be used close to buildings in the knowledge that the crown and root spread will be restricted. Pleached limes could be planted within 2–3 metres of a building whereas a free-

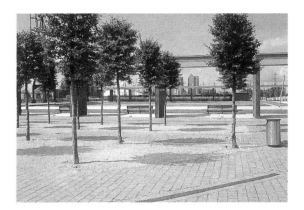

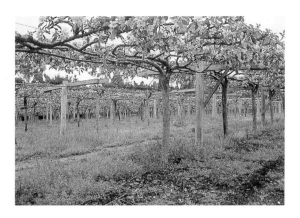

Plate 170 Clipped trees planted in a strict grid in London's docklands redevelopment area. This approach is traditional in France and represents the ultimate in the reduction, abstraction and formalization of the spatial idiom of the forest.

Plate 171 A number of fruit crops, including apple and kiwi fruit are grown on this kind of post and wire structure. There is an opportunity to re-interpret contemporary growing techniques such as this, as well as traditional espalier and fan methods, in amenity landscape and horticulture (Canterbury Plains, New Zealand).

growing tree of this size would normally be located many times this distance away, to avoid problems of shading, branch shedding and root damage.

The choice of species for training and pleaching is more limited than for general avenue planting because they must produce growth that can be trained along wires or bars or must respond to clipping by producing dense side-shoots similar to good hedging plants. Indeed, many of the tree species used for hedging are also suitable for pleaching. The most reliable are hornbeam (*Carpinus betulus*), beech (*Fagus sylvatica*), limes (*Tilia* species), holly (*Ilex aquifolium*), cypress (*Cupressus*) and yew (*Taxus baccata*). These not only produce dense foliage when trained and pruned but can also be kept reasonably free from shoots from the bole once this has been cleared to the desired height. Common spacings for pleached trees are between 2 and 4 metres to ensure quick establishment of a common canopy of even density.

Training trees over a framework of steel and wires to create a tunnel has been practised with laburnum (*Laburnum* species especially *L.* x *vossii*) and wisteria (*Wisteria floribunda* and *W. sinensis*) to give a spectacular display of hanging flowers. Laburnum tunnels can be gloomy at other times, because the foliage is dull and the tunnel can be dauntingly long if it is not properly conceived as part of a varied spatial sequence. Wisteria is better for this purpose because of its longer flowering and better foliage.

Inspiration for new kinds of trained plant form can be found in horticultural practices that use support for vine or tree crops. There is great potential for application to amenity design. Consider, for example, the spatial qualities of trained hop fields and kiwi fruit and how these could be adapted for public landscape or private gardens. Pip fruit are sometimes trained on overhead supports and this practice could also be interpreted in planting design.

Planting vines on specially designed structures is a way of bringing vegetation into small spaces and places where trees would cause damage. It also offers many exciting design opportunities, examples range from the artificial epiphyte pillars of Roberto Burle-Marx to the bougainvillea parasols of Singapore. There are also opportunities to develop local design idioms by interpreting characteristic horticultural practices, such as kiwi fruit growing, or distinctive aspects of natural vegetation, such as epiphytic trees.

CHAPTER 11

Ornamental Planting

Ornamental planting can be described as the furnishing and elaboration of landscape spaces after the basic proportions and structure have been formed by the structure planting framework. This distinction between structure and ornamental planting is not a rigid one, however, as structure planting frequently includes many detailed and decorative aspects, and ornamental planting often contributes to the definition and subdivision of a space. It is really a matter of functional priorities. The main purposes of structure planting include spatial definition, enclosure and microclimatic improvement, whereas those of ornamental planting are the detailed use and enjoyment of a space.

The difference between structural and ornamental functions is also a matter of scale. In small gardens, courtyards and single beds, some kinds of ornamental planting can define space by itself – a seat can be tucked into the sheltered niche between two spreading shrub roses, or a flowering specimen tree can create a refuge below its arching canopy. On the other hand, if we closely examine a selected detail of structure planting, such as a single plant in a forest or a particular contrast in foliage, it is the ornamental qualities we notice first.

Ornamental planting is an important part of the landscape, not just in parks and gardens but in streets, squares, car parks, recreation facilities, residential, health, education, industry, business and retail complexes: in short, anywhere that people can use and enjoy it.

The character and scale of ornamental planting varies from extensive areas of mass shrub planting to the most intensively planted beds and containers. Large-scale public sites demand planting that is reliable, robust and easy to maintain as well as ornamental, but for protected sites and where reasonable maintenance is available, planting can be more intricate and include a wide range of species.

In Part 1, we looked at the principles of visual composition that help us to bind the elements of a scheme into an expressive whole; now we turn to the question of the choice and arrangement of species for ornamental planting.

General Planting Areas

In public and private gardens there is a long tradition of bed and border horticulture, including seasonal bedding, herbaceous and mixed borders, shrubberies and island beds. In most public, corporate and institutional landscape, a different approach is appropriate, partly because of the limited funds and skills commonly available for maintenance, but also because this is where the best opportunities to develop innovative design are often found.

Plate 172 Ornamental shrubs may have a structural role within small spaces. This tree mallow (*Lavatera thuringiaca* 'Kew Rose') separates two seats in the precinct of Leicester Cathedral, UK.

Plate 173 Woodland or scrub structure planting consisting mostly of native species may offer detailed decorative interest of flower, fruit and foliage as well as spatial definition and shelter.

Plate 174 Established shrubs and herbaceous plants spill over the path edge at Knightshayes Court, Devon, UK, to give a delightfully irregular natural outline. Note how the scale of the curves in the outline reflects the size of the plant groupings.

Plate 175 The edges of planting beds need protection in busy areas. These sloping walls of stone sets are both a logical extension of the paving and an attractive complement to the decorative qualities of the plant material (Glasgow, Scotland).

Layout of Planting Areas

Before considering the plants themselves, the size and shape of planting areas need to be determined. First we should pay attention to the relative proportions of planting and grass, or planting and paved surface. Both grass and paving provide an attractive foil to planting. Their visual simplicity and consistency complements and supports the richness of planting. Because of its visual softness, grass can occupy bigger areas than paving without looking bleak. Of course, there are many locations where pavement is essential because of the intensity of use and the extent of planting area that would be ideal may not be available. In these circumstances we can still create a mass of vegetation in balance with the area of hard surface, because what matters is not so much the relative proportions of ground area, as the ratio of visible foliage to paving seen

from normal viewing angles. The visual area of foliage can be maximized by planting trees and larger shrubs and using climbers and trailers to clothe vertical surfaces.

The second question is what shape should planting areas be? It may be dictated by the geometry of other elements in the space and the overall site design (planting should always be an integral part of the overall landscape design). In some cases, the shapes of planting areas might be the dominant pattern form of the space.

One aesthetic quality in popular demand is planting's ability to 'soften' the precise outlines and manufactured construction materials of urban structures. This is achieved by using varied colours and textures of foliage and by the sinuous and irregular outlines of shrubs and trees. These organic shapes are the result of natural plant growth so there is no need to copy them in the outlines of planting areas in order to complement and contrast with geometric construction elements. In fact, nothing looks more contrived than a slavishly irregular wavy outline to an ornamental planting bed. This is not to say it is wrong to use curvilinear form, but if we do, it should be shaped with conviction and be of sufficient scale to remain apparent after the planting has matured.

There are some technical implications for the shape of planting areas that need mention. In public areas, planting is vulnerable to trampling by pedestrians and overrunning by vehicles. It can be given protection by raising it above ground level or by using a high kerb, low wall or a rail to deter access. The correct location of an area and its width are also an effective means of reducing interference. A planting area that adjoins pedestrian areas on both sides should generally be no less than 2 metres in width. This ensures that, even if some damage is done at the edges, a substantial area of planting remains to grow and spread. A border backed by a wall along one side is less vulnerable to trampling and its width can be as little as 1 metre.

The way that the edges of beds and borders are treated affects the character and quality of the design as a whole. Where the edge adjoins a lawn, it is common

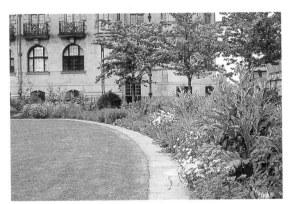

Plate 176 Narrow planting beds do not provide adequate soil conditions and are vulnerable to trampling.

Plate 177 An edging of stone to a herbaceous border has many advantages. Grass cutting is easier, plants can be allowed to spread over the edge, access and work to the border in wet weather will cause less damage to the edge of the lawn, and crispness of line is visually satisfying (Sheffield, UK).

to see the grass edge laboriously clipped and trimmed. This is done for the sake of neatness and ease of cultivation in the border, but results in a stiff appearance and causes the gradual reduction of the grass area through continuous trimming back of the edge. The most convenient way to edge a lawn and planted border is with a mowing strip of paving material such as brick, concrete or stone. This is a classic feature that facilitates maintenance and allows plants to spread without mowing damage. It also gives a crisp line to the edge of the grass and allows the designer more precision in its layout. With a paved mowing edge, a lawn can be laid out and maintained in angular and precise geometric shapes.

By far the most vulnerable parts of beds and borders are the corners. Frequent trampling of angular corners is inevitable in public places and protection is essential. The least intrusive way of reducing the problem is to give corners either gentle radii or generous splays to eliminate sharp corners and protruding sections. Even these more gradual corners should only be planted with the most resilient species. Herbaceous plants or soft low shrubs would stand little chance of survival in corner locations.

Planting Arrangement

The sight of dreary shrub borders and monotonous groundcover is too common in the urban landscape. They consist of a very limited selection of utterly reliable shrubs, a high proportion of evergreens and usually very little to excite us with colour, form or seasonal change. Part of the explanation for uninspiring design is the cost of establishment and maintenance, but costs need not dictate dull planting if the designer has good plant knowledge and imagination. The aim should be to achieve maximum visual quality in public areas without sacrificing the dependability of the planting.

There are a number of ways of doing this: It is possible to introduce herbaceous plants and larger bulbs by growing them through a carpet of groundcover. The smaller trees are another important component of ornamental beds, because of the height and volume of foliage, flower and fruit they introduce, while occupying only a small space at ground level. There is often a reluctance to plant even small, light foliage trees in confined spaces and close to buildings because of shade and potential damage to structures. However, with attention to the locations of underground services and the design of building foundations, there is no technical reason why trees should not enrich small spaces and complement building façades. In other cases, climbers trained on specially designed structures could replace trees. These also have the advantage of being fast to establish.

Canopy Layers

Trees, shrubs, climbers, groundcover, herbaceous plants and bulbs can all be combined to create diverse ornamental planting associations in public and private landscape. The key to ornamental planting areas, just as to effective structure planting, is to fully exploit the available ground area, by making use of the vertical arrangements the canopy and the seasonal rhythms of plant growth. The main layers relevant to ornamental planting are the tree layer, shrub layer and ground layer.

The tree layer should not be too dense, because an open tree canopy will allow more diversity below, where the main focus of detailed ornamental planting is often found. Also, if ornamental beds are in small spaces or close to buildings a dense tree canopy can be too gloomy.

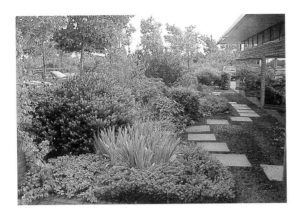

Plate 178 A mixed planting of shrubs and
herbaceous plants creates a fresh and colourful
ornamental landscape for this office development in
Warrington, UK. Herbaceous plants in this scheme
include *Bergenia, Iris, Astrantia major* and *Geranium*
species.

Plate 179 It is partly the close proximity between
the small light-foliaged tree and the building that
makes this planting successful. Harmony of colour
and complementary form and pattern make it a
pleasing association of trees and architecture in
Germany.

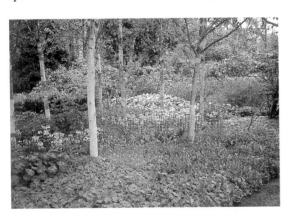

Plate 180 This multiple-layered ornamental
planting at Newby Hall, Yorkshire, UK, includes a
light tree canopy of *Betula jaquemontii*, a scattered
shrub layer of azaleas (*Rhododendron* sp.) and a
diverse low groundcover including *Tiarella cordifolia*,
Bergenia, Polygonum affine and *Alchemilla mollis*.

Plate 181 The revival of interest in planting with
perennials including grasses and their use in public
spaces is well represented here at Thames Barrier
Park in London.

The shrub layer can include shade tolerant or light-demanding species
according to the conditions created by the tree canopy. The role of tall shrubs,
this is those above eye level, in the canopy structure will depend on their form
and habit. Shrubs like *Choisya ternata, Pieris floribunda* and *Leucadendron* species
have a dome-like form and a dense evergreen habit that provides good weed
suppression, at least until they reach an advanced stage of maturity. A similar role
is played by thicket-forming species such as *Nandina domestica, Kerria japonica*,
and *Cornus alba*. Ornamental shrubs whose habit does not provide such good
groundcover and may need underplanting include those with upright and
arching forms, such as many *Rosa, Syringa* and *Weigela*, and especially species in
which the upright habit is combined with a thin canopy, such as *Tamarix*,
Abutilon and *Genista aetnensis*. These shrubs with more open habits give us the

opportunity to establish a layer of shade-tolerant low shrubs or herbaceous plants below them.

The ground layer can include low shrubs with a dense spreading habit, such as *Cistus* × *skanbergii*, *Pimelea prostrata* and *Hebe pinguifolia*; prostrate, layering shrubs, such as *Hedera* cultivars, *Fuchsia procumbens*, *Rubus parvus*, *Cotoneaster dammeri*, *Coprosma* 'Hawera' and *Vinca* species; and herbaceous plants that form a vigorous spreading carpet, such as *Lamium maculatum*, *Geranium macrorrhizum*, *Tiarella cordifolia,* and *Pratia angulata*. Some clump and tussock forming herbaceous plants also make good groundcover when closely planted; examples include renga renga (*Arthropodium cirratum*) and grasses and sedges like *Chiononchloa flavicans* and *Carex testacea*. Most really effective groundcover plants are evergreen or at least partially evergreen. However, there are some that, although deciduous and maybe less attractive in winter, come into leaf early in the growing season and are sufficiently vigorous to be as effective as many evergreens in their ability to suppress weeds. Shrubs like *Stephanandra incisa* 'Crispa', many of the shrubby *Potentilla* cultivars, and herbaceous plants such as *Alchemilla mollis* and *Geranium endresii* are all good examples of effective deciduous groundcovers.

Ground-layer planting might be restricted to areas where there are no taller shrubs or trees or they can be extended underneath the higher canopies. Species should, of course, be carefully chosen to thrive in the conditions they will experience at the time of planting as well as in the shade of the mature border. It is particularly important when planning the ground layer to be sure it will hold its own in competition with weeds. This is because, whereas some 'weed' growth under tall shrubs and trees can be acceptable, low shrubs and herbs are more easily overrun and weed control is more difficult among groundcover than under tall shrubs.

Good groundcover is therefore essential for ground layer planting. Once this is provided for, we can start to introduce additional low shrubs and herbaceous plants that, planted alone, would not suppress weeds. These added plants include two important groups. The first is small deciduous or evergreen shrubs with open habit, such as *Caryopteris* × *clandonensis*, *Thryptomene* cultivars and *Genista lydia*. The second is made up of perennials tall enough to grow up through and emerge above prostrate groundcover, including species and cultivars of *Hemerocallis, Iris, Campanula, Hosta, Crocosmia, Astelia, Agapanthus, Aloe, Yucca, Puya,* sedges and grasses. There are a huge number of very attractive herbaceous plants that can be grown in this way, many of which are rare in public and commercial schemes because they are unsuitable to plant on their own. The upright habit of many of these plants is ideal both visually, because they contrast with a spreading canopy below, and culturally, because the foliage does not cast too much shade on the groundcover plants. Seasonal bulbs such as *Narcissus, Galanthus, Schizostylis* and *Crocus* can also be grown in this way as an alternative to siting them in grass or bare soil, provided that the groundcover will be low enough to allow the leaves and flowers of the bulb to make sufficient growth above it. So the taller *Narcissus* could be planted among *Hedera helix* groundcover cultivars but *Crocus, Leucojum* and *Galanthus* would be more visible and persist longer in lower growing groundcovers such as *Vinca minor* or *Ajuga reptans*. Herbaceous plants, including bulbs, that grow through low groundcover could be called 'emergents' because their perennating buds are below the groundcover, but they grow through this layer each season to emerge above it.

If we were to develop the vertical layering to its maximum potential we would plant, in a single area, a ground layer of prostrate shrubs or groundcover herbaceous plants with groups and drifts of emergent herbaceous perennials and bulbs. Above this layer we would include a variety of medium and tall shrubs that

do not cast excessive shade. These would be in drifts or groups at moderate to wide spacing so that most of the ground layer below remained visible from the path at the edge. Some could be planted as individual specimens or as parts of small specimen groups made up of plants of various height. Finally, occasional trees would be included, grouped or individually, to add the top layer and to punctuate the lower canopies with their trunks. This kind of spatial arrangement allows us to include a lot of diversity without excessive complexity in any of the layers. It would be appropriate for an ornamental scheme that we want to be rich and varied, such as intensive sections of larger areas and in intricate borders in small spaces.

In many designs we deliberately choose to simplify the layer structure for aesthetic reasons. For example, the simplicity of an extensive monoculture may be just what is needed to complement an intricate paving pattern or the façade of a building. We should also remember that multiple-layer planting is comparatively expensive because it packs a large number of plants into a small area and it relies extensively on the smaller types of groundcover plants that require high planting densities. So a simpler layer structure may be a necessity because of cost. Medium and tall shrub thickets are a much cheaper method of covering the ground because far fewer plants are needed. A monoculture can be visually successful provided that the greatest care is taken in the choice of species – it should be one with qualities of line form, texture and colour that combine superbly with the other materials, and that look good through all seasons and include some changes in flower, fruit or foliage through the year.

Successional Growth

Another way to make the fullest use of a given ground area is by selecting plants whose main growth periods occur at different times of the year. This is found in natural plant communities where, in European oak woods for example, pre-vernal plants such as wood anemone (*Anemone nemorosa*) and bluebell (*Endymion non-scriptus*) make use of the period before the tree canopy is in full leaf to grow and flower. Bluebells and other spring bulbs can be used in a similar fashion beneath clumps of late leafing deciduous shrubs such as hazel (*Corylus* spp. and cultivars) and hardy hibiscus (*Hibiscus syriacus*).

A succession of growth can also be achieved within the same canopy layer. For example, *Brunnera macrophylla* and *Hosta* species do not come into full leaf until late spring, often well into May in northern Europe, and this leaves a growth window in early to mid-spring that can be exploited by plants such as bluebell, snowdrops (*Galanthus* species) and *Scilla*. By the time the leaves of the summer herbs have excluded the light, the spring bulbs will have begun to die down and enter their natural period of dormancy.

Composition and Scale

For detailed treatment of the aesthetics of planting the reader should refer to Chapters 6 and 7, on the visual characteristics of plants and principles of visual composition. The effect of scale on plant groupings, however, deserves further attention at this stage.

It is sometimes said that if you look at a planting plan you should be able to understand the essence of the composition simply from the pattern of plant groupings, without reading the names of the species. This is because the scale of the drifts and clumps and specimens of each species should closely reflect its role in composition.

On the ground, the most intricate areas of planting naturally catch our attention and attract closer scrutiny. The observer will dwell on and enjoy areas of detail after passing more quickly over stretches of more uniform or closely harmonious planting. This is true even if these larger drifts are more vividly coloured or of dominant texture. Because of this, areas of intricate planting tend to be the highlights of a composition, and should be reserved for the best locations such as near entrances, and garden architecture, in courtyards, by flights of steps, at pivot points of paths, or in the foreground of views from a seat. All these key locations have something in common: they are places at which we naturally pause. Other sections of planting areas should be simple, in contrast, partly because of the speed of observation and partly because a change in scale will enhance both the bolder and the more intricate associations. It could be said of composition, that variety in scale is more important than variety of species.

Relative scale in ornamental planting can vary by a factor of ten or more. In the simpler parts of a planting scheme, drifts of a species might be ten times the size of groups in the most detailed areas. In a focal plant grouping, one species might occupy no more than 2 or 3 square metres, whereas alongside an approach path or next to a building one species might cover 20–30 square metres. Between these extremes, a transition can be made with planting of intermediate scale or, in some cases, we may want an abrupt contrast.

Accents

Highlights of ornamental planting can be provided by a single, dramatic accent shrub or tree that has outstanding form. This role is well played by plants like *Phormium*, *Yucca* and *Furcraea* with their sword-like leaves and imposing flower spikes or *Aralia elata* 'Variegata' with its handsome, variegated, pinnate foliage radiating from the tops of the stems. Striking colour can also provide an effective accent. If this is the colour of flowers or fruits it will be only temporary, but while in bloom, shrubs like *Embothrium coccineum* with its flame scarlet flowers, *Cornus kousa* with branches clothed in creamy white bracts, and *Magnolia* x *soulangeana* with its white and purple goblets massed on the branches are eye-catching sights. A combination of fruit and foliage colour can be just as striking. *Euonymus oxyphyllus* is clothed in early autumn with purple and red foliage just as its branches are strung with carmine and orange fruits. The feathery foliage of *Sorbus vilminiana* turns a rich purple in vivid contrast to its white berries. Stem colour can be as effective as fruits and, especially when seen with autumn foliage, can provide an effective accent. *Acer griseum*, for example, combines peeling orange-brown bark with the intense reds and oranges of its autumn leaves. The snake bark maples and some birches, especially *Betula ermanii*, *B. albosinensis septentrionalis* and *B. jaquemontii* all offer both ornamental bark and colourful autumn foliage. Form and colour highlights are combined in specimens such as *Cornus controversa* 'Variegata' with tabulate sprays of glistening silver variegated foliage, and *Acer japonicum* 'Aureum' with butter yellow, exquisitely shaped leaves spreading in horizontal tiers. Perhaps the foliage shrub that demands attention more than any other is the pink Chinese toon tree, *Cedrela sinensis* 'Flamingo' with foliage that emerges a shocking pink colour in spring.

The effectiveness of an accent depends on its setting. The background should be comparatively plain and contrast with the main characteristics of the accent plant in front. Yucca foliage and flowers, for example, are most noticeable when their pale colours and bold texture are set against a dark, fine background such as *Taxus baccata*, and the ascending lines of its leaves and flower spike are most dramatic when rising from prostrate form such as that of *Juniperus horizontalis* or

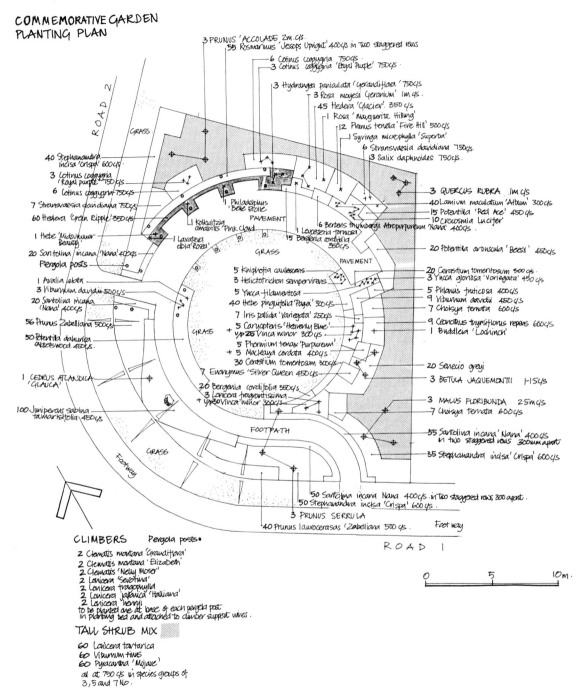

Figure 11.1 Planting for a public garden showing tall shrub mix enclosing the site on two sides, ornamental planting and climbers on pergola. Note the concentration of planting detail near seats and entrances.

alongside the dome of *Viburnum davidii* or *Cistus* × *corbariensis*. The rugged, dark green leaves of loquat (*Eriobotrya japonica*) would provide a strong focus contrasted with the feathery, greyish foliage of olive (*Olea europaea*). *Fatsia japonica*'s luxuriant green foliage is most striking contrasted with the elegance and fine texture of plants such as *Fargesia nitida*.

Even plants that would appear rather ordinary in many combinations, can become a striking accent when placed in an association carefully planned for the purpose. *Sambucus racemosa* 'Plumosa Aurea', for example, against a fine textured, deep green backcloth of *Buxus sempervirens* and with its leaves back-lit by low sun, can be very impressive.

Accent Groups

The role of a visual accent can also be played by a group of, say, three or five species each with its own special merit, but designed to form a harmonious specimen group. In such an association every aspect of form, colour and texture should be carefully worked to provide the right degree of tension between harmony and contrast and to produce a dynamic focus.

Form is a good starting point for composition of an accent group because it is usually the most permanent of the aesthetic characteristics. Preben Jakobsen (1977) emphasized the role of form in accent planting and described some

Plate 182　The assertive form of *Astelia chathamica* in the foreground makes it an effective accent plant in this public square in Whakatane, New Zealand. Here it is contrasted with the fine textures of the korokio (*Corokia* × *virgata*), pohuehue (*Muehlenbeckia axillaris*) and sand coprosma *Coprosma acerosa*.

Plate 183　The inspiration for a specimen group might come from a natural plant assemblage such as this rainforest group of nikau (*Rhopalostylis sapida*) kawakawa (*Macropiper excelsa*) and pate (*Schefflera digitata*) in Paparoa National Park, New Zealand. In suitably shady and moist conditions the three species could be planted to form the ornamental 'plant signature' of the forest from which they originated.

Plate 184 *Astelia, Anigozanthos* and *Pachystegia*, against a background of *Corokia* hedge, make a simple and striking specimen group near the entrance to the observatory in Wellington Botanic Garden.

typical relationships between two, three or four different forms that, together, would create an accent group. The simplest combination he describes is the placing of distinct bold visual dominants in a carpet or 'base plane' of groundcover. Three forms might comprise a sculptural tall shrub anchored by the domes of lower shrubs but both rising above a prostrate groundcover. A further addition would give what Jakobsen called 'A basic triad plant composition', set in a complementary groundcover carpet. This triad 'could consist of a sculptural, multi-stemmed *Aralia elata*, a dome shape or hummock of *Hebe rakaiensis* and a spiky linear form such as *Phormium tenax*.'

Textural and colour relationships in accent groups can support the juxtaposition of forms. In the example given above, the bold foliage of *Aralia* and *Phormium* is emphasized as well as complemented by the fine texture of the *Hebe*. A medium textured groundcover species such as *Pachysandra terminalis* or *Hedera* 'Green Ripple' would be an ideal bridge between the extremes of texture of the main triad. The *Aralia* and *Hebe* both have mid green foliage, although *Hebe* is rather fresher and more yellow-green in hue. This yellowish tint to the foliage could be picked out by choosing a *Phormium* with a cream variegation such as *P. cookianum* 'Cream Delight' or *P. tenax* 'Veitchii'. These bright warm greens and creams would stand out strongly from a dark green groundcover. *Pachysandra* would be a possible choice or the groundcover could contribute colour highlights in harmony with the main triad: *Hypericum* × *moseranum* combines a neat medium textured foliage carpet with a long display of abundant large yellow flowers. In warmer climates *Lantana* 'Spreading Sunshine' provides a low carpet with cream and yellow flowers.

Planting Patterns

Our discussion so far has been concerned mainly with vertical distribution of plants but should also consider their arrangement in the horizontal plane. Within the main canopy layers, different species can be arranged in a variety of different patterns. Each type of arrangement will have different effects on the finished composition.

In nature, shrub and herb communities typically consist of 'colonies' of a species massed together, or of small groups and individuals intermixed with other species. Massing, grouping and mixing are also used in planted associations, both where the aim is a naturalistic appearance and in the exotic ornamental schemes.

The planting patterns that we use will depend on both aesthetic and technical factors. Some species are particularly gregarious and mingle well with others of

similar stature to produce a tapestry of foliage. Others are more 'self-contained'. These grow better and look more at home grouped with their own kind or as individual specimens. For example, mass planting appears to suit the visual character of many groundcovers such as ivy (*Hedera helix*, *H. canariensis* and *H. colchica*), rose of Sharon (*Hypericum calycinum*) and *Pachysandra terminalis*, renga renga (*Arthropodium cirratum*) and grasses and sedges. Taller plants that are effective in mass planting include *Hebe* species and harakeke (*Phormium tenax*).

There are two patterns of plant arrangement commonly seen on planting plans. One comprises blocks of a single species and occasional mixtures that are butted-up together to fill the planting area. The other consists of each plant individually marked. These are both well-practised techniques. The first has the advantages of providing a bold mass of each plant that confidently displays its aesthetic qualities, and is simple and quick to draw. The second method allows detailed control of design and precision in the instructions shown on the plan – every single plant is accounted for. There are, however, other and combined methods of arranging the plants and showing this on plan that allow both subtlety of design and economy of drafting.

The shapes of the blocks of each species have an effect on the three-dimensional appearance of the planting on the ground. Rounded or near-square areas will produce a patchwork quilt appearance from above. From eye level, however, the blocks will appear smaller in scale and self-contained, even isolated, because their full depth is either foreshortened or hidden. The relationship between adjacent species in this kind of layout can appear rather rigid, but if we allow the groups to interlock and interweave the relationships become more intimate and more varied and we can see new aspects of each species, as they associate in different ways with their neighbours. One species can appear in front of, behind and within a block of another. In this way we can get various permutations from a given range of species. An effective method of linking species, particularly if the bed is narrower than it is long, is to stretch them in the direction of the bed to form extended drifts. These drifts can run in front of and behind their neighbours and bind the planting together into a woven tapestry. When viewed in elevation, linear drift planting appears well grounded because the blocks of species are longer than they are tall. The spreading, horizontal outlines of plant masses can be punctuated by well placed vertical accents and anchored by the occasional solid dome-shaped shrub or small group. Drift planting also improves the appearance of the planting as a whole when some of the plants are not at their peak, because the overlapping of drifts allows other species in front and behind to take over. This applies both to deciduous herbaceous, which die back in the dormant season, and to shrubs that are leafless or of less interest at certain times of the year.

Another way of enlivening blocks and drifts of a single species is to introduce some overlap and mixing at the edges. An intermediate strip between species blocks can be planted with a mixture of the two adjacent species. The width of this overlap can be whatever we like, but 10 to 20 per cent of the width of the blocks would usually be an effective proportion. The mix could be half and half, or the percentage of one species may be increased to compensate for the greater vigour of the other. This arrangement of overlapping groups is similar to some of the patterns of distribution we find in nature and it will give the association a spontaneous, informal appearance.

Overlapping will speed up the process of territorial competition that would happen anyway unless effort was applied to maintain separation between the species. Such dynamic development of ornamental planting is not necessarily a problem; it can be rewarding to watch the balance between species and the

character of the composition change. Landscape managers and gardeners sometimes regard it as their duty to impose a strict discipline, stifling change and rigidifying the appearance of planting. This is mostly unnecessary. It is only if valuable species are likely to be altogether lost, or if the planting is not serving its purpose, that intervention is needed.

On the other hand, designers should take care to choose species that are compatible in the growth rate and mode of spread. Otherwise many of the plants included in the initial planting may have disappeared within four or five years, having been suppressed by more vigorous neighbours.

We can take the grouping and mixing of species as far as we wish. We could cover a defined area with a mix of several different species in a similar way to much structure planting. The mix could be of ground layer or of taller species and distribution within it random or grouped. For example, *Cotoneaster simonsii, Pyracantha rogersiana* and *Cornus alba* 'Elegantissima' are shrubs that combine well in an intimate tall mix and *Vinca minor, Hosta lancifolia* and *Campanula poscharskyana* could be grouped to form a diverse groundcover in light shade.

Ecological Ornamental Planting

An ecological approach is not only relevant to native planting. The same principles of closely matching species to habitat and planning for dynamic plant associations can be applied to design with exotics including ornamental planting. It is also true that many exotic garden species planted for their decorative qualities also provide valuable food and shelter for wildlife. *Buddleja davidii* and *Fatsia japonica* both attract large numbers of butterflies, and many familiar garden plants such as hebe, lavender and *Skimmia japonica* attract bees. Many birds also find a valuable food source in gardens, feeding on flowers, fruit and insects.

The use of ecological principles in ornamental planting was first advocated by the British Victorian garden designer and writer William Robinson. He developed

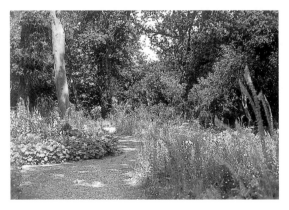

Plate 185 This woodland wild garden at Wisley in Surrey, UK, consists of a mix of naturalized exotic herbaceous species including *Alstroemeria, Campanula, Geranium, Astrantia major, Aconitum* and *Astilbe* mixed with natives such as *Digitalis purpurea* and *Hieracium*. The utmost sensitivity in management is required to establish and maintain this kind of planting.

Plate 186 A meadow and scrub wild garden at Santa Barbara Botanic Gardens features Californian native herbs and shrubs in a setting of mountains clothed in chaparral scrub.

an approach that he called wild gardening: '... the term "Wild Garden" ... is applied essentially to the placing of perfectly hardy exotic plants under conditions where they will thrive without further care' (Robinson, 1870). William Robinson was particularly interested in herbaceous plants and thoroughly approved of mixing robust exotics like Michaelmas daisy (*Aster novi-belgii*), golden rod (*Solidago*) and evening primrose (*Oenothera missouriensis*), with attractive natives such as bluebell (*Endymion non-scriptus*), foxglove (*Digitalis purpurea*) and lily of the valley (*Convallaria majalis*). He also showed how hardy, vigorous shrubs such as *Spiraea* species and *Clematis montana* could coexist happily with native plants. One of Robinson's objectives was to reduce the labour required to maintain plantings. Because this aim is still relevant in most landscape projects today, we find ourselves using many of the same exotic shrubs species for similar reasons.

The principles of wild gardening with herbaceous plants have been taken up and developed by horticulturalist-designers like Richard Hansen in Germany, who seeds and plants meadows and borders with exotic perennials carefully chosen to suit the habitat conditions and with the intention that they will at least maintain themselves if not naturalize. His plantings do not require conventional ongoing weed control, only the initial suppression of the most competitive 'weeds', in order to allow the introduced species enough time to establish.

The best British examples of wild gardens can be found in the woodlands of old established gardens such as Wisley in Surrey and Knightshayes Court in Devon. Here we can see perennials such as *Alstroemeria, Campanula lactiflora, Tradescantia, Astilbe, Astrantia major, Aconitum* and *Crocosmia* x *crocosmiiflora* spreading among showy natives like *Digitalis purpurea, Hieracium, Dactylorhiza* and *Geranium pratense* and competing vigorously with other indigenous woodland field-layer plants. The delight of this kind of association is in the spontaneity and luxuriance of growth which combines with as much colour and flower as would be found in any formal display.

Even if we do not stress the ecology of plant relationships at the design stage there will still be the chance to benefit later from the natural opportunism of both native and exotic plants. A groundcover of *Hedera helix*, for example, is an ideal site for the establishment of tree seedlings. Most tree species have little difficulty in growing through its low foliage and, once above it, will benefit from the high light levels but not suffer the intense competition that would come from vigorous weed growth. Trees like oak and ash, which carry a substantial food store in their seed, are capable of establishing above taller shrub groundcovers such as *Lonicera pileata* and *Symphoricarpos* x *doorenbosii*. Some ornamental shrubs such as *Buddleja davidii* and herbaceous plants such as *Alchemilla mollis*, set seed prolifically and their progeny emerge in large numbers from patches of bare earth, gravel and the joints in paving and walls. We can allow selected seedlings to establish and form part of the association as long as they are not likely to cause problems of shading or obstruction in the future. The result can be a lively spontaneity that would be difficult to achieve on the drawing board.

Plant Spacing

Planting distances often cause some consternation to students undertaking their first planting projects. This is because there are no hard and fast rules for a seemingly straightforward aspect of horticultural technique. In addition, students may be familiar with the planting distances employed in traditional parks and private gardens. These can be much greater than those suited to most landscape projects, and so the numbers of plants specified on landscape planting

plans can appear inordinately large. There are horticultural, practical and aesthetic reasons for these differences.

In most planting schemes for public authorities or other organizations, and even in some private gardens, one of the first objectives will be to reduce the labour of maintenance to the lowest level compatible with the character of the planting. This demands a weed-suppressing canopy as soon as possible. Most landscape contracts include a two-year aftercare and establishment period and the planting will stand the best chance of success after this period if substantial groundcover has already been achieved before the site is handed back to the client. The client is usually prepared to pay the capital cost of dense planting in order to keep the ongoing cost of maintenance as low as possible. Groundcover also allows us to get the maximum visual interest in the given area. Bare earth is not as attractive as foliage and flowers, so why continue to pay for it, year after year?

The popular tradition of widely spaced plants in cultivated ground derives from the methods of growing herbs and vegetables and flowers for cutting and also from the Gardenesque school of design in Victorian England. The originator of this style was J. C. Loudon who proposed that trees and shrubs be grown as specimens '... not pressed on during their growth by any other objects and allowed to throw out their branches equally on every side, uninjured by cattle or other animals; and, if touched by the hand of a gardener, only to be improved in their regularity and symmetry' (Loudon, 1838).

The Gardenesque style has remained strongly represented in public amenity horticulture to this day and this is reflected in public taste and in many private gardens. A typical spacing for flowering shrubs such as the larger *Philadelphus* or *Rhododendron* in a traditional park would be 2 metres or more apart. This will allow each plant to develop a full, spreading canopy and a gardener to hoe or spray beneath its canopy. However, if these shrubs were used in a landscape planting for quick establishment and weed suppression their spacing would need to be planted in a thicket between 1 and 1.5 metres, that is, between two and four times the density.

High planting densities common in landscape work do sometimes cause problems as the scheme approaches maturity. Species like broom (*Cytisus* species) and sea buckthorn (*Hippophae rhamnoides*) are apt to become drawn and leggy and this is exacerbated by close planting. In many cases this can be overcome by hard pruning to promote bushy growth from the base, but some shrubs, such as *Cytisus* and *Lavandula*, rarely recover from this treatment. For species that cannot be hard pruned we must either accept bare stems in the lower canopy or plant them more widely, with a carpet of groundcover below.

The precise spacing for a particular species will depend on several factors: its role in the association, the soil and climatic conditions, and the level of maintenance care that will be available. However, we can establish some rules of thumb for groundcover spacing. The mature height of the species gives some guidance, but there is no simple, direct relationship between height and spread and the choice of spacing and it is further complicated by the relative rates of growth of different species. For example, *Brachyglottis* 'Sunshine' and *Spiraea thunbergii* both grow to 0.8–1 metre tall in cultivation but the *Brachyglottis* is more spreading and faster growing and so can be planted at approximately half the density of the *Spiraea*. The mode of spread as well as the vigour of prostrate shrubs dramatically affect the time it takes to form a closed canopy over a given area. *Rubus tricolor* and *Juniperus sabina* 'Tamariscifolia' are similar in height but the speed of growth and the layering habit of *Rubus* enable it to cover large areas within two or three growing seasons. The juniper, on the other hand, spreads evenly but slowly, and to achieve cover in the same time would need to be planted at two or three times the density.

Because of such differences in habit and vigour good plant knowledge is necessary if we are to be confident of choosing the ideal spacing for any species in a particular location. However, it is possible to give indicative ranges of density for typical plants in a number of different categories, based on experience of their performance in a range of site conditions.

Table 11.1 Typical plant spacings

Plants	Spacing	Density
Vigorous alpines, compact dwarf herbaceous plants, dwarf grasses up to 200 mm high e.g. *Festuca glauca, Ophiopogon japonicus* *Ajuga reptans, Acaena caesiiglauca*	200–350 mm	25–8/m²
Spreading herbaceous plants, grasses and prostrate shrubs up to 300 mm high e.g. *Geranium macrorrhizum, Hebe pinguifolia,* *Liriope muscari, Scleranthus biflorus*	300–450 mm	11–15/m²
Dwarf hummock shrubs, herbaceous, grasses 300–500 mm high e.g. *Lavandula* 'Hidcote', *Felicia amelloides* *Sarcococca hookeriana* var. *humilis*	350–500 mm	8–4/m²
Vigorous spreaders, small to medium grasses up to 500 mm high e.g. *Hedera* 'Hibernica', *Convolvulus sabatius,* *Carex testacea, Fuchsia procumbens*	450–700 mm	5–2/m²
Small shrubs, medium grasses 500 mm–1.0 m high e.g. *Brachyglottis* 'Sunshine', *Coleonema* 'Sunset' *Viburnum davidii, Chionochloa flavicans, Convolvulus* *cneorum*	600–900 mm	3–1.25/m²
Medium shrubs, tall grasses 1.0 m–1.5 m high e.g. *Rhaphiolepis* × *delacourii* 'Enchantress', *Hebe* 'Midsummer Beauty', *Correa alba, Cortaderia fulvida*	700 mm–1 m	2–1/m²
Tall shrubs 1.5 m–2.5 m high e.g. *Pyracantha* cultivars, *Berberis linearifolia* 'Orange King', *Cassia corymbosa* 'John Ball', *Abelia* × *grandiflora*	800 mm–1.5 m	1.5–0.5/m²
Vigorous shrubs over 2.5 m high e.g. *Photinia davidiana, Amelanchier canadensis,* *Viburnum odoratissimum, Banksia ericifolia*	1–2 m	1–0.25/m²
Transplant trees and shrubs in mass plantation e.g. two- and three-year-old native trees and shrubs	1–2 m	1–0.25/m²

Note that heights apply to the foliage canopy at early maturity and under average growth conditions and that the categories for grasses should be taken to apply also to the sedges, rushes and other comparable plants. Within each category the least vigorous species should be spaced towards the dense end of the range and the most vigorous towards the sparse end of the range. In poor soil or high exposure, or if aftercare work must be kept to an absolute minimum, spacing should be at the close end of the range; but if growth conditions are very good and aftercare provision

generous, we can widen the spacing and economize on planting stock. For example, in average conditions *Brachyglottis* 'Sunshine' can be planted at 700 mm apart and be expected to form a more or less closed canopy after three years. If the growing season is long and moist two years will be sufficient. *Spiraea thunbergii* is rather slower spreading and would need an initial spacing of 500 mm to form groundcover in three seasons. In very poor, dry soil it would be advisable to plant *Brachyglottis* at 600 mm apart and *Spiraea* at 400 mm apart. In a deep, rich soil on a sheltered site we could plant *Senecio* at 900 mm apart and *Spiraea* at 600 mm apart.

Table 11.1 can be used as a guide but the best way to judge planting spacing is to observe planting schemes at various stages of development on the ground and assess the spacing used. We should remember that it is really only when a species has been planted in order to provide groundcover that spacing is critical. If it is to form a specimen group with groundcover provided by a lower layer of planting or if it is growing out of gravel or rocks (inorganic groundcover) then its spacing is purely a matter of aesthetic judgement.

On planting plans it is best to indicate centres (spacing) rather than density, because it is easier to achieve consistency by setting out at, say, 700 mm centres than by marking 1 metre × 1 metre squares and trying to decide exactly where in the square the two plants should be located. When it comes to the effectiveness of the planting it is the distance between each plant measured on the ground that is important. However, in the case of very close spacing the specification of density is acceptable because at, say, 250 mm apart the exact positioning of the 16 plants in each square metre matters little provided that they are evenly distributed.

When plant quantities are 'taken off' a drawing or we need to calculate a budget cost estimate, centres must be converted to densities in order to find the numbers required. Table 11.2 gives approximate equivalents accurate enough for calculating quantities in most circumstances.

Table 11.2 Converting spacing to density

Planting centres (mm)	*Planting density* (No/m²)
200	25
250	16
300	11
350	8
400	6
450	5
500	4
600	3
700	2
800	1.5
900	1.25
1000	1
1200	0.7
1500	0.45
2000	0.25

Note that these densities assume a square grid and that this grid can be staggered without affecting the quantity of plants. Much planting consists of even spacing but is not necessarily set out in lines. Such an arrangement would approximate to a staggered grid and so the same densities apply. Because careful placing of individual plants is often needed at the corners and edges of a bed it is wise to allow a few extra plants for this, or at least to round up the numbers to the nearest five or ten.

Setting Out

The setting out of planting never requires as much precision as is needed for some hard landscape. For most planting it is enough to draw the positions of groups and individuals on the plan so that they can be read with a scale rule. Sometimes, however, figured dimensions are advisable. Exact positions of plants lines in hedges are best set out by showing a dimension from a fixed point. The positions of specimen trees can be critical, and figured dimensions from a building, wall or pavement edge are needed. This is important in formal avenues, because the visual effect is dependent on a regular interval between trees. It may also be necessary to specify the distance of trees from underground or overhead services to make sure that planting meets guidelines and easements. Although most of these locations can be determined in the studio, it is often easier to locate trees in relation to services on site, at the time of planting. We can note on the planting plan that trees are 'to be set out on site by the landscape architect'.

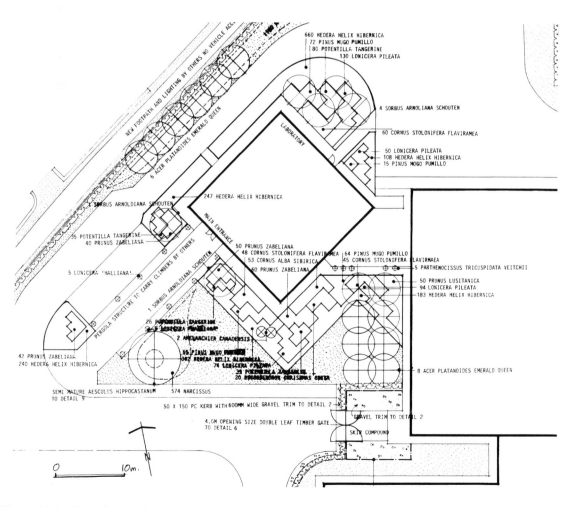

Figure 11.2 Part of a drawing showing ornamental shrub and tree planting around a unit in a technology park.

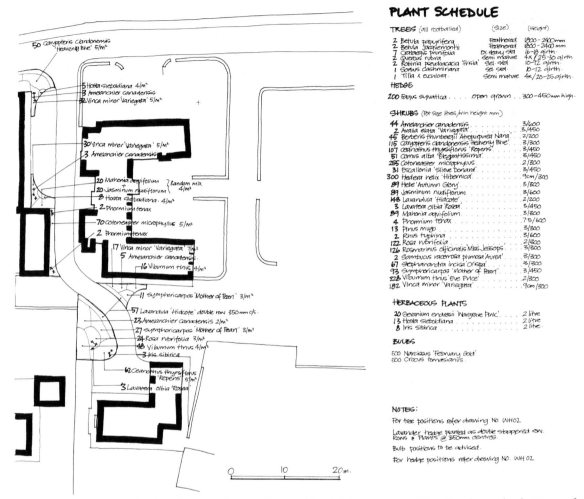

PLANT SCHEDULE

TREES (all rootballed)	(Size)	(Height)
2 Betula papyrifera	feathered	1800-2400mm
2 Betula 'jacquemontii'	feathered	1800-2400 mm
7 Crataegus prunifolia	ex. heavy std	16-18 girth
2 Quercus rubra	semi mature	4x/25-30 girth
2 Robinia pseudoacacia 'Frisia'	sel. std	10-12 girth
1 Sorbus cashmiriana	sel. std	10-12 girth
1 Tilia x euchlora	semi mature	4x/20-25 girth

HEDGE

200 Fagus sylvatica open grown . 300-450mm high.

SHRUBS (Pot size litres /min height mm)	
44 Amelanchier canadensis	3/600
2 Aralia elata 'Variegata'	3/450
45 Berberis thunbergii 'Atropurpurea Nana'	2/200
115 Caryopteris clandonensis 'Heavenly Blue'	3/300
107 Ceanothus thyrsiflorus 'Repens'	3/450
51 Cornus alba 'Elegantissima'	3/450
255 Cotoneaster microphyllus	2/300
31 Escallonia 'Slieve Donard'	3/450
300 Hedera helix 'Hibernica'	9cm/300
89 Hebe 'Autumn Glory'	3/300
89 Jasminum nudiflorum	3/600
148 Lavandula 'Hidcote'	2/200
3 Lavatera olbia 'Rosea'	5/450
89 Mahonia aquifolium	3/300
4 Phormium tenax	7.5/600
13 Pinus mugo	3/300
2 Rhus typhina	3/600
122 Rosa rubrifolia	2/300
126 Rosmarinus officinalis 'Miss Jessops'	3/300
2 Sambucus racemosa plumosa 'Aurea'	3/300
67 Stephanandra incisa 'Crispa'	3/300
93 Symphoricarpos 'Mother of Pearl'	3/450
228 Viburnum tinus 'Eve Price'	2/300
182 Vinca minor 'Variegata'	9cm/300

HERBACEOUS PLANTS

20 Geranium endressii 'Wargrave Pink'	2 litre
13 Hosta sieboldiana	2 litre
8 Iris sibirica	2 litre

BULBS

500 Narcissus 'February Gold'
500 Crocus tommasianus

NOTES:

For tree positions refer drawing. No. WH02

Lavender hedge planted as double staggered row.
Rows & Plants @ 350mm centres.

Bulb positions to be advised.

For hedge positions refer drawing No. WH 02

Plan labels:
- 50 Caryopteris clandonensis 'Heavenly Blue' 5/m²
- 5 Hosta sieboldiana 4/m²
- 8 Amelanchier canadensis
- 52 Vinca minor 'Variegata' 5/m²
- 30 Vinca minor 'Variegata' 5/m²
- 3 Amelanchier canadensis
- 20 Mahonia aquifolium + 20 Jasminum nudiflorum } Random mix 4/m²
- 8 Hosta sieboldiana. 4/m²
- 2 Phormium tenax
- 70 Cotoneaster microphyllus 5/m²
- 2 Phormium tenax
- 17 Vinca minor 'Variegata' 7/m²
- 5 Amelanchier canadensis
- 16 Viburnum tinus 4/m²
- 11 Symphoricarpos 'Mother of Pearl' 3/m²
- 57 Lavandula 'Hidcote' double row 350mm c/s
- 23 Amelanchier canadensis 2/m²
- 27 Symphoricarpos 'Mother of Pearl' 3/m²
- 24 Rosa rubrifolia 3/m²
- 48 Viburnum tinus 4/m²
- 3 Iris sibirica
- 62 Ceanothus thyrsiflorus 'Repens' 5/m²
- 3 Lavatera olbia 'Rosea'

Scale: 0 10 20 m.

Figure 11.3 Part of a drawing showing planting for a residential development. Note the domestic character of the planting which includes familiar garden species such as lavender, rose, tree mallow and hosta.

The advice given so far is applicable to all kinds of ornamental planting. There are some places and kinds of planting, however, which have additional constraints and opportunities. We will now look at how the designer can take advantage of these.

Raised Planting and Container Planting

Raised beds and container planting are common in streets, squares, courtyards, car parks and private gardens. They may be built for a variety of reasons: to allow for topsoil where there is none at ground level and excavations is not possible; to protect the planting from trampling; to provide spatial definition and enclosure; and to make planting more accessible to people, especially children and the disabled. Small containers, pots and hanging baskets are used to provide temporary and mobile flower and foliage displays for buildings, gardens and shows.

When we choose species for raised beds and containers we keep in mind the relatively inhospitable growth environment they will experience. The topsoil will

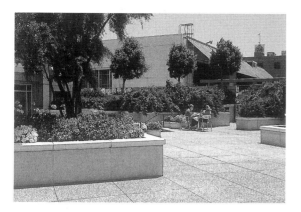

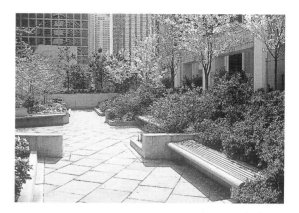

Plate 187 To allow luxuriant growth, planters that are separate from natural ground (such as these on a roof garden in San Francisco), must be of sufficient width and depth to provide adequate soil volume and avoid rapid drying out.

Plate 188 If raised planters are to include standard trees, a generous width is desirable because this allows good capture of natural precipitation (Union Square, Seattle, USA).

almost certainly have to be imported and may be composed of a mixture of mineral based, natural topsoil and manufactured composts and so we need to specify it closely to ensure quality. A minimum topsoil depth of 400 mm is advisable, unless the planting is restricted to undemanding groundcover species; and 500 mm would be better for small beds. Proper drainage is essential to avoid waterlogging. Raised beds are vulnerable to drought and so automatic irrigation can be a great advantage, but, for a small amount of planting, the cost of this may not be justified.

Unless they are irrigated, plants in raised beds and containers will experience more frequent and more severe water stress than those in natural ground. This is because the surface area for water collection is small, the lateral movement of ground water is obstructed, and the soil in the bed is either disconnected from natural ground (preventing upwards movement of water from the natural water table), or it is at least raised further above the natural water table. The water-holding capacity of a given volume of growing medium is partly dependent on its shape: the narrower and higher the bed, the less water will be held against gravitational drainage. This is one reason why wide raised beds are better than narrow ones. Widths of less than one metre will make establishment significantly more difficult.

Whatever the shape of the planter it is still wise to choose drought resistant species, particularly if the bed is in a sunny position where soil evaporation and plant transpiration are greater. Planting large nursery stock in raised planters is only likely to be successful if there is an irrigation system, because bigger transplants are particularly vulnerable to water stress. Standard trees, for example, in raised beds rarely establish and are often seen with severe die-back.

Raised planters are often found where planting space is severely restricted and so the designer needs to make maximum use of a small area. Tall growing shrubs provide the bulk of foliage, and trailing plants can be valuable when planted at the edges to clothe the sides of the planter.

Raised planting allows small shrubs and herbaceous plants to be easily enjoyed at close quarters. Because of this, raised planters can make planting more accessible to people with disabilities and also give an opportunity for intricate

and small-scale work that needs to be appreciated close-to. The planters and troughs traditionally used for displaying alpine plants are examples of the scale of horticulture that can be accommodated in raised planters and containers. This kind of intricacy is most successful if generic scale relationships are maintained by locating it in comparatively small scale spaces.

Walls, Pergolas, Trellis and other Vine Supports

These provide spatial definition, giving enclosure, separation and shelter, but they usually combine their structure role with a decorative one, so we will discuss their planting further. Vertical surfaces of walls and the open frameworks of pergolas, trellis and other plant supports provide prime opportunities to grow ornamental plants that cannot be established in the open. Also, the contrast between the architecture of the structure and the character of the plants heightens the qualities of both.

Masonry walls, whether free-standing or part of a building, affect the microclimate in their vicinity. If they face the midday sun, these walls will receive a great deal of direct sun during the day. The warmth is absorbed and reradiated at cooler times of day. Masonry walls work on the same principle as an electric storage heater, which contains bricks that store and slowly radiate heat. A wall that faces the afternoon sun (south-west in the northern hemisphere, north-west in the southern hemisphere) is ideal for plants that are not cold hardy. These walls absorb the midday and afternoon sun and retain warmth for longer after sunset than walls that get sun earlier in the day. Walls and fences also give shelter from wind and thus reduce transpiration on hot days and wind chill in the winter. Even walls that face away from the sun give some shelter and create a good growth environment for shade loving plants.

East-facing walls catch the early morning sun and, if this occurs after a severe night frost, the rapid warming of plant tissues can damage the foliage or flowers of less hardy species. So for east-facing walls in cold climates it is best to avoid plants such as some *Camellia* and *Magnolia* species that come into leaf or into flower in early spring when there is still danger of severe frosts.

Walls with a sunny aspect provide a great opportunity to extend the range of species and grow plants that are outstanding in their aesthetic qualities but unreliable without some protection. In cool temperate areas, *Ceanothus*, *Magnolia*, *Abutilon* and *Abelia*, for example, can be planted here with confidence. In warm temperate climates such sheltered protected locations allow the growth of subtropical species.

Overhead protection can be important for less hardy plants for two reasons. First, it reduces frost by interrupting radiation of heat from the ground. Second, it moderates the extremes of climate and creates a microclimate in which plants are less likely to dry out, suffer from wind chill and wind desiccation, and from overheating of leaf tissue. Vireya rhododendrons, orchids, many bromeliads and bouvardias all appreciate conditions of partial shade and shelter that resemble those of the forest interior.

West-facing walls are good locations for plants that benefit from protection from cold and windy aspects but do not like the hotter and dryer conditions of the midday sun. In Britain such plants include *Solanum crispum*, *Camellia* species and *Itea illicifolia*. A shady wall, although it does not provide a site for growing tender specimens, can be clothed with shrubs and climbers that flower and fruit well without extended sun exposure. *Pyracantha* cultivars, *Mahonia* x *media* and *Hydrangea petiolaris* species all enjoy the partial protection of a north-facing wall in Britain. Shade-loving foliage plants such as *Fatsia japonica*, *Hosta* species and

Plate 189 A south-west facing wall is an ideal location for growing tender climbers and shrubs such as *Camellia saluenensis, Cytisus battandieri, Acacia dealbata, Abutilon* species and *Magnolia grandiflora* (Bodnant, Wales).

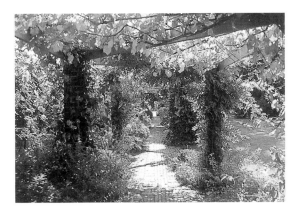

Plate 190 A well-proportioned pergola furnished with *Vitis, Wisteria* and *Clematis* at Barrington Court, UK.

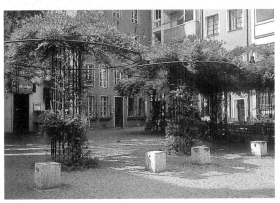

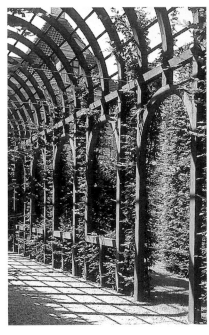

Plate 191 These steel and wire structures are specially designed to introduce vegetation into a busy confined space in Germany. The climber is *Wisteria*.

Plate 192 This pergola displays a relatively high proportion of structure to foliage but the balance is successful because of the quality of the timber-work at Het Loo, The Netherlands.

ferns find the conditions ideal because shade is provided without the dry conditions typical below a tree canopy.

Along with the advantages offered by wall culture there are two common problems. The soil adjacent to the bottom of a wall is likely to be dry because the masonry will absorb moisture. Also, the lime in mortar and foundation rubble causes an alkaline soil reaction and so calcifuges make poor wall shrubs. The other disadvantage is that a building wall topped by eaves or an overhang creates a rain shadow, and if there is no guttering the drip can also be damaging. Because of this, climbers and shrubs are best planted away from the wall (at least 300 mm) and trained towards it as they grow, and groundcover needs to be drip tolerant.

Plate 193 This decorative fence is designed with climbers in mind. *Hydrangea petiolaris* is able to scramble up the open timber-work with the aid of occasional tying in to the laths (German garden festival site).

Plate 194 *Vitis coignetiae* rambles through this double row of steel posts with the aid of wires strung between the posts and forms a sculptural combination of hard and soft elements at Broadwater Park, Denham, UK.

Pergolas, trellis, fences and arbours also provide the opportunity to grow climbers. Indeed climbers are usually essential ingredients in the success of these structures. Climbers fall into two general groups. There are those that twine and scramble over other trees and shrubs, attaching themselves by devices such as twining stems (e.g. *Wisteria*), tendrils (*Passiflora*), petioles (*Clematis*), or thorns (roses); and those climbers that attach themselves to tree trunks, rock faces and walls by means of aerial roots (e.g. *Hedera* and *Metrosideros* sp.) or small sucker pads (e.g. *Parthenocissus* sp.). The first group are ideal for pergolas and trellis where they can weave in and out of a framework. If they are to be grown against a wall, they need the support of a trellis or wires. The 'self clinging' climbers are less suited on an open framework, preferring a solid surface provided it is not too smooth, but they do benefit from a wire or small trellis to which they can be tied until their shoots have become attached to the surface.

The choice of climbers for pergolas and trellis depends on aspect, but because the structure is permeable, variations in shelter and shade will be less dramatic than for wall planting. The most demanding climbers should be reserved for sheltered walls. In northern Europe and other cool temperate areas these might include *Wisteria* species, *Vitis* species, *Akebia quintata*, *Aristolochia macrophylla*, *Campsis grandiflora* and *Eccremocarpus scaber*. For free-standing trellis, climbers need to be more dependable, like clematis (especially *C. montana* cultivars, *C. alpina* and *C. macropetala*), honeysuckles (*Lonicera periclymenum* and *L.* x *tellmanniana*) and climbing roses (such as *Rosa* 'Albertine' and *R.* 'Zephirine Drouhin'). Although roses are among the most showy of climbers we should remember that they do need a lot more pruning and training than other species and so may be unsuitable for many sites. Reliable climbers for warm temperate areas include *Campsis*, *Hardenbergia*, *Jasminum*, *Bougainvillea*, *Lonicera hildebrandtiana*, *Wisteria*, and such like.

The object of most climber and wall shrub planting will not be to create a continuous mass of foliage but to achieve a balance between the foliage area and the masonry façade or pattern of the climbing framework. Because of this, mass

planting and close spacing is not necessary and most wall shrubs and climbers are treated as specimens or small groups, while groundcover for the planting bed is provided by a lower canopy layer. The spacing of climbers on a wall is determined by the balance of foliage to wall that is wanted and the positions of windows and doors. Trellis and frameworks constructed specifically to support climbers could be more regularly and densely planted, but it is often best to keep a proportion of uncovered trellis to provide a contrast to the climber's foliage. Spacing most climbers between 1 and 3 metres apart, depending on their vigour, usually achieves a good balance.

Trellis, mesh or a climber framework can be used where a dense barrier and screen is needed quickly and in a narrow strip of ground. This kind of structure is like a narrow hedge and can be established within a width of about 0.5 metres. Such a 'living fence' would be planted generously with vigorous climbers. Russian vine (*Polygonum baldschuanicum*) and traveller's joy (*Clematis vitalba*) are the fastest growing and need only be planted at 2 metres apart along the line of the fence. If the living fence is located close to shrub planting it may be necessary to carry out regular tying-in and trimming as if it were a hedge, to make sure the climbers do not smother nearby shrubs. Other species are Japanese honeysuckle (*Lonicera japonica* 'Halliana') that, being evergreen, gives winter cover, *Clematis montana* and cultivars and the deciduous honeysuckles (especially *Lonicera periclymenum* and cultivars). These are less vigorous and so should be planted at 1–1.5 metres apart to achieve rapid cover.

Ornamental Planting in Specialized Habitats

We have discussed design and plant selection for various visual characters, microclimate and soil conditions. Ornamental planting can also be very effective in specialized habitats like ponds, boggy ground, gravel and boulder screes, rockeries and drystone walls. Here we need plants that are adapted to the

Plate 195 Alyssum and aubrietia have colonized and are being maintained over large areas of this stone retaining wall at Haddon Hall, Derbyshire, UK. They combine well with climbers and other planted species.

particular environmental conditions. In addition, the design objectives can be different. For example, complete groundcover is not needed in a scree garden or a pool because the stone and, of course, the water are part of the composition.

For discussion of design and species the reader is referred to the gardening and landscape literature on specialist gardening. Recommended as an introduction are Gertrude Jekyll's classic *Wall and Water Gardens*, introduced and revised by Graham Stuart Thomas (1983), and Allan Hart's chapter Water Plants in *Landscape Design with Plants* (1977). Although choice of species and growing techniques will be different for a pool margin than a shrub border, the principles and the process of design is the same. The guidance offered in this chapter would be a basis for ornamental design in all locations, but under more specialized growing conditions, horticultural expertise becomes increasingly important if we are to achieve a similar level of aesthetic success with the planting.

CHAPTER 12

Conclusion

With the help of planting design we can create a landscape which is both rewarding and inspiring to live in. It gives us the opportunity to enrich people's lives and to create special places of beauty. To achieve this is no mean feat, and this book's premise is that success depends on using the form of plants to give meaningful structure to space, and using their visual and other aesthetic qualities to enrich those spaces.

Planting could be regarded as living sculpture or living art. If it is an art, then it is a cultural and individual response to the natural world. Like other arts and crafts, planting design communicates meaning. To any person who stops to notice, it will say something about the ideas and the intentions of the creator. It is hoped that this book has helped to establish a language of planting design which will enable the designer to speak more purposefully and more eloquently.

Of course, we do not always intend to express personal or cultural themes directly, and sometimes we let natural processes speak for themselves. This is possible even within some of the most intensely humanized environments, but because of the extent of human pressure and urbanization on much of the world's habitable landscape, a conscious decision is often needed to make space for the spontaneous processes of nature. As planting designers we are in a position to assert the benefits of this laissez faire.

The technical and scientific aspects of planting have not been the focus of this book, but we should remember the importance of horticulture for the success of landscape design and the power of the natural sciences to argue the case for environmental responsibility and positive ecological action. Ecologists have shown the complexity of vegetation systems and inspired enthusiasm for habitat creation and nature-like planting – both for biodiversity and visual beauty. Planting design gives a way to unite the scientific understanding of the ecologist, the technical skill of the horticulturalist and the emotional and spiritual vision of the artist.

References and Further Reading

Appleton, J. H. (1986) *The Experience of Landscape*, Revised edn, London and New York: John Wiley & Sons.

Arnold, H. F. (1980) *Trees in Urban Design*, New York: Van Nostrand Reinhold.

Ashihara, Y. (1970) *Exterior Design in Architecture*, New York: Van Nostrand Reinhold.

Austin, R. L. (1982) *Designing with Plants*, New York: Van Nostrand Reinhold.

Bacon, E. N. (1974) *Design of Cities*, Revised edn, London: Thames & Hudson.

Baines, C. (1985) *How to Make a Wildlife Garden*, London: Elm Tree Books.

Baines, J. C. (1986) Design Considerations at Establishment, in Bradshaw, A. D., Goode, D. A. and Thorp, E. H. P. (eds) *Ecology and Design in Landscape*, the 24th Symposium of the British Ecological Society, Manchester (1983) Oxford: Blackwell Scientific Publications.

Beer, A. R. (1990) *Environmental Planning for Site Development*, London: Chapman & Hall.

Beever J. (1991) *A Dictionary of Maori Plant Names*, Auckland Botanical Society Bulletin No. 20, Auckland.

Beckett, G. and Beckett, K. (1979) *Planting Native Trees and Shrubs*, Norwich: Jarrold.

Billington, J. (1991) *Architectural Foliage*, London: Ward Lock.

Birren, F. (1978) *Colour and Human Response*, New York: Van Nostrand Reinhold.

Blackmore, S. and Tootill, E. (eds) (1984) *The Penguin Dictionary of Botany*, London: Allen Lane.

Bollnow, O. F. (1955) *New Geborgenheit*, 2 vols., Stuttgart: W. Kohlhammer.

Booth, N. K. (1983) *Basic Elements of Landscape Architecture Design*, Amsterdam: Elsevier.

Bourassa, S. C. (1991) *The Aesthetics of Landscape*, London: Belhaven Press.

Bradbury, M. (ed.) (1995) *The History of the Garden in New Zealand*, Auckland: Penguin.

Bryant, G. (ed.) (1997) *Botanica*, New Zealand: Albany.

Buckley, G. P. (1990) *Biological Habitat Reconstruction*, London: Belhaven Press.

Caborn, J. M. (1975) *Shelterbelts and Microclimate*, Forestry Commission Bulletin 29, London: HMSO.

Caborn, J. M. (1965) *Shelterbelts and Windbreaks*, London: Faber.

Carpenter, P. L. and Walker, T. D. (1990) *Plants in the Landscape*, 2nd edn, New York: W. H. Freeman.

Ching, F. D. K. (1996) *Architecture: Form, Space and Order*, 2nd edn, New York: Van Nostrand Reinhold.

Clamp, H. (1989) *Landscape Professional Practice*, Aldershot: Gower.

Clouston, B. (ed.) (1990) *Landscape Design with Plants*, 2nd edn, London: Heinemann.

Coombes, A. J. (1985) *Dictionary of Plant Names*, London: Hamlyn Publishing Group Ltd.

County Council of Essex (1973) *A Design Guide for Residential Areas*, Chelmsford: Essex CC.

Crowe, S. (1972) *Forestry in the Landscape*, Third impression with amendments, London: HMSO.

Cullen, G. (1971) *Townscape*, London: Architectural Press.

Dawson, J. (1988) *Forest Vines to Snow Tussocks, the story of New Zealand plants*, Wellington: Victoria University Press.

de Sausmarez, M. (1964) *Basic Design: The Dynamics of Visual Form*, London: Studio Vista.

Dewey, J. (1934) *Art as Experience*, New York: Perigee.

Dreyfuss, Henry (1967) *The Measure of Man: Human Factors in Design*, New York: Whitney Publications.

Eliovson, S. (1990) *The Gardens of Roberto Burle Marx*, London: Thames and Hudson.

Evans, B. (1983), *Revegetation Manual, a guide to revegetation using New Zealand Native Plants*, Wellington: Queen Elizabeth II National Trust.

Evans, J. (1984) *Sylviculture of Broadleaved Woodlands*, Forestry Commission Bulletin No. 62, London: HMSO.

Fieldhouse, K. and Harvey, S. (eds) (1992) *Landscape Design – an international survey*, London: Laurence King.

French, J. S. (1983) *Urban Space*, 2nd edn, Dubuque, Iowa: Kendal Hunt.

Gabites, I. and Lucas, R. (1998) *The Native Garden*, Auckland: Godwit.

Gilbert, O. L. (1989) *The Ecology of Urban Habitats*, London: Chapman and Hall.

Goethe, J. W. ([1840] 1967) *Theory of Colours*, trans. C. L. Eastlake, London: Frank Cass.

Goldfinger, E. (1941) 'The Sensation of Space', *Architectural Review*, November 1941.

Greater London Council (1978) *An Introduction to Housing Layout*, London: Architectural Press.

Greenbie, B. B. (1981) *Spaces*, New Haven and London: Yale University Press.

Griffiths, Mark (1994) *Index of Garden Plants*, The Royal Horticultural Society, Macmillan.

Gustavsson, P. (1983) The Analysis of Vegetation Structure in Tregay, R. and Gustavsson, P., *Oakwoods New Landscape*, Warrington: Sveriges Lantbruksuniversitet and Warrington and Runcorn Development Corporation.

Hart, A. (1977), Water Plants in Clouston, B. (ed.), *Landscape Design with Plants*, Heinemann.

Hansen, R. and Stahl, F. (1993) *Perennials and their Garden Habitats*, 4th edn, trans. R. Ward, Cambridge: Cambridge University Press.

Haworth Booth, M. (1961) *The Flowering Shrub Garden Today*, London: Country Life Ltd.

Haworth Booth, M. (1938) *The Flowering Shrub Garden*, London: Country Life Ltd.

Helios Software Ltd. (2002) *Helios Plant Selector*, CS Design Software, Leicester, www.gohelios.co.uk

Higuchi, T. (1983) *The Visual and Spatial Structure of Landscape*, Cambridge, Mass: MIT Press.

Hillier Nurseries (1991) *The Hillier Manual of Trees and Shrubs*, 5th edn, Newton Abbot, Devon: David & Charles.

Hobhouse, P. (1985) *Colour in Your Garden*, London: Collins.

Jakobsen, P. (1977) Shrubs and Ground Cover, in Clouston, B. (ed.) *Landscape Design with Plants*, London: Heinemann.

Jekyll, G. (1908) *Colour Schemes for the Flower Garden*, Country Life Ltd, London, reissued with revisions by G. S. Thomas, (1983) New Hampshire: Ayer.

Keswick, M. (1986) *The Chinese Garden*, 2nd edn., London: Academy Editions.

Keswick, M., Oberlander, J. and Wai, J. (1990) *In a Chinese Garden: The art and architecture of the Dr Sun Yat-Sen Classical Chinese Garden*, Vancouver: The Dr Sun Yat-Sen Garden Society.

Kingsbury, N. (1994) 'A Bold Brazilian' in *Landscape Design* (234), October, Reigate.

Kirk, T. (1889) *The Forest Flora of New Zealand*, Wellington: Government Printer.

Lancaster, M. (1994) *The New European Landscape*, Oxford: Butterworth Architecture.

Lancaster, M. (1984) *Britain in View: Colour and the Landscape*, London: Quiller Press.

Laseau, P. (2000) *Graphic Thinking for Architects and Designers*, 3rd edn, New York: John Wiley

Lisney, A. and Fieldhouse, K. (1990) *Landscape Design Guide, Volume I, Soft Landscape*, PSA and Gower Publishing Co.

Arboretum et Fruiticetum Britanicum, quoted in Turner, T. D. H., Loudon's Stylistic Development (1838), *Journal of Garden History*, Vol. 2, No. 2.

Lyall, S. (1991) *Designing the New Landscape*, London: Thames and Hudson.

Lynch, K. (1971) *Site Planning* 2nd edn, Cambridge, Mass.: MIT Press.

Lynch, K. and Hack, G. (1985) *Site Planning*, Cambridge, Mass.: MIT Press.

Matthews, J. D. (1989) *Sylvicultural Systems*, Oxford: Clarendon Press.

Metcalf, L. (1991) *The Cultivation of New Zealand Trees and Shrubs*, 2nd edn, Auckland: Reed.

Mitchell, A. (1974) *A Field Guide to the Trees of Britain and Northern Europe*, London: Collins.

Ministry of Agriculture, Fisheries and Food (1968) *Shelterbelts for Farmlands*, MAFF leaflet 15, HMSO.

Moore, C. W., Mitchell, W. J. and Turnbull, W. Jnr (1988) *The Poetics of Gardens*, Cambridge, Mass.: MIT Press.

Morton, J., Ogden, J. and Hughes, T. (1984) *To Save a Forest, Whirinaki*, Auckland: David Batemen.

Nelson, W. R. (1985) *Planting Design: A Manual of Theory and Practice*, 2nd edn, Champaign, Il.: Stipes Publishing Company.

Newman, O. (1972) *Defensible Space*, London: Architectural Press.

Newsome, F. P. J. (1987) *The Vegetative Cover of New Zealand*, Wellington: National Water and Soil Conservation Authority.

Notcutts Nurseries Ltd, *Notcutts' Book of Plants*, published annually, Woodbridge, Suffolk: Notcutts Nurseries Ltd.

Oehme, W. and Van Sweden, J. (1990) *Bold Romantic Gardens: the New World landscapes of Oehme and Van Sweden*, Port Melbourne: Lothian.

Oudolf, P. (1999) *Designing with Plants*, Conran.

Paddison, V. and Bryant, G. (2001) *Trees and Shrubs*, Auckland: Random House.

Palmer, S. J. (1994) *Palmer's Manual of Trees, Shrubs and Climbers*, Queensland: Lancewood.

Papanek, V. (1985) *Design for the Real World*, London: Thames and Hudson.

Pollard, E., Hooper, M. D., and Moore, N. W. (1975) *Hedges*, London: Collins.

Robinette, G. O. (1972) *Plants, People, Environmental Quality*, US Department of the Interior/ASLA.

Robinson, F. B. (1940) *Planting Design*, Champaign, Ill.: The Garrard Press.

Robinson, N. (1994) Place and planting design – planting structures, *The Landscape*, No. 54.

Robinson, N. (1993) Place and planting design – plant signatures, *The Landscape*, No. 53.

Robinson, N. (1993) Planting: new dimensions, *Landscape Design*, No. 220.

Robinson, W. ([1870] 1983) *The Wild Garden*, London: Century Publishing.

Salisbury, E. J. (1918) *The Ecology of Scrub in Hertfordshire* in Trans. Herts. Natural History Society, 17.

Scott, I. (trans. 1970) *The Lüscher Colour Test*, London: Jonathan Cape Ltd.

Simonds, J. O. (1983) *Landscape Architecture*, 2nd edn, New York: McGraw Hill.

Stevens, P. S. (1976) *Patterns in Nature*, Harmondsworth, England: Penguin.

Stilgoe, J. R. (1984) Gardens in context, in *Built Landscapes*, Vermont: Battleboro Museum and Art Centre.

Sydes, C. and Grime, J. P. (1979) Effects of Tree Litter on Herbaceous Vegetation, *Journal of Ecology*, 66.

Tanguy, F. and Tanguy, M. (1985) *Landscape Gardening and the Choice of Plants*, Sheridan (trans.) University Press of Virginia.

Tansley, A. G. (1939) *The British Isles and their Vegetation*, Cambridge: Cambridge University Press.

Thomas, G. S. (1990) *Perennials – A Modern Florilegium*, London: J. M. Dent and Sons Ltd.

Thomas, G. S. (1985) *The Old Shrub Roses*, 4th edn revised, London: J.M. Dent and Sons Ltd.

Thomas, G. S. (1984) *The Art Of Planting*, London: J. M. Dent & Sons.

Thomas, G. S. (1983) Gertrude Jekyll's *Wall and Water Gardens*, New Hampshire: Ayer.

Thomas, G. S. (1967) *Colour In The Winter Garden*, London: J. M. Dent & Sons.

Tregay, R. (1983) *Design Revisited*, Sweden: Sveriges Lantbruksuniversitet.

Tregay, R. and Gustavsson, R. (1983) *Oakwoods New Landscape*, Warrington: Sveriges Lantbruksuniversitet and Warrington New Town Development Corporation.

Turner, T. D. H. (1838) Loudon's Stylistic Development, *Journal of Garden History*, Volume 2, No. 2 pp. 175–88.

Turner, T. D. H. (1987) *English Garden Design: History and Styles since 1650*, Antique Collector's Club.

Walker, P. and Simo, M. (1998) *Invisible Gardens – the Search for Modernism in the American Landscape*, Cambridge, Mass.: MIT Press.

Walker, T. D. (1990) Basic principles of planting design, in Carpenter, P. L. and Walker, T. D., *Plants in the Landscape*, 2nd edn, New York: W. H. Freeman.

Walker, T. D. (1988) *Planting Design*, Mesa, Arizona: PDA.

Ward, Richard (1989) Harmony in Wild Planting in *Landscape Design* No 186, pp. 30–32, Reigate, Surrey: Landscape Design Trust.

Wardle, P. (1991) *Vegetation of New Zealand*, Cambridge: Cambridge University Press.

Index